# Sisters of the Brush

Women's Artistic Culture in Late
Nineteenth-Century Paris

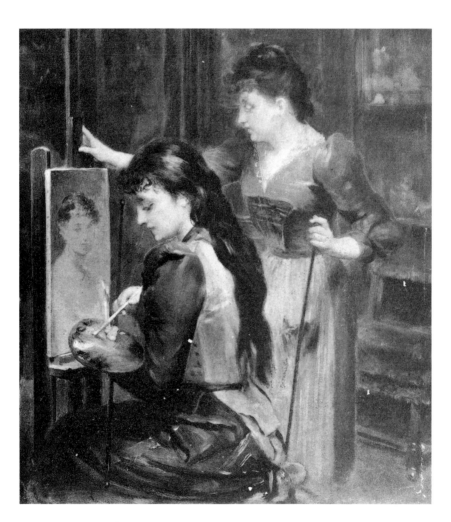

# Sisters of the Brush

## Women's Artistic Culture in Late Nineteenth-Century Paris

Tamar Garb

Yale University Press
New Haven and London
1994

For my grandparents, Anne and Jack Bloch

Designed by Miranda Harrison
Set in Sabon by Best-set Typesetter Ltd, Hong Kong
Printed and bound in Great Britain by Bath Press, Avon

**Library of Congress Cataloging-in-Publication Data**

Garb, Tamar.
Sisters of the Brush: women's artistic culture in late
nineteenth-century Paris / Tamar Garb.
p.   cm.
Includes bibliographical references and index.
ISBN 0-300-05903-5
1. Union des Femmes peintres, sculpteurs, graveurs, décorateurs – History.
2. Feminism and art – France – History – 19th century.
I. Title.
N72.F45G37   1994
701'.03 – dc20

93-43147
CIP

A catalogue record of this book is available from
The British Library

Frontispiece: Detail from fig. 29, Mlle J Houssay, *Un Atelier de Peinture*

# Contents

4

$41.85

BITCH

# Acknowledgements

LIKE ALL DISSERTATIONS that have been transformed into books, this project has been long in the making. It was begun ten years ago, during which time I have accrued many debts and drawn widely on the support and expertise of family, friends, colleagues and teachers. My involvement with this research project has paralleled my involvement with the women's movement, and it is to the strength and vigour of thought that I have found in that arena that the book owes its major debt. But there are more specific debts which I would like to acknowledge. My thanks are due to John House and Griselda Pollock for their willingness to supervise the project as a dissertation, and for the comments and advice which they gave me during the course of its progress. The work of the late Nicholas Green provided a model for me at a very crucial stage in the development of the project. Lisa Tickner and Helen Weston both read the manuscript in its entirety and gave me invaluable feedback and encouragement. Linda Nochlin has been both a critical reader and invaluable friend during the time that I have worked on this project. Her professional judgement, intelligence and warmth have sustained me through many rough patches. I shared, at different times, the joys and sorrows of the Paris archives with Neil MacWilliam, Adrian Rifkin, Katy Scott, Abigail Solomon-Godeau and Martha Ward, all of whom showed me their own path through its sometimes terrifying complexities. Research summers in Paris would not have been possible without the generous hospitality of the Couder family, whose house in the 13th arrondissement was the true site of production for much of the thinking that went into this book, and for the socialising that was one of its more pleasant by-products. My task was often made easier by the help of long-suffering librarians who struggled to maintain their equilibrium in the stifling summer heat. I am particularly grateful to librarians at the Bibliothèque Nationale, Archives Nationales, Bibliothèque Historique de la Ville de Paris, Archives de la Préfecture de Police, Bibliothèque Marguerite Durand and Bibliothèque Jacques Doucet.

At home in London, Caroline Arscott, Briony Fer, Tag Gronberg, Andrew Hemingway, Alex Potts and David Solkin were often there when I needed support, encouragement and lengthy phone conversations. Kathleen Adler has been a willing listener and critical reader from the beginning of the project, and has offered sound advice and much support throughout. Gillian Malpass has been a model editor; patient, astute and, where necessary, indulgent. Miranda Harrison has painstakingly copy-edited the manuscript. Moira Benigson, Thelma Koorland, Vivienne Koorland and Myra Stern have listened to more moaning and complaining than any friends should have been asked to bear and have not, as yet, deserted me.

My family, as always, has given me the strength and wherewithal to complete this book.

My parents, Ivor and Cynthia Garb, have helped me in more ways than they can imagine and without them none of this would have been possible. My husband, Rasaad Jamie, has shared the entire project with me, listening tirelessly to uncompleted drafts, commenting, cajoling and criticising as the occasion demanded. My son, Gabriel Jamie, was born at the crucial stage of transition from dissertation to book, and his arrival both delayed its completion and initiated me into a creative but anxious encounter with one of the central conflicts of womanhood. I would not have done without it for anything in the world. But it is to my grandparents, Anne and Jack Bloch, that I dedicate this book, for their fortitude, their strength, and their love.

# Introduction

THE AIM OF THIS BOOK is twofold. On the one hand, it sets out to tell a story that has never been told, on the other to rewrite an old narrative from a new perspective. Paris has long been enshrined as the 'capital of the nineteenth century', not only by its contemporary chroniclers, but by subsequent cultural historians. Yet it is, for the most part, a highly selective Paris that has functioned in this way, the Paris of the boulevards, music halls and public spaces, the Paris of discreet encounters, sexual promise and seductive glances.[1] In this metropolitan space 'Woman' functions as a sign, a spectacle, an object of exchange. Icon of modernity, allegory of State, object of consumption, she is enshrined in the iconography of the city at all institutional levels, on the walls of the Salon, the pages of the news-sheets, the public statuary of State. In such a narrative women are silent. They are spoken through, they are spoken of, but rarely heard. Their presence as image is dependent on their silence as subjects.

Listening to the voices of a particular group of women, this book tries to do justice to the situation that they speak. Not that such a strategy offers access to the authentic voice of women. Our 'heroines' frequently sound more like ventriloquists' dummies than autonomous agents. They function variously as mouthpieces of the State, the Church, the family, but they do offer an alternative view of these institutions, even if it is one which ultimately re-enshrines their authority. For us, their perspective is invaluable. It offers a way out of the tired clichés of modernist narratives with their paper cut-out heroes, over-trampled masterpieces, and simplistic institutional models. The margins offer a position from which to turn the tables on the centre, not in order to reverse old systems of value, to revise the canon and exchange new masterpieces for old, but to enter the world of the 'Other', to discover its complexity, untangle its intricacy, and split apart its mythic unity.

This account attempts to examine a complex world of institutions, political enagagements and aesthetic theories. In telling the story of the *Union des Femmes Peintres et Sculpteurs*, it tries to be adequate to the fortitude, commitment and energy of the founders and members of the first all-women's exhibiting society in France. In many ways, their conflicts, struggles and debates remain ones which are vivid and relevant to contemporary feminist art practice. The value of separatism, the problems of selectivity, elitism, coercion and collusion remain issues for women artists and critics today. It is important to know that we did not invent these issues, but that some one hundred years ago, in very different historical circumstances, they were already vivid and urgent. But this is by no means the whole story. The *Union des Femmes Peintres et Sculpteurs* did not operate in isolation. It functioned in a particular historical and institutional context to satisfy the perceived needs of a group of women. That context is as much the world of political

activity as artistic endeavour. It is as a site for the interplay of these, of their absolute indissolubility, that the *Union* and its annual exhibitions offer a useful model. In the physical layout of the exhibitions, the organisational structure of the *Union*, and the writing that it generated, art and politics met over the question of gender.

The *Union* provides, therefore, a focus for a re-examination of the most over-visited field of art history, that of late nineteenth-century Paris. By starting from a different position, this book aims both to uncover a world which has hitherto been hidden, and to tell a new story about an old territory. The conventional heroes of modern art appear in this account as shadowy figures haunting the edges of the narrative. Their marginalisation is both strategic and necessary if an alternative history is to be written, one which stands outside of the conventional oppositions which structure perceptions of the period. At the same time, institutions which have hitherto been regarded as progressive are revealed to be divisive and reactionary when viewed from the perspective of contemporary women. This is true, for example, of the exclusive world of men's private clubs which characterised bourgeois metropolitan culture. On the other hand, institutions which history has labelled backward-looking and outmoded, like the *Ecole des Beaux-Arts*, achieve an urgency and new meaning in relation to women's aspirations. Women's vision, understood symbolically, provides a new angle from which to look. It involves seeing from a different subject position, one which dislodges the received wisdom of conventional accounts.

The choices, both aesthetic and political, that the *sociétaires* of the *Union des Femmes Peintres et Sculpteurs* made, are not necessarily those that feminist art historians would prefer. Nor can we easily identify with the narratives of self that they wove, but we can try to explain these in relation to the realm of possibility within which they lived. This book aims to do just that. It begins by constructing the story of the first fifteen years of the *Union*'s existence, a tale which gives a detailed account of how the organisation worked, what issues were at stake in its structure, what crises, difficulties and decisions it faced. These are then placed into a more synchronic perspective and read across contemporary institutional and discursive formations. Specifically, the *Union* is situated in the broader institutional context of the Paris art world, contemporary educational debates and the complex field which is late nineteenth-century feminism. Contemporary perceptions of the *Union* are analysed through an assessment of the critical response to its annual exhibitions, and this is juxtaposed with the rhetoric evolved by the members to make sense of their position in the world. The study starts, therefore, with a close institutional analysis of the *Union*, proceeds to the wider context in which it was situated, and concludes by focusing back on the *Union*, but this time engaging with its strategies of self-narration which are best understood in relation to the wider political and artistic context.

This is a book about women, about their relationship to the category 'Woman', and about an art world as experienced by those to whom it was only accessible in highly circumscribed ways. In the telling confrontation of 'Woman' and 'Art' lies a story which goes to the heart of late nineteenth-century constructions of subjectivity, sociality and national identity. Our understanding of these, and of the role of art as a site of their articulation, depends on looking beyond the prism through which Paris is so often projected, beyond conventional judgments of value, and beyond the boundaries traditionally erected by the discipline of Art History.

# Chapter 1

# Vision and Division in the Sisterhood of Artists

> Let us gather together to count ourselves, to defend ourselves! Let us be united for the faithful struggle. Let us call ourselves the "Union of Women Painters and Sculptors".[1]

IT WAS WITH THESE WORDS that the sculptor and teacher, known as Mme Léon Bertaux, inaugurated the first sustained attempt by women artists in France to organise themselves collectively. Mme Bertaux's words have the feeling of a rallying cry, a call to arms. They convey the implicit belief that women's interests could best be served by collective action. As a union, strong in number and united in purpose, claimed Mme Bertaux, women artists could achieve together what few could manage as individuals. As a group, they would be able to improve their own status as artists whilst making an indispensable contribution to the artistic culture of France. Without the union they, and the nation, would be the poorer.

Something of the tenor of this unique and complex organisation is captured in the phrase by which Rosa Bonheur, their model and mentor, referred to the *sociétaires*, the members of the *Union*. Writing to explain her absence from their *grand banquet* in 1895, she addressed them as her *soeurs de pinceau*, her 'sisters of the brush'.[2] The conjunction set up by these words invokes a sorority united in a public and professional endeavour, a familial group with a common purpose, a group of women gathered around a masculine totem. For that which draws this group of disparate women together, that around which they all rally, is a professional implement strangely phallic in its associations. It belongs to the world of men. Women's relationship to it, and their right to claim it for themselves, is complex, even ambivalent. Their embracing of the familial term 'sisters' is equally telling. It suggests the ideal relationship of community and support which the rhetoric of the *Union* fostered, but which the reality of working together could not always sustain. Bonds of affection, conspiratorial and collusive allegiances, and shared experiences, were offset by envy and competitiveness, rivalry and personal ambition. Like sisters, the members of the *Union des Femmes Peintres et Sculpteurs* were bonded together against the hostility of an exclusionary outside world, but like sisters they had to deal with the negative emotions which characterise all classic family dramas. Politics and power were to intervene in the fantasy of plenitude which sisterhood connoted. The sisters, like faithful but exacting brides, rallied around the paintbrush, that world of public practices and institutions called 'Art', measuring themselves in relation to it, investing their energies into its reform and wanting more than anything to have a stake in its power base. Inevitably,

both political and personal differences between women were to surface and erode the unity which Mme Bertaux and the founding members had seen as the bedrock of the organisation.

At the moment of its formation in the spring of 1881, however, it was the idea of creating a united front against the hostility of an exclusionary art world that propelled the *Union* forward. That many women felt the need for such collective action is demonstrated by the rapid growth of the organisation. From an exclusive coterie gathering around the dynamic personality of Mme Bertaux, with her home in the avenue de Villiers as its headquarters, the *Union* grew into a major public arts organisation. At the time of its first *Salon des femmes* (women's exhibition), held in January 1882, there were forty-one *dames fondatrices* or founding women. By 1896, the year that the first women were permitted to attend classes at the *Ecole des Beaux-Arts*, there were no fewer than 450 paid-up *Union* members, with 295 women showing nearly 1000 works at the fifteenth annual exhibition.[3]

Like all official organisations in France during this period, the *Union* had to follow strict guide-lines in its internal organisation and structure. Annually published statutes, giving details of regulations for members and obligations of title holders in the *Union*'s hierarchy, were very important, not only in providing a written constitution for the conduct of business, but as part of the necessary process of legitimising the society by the *Préfecture de Police*.[4] Anxiety that private organisations would be used for politically subversive ends still haunted the Republican administration during this period. Political clubs remained banned, and all societies had to apply for official sanction to reassure the authorities of their apolitical nature. Although laws on social gatherings had been considerably liberalised since the consolidation of the power of the Republicans in the Assembley in the late 1870s, it remained obligatory to inform the authorities of the place, day and hour of all public meetings, make no modification to the published statutes without police permission, admit only registered members to meetings, lodge the minutes of all meetings with the police, and provide them with an annual list of the names, addresses and professions of all the *sociétaires*, as well as copies of all special documents on changes in personnel and financial affairs. Infringements of these restrictions could mean the immediate dissolution of the Society. This women's organisation functioned therefore under the watchful eye of a paternalistic State, pandying to its demands, craving its approval and even seeking out its official accolades. An important contradiction of the *Union* resides in its strange amalgam of reformist fervour with its reverence for existing symbols of authority. For the *Union* not only tolerated State surveillance, it embraced it, opening itself up to scrutiny by seeking to legitimate and valourise its activites with conventional markers of success. Symptomatic of this was the three-year struggle in which the *sociétaires* campaigned for recognition as a '*société d'utilité publique*', a society of public service, finally awarded by the State in 1888.[5] The award was seen by the *sociétaires* as a public sanction of their aims. Such recognition, it was believed, would contribute to the status of the organisation and help to raise the standard of exhibits at the *Salons des femmes*. It was around the fraught question of standards and quality that internal conflict within the *Union* was to emerge, eventually leading to the unseating of Mme Bertaux as its president by the successful young painter, Virginie Demont-Breton. Both women were

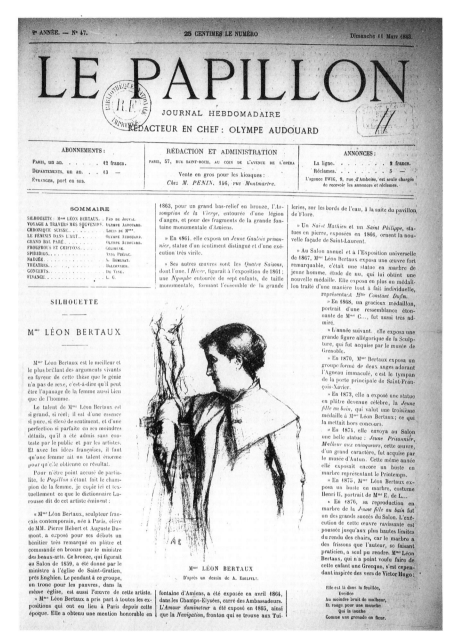

1. Engraving of Mme Léon Bertaux on front page of *Le Papillon* (11 March 1883); Bibliothèque Nationale, Paris.

charismatic figures who drew public attention, and were featured on the cover of the literary journal *Le Papillon* in the early 1880s (figs. 1 and 2).

From the start, the *Union* had defined its aims somewhat differently from those of other emergent exhibition societies. This was no conventional artists' organisation, committed to the prestigious display of its members' work to enhance their personal reputations. Although the provision of a high profile exhibiting forum for ambitious individual artists, intent on selling their works, was central to the *Union*'s project, this goal was carefully

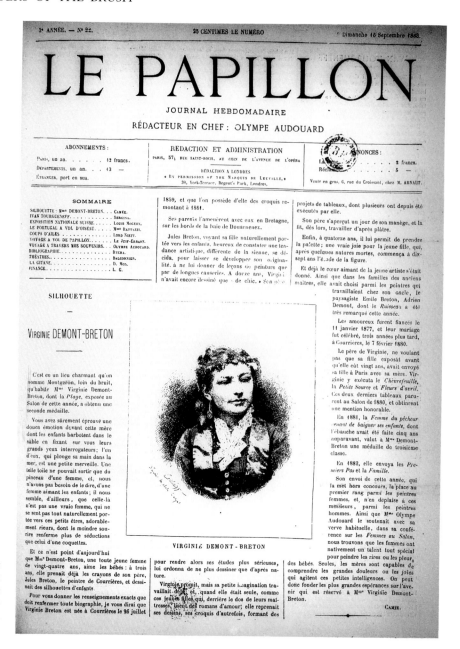

3ᵉ ANNÉE. — N° 22.          25 CENTIMES LE NUMÉRO          Dimanche 16 Septembre 1883.

# LE PAPILLON

JOURNAL HEBDOMADAIRE

RÉDACTEUR EN CHEF : OLYMPE AUDOUARD

| ABONNEMENTS : | RÉDACTION ET ADMINISTRATION | ANNONCES : |
|---|---|---|
| Paris, un an . . . . . . 12 francs. | PARIS, 57, RUE SAINT-ROCH, AU COIN DE L'AVENUE DE L'OPÉRA | La . . . . . . . . 2 francs. |
| DÉPARTEMENTS, un an . . 13 — | RÉDACTION A LONDRES | Récl . . . . . . . 5 — |
| ÉTRANGER, port en sus. | « BY PERMISSION OF THE MARQUIS DE LEUVILLE, » 30, York-Terrace, Regent's Park, Londres. | Vente en gros, 6, rue du Croissant, chez M. ARNAUT. |

## SILHOUETTE

—

### VIRGINIE DEMONT-BRETON

C'est en un lieu charmant qu'on nomme Montgeron, loin du bruit, qu'habite Mᵐᵉ Virginie Demont-Breton, dont la *Plage*, exposée au Salon de cette année, a obtenu une seconde médaille.

Vous avez sûrement éprouvé une douce émotion devant cette mère dont les enfants barbotent dans le sable en fixant sur vous leurs grands yeux interrogateurs; l'un d'eux, qui plonge sa main dans la mer, est une petite merveille. Une telle toile ne pouvait sortir que du pinceau d'une femme, et, nous n'avons pas besoin de le dire, d'une femme aimant les enfants; il nous semble, d'ailleurs, que celle-là n'est pas une vraie femme, qui ne se sent pas naturellement portée vers ces petits êtres, adorablement rieurs, dont le moindre sourire renferme plus de séductions que celui d'une coquette.

Et ce n'est point d'aujourd'hui que Mᵐᵉ Demont-Breton, une toute jeune femme de vingt-quatre ans, aime les bébés : à trois ans, elle prenait déjà les crayons de son père, Jules Breton, le peintre de Courrières, et dessinait des silhouettes d'enfants.

Pour vous donner les renseignements exacts que doit renfermer toute biographie, je vous dirai que Virginie Breton est née à Courrières le 26 juillet

1859, et que l'on possède d'elle des croquis remontant à 1861.

Ses parents l'amenèrent avec eux en Bretagne, sur les bords de la baie de Douarnenez.

Jules Breton, voyant sa fille naturellement portée vers les enfants, heureux de constater une tendance artistique, différente de la sienne, se décida, pour laisser se développer son originalité, à ne lui donner de leçons de peinture que par de longues causeries. A douze ans, Virginie n'avait encore dessiné que de chic. Son père

VIRGINIE DEMONT - BRETON

pour rendre alors ses études plus sérieuses, lui ordonna de ne plus dessiner que d'après nature.

Virginie promit, mais sa petite imagination travaillait déjà, et, quand elle était seule, comme ces jeunes filles qui, derrière le dos de leurs maîtresses, lisent des romans d'amour; elle reprenait ses dessins, ses croquis d'autrefois, formant des

projets de tableaux, dont plusieurs ont depuis été exécutés par elle.

Son père s'aperçut un jour de son manège, et lui fit, dès lors, travailler d'après plâtre.

Enfin, à quatorze ans, il lui permit de prendre la palette; une vraie joie pour la jeune fille, qui, après quelques natures mortes, commença à dix-sept ans l'é.ude de la figure.

Et déjà le cœur aimant de la jeune artiste s'était donné. Ainsi que dans les familles des anciens maîtres, elle avait choisi parmi les peintres qui travaillaient chez son oncle, le paysagiste Émile Breton, Adrien Demont, dont le *Ruisseau* a été très remarqué cette année.

Les amoureux furent fiancés le 11 janvier 1877, et leur mariage fut célébré, trois années plus tard, à Courrières, le 7 février 1880.

Le père de Virginie, ne voulant pas que sa fille exposât avant qu'elle eût vingt ans, avait envoyé sa fille à Paris avec sa mère. Virginie y exécuta le *Chèvrefeuille*, la *Petite Source* et *Fleurs d'avril*. Ces deux derniers tableaux parurent au Salon de 1880, et obtinrent une mention honorable.

En 1881, la *Femme du pêcheur venant de baigner ses enfants*, dont l'ébauche avait été faite cinq ans auparavant, valut à Mᵐᵉ Demont-Breton une médaille de troisième classe.

En 1882, elle envoya les *Premiers Pas* et la *Famille*.

Son envoi de cette année, qui la met hors concours, la place au premier rang parmi les peintres femmes, et, n'en déplaise à ces messieurs , parmi les peintres hommes. Ainsi que Mᵐᵉ Olympe Audouard le soutenait avec sa verve habituelle, dans sa conférence sur les *Femmes au Salon*, nous trouvons que les femmes ont nativement un talent tout spécial pour peindre les rires ou les pleurs des bébés. Seules, les mères sont capables de comprendre les grandes douleurs ou les joies qui agitent ces petites intelligences. On peut donc fonder les plus grandes espérances sur l'avenir qui est réservé à Mᵐᵉ Virginie Demont-Breton.

CAMÉE.

2. Engraving of Mme Virginie Demont-Breton on front page of *Le Papillon* (16 September 1883); Bibliothèque Nationale, Paris.

balanced with more idealistic and far-reaching aims. Here was an organisation intent on providing a context for the flowering of 'feminine' art, of offering support to younger and struggling women artists, of representing their interests and campaigning for reform in the wider Paris art world, and of contributing to the elevation of artistic standards in general. Individual ambition was to be balanced with an altruism deemed fitting to women's nature and sensibility.[6] Some supporters and members even campaigned for a programme which would improve women's intellectual, professional and creative lives in the broadest

sense. There was talk of creating a library for women artists, of expanding the *Union* to become an umbrella institution for all sorts of useful services for women, including medical advice, courses, lecture programmes and bursaries. Through the publication of an ambitious journal, the *Journal des femmes artistes*, the establishment of headquarters, the founding of a women's archive, and even the creation of a small museum, it was envisaged that women artists could construct an entire world for themselves which would nourish their ambitions and provide a context for the exchange of information and views.[7] In the event, few of these wider ambitions were realised. But the *Union* did become the major campaigning body for women artists, the *Salons des femmes* were big, successful events, the fortnightly *Journal des femmes artistes* operated for a time as an organ of communication and a vehicle for the dissemination of information to all *sociétaires*, and Mme Bertaux's home functioned as the operational headquarters and, after 1891, as a social centre for women artists. (Her home was opened on Friday afternoons and evenings for the exchange of ideas about art.) Both informal and formally orchestrated gatherings became part of union life. Annual general meetings were meticulously organised and scrupulously conducted. These provided opportunities for dealing with administrative business, voting for new office bearers, debating issues of general concern, voting on policy (schematised in the annually published statutes), reassessing direction and hosting guest speakers invited to talk on relevant topics. In the 1890s, solidarity and unity were fostered by the organisation of annual banquets which became sumptuous events widely reported in the general press. Selected critics, government administrators and famous male artists were invited to attend and sometimes to address the gatherings.

During its first twelve years, the aims and ambitions of the *Union* were dominated by the powerful personality of its first president. Although the early statutes had stipulated that office holders in the *bureau*, the executive committee, should not remain in their positions for longer than three years, this policy was never upheld.[8] By popular demand Mme Bertaux was re-elected four times until she was finally replaced in 1894 by the younger Virginie Demont-Breton. Mme Bertaux never escaped from perceiving herself as a teacher. She had faith that, with proper support and encouragement, even the youngest and least experienced women artists could contribute to the creation of a vibrant artistic culture for women. At any rate, it was up to more experienced and talented artists to provide an example for them and the necessary encouragement they needed. She herself had achieved considerable success both as an exhibitor at the Salon and with private commissions. By the time of the founding of the *Union* she had an established reputation as a sculptor. Born Hélène Pilate, she had first shown in the Salon in 1849 under the pseudonym 'd'Allelit', but from 1857 used her married name to sign her work. By 1881, a number of her works had already been acquired by the State, including the *Assomption de la Vierge*, shown in the Salon of 1861 and bought in 1868, and *Une Jeune Gaulois Prisonnier*, bought in 1867 (fig. 3). She had received a number of State commissions, notably for *Une Jeune Fille au Bain*, shown in the Salon of 1876 and the *Exposition Universelle* of 1878, and had executed prestigious works for the city of Paris and numerous churches (figs. 4, 5).[9] Mme Bertaux was also widely respected as an art educator. In 1873 she had opened the *ateliers d'études*, courses in sculpture for young girls and women, having become aware of the paltry training facilities available to aspirant

3. Mme Léon Bertaux, *Une Jeune Gaulois Prisonnier* (1867); Musée des Beaux-Arts, Ville de Nantes.

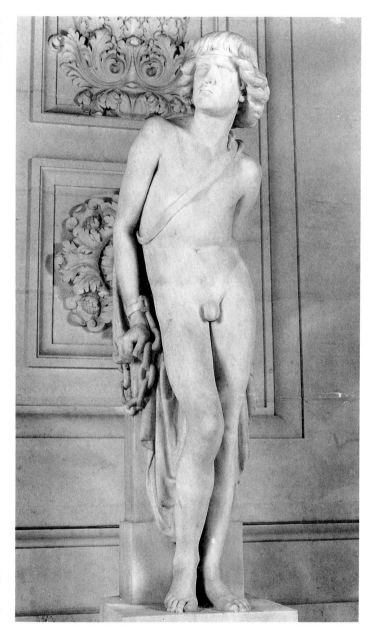

4 and 5 (facing page). Mme Léon Bertaux, *Une Jeune Fille au Bain* (Salon 1876); Musée Dénon, Chalon Sur Saône.

women sculptors in Paris. The success of these led her, in 1879, to build a sculpture school for women. According to her biographer, Edouard Lepage, it was through her involvement with her students and her awareness of the difficulties which aspiring women artists faced, that she conceived of the idea of an organisation which could represent the interests of all serious women artists, irrespective of the level of competence they had reached, and would facilitate the exhibition of their work.[10] Confident of her own reputation as an artist, and committed to the pedagogical role she had assigned herself, Mme Bertaux saw

the *Union* and its annual *Salons des femmes* as much a facilitating institution as a forum for display. At a meeting of the general assembly of 1885, she put forward her very strong views on the matter:

> There are two distinct elements that compose our Society, consummate talents and nascent talents: the first provides an attraction for the public whom it draws to this special *Salon* by the display of its works, and then there are the novices to art, nascent talents, the weak, equally placed on display who follow the example and sometimes receive advice from the stronger ones. In this way the real talents provide a generous service.[11]

Under Mme Bertaux's leadership, therefore, the *Union* offered a unique conception of an exhibition as a collective endeavour, one in which quality was not the major criterion for inclusion. In the words of the painter Mme Aron-Caën, the *Union* had both to cater for the 'advancement of the older members and the flowering of the younger ones'.[12]

The layout of the *Salons des femmes* was suitably non-hierarchical and the range of works on show was appropriately broad. All genres were represented, from oil paintings and sculptures to watercolours, drawings, miniatures, enamels, fans, *faïence* (earthenware), and porcelain.[13] From 1895, a room of decorative arts was also included. The organisers took great care to decorate the exhibition halls in a pleasing manner and to affect an atmosphere of homeliness and elegance in the large impersonal spaces. In the early years, the approach to the exhibition was decorated with pots of flowers, and funds were used to buy a carpet and to repaint the walls. Professional decorators and exhibition installers were hired, and the installation became more grand and luxurious with time. Describing the 1888 exhibition halls, one commentator mentions jars of fresh flowers, comfortable divans on which visitors could rest, and luxurious carpeting.[14] The cold and

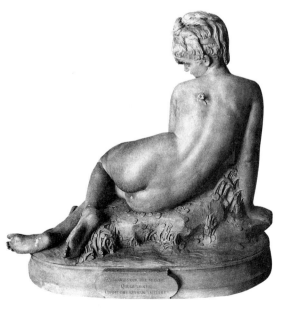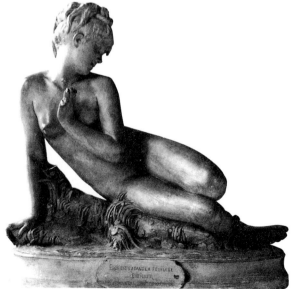

impersonal spaces of the hired rooms at the *Palais de l'Industrie* were thereby transformed into ones which more closely resembled grand domestic interiors or elegant private clubs. The public arena of art was suitably privatised, even domesticated, thus submerging the commercial implications of the display in an aura of homeliness, deemed at the same time to be both appropriately feminine and rarified.[15] Although the commercial element was emphatically there, it was not displayed in a vulgar fashion. A fine balance between the commercial goals of the exhibitions and their more far-reaching ambitions had to be maintained. To be successful, and to cater for the needs of the membership, the *Salons des femmes* had to operate as a much needed market place for women's work. As a non-profit making organisation, no commissions were charged on work sold at the exhibitions, and prices were listed on a register kept at the desk. In the early years, a discount of ten percent was offered on any work sold during the exhibition. But the selling of works was not the primary aim of these shows. They existed as much to bring women's art to public attention, and to promote women's interests in the broadest sense, as to advance the careers of the individual exhibitors.

In keeping with the atmosphere of co-operation rather than competition encouraged by the *Union*, the display of works was arranged in an unprecedently non-hierarchical way. *L'Art français* applauded the atmosphere of mutual support evidenced in the *Union's* hanging policy:

> With the women artists, the good places are not monopolised by the members of the jury. . . The *cimaise* [central picture rail] is given over to beautiful works without regard to signature and success goes to talent from wherever it comes. Beginners are not excluded, rather they are encouraged, and after having exhibited studies which are often mediocre, they work with more fervour and soon one sees them submitting serious works which take their place amongst those of their elders.[16]

Because of such values, the exhibitions differed markedly from standard conventions of display in Paris at the time. Whereas the Salon des Champs-Elysées was very hierarchically hung, with the best places being given to members of the jury, prestigious artists and award winners, while lesser-known contributors were often skied or placed in obscure corners, the *Union* leadership was determined to give all exhibitors an equal opportunity to display their talents.[17] They were convinced that it was unfair to hang work according to quality and to afford certain exhibitors better positions than others. The exposure of the work of newcomers would encourage them, it was felt, and would contribute to the overall elevation of standards which would benefit all women artists. In the early years, the exhibition rules stated that each exhibitor had, therefore, the right to have one work on the *cimaise*. As the exhibitions grew in size this became increasingly difficult to assure and the guarantee was removed from the rules in 1887. But the principle that the *cimaise* itself was not to have an evaluative function, and that exhibitions were arranged according to harmonious placement rather than merit, was continued. Such an egalitarian attitude to hanging was described by one positive reviewer in 1890 as 'an excellent concern and altogether maternal'.[18] An artist's works were not, therefore, necessarily hung together. Unlike the alphabetical arrangements at the mixed Salon which meant that

individual artists' works were grouped and easy to find, works at the *Salon des femmes* could be scattered among several rooms. Each wall or panel was hung separately, and the placing was determined by thematic, practical (size and shape for example) and decorative criteria rather than the presentation of an individual's *œuvre*. The exhibition was meant as much to be apprehended as a whole as by the display of coherent authored bodies of work. The arguments for and against overall effect as a criterion for placement were clearly articulated in an article in the *Journal des femmes artistes* in 1894, when the issue was still being discussed by the *sociétaires*. The writer rejected the conventional arrangement of grouping works by artists, because it risked making the exhibition look like a *salle de vente*, or saleroom, and thereby vulgarising it. The effect that she preferred was that of '*un véritable salon*', a real living room. In her description of the *Salon des femmes* she gives some insight into how decorative panels were arranged; generally, a big or very vibrant work would be placed in the middle of the wall, with works arranged successively at right and left. Their frames, genre and tonality would be examined to see whether they set one another off well and whether they formed a balanced arrangement with their neighbours. The idea, according to her, was to create an overall harmonious effect, like that of a beautiful symphony.[19]

Such a hanging policy was not uncontroversial. It was certainly unconventional, and to assure that there was no confusion on the part of the artists or viewers unused to such hanging arrangements, a statement explaining the display was printed at the top of the catalogue for each exhibition. The policy proved very frustrating for those critics who had not previously been exposed to such an idea, since many followed the traditional format for writing *Salon* reviews in which a few general comments were made, highlights noticed, and then artists discussed alphabetically. For such critics, it was the assessment of an individual artist's production rather than the overall impression of the exhibitions which counted. An exhibition was only as good as the sum total of the individual talents on display.[20]

It was not only selected critics and viewers who objected to the decorative display. Many of the *sociétaires* themselves were unhappy about the dispersal of their works. But a change to this policy had to wait for a change in leadership. It was only after Mme Virginie Demont-Breton, more committed than her predecessor to the support of individual reputations, took over the presidency of the *Union* that the policy was changed by popular demand. The vast majority of *sociétaires*, it turned out, preferred to see their works grouped together. Individualism was the catchword of the day, both in the broader cultural context and in the world of women's art. Here, as in most places, it had triumphed over collectivism.[21]

The hanging of the exhibitions was not the only innovative practice initiated by the *Union*. Even more controversial than the radical splitting up of an artist's work and the non-hierarchical access to the *cimaise*, was the inclusiveness of the organisation's admissions policy. During the early years, the mechanics of selection at the *Salons des femmes* were suitably liberal. Any paid-up member of the *Union* (the annual fee varied from twenty-five to fifty francs) was eligible to exhibit at the annual exhibition.[22] A fee of five francs per work was charged to the exhibitor, but no artist was expected to pay more than twenty francs irrespective of how many works she exhibited. This assured that there was

no discrimination against poorer women who were encouraged to join. Initially, each artist could show three works of the same genre or a maximum of five works representing several genres. By 1887, each exhibitor was allowed to send four works from each genre.[23] Works were all listed alphabetically under the artists' names in catalogues which were published annually and sold at the exhibitions for a small sum. The order of appearance in the catalogue bore no relation, therefore, to the distribution of the works in the exhibition halls. Nor was it organised by status or position.

In the 1880s, the idea of a jury to select exhibits was repeatedly eschewed by members of the *Union*. The divisive effect of a jury was thought by many to be counter-productive. There was little enthusiasm for the establishment of an élite within the organisation. It had always been a principle of the *Union* that membership of the *bureau* (as already seen, an administrative hierarchy was made mandatory by the Republican government) was no indication of artistic merit and that all *sociétaires*, who had French citizenship, were eligible. The principle by which the exhibitions ran was that the artists would be self-selecting. In the interests of maintaining standards, they were asked not to hold back all their important works for the mixed *Salons* while reserving works on paper and less ambitious works for the *Salon des femmes*. It was necessary for the prestige of the shows that large, complex pieces be exhibited here. But no overseeing authority was elected to police this. The aim was to foster a harmonious, self-regulating environment, one in which self-promotion was balanced with generosity and where the identity of 'artist' would be as inclusive as possible. Establishing and maintaining high standards, it was believed, would follow accordingly.[24]

The competing claims of standards and solidarity were, however, to haunt the *Union* right from the beginning. The issue of selection or non-selection was taken up in the press. Very few critics shared the views of Emile Cardon, editor of the *Moniteur des arts* (Mme Bertaux had exhibited a portrait bust of him at the 1880 Salon), who consistently praised the emphasis on co-operation and called for the scrapping of the jury at the annual mixed *Salons* as well.[25] Most, like Jean Alesson, editor of the *Gazette des femmes*, regretted the leniency of admissions to the exhibition and thought that just and fair selection would serve the cause of women's art better.[26] The influential Albert Wolff, of *Le Figaro*, claimed that the *Union* would not achieve serious critical attention until it became more severe over admissions.[27] There were those who ruthlessly mocked their inclusiveness, and urged them to rid themselves of 'amateurs', 'pleasant young women' and 'fashionable women', as they trivialised the exhibitions.[28] Few critics appreciated that the principle of non-selection was in keeping with a policy which strove to support women rather than to undermine or judge their efforts.

The pressure to initiate some form of selection, both from inside and outside the *Union*, grew steadily. It is difficult to establish exactly when a jury was implemented, as contemporary sources conflict over the selection process in operation in the 1880s. Calls from the press for the institution of a jury are evident from very early on, and scrutiny of critical accounts reveals that a form of lenient selection was already in operation before the establishment of a jury, in spite of the rhetoric of non-competitiveness which characterised statements issued from the *Union*. In an article of 1884, Jean Alesson alluded to a process of selection by individuals.[29] The critic for the *Journal des artistes* attributed the high

standard of exhibits in 1886 to the presence of a jury, but in 1888, according to Emile Cardon, there was still no jury.[30] According to their own records, it was at a general assembly of the *Union*, held on 14 December 1890, that the decision to establish a formal jury was made. This was included for the first time in the statutes in late 1890.[31] By 1891 a jury was functioning, but it had the unconventional role of being primarily a supportive body and was extremely reluctant to exclude works.[32]

Once the decision to implement a jury was taken, Mme Bertaux and her committee sought the most democratic way of electing it. As we have seen, throughout Mme Bertaux's presidency the encouragement of new talent remained a priority. When a jury was implemented, therefore, Mme Bertaux and her fellow committee members wanted to assure that any keen *sociétaire* would be eligible to sit on it, and that they would not be guilty of creating an élite within the *Union*. They wanted to make certain that while standards were maintained, democracy would be assured, and the supportive environment in which the *Union* prided itself would be safeguarded. They invented, therefore, an extremely unorthodox system for selecting jurors. A pool was formed, consisting of *sociétaires* who had received prizes at the official Salon, those who had exhibited at least five times at the *Salon des femmes*, and ten whose names were pulled out of a hat from all those who had indicated a willingness to stand.[33] Lots were then drawn from these names. In this way, quality, experience and plain enthusiasm were supposed to be represented. Standards would be balanced with sisterliness.

Not all the *sociétaires* were convinced. Personal ambition, pride, and a sense of fairness could not be reconciled with such a non-hierarchical system. The method of electing jurors

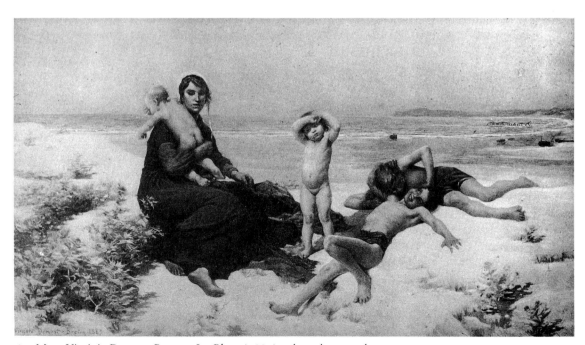

6.   Mme Virginie Demont-Breton, *La Plage* (1883); whereabouts unknown.

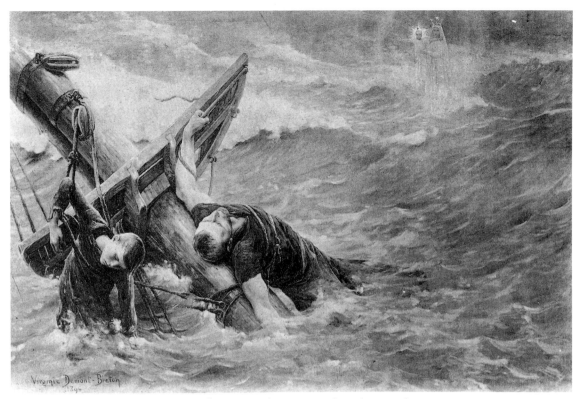

7. Mme Virginie Demont-Breton, *Stella maris* (Salon 1895); whereabouts unknown.

by drawing lots was to become the most contentious issue in the *Union*'s internal history. It was this issue more than any other that was to precipitate change in the *Union*'s hierarchy, resulting in the resignation of Mme Bertaux as president, and the election of Virginie Demont-Breton to the post. By the time she became president in 1894, Mme Demont-Breton's achievements as a painter were considerable. The daughter of Jules Breton, the successful painter of idealised peasant scenes, she was exposed to art from early on, making her first painting at the age of fourteen. Her father presented the renowned *animalier*, Rosa Bonheur, to her as a role model, and when she became the second woman in France to be awarded the *Légion d'honneur* in 1894 (the first had been her mentor), it was her father who proposed a toast to her at a banquet hosted by the *Union*. She first received an 'Honourable Mention' at the Salon of 1880 at the age of twenty-one. By the age of twenty-four, she had already received awards at the Salon for *Femme de pêcheur venant de baigner ses enfants* in 1881 and *La Plage* in 1883, and had been placed '*hors concours*' (fig. 6). In 1889, she was awarded a gold medal at the *Exposition Universelle*, and in the 1890s was to produce some of her most ambitious figure subjects (figs. 7, 8). Virginie Demont-Breton matched herself against the most successful contemporary artists.[34] She was not interested in playing second fiddle to anyone. Nor was she prepared to be associated with anything but the finest quality work. She was certainly not interested in having her own or her friends' works submitted to a jury in whose powers of judgement she had no faith.

It is not surprising, therefore, that she was among a group of women who found the method of selecting jurors by the drawing of lots too unreliable, and she was one of those who challenged this practice at a committee meeting of 21 December 1892. The *Union*'s

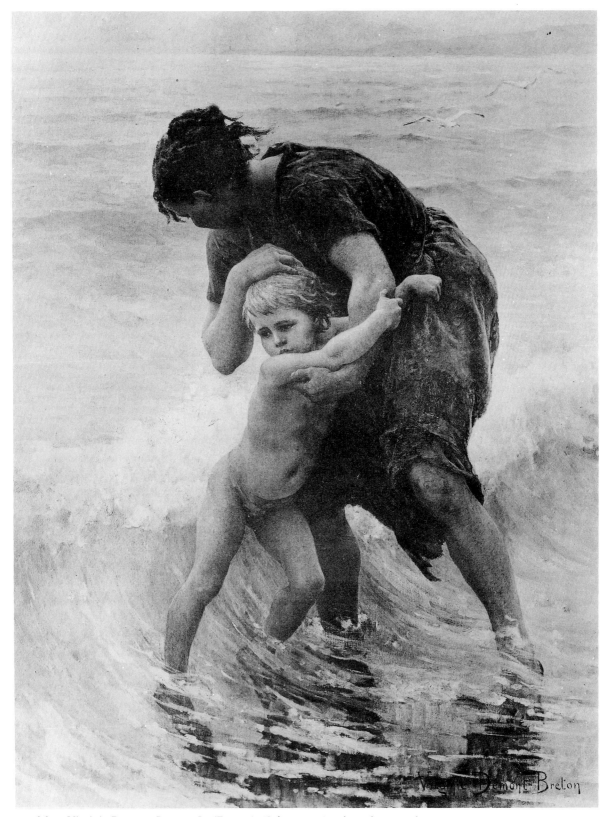

8. Mme Virginie Demont-Breton, *La Trempée* (Salon 1892); whereabouts unknown.

method of selection, they argued, was too arbitrary. They suggested the institution of a system that would guarantee both the representation of artists of all genres, and the standards of the judges. However, a resolution endorsing the proposed new form of selection and allegedly passed at the 1892 meeting, was subsequently declared invalid by Mme Bertaux, who had not been present at the meeting, on the grounds that it had not been published in the agenda and that the rules for exhibition for the following year had already been accepted by the general assembly. Acceptance of this resolution would have involved a breach of protocol. It was therefore appropriate, according to Mme Bertaux, to bring the issue up at the subsequent general assembly to allow the full membership to vote on this important matter. When the time came, under the watchful eye of Mme Bertaux, a vote of seventy *against* a selected jury, and sixteen *for* a selected jury, was registered.[35] The majority, therefore, were in favour of the drawing of lots. However, this was not to be the end of the controversy. Mme Demont-Breton had never accepted the allegation that the decision at the committee meeting of 1892 had been unconstitutional and, alleging that the voting procedures had been irregular, she handed in her resignation as vice-president of the *Union*.[36] The affair now became both public and nasty. The allegations of mishandling were strongly denied in an open letter written by the committee and published in the *Journal des artistes*, a newspaper read by many artists and critics, both men and women. The *Union* found itself divided, conflict-ridden and exposed to public scrutiny. There were, of course, reporters who revelled in the spectacle of women in battle, and much was made of the rivalry between the principle protagonists.

The controversy highlights some of the debates which surrounded women's art practice and display during this period. Mme Demont-Breton alleged that not only had there been a procedural mishap and miscarriage of justice, but that her position had been misinterpreted. What concerned her and her colleagues more than anything, she declared, was a 'wish to give the Society the serious character which its title carried'.[37] The pro-selection lobby worried that their submissions would be judged by unworthy people, by inexperienced artists whose talents were less developed than their own, and they feared the anomalies that might result from this. Supportiveness was all very well, but what was to happen to standards? They argued that their position had been misrepresented and that they were not an elitist group wishing to seek power, but were genuinely convinced that a vote for a jury of merit would result in a more serious exhibition in which consistant standards of quality would be met. They wished, for example, to prevent the possibility of the election of a jury consisting of artists of one genre only, flower painters or watercolourists for example.[38] It was the perception of the *Union* by the outside world which was at stake here. The unevenness of the work on display reflected badly on women's art in general, and reinforced current perceptions of women's work as weak.

The dispute seems to operate on more than one level. Whilst it centred on the character and function of the exhibitions, with certain prominent artists obviously feeling that their interests were not served in an exhibition that had such a diverse range of talent and discrepancies in quality as the *Salon des femmes*, it also had to do with a challenge to Mme Bertaux's leadership. A group of well-known women artists had already set up an exclusive exhibition at the dealer George Petit's in 1892, which became dubbed by critics as '*Le Champ de Mars des femmes*' (alluding to the conservative Meissonier's break-

away *Salon* with its hierarchical structure and appointed jury) and was widely seen as a rival, more select organisation. The *Union*'s publicists were anxious to assure the public that it welcomed this new society, and did not see it as a competitor but as providing a complementary exhibition forum.[39] There were *sociétaires*, though, who felt that the *Union* had become too strongly identified with Mme Bertaux's personality, and sought different outlets for their works.[40] Political and personal differences had become confused. In the light of these disputes, Mme Bertaux decided not to stand for re-election for the presidency. One of the vice-presidents, Mme Aron-Caën, resigned with her. In her letter of resignation, Mme Bertaux urged members to give all their votes to Mme Demont-Breton whom she promoted as her appropriated successor.[41]

In accepting the position, Mme Demont-Breton was keen to assure the membership that the fundamental aims of the *Union* would not change under her leadership, but that a more selective policy of admissions would be instituted in the interests of raising the standard of exhibitions and demonstrating to the outside world the seriousness of women artists. She wanted, above all, to create a prestigious exhibition society, one which would attract artists of quality and thereby bring honour to 'feminine art'. 'It is to those who feel a true love for art for whom we have, above all, a sympathy and in whom we show an interest', she declared.[42] The *Union* would no longer be open to first-comers who only had to pay their membership fees to guarantee a place at the exhibition. Now they would have to be passed by a committee responsible for assessing the artistic merit of would-be members. Yet, some of the old rhetoric remained, and Mme Demont-Breton was quick to reassure members that all efforts would be made to show great indulgence to newcomers and to encourage the young and inexperienced. In 1896, a new way of electing the jury for the *Salon des femmes* was implemented. It was to consist of fifty members who were to be elected by vote. Those eligible would include *sociétaires* who had exhibited at least five times at the *Salon des femmes*. From the fifty, who would function as the jurors for three years, eighteen would be drawn by lots, each year, to operate as the jury for the *Salon* of that year.[43] In this way a compromise was reached. The drawing of lots assured members of a fair and impartial selection committee, while the election of the pool from which lots were drawn facilitated, in theory, the election of a competent and skilled group of jurors.

The conflict that emerged between the *Union*'s first two powerful leaders points to differences, not only in personality, but in attitude. Encapsulated in their positions are opposing strategies for the fostering of women's art. While Mme Bertaux placed most emphasis on solidarity as a means of achieving higher standards, Mme Demont-Breton was committed to quality first. Anything less would redound badly on women generally, and would fulfil the critics' worst fears. It was the balancing of the demands of standards, so that women's art would be shown at its best, with solidarity, so that a nurturing environment would be provided, which proved difficult to achieve. *Sociétaires* were divided as to whether priority should be given to the former or the latter. For some, the sacrifice of 'quality' in favour of an open supportive environment would be counter-productive. For others, the atmosphere of competition and exclusiveness which exhibitions of quality necessitated was at odds with the spirit of mutual support which a women's organisation should provide.

The personal animosity between Mme Bertaux and Mme Demont-Breton seems to have continued after the resignation of the first president. In 1896, Mme Demont-Breton initiated a public reprimand of the first president for having sent round a circular which she and the *bureau* believed brought disrespect on the *Union*. From the support that Mme Demont-Breton received from her committee in this instance, it is clear that the era of Mme Bertaux's power and control was definitely over.[44] Although the *Salons des femmes* continued to attract large numbers of exhibitors and visitors during this period, the excitement of the first fifteen years was never to be recaptured. While the debates surrounding women and their potential contribution to art continued, these seemed to focus more around the State's initiatives in the decorative arts, and in the controversy surrounding the opening of the *Ecole des Beaux-Arts* to women, than around the exhibitions of the *Union*. The novelty of these had worn off. The early years of the *Union* had been characterised by a tension, perhaps irreconcilable at this historical moment, between the demands for a support system that would enable women to act creatively in the world, and the establishment of a prestigious exhibition forum at which independent professional artists could excel. Both of these positions could be seen to be maintained in the interests of the flowering of female culture. For those who gave priority to the first, it was this environment which would allow the latter to flourish, but for those who gave priority to the latter, no respect would be accorded to women's art or power given to women if they could not be seen to compete with the best of contemporary French painting. At stake here were debates about professionalism, debates about feminism and 'femininity', and debates about quality. Crucial to all of these was the issue of education. It is these issues that will be explored in the following chapters.

## Chapter 2

# Amidst 'a Veritable Flood of Painting'; The Union of Women Painters and Sculptors in context

TWO SUGGESTIVE CARICATURES of the early 1880s show a dismayed passer-by recoiling from posters advertising comtemporary exhibitions (figs. 9 and 10). In fig. 9, a top-hatted gentleman holds up his arms in horror in response to an advertisement for the 'Exposition Femmes Peintres et Sculpteurs'. In the distance a fashionable couple stroll by, with the arm of the woman appropriately hooked into that of her elegant companion. It is possible to read the image as one which constructs normative and deviant representations of femininity. The passer-by's response appears to be a reaction against the phenomenon of the woman artist who seizes the public sphere by advertising her work on the walls of the city. He seems to recoil in horror. In contrast, the woman who walks away is both chaperoned and appropriately packaged in corset, bustle and hat. But is the only source of the gentleman's concern the fact that it is a women's exhibition with which he is faced? The poster advertising the 'Exposition Femmes Peintres et Sculpteurs' is, after all, juxtaposed with another one advertising an 'Exposition Raffaëlli,' and the inscription below invokes a fear of the abundance of small exhibitions with which he is surrounded as much as the particular phenomenon of an all-women's exhibition. In another contemporary caricature, the startled passer-by is shown to react with horror at the sheer number of exhibitions on offer in spring (fig. 10). The words '*giboulée de mars*' (April shower) suggest a flood, an uncontrollable proliferation by which he is overcome. Here the exhibition of *femmes peintres* is securely situated among other small group shows. It takes its place amongst the watercolourists, *animaliers*, independents, landscapists, Russian painters, Scandinavian painters and numerous *cercles*, all intent on advertising their existence. The members of the *Union* were not alone, it seems, in forming an independent artists' organisation, or seeking new outlets for the display of their work. In fact, they were participating in a much wider trend in the Paris art world, one which would transform the artistic field unrecognisably.[1]

The establishment of women-only exhibitions and the founding of the *Union des Femmes Peintres et Sculpteurs* can be accounted for, to some extent, by situating them in the context of the massive diversification of the Paris art world during this period. The growing complexity of the art market, the expansion of exhibition forums, the withdrawal of the State from the organisation of the annual Salon, and the increasing encouragement to artists to organise themselves, were all important contributing factors. In order to understand the necessity which artists, both men and women, felt for organisations to protect their interests, sense needs to be made of the official Republican discourse on art,

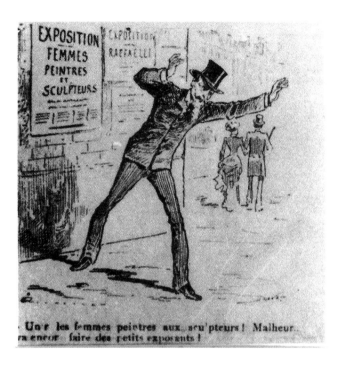

9. Draner, 'Exposition des femmes', *Pièces sur les arts*; Bibliothèque Nationale, Paris.

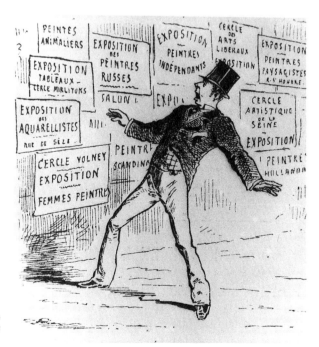

10. Draner, 'Giboulée de mars', *Pièces sur les arts*; Bibliothèque Nationale, Paris.

of changing perceptions of the role of the State in matters concerning art, of the relation-
ship of art to commodification and the market, and of the changing patterns of metropoli-
tan life with its concomitant new forms of sociability.

By 1882, the year of the first two separate women's art exhibitions (that organised by
the newly formed *Union* in January, and the independently organised, one-off women's
show held at the *Cercle de la rue Volney* which opened only a month later), many critics
were commenting in the press on the visible changes in the institutional network of the
Paris art world. No longer could the artistic calendar be structured around the annual
Salon, the exhibition of the prize winners of the *Prix de Rome*, and the occasional special
exhibition. The Paris artistic season now remained open throughout most of the year. One
critic noted, disapprovingly, that in the traditionally quiet month of November no fewer
than three exhibitions were open at once.[2]

So varied and busy was the programme of exhibitions, competitions and events, that a
new journal was founded which was aimed specifically at informing artists of the range
of activities and exhibition opportunities open to them. In the editorial of the first issue of
the *Journal des artistes* of May 1882, the editor, Henry Esmont, commented on the
decentralisation which characterised the Paris art world in the 1880s, and on the decline
of the importance of the Salon de Paris.[3] The founding of a journal aimed at informing
artists of the professional opportunities available to them marks a significant change in
the way that their activity is understood. They come to be regarded as independent
professionals who choose from a range of exhibition opportunities, who are dependent on
the demands of the market as well as on the favours of the State (still an important
promoter of contemporary art through commissions and purchases), and must struc-
ture their 'careers' according to political and aesthetic commitments and commercial
considerations.

The atmosphere of active encouragement within which the first *Salon des Indépendants*
was founded in 1884 is symptomatic of the new attitude towards the autonomy of the
artist which characterised this period. Whereas the authorisation of the first *Salon des
Refusés* in 1863 had been a public relations gesture on the part of Napoleon III in response
to artists' complaints about admissions practices at the Salon, the '*Indépendants*' was
established by artists themselves, and endorsed by the Republican administration whose
representatives attended its opening.[4] Contrary to modernist histories which have con-
structed the *Indépendants* as an oppositional institution and the natural inheritor to the
*Refusés* via the Impressionists, the 1884 initiative was not a move on the part of artists to
free themselves from the centralised control of exhibition forums by government and its
appointed institutions.[5] Since at least 1879, the Republican administration had actively
*encouraged* the professionalisation of artists and artists' organisations. In the name of
'liberty', 'independence' and 'individualism', all Republican catchwords, the autonomy of
artists' groups was both facilitated and endorsed.[6] The expansion of exhibition opportu-
nities, which stretched far beyond the establishment of sites for the display of what have
come to be regarded as avant-garde practices, should be seen as flowering in a climate of
consent rather than as a rebellious gesture aimed at undermining centralised control, as
the mythologies of modernism would have us believe.[7] Indeed, as Marie-Claude Genet-
Delacroix has argued, the professionalisation of artists and the proliferation of profes-

sional interest groups fitted into the broader Republican programme of fostering a liberal economy.[8] In the face of competition in the production of luxury goods from both Britain and Germany, it was in France's interest to have its capital perceived as a thriving centre of artistic competition, and the growth of private exhibition initiatives reinforced this. Easel painting could find its place amongst luxury goods as the type of merchandise that needed to be displayed in order to be consumed. Private exhibitions could provide the sites for such display. Freedom of artistic expression was harnessed to the project of the free market, and it was the Republican government who promised to ensure both.

The diversification of the artistic field did not mean, however, that the State no longer had an interest in directing artistic affairs, but that the way of understanding these had changed under the Republican settlement.[9] The promotion of 'self-help' strategies, and the establishment of institutional networks which went beyond the old forms of patronage and protection, were seen as practical demonstrations of the functioning of the new participatory democracy for which Republicanism stood. Notions like 'independence' and 'individuality' became part of the official rhetoric of the State. It was the Academy that was produced as the conservative, backward-looking institution, emblematic of pre-Republican values and a *retardataire* social system. Reminiscent of the old Académie Royale, it smacked of aristocracy and authoritarianism.[10] However, while the power of the Academy as an institution was firmly contained, its reverence for *la grande peinture* (a painting which was didactic, uplifting and public) could be transformed to serve the interests of the new Republic. To create an identity for the young Republic, public symbols which could rival those of monarchy and empire had to be invented and invested with stature. In the arena of fine art, it was to the education of public taste through commissions, and the rewarding of excellence through awards, that the focus of State control turned.[11] In 1885 the Republican apologist, L. de Ronchaud, wrote:

> The State needs to work with art in order to foster the education of public taste and intellect, and to allow the appreciation of beauty and the spirit of peace, of order and progress, to penetrate the breast of the masses.[12]

The means to do this, he argued, was through competitions and the decoration of public buildings suitably representing grand historical, civic or patriotic scenes. In this way, the government would be able to influence artistic trends, and do some work in elevating moral standards and civilising the population. An old-fashioned belief in art's moral purpose is harnessed here to a new political project. While artistic diversity was encouraged in the market place, arts officials still favoured, for the most part, an elevating public art with edifying narratives, even if the subjects could now be drawn from post-revolutionary France rather than ancient Rome.[13] (Antonin Proust, the controversial liberal minister for the arts in the short-lived Gambetta government of 1881 to 1882, was exceptional among Republican deputies in his endorsement of realist contemporaneity, of the type practiced by Courbet and Manet, as most suited to the expression of national life.)

So it was that the liberalising tendency with regard to exhibitions, and the extolling of the virtues of individualism, was accompanied by a concerted effort on the part of the State, on the one hand to use art as a means of forging a new national identity, and on

the other as a conviction that certain aesthetic principles should be integrated into the education of all citizens in order to form a sound, rational and prosperous democracy.[14] In the interests of progress in both art and industry, the unity of which was repeatedly stressed, it was in the area of education that successive Republican administrators really invested their energies. The *Ecole des Beaux-Arts* had already been made accountable to central government and been taken away from the control of the Academy, together with the judging of the *Prix de Rome*, in 1863. In 1871, however, the Academy was once again given the power to choose the beneficiaries of the *Prix de Rome*, a fact which was lamented by subsequent Republican historians of arts administration who saw the complete severing of the Academy from the *Ecole* as a liberating gesture appropriate to the democratic values which they associated with Republicanism.[15] Reform of the *Ecole* to accommodate Republican principles of art education caused considerable upheaval in the art world in the early 1880s. Under the ministerial direction of Antonin Proust, this involved the altering of the curriculum to include an integration of design principles with the fine arts, and attempts, which were greeted with loud protests from artists and students, to suppress the *ateliers* in which students were trained in the style of the master. In the event, the reforms had to be tentatively and only partially instituted. The new curriculum integrated the teaching of the three traditionally separated areas of sculpture, architecture and painting, in the name of the inculcation of underlying aesthetic principles which were relevant to all, and which could be harnessed to the creation of a public and decorative art.[16] It was these principles too, which, it was believed, would provide the basis of a design education able to assure France's ability to compete with her industrial competitors.[17]

Such reforms were accompanied by the expansion of art educational programmes in primary and secondary schools; in provincial schools; in the development of the *Ecole Nationale des Arts Decoratifs*, into which the old *Ecole de Dessin et de Mathematiques* for young men was subsumed; and in the promotion of the *Ecole Nationale de Dessin pour les Jeunes Filles*. The Republicans believed that art could be used to cultivate the perceptual and organisational faculties of all French citizens and to provide them with a pre-verbal system of communication. Through studying art and learning to draw, they believed all students could learn to organise their thoughts and perceptions in an ordered and coherent way, and thereby contribute to the building of a rational and prosperous society premised on responsible citizenship.[18] That these values were themselves constructed within the parameters of gendered notions of the 'citizen', and the 'family', the 'public' and the 'private', is clear. French men and women were called upon to contribute to the building of the new social order, in ways which were in keeping with their essential natures. In the ubiquitous symbol of Marianne, the decorative schemes of the *mairies*, or town halls, of Paris, and the decoration of the Panthéon, not to mention the differing programmes of art education for boys and girls, men and women, the models of Republican 'masculinity' and 'femininity' were at stake.[19] They were at stake too in the expansion of exhibition opportunities which was fostered during the Third Republic.

Throughout the 1870s, the role of the State in the organisation of public exhibitions had been under discussion.[20] By the early 1880s, there was some consensus that it was not at

the level of exhibition that the State should exercise control over the visual arts. Notwith-standing the belief, expressed by some influential Republicans, that the exhibition re-mained an important site of public education and a means through which the national spirit could be elevated, for many it came to be seen primarily as providing an opportunity for artists to show their products to advantage. The State took on the role of sponsor (providing the venue and covering the costs) and privileged client (it retained first refusal on purchases for acquisitions), with the annual Salon functioning as a market which was widely acknowledged as a show-case for artists who needed to encourage buyers for their work.[21] Critics hostile to such a development saw it as beneath the function of the State 'to open bazaars for the sale of pictures and statues', and conceived of the State's role in exhibitions as much grander than this.[22] They welcomed the State-organised *Expositions Universelles* as forums for the display of France's achievements in art and industry. They dreamed of State-sponsored *expositions de choix*, selected exhibitions, where the best of French art would be on show as a testimony to France's achievements and an encourage-ment to artists to aim high. To this end, arts administrators resolved to convene triennial displays which aimed to influence public taste, set up good role-models for aspiring artists, and harness the brilliance of the fine arts to the glory of the nation.[23]

For many Republicans, however, diversity of genre and style could be seen as emblem-atic of the individualism for which their political credo stood. The withdrawal of State control over the Salon, prompted by a dispute between the *Beaux-Arts* administration and the Salon jury over the embarrassing quantity of admissions to the Salon of 1880, could be explained, after the event, as a move which was in keeping with the concept of personal freedom and anti-monopolism which was part of Republican ideology. By the end of 1881, definitive statutes were drawn up for the new society, now to be called the *Société des Artistes Français*. The statutes were adopted on 15 June 1882, and approved by decree on 11 January 1883.[24] The wording of the decree (formulated by Jules Ferry, then Minister of '*instruction publique*' and Turquet, his Under-Secretary of State for Fine Arts) demonstrates the official view that it was in the interests of the State and the nation that artists become a professionalised and independent class of producers. Free competition on the open market was deemed to be beneficial, as it would lead to the raising of standards.[25] The buying and selling of art works was thought to be appropriate in a free market economy regulated by supply and demand, and the withdrawal of State control over the Salon was seen as entirely fitting.[26] The only power that the State retained in relation to the Salon after 1881 was the award of prizes, especially the *bourses de voyage* or travel bursaries, and the acquisition of works for the national collections.[27]

However, the relationship of the State to the Salon remained complex. Although the State had abdicated all rights to direct the affairs of artists at their national exhibition, deputies responsible for the arts liked to think of the *Société des Artistes Français* as a unified corporation of artists who would co-operate with one another, both for their own interests and for the sake of France's reputation as the leading artistic nation in the world. When a split occured in the ranks of the artists with Meissonier's breakaway group in 1890, and the formation of the new *Société Nationale des Beaux-Arts*, the hegemony of the old Salon was decisively ended. The administration was thrown into a state of confusion in relation to its awards policies which were traditionally made at the Salon.[28]

The artists of the new society called on the State to honour its commitment to the autonomy of the artist and to recognise both *Salons*. A supplementary acquisitions budget had to be approved so that purchasing could be expanded, and in May 1891 the *Salon* of the *Société des Artistes Français* was deprived of its monopoly over the award of travel bursaries.[29] The State now really did function as an umbrella organisation, which had to stand by its commitment to foster diversity. No longer could the word Salon be used to mean one thing only. There were many *Salons*, and among them there was even a, by now well established, *Salon des femmes*.

At the moment of the formation of the *Union des Femmes Peintres et Sculpteurs* though, only one Salon existed, and this was the largest and historically most important exhibition forum in Paris. Even then, however, the works on show could on no account be seen to be representative of an 'official' taste, let alone an academic orthodoxy, and neither could the organisational structure be considered emblematic of a form of 'State repression', against which alternative institutions had of necessity to rebel in the name of artistic freedom. Whether the new independence of the Salon represents the liberalism of the Third Republic, defender of individualism, as the revisionist and Republican apologist Pierre Vaisse has argued, or is a demonstration of the hegemonic power of Republican ideology in the era of 'High Capitalism', with its fostering of a myth of individual autonomy, as Nicholas Green has argued, what cannot be defended is a model of a homogeneous, repressive State, holding onto centralised control of exhibition forums in the name of a conservative academicism. Nor does the modernist construction of the true artist as a disinterested and disenfranchised marginal figure, unconcerned with the vulgar operations of the market, hold up at this point. The outmoded cliché of bohemian artistic identity was already recognised as a myth by an astute woman artist writing for the woman's suffrage journal, *La Citoyenne*, in 1888:

> The legend of the down-at-heel artist with a threadbare cardigan and smashed up hat, is a good story which doesn't hold true anymore . . . In our society, artists are spoiled, honoured and, for the most part, rewarded. Obviously there are some unfortunate ones. It is even possible that there are, alas, those that are dying of hunger. Mme Boucicaut was a rich businesswoman who amassed millions; alongside her, a rich cloth merchant, there is the hawker of bird-seed. They are both businesswomen . . . Between Meissonier who sells his pictures for 100,000 francs and a poor painter who makes paintings in standard measurements, there is the same difference that we find between the bird-seed seller and the rich cloth merchant.[30]

The artist is represented here as a commercial operator like anyone else. There are rich ones and poor ones, and it is up to them to find outlets for their work. Much store was put on the artist's intitiative. Independent exhibitions, far from being viewed as rebellious gestures on the part of artists, were actively encouraged, and the more diverse they were, the better. Such a construction of the role of exhibitions would not, of course, have been possible without the general acceptance of the idea of the art object, at least on one level, as a tradeable commodity, and of the individual artist as a professional producer. While individual artists and artists' groups may have rebelled at such a vulgar definition of their role, and strived to create a non-commerical atmosphere for the display of their works in

private exhibition forums, the truth was that these existed to sell works and to introduce artists to patrons. The apparent privacy and exclusivity of such environments enhanced the desirability of the objects on show. Their identity as commodities was assured.[31] The growth of the dealer system is crucial here. As Nicholas Green has shown, by the late 1860s art dealing was already big business, with the functioning of large, lucrative auction houses, dealer galleries or shops, and the growth of a domestic and international market for contemporary art as well as the established trading in 'old masters'.[32] Already in the late 1830s, shops which sold art were springing up in Paris, and in 1845 Millet had organised a sale of his own works, a practice which was to become popular in the middle of the century. By this time, artists were submitting works to the open market at auctions of contemporary art, and by 1875 their own sales were numerous and used by artists of all persuasions. By the 1880s, the idea of trading in art objects (of exchanging them for fluctuating sums of money, of watching their prices rise and fall like stocks and shares, and of viewing them as investments) was, as we have seen, a naturalised part of Republican ideology. The exhibition was widely regarded as the place where art objects would be viewed, assessed and bought or sold. Even if the trading did not take place at the exhibition itself, reputations would be made, contacts established and the ground laid for future transactions.

Although the Salon remained the most prestigious exhibition forum, and the prices that artists could fetch for their works were strongly affected by their status there, it alone could not provide a sufficient forum for the display of art objects in such a commercial context. Artists were restricted to a small number of submissions, they were dependent on juries for admission, they were not in control of the way in which their works were displayed, smaller works, watercolours and pastels were dwarfed by larger submissions and risked being missed among the plethora of stuff on display, and, most importantly, the Salon was only held once a year. If reputations and fortunes were to be made through sales, the Salon alone could not fulfil the demands of artists, dealers and the expanding bourgeois market.

If the Salon was felt by most male artists to be an insufficient forum in which to show their work to advantage, this was even more acutely felt by many women artists. The Salon, argued women artists and their supporters, let women down. Complaints about how women's work was treated by the jury were already being made in the 1870s. In 1876, the Republican feminist Maria Deraismes berated the jury for their neglect of the sculptor Marcello, and saw this as part of a masculine 'system of discouragement aimed at diminishing the number of women artists'.[33] In 1880, the journalist Jean Alesson, indefatigable campaigner for the rights of women artists, addressed a letter to Turquet and to all the members of the Salon jury, bringing to their attention the discrepancy between the number of women artists exhibiting at the Salon, and the number of awards received by women. Analysing the catalogues for the five previous Salons, Alesson concluded that nineteen out of every one hundred exhibitors were women, but that of one hundred awards, only five were given to women.[34] The numbers of women artists accepted at the Salon had increased throughout the 1870s. From 286 women in 1874, the number had grown to 648 by 1877 and as many as 1081 by 1880, the year in which the jury adopted a controversially lenient admissions policy.[35] Throughout this time, though, the propor-

tion of awards given to women remained low, and when they did win something it was most often only an honorable mention or a third-class medal.[36] In 1881, at the first Salon organised by artists themselves, the number of female admissions was halved when an altogether stricter admissions policy was introduced. Only 658 women were admitted, but in 1882 there was a small increase to 832. During this year, the only award made to a woman was one third-class medal.[37] In 1883, the number had dropped again, down to 630.[38] The complaint over the discrepancy between the numbers of women exhibiting at the Salon, and the awards they received, was still being made at the end of the decade. In 1889, a woman artist writing for *La Citoyenne* complained that, although women comprised almost a quarter of exhibitors at the Salon, they had not even been awarded a fifth of the prizes. The same was true of State acquisitions. In painting, out of the 287 works exhibited by women, only three had been acquired by the State. Out of the drawings and cartoons where the number of women had equalled men, and, according to this writer, surpassed them in quality, only one watercolour, executed by a man, had been purchased by the State. No sculptures by women had been bought.[39] In 1894, an artist writing for the *Journal des femmes* did not mince her words. Proclaiming that women were not being given their due at the mixed *Salons*, she alleged that had Mme Demont-

11.   Mme Virginie Demont-Breton, *Jean Bart* (Salon 1894); whereabouts unknown, photograph: Bibliothèque Nationale, Paris (faulty, unfortunately).

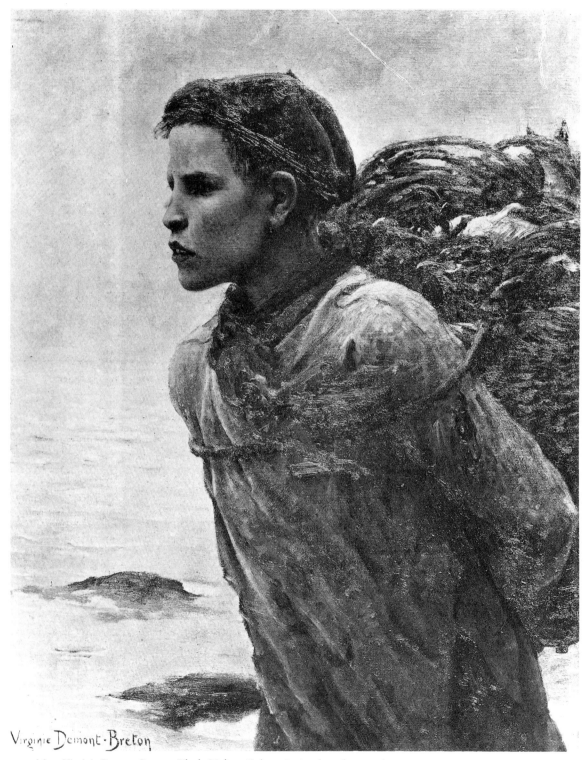

Virginie Demont·Breton

12. Mme Virginie Demont-Breton, *Fils de Pêcheur* (Salon 1894); whereabouts unknown.

Breton been a man, she would have been awarded the *Prix de Salon* for her submissions of that year, amongst which were her ambitious figure paintings, *Jean Bart* (fig. 11) and *Fils de Pêcheur* (fig. 12).[40] The following year this complaint was reiterated, when the critic for the same paper alleged that women did not receive justice in the press, in State purchases or in honorary awards.[41]

Such complaints were accompanied by allegations that women's achievements went unnoticed when their work was shown at the mixed *Salons*. The public who did not bother to read the labels, assumed that their works were by men.[42] Moreover, women's works were often hung so badly, sometimes being placed so high that they were barely visible, that they necessitated a concerted effort on the part of the public if they were to be appreciated.[43] It was the feeling that they were not given a fair chance at the mixed *Salons* which, according to an editorial in the moderate *Gazette des femmes*, prompted a group of women to form their own exhibition organisation: 'Rightly or wrongly, they have judged that at the Salon male artists claim the lion's share and treat women's work with too much disdain.'[44] A writer for the radical *La Citoyenne* had no doubts about the appropriateness of the women's initiative, and welcomed it with the words:

> These women who are excluded from the *Ecole des Beaux-Arts* are right; they who do not form part of the jury responsible for judging the works at the Salon should make an exhibition of works of their own sex separate from that of the men.[45]

However, it was not only in the feminist press that such claims were made. Albert Wolff, the prominent critic for the conservative daily *Le Figaro*, and no friend to feminist campaigns, endorsed the formation of separate women's exhibitions with the words: 'Women are right to group themselves in this way, because they are truly sacrificed in the *Salons* organised by the men.'[46] Critics like Franck-Lhubert, writing for *L'Artiste*, realised that women had no representation on the Salon jury and that they were therefore 'obliged to be subjected to the law of the strong sex', which put them at a disadvantage and prompted them to gather forces and group together.[47] Supporters of the woman artist were acutely aware of how the jury procedures mitigated against women's chances of recognition. 'Jacques', writing in *La Citoyenne*, called it one of the monopolies which '"MM. les artistes" reserve exclusively for themselves', and described women's difficulties as follows:

> That which the public doesn't see is the procedure by which prizes are awarded; comaraderie and cliques are most often favoured there. Also, a member of the jury voices his support for a certain work on the condition that his colleague reciprocates and because generally these unfortunate women have neither the luck nor the honour of working under the direction of a master, they find themselves neglected . . . is it sufficient to have well-studied, well-rendered work in order to be awarded a prize? Certainly not: it needs more than this, it needs a voice to be raised in your favour, to draw you to attention, to defend you in front of the jury.[48]

'Jacques' believed that the solution lay in electing women to the Salon jury. Only in this way would there be a voice to represent those with neither patronage nor contacts to assure their success.

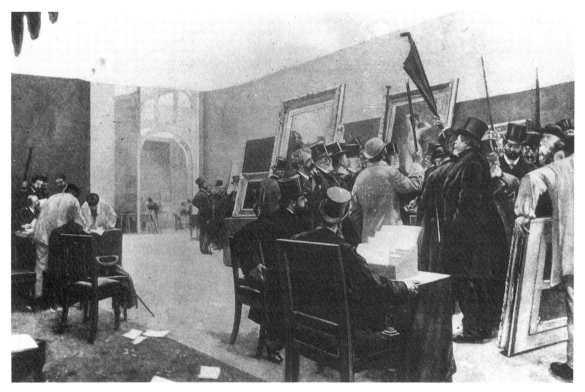

13.   Henri Gervex, *Une Séance de jury de peinture* (1885); Musée d'Orsay, Paris.

The very masculine nature of the jury is encoded in a modern-life painting by Henri Gervex. *Une Séance de jury de peinture*, exhibited at the Salon of 1885, shows the bustle and confusion that surrounded the top-hatted members of the all-male jury as they made their decisions, while workmen removed, unpacked and brought in the entries. Against the wall behind their phallic, raised sticks and umbrellas, is the object over which they are shown to be voting: a painting of an idealised female nude. In what is a familiar scenario, an all-male community assesses and judges a representation of 'Woman', while the absence of actual women guarantees the symbolic power of the image around which they gather (fig. 13). In the same Salon, a second picture of a jury, Vianelli's *Une Jury* (*sic*), was exhibited, this time showing two discerning, young, middle-class women in a smartly furnished interior looking at an album (fig. 14). What the Gervex presents is an official gathering where men are shown exercising their professional judgement in a public arena, whereas in the Vianelli, the female 'jurors' are making their judgements in the refined, intuitive manner deemed appropriate to women and situated in the comfortable and contained sphere of the drawing room. The domains of public and private are inscribed as masculine and feminine in these paintings. It was entrenched notions such as these which would have to be overturned if women were ever to achieve representation on public bodies.

The issue of the lack of women's presence on Salon juries was to be an important one

14.  Vianelli, *Une Jury (sic)*, (Salon 1885); whereabouts unknown.

throughout the 1880s and 1890s. When a number of women's names were put forward as possible candidates for the jury in 1884, this was reported with a degree of mockery by the *Moniteur des arts*.[49] But as the *Union* grew in size and confidence, the question of women's representation on the Salon jury became an important rallying point for women artists. According to the *Journal des artistes*, at the general assembly in December 1890 of the *Union des Femmes Peintres et Sculpteurs*, it was unanimously decided to propose

Virginie Demont-Breton and Elodie la Villette as candidates for the following year's Salon jury.[50] On 15 January 1891, Mme Bertaux wrote to the president of the *Société des Artistes Français* in this connection and received a sympathetic response.[51] At this point, instead of Mme la Villette, Rosa Bonheur's name was nominated. In the event neither Mme Demont-Breton nor Rosa Bonheur was voted on to the jury, and it was not until 1898 that Mme Bertaux became the first woman to be elected.[52] Representing the Salon jury was to become an issue for which the members of the *Union* were to campaign vigorously. If exhibiting at the Salon was important, then it was crucial to women's professional status that they had representation on a jury which decided admissions and rewards.

The initiative for representation on the Salon jury was tiny, however, compared with the energy and organisational skills required to set up an annual *Salon des femmes* of the scale and ambition envisaged by the founding members of the *Union*. There were, of course, many critics who could see no need at all for the formation of women's *Salons* and poured scorn on the idea. Whilst some of these were driven by predictably misogynist prejudices (from claims that women were incapable of creativity to lamentations that the artistic profession was so overcrowded that the entry of women into the field would only make matters worse), others were merely bewildered by the explosion of exhibition forums which threatened to swamp the beleaguered critic of the early 1880s. It was not, as we have seen, women alone who felt the need for alternative exhibition venues to the Salon. What was universally agreed upon was that the Salon's centrality was being challenged with an unprecedented intensity during this period.

The diversification of exhibition venues did not originate in the Third Republic, even though it was during this period when, in the name of Republicanism, the laws of association were gradually liberalised and the already well-established free market economy was embraced wholeheartedly.[53] The idea of protecting artists' interests through a professional grouping had been central to the philanthropist Baron Taylor's *Association des Artistes Peintres, Sculpteurs, Architectes, Graveurs et Dessinateurs*, formed in 1844, and recognised as an organisation of public service by the Republican administration in 1881. Directed by a committee of artists, part of its resources were devoted to the organisation of exhibitions. Associations of artists and dealers like the *Société Nationale des Beaux-Arts*, created with the dealer Martinet, went back to 1862.[54] Dealers like Paul Durand-Ruel and Georges Petit not only sought out works at public exhibition venues and in the studios of artists, but organised exhibitions on their own premises or let these out for the use of independent groups.[55] The integration of the dealer with most forms of independent professional organisation was by this time complete. Not only could he be called upon to rent out his premises, but the circulation of art objects was, to a large extent, dependent on his existence as the 'middle-man' who could transform non-productive merchandise into objects of exchange.

There were also initiatives to create forums of display where the artist was not seen to be dependent on the dealer, and where the commercial nature of the exercise was not overtly displayed. Among these were the rapidly expanding private and exclusive *cercles*, the French equivalent of the gentleman's club, which increasingly provided exhibition space for their members. A small number of these had already catered for artists and amateurs in the 1860s and 1870s, although precedents for such groups went back to the eighteenth century. In January 1880, the critic Louis Enault stressed the increasing

importance of these rapidly growing forums. They had become indispensable, he implied, for the effective circulation of art works and for putting artists into contact with high society (*gens du monde*) and art lovers.[56] Enault points to the need for direct communication between the producers and consumers of art. It was the *cercles* which could, in his view, facilitate this. Maurice Agulhon has described the *cercle* as a typical form of bourgeois sociability, although not necessarily the most common one. According to Agulhon, the *cercle* represented, on the one hand, the bourgeois answer to the exclusivity of the aristocratic *salon*, while it was predicated on the other hand on the existence of money, which placed it outside the realm of proletarian forms of sociability.[57] He placed its origins in earlier social institutions, particularly those of the last decades of the Ancien Régime, but contended that whereas the *cercle* represented a minor social phenomenon at this time, it came in the early to mid-nineteenth century to typify the form of institutionalised social interaction of bourgeois society. In the seventeenth century, the word *cercle* had denoted the circle of women surounding the sovereign at the court; in the eighteenth century, it referred to an intimate social circle of men and women within the confines of the private *salon*. It is only in the nineteenth century that it came to refer to a formal gathering of a group of people, usually male, outside of the home environment. Such a move from private to public forms of sociability marks significant changes in the transformation of social life, from sexually mixed home-based interactions to the emergence of more public and segregated types of entertainment and leisure in the forms of cafés, men's clubs and *cercles*.[58]

While the early *cercles* of the Restoration often struggled for legal recognition, the period of the July Monarchy saw the growth of many such institutions, a development which parallels the gradual bourgeois separation of male and female leisure and social interaction, and the growth of collective forms of recreation for the bourgeois male. The aristocratic *salon* had involved the social mixing of men and women within the home, but the ideology of the 'separation of the spheres' and the formation of the concept of the *femme au foyer*, the housewife, which informed bourgeois social order of the nineteenth century, manifested itself in the separation of female and male forms of labour and leisure. That of the former was centred on the home and family, that of the latter on the public sphere with its growing range of entertainments, the café and the *cercle*. For Agulhon, life in the bourgeois *cercle* connoted novelty, Englishness and relative equality, while that of the aristocratic *salon* brought tradition, Frenchness and hierarchy to mind.[59]

The relative egalitarianism to which Agulhon refers relates to issues of class rather than gender, of course. For Agulhon this did not disqualify the *cercle* from being regarded as a progressive social institution. What he does not acknowledge is that its exclusive masculinity was not an irresponsible oversight, easily remedied, but an integral part of the structure of bourgeois social order on which it was dependent. It was not incidental but structurally necessary that the *cercle* be a male preserve, and this must surely temper, or at least complicate, our understanding of it as a liberal, democratic institution. The idea of the *cercle* as a male preserve was built into contemporary definitions. According to the *Grande Encyclopédie*, the exclusion of women as members was even a condition of their authorisation by the State.[60] The habitual desertion of the *femme au foyer* for the *cercle* by the bourgeois Parisian male became a theme of complaint in a number of women's journals during this period. It was the *cercle* that was produced as one of the primary

15.   Jean Beraud, *Le Cercle*; Musée d'Orsay, Paris, courtesy of Service Photographique de la Réunion des Musées Nationaux.

threats to domestic harmony, although women were asked to be grateful that it was not for the brothel that their husbands deserted them.[61]

So rapidly were *cercles* opening up during this period that in December 1879 a new journal, the *Moniteur des cercles*, appeared on the scene, aimed at informing its readers of activities in Parisian and foreign *cercles*. The editors stressed that this was a journal for men only. It intended to disclose everything interesting that was happening in Paris and would, therefore, contain *anecdotes piquantes*, so fathers should be circumspect about allowing their daughters to read it.[62] The editors described the *cercle* as a male 'sanctum sanctorium', and contemporary visual representations of this space endorsed this. In Jean Beraud's painting of *Le Cercle*, two fashionably dressed men are shown lounging at the fireside in attitudes of relaxation and unselfconsciousness (fig. 15). They are 'at home' in this exclusively masculine environment, designed for their diversion and pleasure. The entry of women into such a space would not only disrupt its easy informality and inhibit

the freedom of male behaviour, but it would put women themselves at risk. In the words of one commentator writing in the *Gazette des femmes*, the admission of women into the *cercle* would lead to their adoption of unseemly masculine habits.[63] This gallant protector of female modesty was the very same figure who, in 1879, had introduced the prestigious *Cercle des arts liberaux* to the public in a letter to the *Moniteur des arts*. This *cercle*, he claimed, aimed to form a '*grande famille artistique*'.[64] It was clear that this was a family for men only. The only women to be admitted were to be servants, wives or companions on special events, and the occasional performing artist for the amusement of the members. Even if women were not explicitly forbidden from joining certain *cercles*, it was understood that these were masculine environments in which women would not be welcomed as members. Some *cercles* were prepared, however, to hire out their premises to exhibitions of work by women artists. It was in this way that the first all-women's art exhibition in Paris, organised by the newly formed *Union*, opened at the premises of the *Cercle des arts liberaux* and was quickly followed by a second exhibition at the *Salon de la rue Volney*.

While the *cercle* of the mid-century was generally a non-lucrative, private establishment, dedicated to providing an exclusive environment for the pursuit of leisure of groups of wealthy men of common interest, the café, on the other hand, was seen as a place which was commercial, public and open. The *cercle*, therefore, offered a locus of pleasure outside the home which was protected from the mingling and mixing of classes. It allowed the wealthy to participate in public metropolitain culture while retaining their exclusivity. The contemporary Larousse definition of the *cercle* emphasised this aspect of its character, describing it as 'an aristocratic gathering of men who are bored with their families and who wish to go out without mixing with the masses, the people, who today clutter up all the public places'.[65] Very often the *cercles* had luxurious premises like those of the exclusive *Cercle de l'union*, whose lodgings in the boulevard des Capucines after 1857 comprised three floors, including playing rooms, reading rooms, a library, a courtyard and two large dining rooms.[66] They were elegantly furnished and extravagantly decorated. The *Cercle des arts liberaux*, on the fashionable rue Vivienne, was approached by elegant staircases, had walls covered in red velvet and was filled with exotic plants.[67]

The non-commercial nature of the *cercle* did not always remain intact. Although ostensibly a centre for leisure, it became increasingly a meeting place for people with professional and commercial interests, and was an important site for the forming of contacts, the establishment of trust and informal business transactions. It was in these terms that the Larousse defended the *cercle* and the abandonment of families:

The habit introduced by the *cercles* of leaving one's wife and family and going to spend the only moments one has spare with indifferent company or around a games table is one that one could call immoral; but one has to recognise that in addition to the ease that the *cercle* offers pleasure seekers in absenting themselves too much from their homes, it also has a useful purpose: besides enabling one to see and appreciate men who have very diverse opinions and aspirations so contributing to removing ideas from the too narrow horizon of the family, it is at the *cercle* that the businessman can encounter the information he needs on the solubility of a purchaser, on the price of certain merchandise.[68]

These commercial interests not only affected the businessman or financial investor who frequented the prestigious Jockey Club or the *Cercle agricole* and the *Cercle de chemins de fer*. The artistic *cercles*, although never overtly commercial in their tone, became places where future buyers and artists could inhabit the same sphere and where valuable contacts could be made. The *Union Artistique*, for example, was formed to offer a site for the interaction of the artist not used to the ways of society, and the fashionable people with cultural pretensions who were his potential audience and clients. The artist's social mobility was assured by his talent, and he was tolerated and fêted by his social superiors because of this. The *cercle* hosted a permanent exhibition of art works of all genres in the *Salon de cercle*, claimed by a subsequent critic to be the first of this type of exhibition.[69] The *Union Artistique* organised open days for the admission of the public to view the work, and annual lotteries to facilitate the purchasing of works. Charles Yriarte, who published the first lengthy study on the *cercle* in 1864, described this exhibition venue in glowing terms. Claiming that of all existing galleries it offered the most propitious location for the exhibition of art works, he praised the gentle quality of light which illuminated the hundred or so canvases filling the long elegant hall.

Although the *Union Artistique* had organised its first exhibition in the 1860s, it was only in the 1870s and 1880s that such forums began to multiply and that critics began to take the work shown at such venues seriously. Not all critics even knew of the work of the *Union Artistique* in the 1870s. When the *Cercle des beaux-arts* was founded in 1872, one approving critic hailed it, erroneously, as the first such exhibition initiative.[70] It was during this period too that new professional societies organised by artists themselves, and centering on medium and subject matter, began to spring up. By the 1880s the Society of Watercolourists, formed in 1879, co-existed with groups such as the Society of Pastelists, the Society of Artists in Black and White, the Orientalists, the Society of French Animal Artists, and many others. Louis Enault, a great supporter of diversification, framed his welcome of the formation of the watercolourists in terms of their autonomy from both government and dealer, and defined the aims of the society as putting the producer into direct contact with the buyer.[71] By 1892, according to Charles Yriarte, everybody had to have an opinion on the art shown in the *petits Salons*, as the fashionable exhibitions in the societies and *cercles* came to be called. It was not only a certain section of society who had adopted them but society at large. To be ignorant of them showed one up as either a social failure or a foreigner.[72]

However, as the startled passer-by had shown in the caricatures by Draner, with which this chapter began, not all critics were as enthusiastic about these new exhibition forums as Enault and Yriarte. Reviews in the press of the *petits Salons* were mixed. Their existence and rapid expansion were widely noticed, and the subject of comment in most reviews, but opinions as to their worth and validity varied. While some critics were openly hostile to this diversification, others welcomed it for the variety of exhibition opportunity it could afford. There were those who felt that the pressure on artists to produce works and to exhibit them frequently had 'reduced' the artist to a manufacturer, and that the special nature of the creative work of the artist had thereby been compromised. Such critics were most often the ones who were at odds with the Republican project at large and who mourned the loss of importance attributed to the annual Salon, in their view the most

appropriate and illustrious forum for the display of carefully considered and well-wrought works. There were those who felt uneasy about the quantity of art works circulating in the Paris art world, fearing that quantity had replaced quality. Others lamented the quality of works submitted to the *petits Salons*, attributing this to the fact that artists held back their most important works for the Salon. Some felt that the *cercles* were too lenient to newcomers and urged more stringent entry procedures if standards were to be raised.[73] One of the harshest critics of the *petits Salons* was Albert Wolff, despite being favourably disposed to the women's *Salons*. He wished to 'eliminate all fine art in the *cercles*', because of what he saw as the poor quality of the work and the leniency of these institutions to undeserving amateurs.[74] (Such complaints echo the concerns he had over the admissions policy of the *Union*.) The exhibitions in the *cercles* became the focus for the expression of some of the anxieties felt by those critics who were disturbed by the radical and visible changes which they observed in the artistic field. The language of some of the critics betrays their anxiety at being 'swamped' or 'overrun' by the explosion of exhibitions. One critic declared that in the midst of this 'veritable flood of painting', an April shower indeed if one recalls the caricature cited at the beginning of this chapter, journalists did not know where to turn their heads.[75]

As professional organisations alone and not sites of 'leisure', the societies were far more open to women than the *cercles*. Only one, the *Salon de la Rose-Croix*, home of some of the misogynist imagery which characterised certain types of Symbolism, expressly forbade women from joining.[76] Other such organisations could potentially provide some women with the kind of institutional outlet that the *Union des Femmes Peintres et Sculpteurs* was designed to fulfill. The well-known Madeleine Lemaire, for example, who had at first been billed as one of the founders of the *Union* by the *Moniteur des arts*, but had later withdrawn from all involvement with the group, chose to exhibit with the exclusive Society of French Watercolourists, whose statutes forbade its members from joining other exhibiting organisations.[77] Mme Lemaire was never to exhibit with the *Union*. She had made her choice. Her first commitment was as a professional artist, a watercolourist. She would show in one-off separate women's exhibitions like the 1882 exhibition held at the *Cercle de la rue Volney* (when nearly four hundred works were on show), if this did not jeopardise her professional position, but she would not give up the status and exhibiting opportunities afforded by her professional association for the sake of women artists or the elaboration of a feminine art. She and her fellow watercolourist, the Baronne Nathaniel de Rothschild, abstained from taking part in the *Salons des femmes*, although their absence was often remarked upon by critics, preferring to submit work to the Watercolourists and the annual Salon or take on private commissions. After 1886, when Madeleine Lemaire ceased to show with the Watercolourists, leaving the Baronne de Rothschild as its only female member until 1895, her independent career was so well established that she did not need the *Union* as a forum of display. Mary Cassatt, like Marie Bracquemond, also took advantage of the formation of a specialist society to show her work. Cassatt exhibited twice with the Society of Painter-Printmakers in the late 1880s, until her foreign identity prevented her from showing with a group which had decided to make Frenchness a condition of membership. By this stage, Cassatt was established enough to arrange her own one-person exhibition. In the 1870s and 1880s, she

and Berthe Morisot, having rejected the Salon as a forum, had found sufficient outlet for their work in the Impressionist exhibitions (at which they and two other women showed), and in private initiatives, and never showed in the *Salons des femmes*. Their identification with naturalist practices, and friendship with Impressionist artists, made these independent forums the obvious contexts in which to show their work. Here they could select their own exhibits, and participate in the organisation of the exhibitions as equal partners. Morisot never identified with women's struggles in any political way, and Cassatt's political involvement with feminist issues expressed itself in the American rather than the Parisian context. By the 1880s, both Cassatt and Morisot had established connections with dealers, and while they were keen to sell their work neither was dependent on sales for their livelihood.[78]

Eva Gonzalès, on the other hand, eschewed the Impressionist exhibitions and followed the initiative of her teacher Manet by showing in the Salon. She was willing, however, to show in all-women environments as her participation in the 1882 women's exhibition at the *Cercle de la rue Volney* testifies.[79] Louise Abbéma's attitude to the *Union* appears to have been ambivalent. In an interview published in *L'Eclair*, she was reported to have rejected the idea of all women's exhibitions with the words: 'I don't know why women have their own exhibitions because this amounts to saying: We don't have enough courage to compete with men'.[80] However, having been chastised for her comment by a reporter in the *Journal des femmes artistes*, she backed off and defended her position by saying that while she admired the *Union*, and regarded it as an interesting and brave organisation, her 'love of independence' had prevented her from joining any artist's association. Although Abbéma clearly did not want to be associated with the *Union*, she was reluctant to be seen as hostile to it.

As is evident, there were many ways to negotiate one's position as an independent professional, and a woman, in the art world of the early 1880s. There were certainly those women who wanted nothing to do with separatist ventures, but there were still many women artists who saw the point of organising themselves independently. These were the ones who felt strongly that women were not sufficiently catered for by the narrow constraints of the special interest societies, and who experienced their exclusion from the prestigious and exclusive *cercles* as a real practical disadvantage.

By 1881, most professional artists supplemented their annual submissions to the Salon with work submitted to the *cercles* or societies to which they belonged. For the increasing numbers of women artists this presented a problem. Louis Enault, whose wife Alix was an artist and *sociétaire* (fig. 16), wrote in the journal *Henry IV*:

> Almost all the painters and sculptors with any talent belong to one or two of the *grands cercles* which are well placed, very much on view and which, every year, organise one or more exhibitions, to which crowds of art lovers, dilettantes and society's élite rush. But the rules of most of these *cercles* only allow works by their members to appear at their exhibitions and as women cannot belong to these, their works are fatally excluded.[81]

Enault goes on to distance himself from any association with overt feminist agitation, by declaring: 'I am not saying that this is unjust', but he does say:

I find that women's position is really tough . . . official exhibitions will soon become discredited which a number of factors make inevitable. Special exhibitions will become more interesting and advantageous day by day. Not to be able to benefit from them will result in a real inferiority for the victims of this unreasonable ostracism. And these victims are women.[82]

Two months later Enault wrote an impassioned letter to Olympe Audouard, editor of *Le Papillon*, expanding on these points. Reiterating his views on the demise of public exhibitions, he outlined the importance of exhibiting in the *cercles*:

These special exhibitions, which usually precede the official and public exhibition at the Champs-Elysées by a few weeks, are like a visiting card which our fashionable sculptors place within the public's reach; in this way they attract attention to their works for the first time, and we see them again with more pleasure when we find them at the Salon.[83]

16. Mme Alix Enault, *Fleurs de Serre*; whereabouts unknown.

Two years later, Dame Pluche of the *Gazette des femmes* wrote of the prestige which exhibitions in *cercles* had, by this stage, achieved. 'Everyone comes together there', she wrote, 'famous artists, lofty aristocrats, intellectuals. Most well-known painters belong to the *Mirliton*, which permits the organisation of exhibitions there which, despite being less official than those at the *Palais de l'Industrie*, are not less successful'.[84]

In 1893, Charles Yriarte was still lamenting the fact that the *cercles* were closed to women artists.[85] There is no doubt that certain women artists felt their exclusion from many such groups as a considerable disadvantage. In a speech at the general assembly of the *Union* in 1883, Mme Bertaux addressed the issue of the *cercles*, referring to 'these gentlemen who come together in small groups, organise small but very interesting exhibitions from which we are generally excluded.'[86] Like them, she claimed, women artists sought to appeal to the public outside of the framework of the annual Salon, and by so doing to draw attention to their works which risked becoming confused and lost in a larger forum. It was the discrimination against women at an institutional level, therefore, which was one of the primary motivations for the formation of the *Union*. In the inaugural speech of the *Union*, Mme Bertaux outlined women's position in the art world as she saw it:

> The woman artist is an unknown power, unrecognised, held back from developing fully! A type of social prejudice still weighs her down, and despite this, every year, the number of women committed to art increases with a frightening rapidity: I say frightening because our institutions still do nothing for the greater cultivation of these minds hard at work, the results of so many efforts are often powerless or ridiculous . . . Should one conclude from this that women should abstain [from art] or resign themselves to occupying an inferior place amongst artists? This is not how I see it. Wherever there is feeling and the will to express it, there is a vital power which a country allied to progress has neither the right to ignore nor to leave unactivated. We are this power, and in order to demonstrate it and provide the evidence, we are going to group together. In order to get themselves noticed, men have decided to put themselves in societies, sometimes in cliques, from which, a short time ago, we were systematically excluded. Let us gather together to count ourselves, to defend ourselves! Let us be united for the faithful struggle. Let us call ourselves the 'Union of Women Painters and Sculptors'.[87]

The *Union* was formed, therefore, to provide women with a supplementary exhibition forum to the annual Salon. It could equal such institutional initiatives as the *cercles*, and could cater for a more broad-ranging representation in both medium and subject matter than that for which the specialised societies provided. The institutional prototypes for the *Union* were, to some extent, these new forums of display. The *Union*'s attempt to create exhibition spaces which emulated the appearance of a wealthy *salon* was in keeping with the atmosphere created in the *cercles*, and promoted by dealers like Georges Petit who hosted many of the exhibitions of the societies. But there were also some significant differences between the *Union* and these ever expanding forums. Unlike the *cercles*, the *Union* did not have permanent premises which could function as a leisure club for its members as well as a context for the forming of professional contacts. The *Union* was

always less exclusive than the *cercles*, with its aspirations to provide a forum for newcomers who would neither be eligible to show work at the prestigious societies (some of whom operated highly exclusive admissions policies) nor at the *cercles* with their decidedly masculine atmosphere. Exhibitions at the *Union* soon became much larger than those at either the *cercles* or the societies. In that sense, it functioned more as a *Salon*, providing an annual large exhibition space for the display of works. But the particular aspirations of the *Union* in terms of its role in the promotion of a female culture, and the values of co-operation and support which were intrinsic to its formation, as well as its elaborate infrastructure of members, fees and elected representatives, separate it from the Salon. The *Union* occupies, therefore, a unique space between these social forms.

Catering for the needs of women in an environment which was at best neglectful, at worst hostile, the *Union* drew from a range of possible institutional prototypes, forming a hybrid which could go some length in catering for the needs of women within a particular historical context. Only by initiating an independent exhibition forum, with its own complex institutional infrastructure, did Mme Bertaux and her colleagues believe that they could begin to compete with their contemporaries, ensure exposure for their work, and at the same time create a supportive environment for the encouragement of younger female talent, vital for the creation of a vibrant feminine culture.

The ability to articulate such needs, indeed the language in which they were framed, had its origins outside of the established discourses of the art world. It is to the emergent world of feminist struggle, and to wider debates on 'the woman question', that we must now turn in order to make sense of the broader context within which the *Union* could both come into being and develop into a thriving organisation.

# Chapter 3

# Feminism, Philanthropy and the *femme artiste*

ON 27 JUNE 1892, Mme Léon Bertaux put her name forward as a candidate to fill the seat vacated by the death of the sculptor Bonnaisieux in the all-male *Académie des Beaux-Arts*, fourth class of the *Institut de France*.[1] Predictably, such presumption provoked mixed reactions. The Paris art world was divided as to her eligibility for the position and the appropriateness of her gesture. For some critics this presented no problem. Emile Cardon of the *Moniteur des arts* declared emphatically that had she been a man, Mme Bertaux was sure to have been elected a member fifteen years earlier.[2] The critic for the *Journal des femmes* was equally convinced of this, and made a plea for artistic honours to be above differences of sex:

> There is no doubt that had the eminent sculptor been a man, his nomination would already be an established fact. We ask artists, for whom the ideal should be something sacred, to elevate themselves above distinctions of sex, in the same way they have already placed themselves beyond prejudices of class and to honour the chisel which produces masterpieces without looking to see if the hand which guides it belongs to a man or a woman.[3]

Another writer for the *Journal des femmes* saw Mme Bertaux's rights as similar to those of all women professionals, who had long demanded equal access to educational facilities and an equal share of the awards and honours through which talent was fostered. Mme Bertaux's experience was seen as an instance of a much wider struggle:

> When one thinks of the amount of effort required by a woman artist, doctor, lawyer, writer or journalist, to reach the position which men, having had the way cleared before them, arrive at without difficulty, one asks oneself whether they [women] do not deserve to be doubly recompensed.[4]

There were even critics prepared to argue that Mme Bertaux was worthy of the award because of her indefatigable efforts to raise the professional status of the woman artist. André Marty of the *Journal des artistes* acknowledged that Mme Bertaux's talent alone was sufficient to give her the authority to canvass support for election to this office, but asserted that her real eligibility lay in her campaigns and projects on behalf of the woman artist. Her candidature at the *Académie des Beaux-Arts* would, in his opinion, only claim for women under the Republic that which women had already enjoyed under the Ancien Régime.[5]

A comparison between the situation of women under the Ancien Régime and the Third Republic was controversial territory. The Republican leadership was constantly being

confronted with a reminder that it had been easier for certain women to occupy elevated positions before the Revolution than after.[6] 'It is unbelievable', wrote Emile Cardon, 'that in the age in which we live, in a Republic, the State shows less liberalism than under either the old monarchy or the empire'.[7] In 1885, Octave Fidière had published his account of women's position in the old *Académie Royale*, which counted fifteen women artists on its register.[8] In the same year, the *Moniteur des arts* ran a series of articles detailing the history of female academicians of the past, and framing this within the context of a criticism of women's exclusion from equivalent contemporary institutions.[9] Although the new *Académie* did not expressly prohibit female candidature, custom prevented it. However, for stalwart Republicans like Jules Simon writing in *Le Temps*, it was important that the Ancien Régime was not seen to triumph over the beloved Republic.[10] Anxious to defend the Republic, he talked of women's 'progress' in recent years, their increasing access to higher education, and their proven capacity to succeed in all faculties at the university. The Republic, he proclaimed, should give women everything that they wanted, except when they demanded to be men. That would entail an inversion of natural laws. The Republic would lose women and gain difficult colleagues, and the immediate result would be the loss of the Republic itself and the triumph of the clergy (traditionally supported by women). Yet, in the matter of the candidacy to the *Académie*, he believed there was no risk. Mme Bertaux sought neither to be a deputy nor a minister. She only wanted to be a member of the *Institut* and this was, after all, not a job but an honour, and therefore eminently suitable for a woman.[11] The Republic could safely support such efforts. By all accounts many journalists were in agreement with him. The critic for the *Journal des femmes* saw the generally positive response to Mme Bertaux's candidacy as a sign of the times.[12]

There were, though, some vociferous exceptions. Die-hards like Gonzague Privat of *L'Evénément* used this opportunity to mock women's aspirations, and to invoke the incongruity of their presence in the hallowed *Institut*. He, for one, could not understand what women stood to gain. Women artists, he believed, had nothing to complain about. They were welcomed at the Salon where they were amply rewarded, and men had everywhere proven their appreciation of their 'colleagues in skirts'. By initiating a women-only exhibition organisation, Mme Bertaux had shown herself to be exclusive and discriminatory in her practices. What was more, she had demonstrated women's essential flaw, a lack of logic:

> Mme Bertaux does not want men in her exhibition, but, on the other hand, she wants at least one woman in the *Institut* and, to be logical to the end, she wants this woman to be no other than herself. This is questionable logic.[13]

Privat was by no means alone in his hostility to women's entry to the *Institut*. According to the writer for *Le Temps*, there was still a strong current within the Academy itself which was opposed to women's candidature.[14] Such antagonists were to be expected. What is more surprising is that some of the most virulently negative comments came from successful women artists like Mme Madeleine Lemaire, who was emphatically opposed. For one thing there was, in her view, no contemporary woman artist who could match up to Elizabeth Vigée Lebrun, one of the last two women, together with Adelaide Labille

Guyard, to be elected an academician under the Ancien Régime. Nor did women have anything to complain about. All that counted was talent, and if women had enough of that, they would succeed. What was more, the demand to be admitted into the *Institut* smacked of a certain *féminisme* with which she had no sympathy.[15] There was little real cause for alarm. According to M. Valquerie, writing in *Rappel*, Mme Bertaux's candidacy had little chance of succeeding: 'It is readily acknowledged that there are queens and empresses, but '*académiciennes*'! It's mad to even think about it.'[16]

In the Paris of the 1890s, it was not surprising to see *féminisme* behind Mme Bertaux's gesture, and Madeleine Lemaire was not the only one to do so. After all, *féminisme* was one of the key issues of the decade: 'it is almost developing into a fashionable craze', wrote Virginia Crawford in 1897, and everyone was talking about it.[17] Not everyone though, interpreted it in such a negative light. As we have seen, the *Journal des femmes* felt able to support Mme Bertaux's candidature in the name of women's advancement in the professions. One of the critics for *Le Temps* was prepared to see this as a test case:

> There is much talk of women's rights since Mlle Jeanne Chauvin achieved the title of doctor of law. We will soon see whether the cause of women's emancipation has made as much progress as one would like when the *Académie des Beaux-Arts* gives its verdict on the candidature of Mme Léon Bertaux.[18]

It was of course debatable whether the campaigns for women's advancement in the arts could be claimed as feminist initiatives or not. Certainly, there were many people who called themselves feminists and saw the support of the woman artist as part of their wider project of reform of women's social position. Maria Deraismes, the Republican feminist, had already clearly articulated this position in the 1870s:

> It is probably the case that those who have spoken lightly of women artists have never met them. It is really time to put an end to these slanderous claims which are without foundation. For us, the entry of women into the domain of the sciences, their well-known progression in art, is a guarantee of a reform of customs in the future.[19]

There were, however, many ways in which it was possible to be a feminist in the late nineteenth century, and there were also ways in which one could define oneself as a supporter and promotor of women's well-being without associating with feminism at all. Some enthusiasts like Jules Alesson, for many years editor of a series of serious periodicals aimed at promoting the interests of the modern cultured woman, saw no contradiction in supporting the institutional campaigns of women artists, while denigrating the attempts of other women to gain recognition in those male professions which had to do with legal and civic duties.[20] Alesson was overjoyed when the president of the *Société des Artistes Français* declared that there was nothing to prevent women from being nominated to the Salon jury. This result was, for him, much more remarkable than the famous question of women's rights and the aspirations of certain women to be deputies and lawyers. The latter he saw as a demand which was both undesirable and tactically unsound, as it would open all women's aspirations to ridicule. But to ask for women to be eligible for election onto a jury for the judgement of art works was eminently reasonable. It was a demand which was suited to women's nature and role, and strategically it was wise to restrict a

woman's campaigns to: 'the sublime services which she could render through her delicate intelligence, her patient skill, her exquisite tact, her unnalterable tenderness'.[21]

Even if critics like the conservative Jean Alesson, or for that matter the cautious Louis Enault, did not self-consciously identify with a feminist programme of reform or revolution, their support of women's involvement in the arts stemmed from a new consciousness of women's demands, and an acknowledgement of women's rights, however tentative, which came to be identified by contemporaries as 'the woman question'. That these concerns had entered, by the 1880s, into the arena of public debate so that a language for the discussion of women's issues was now both available and in the process of formation and revision, is the product of the growth of feminism, as it came to be called, as an area of public interest during the early years of the Third Republic. Enault and Alesson, as we have seen, were not alone in their unwillingness to be seen to be involved with something so politically contentious and potentially subversive as feminism. Organised feminism was widely regarded in circles across the political spectrum as a divisive and harmful force, which would corrode the family and the traditional forms of social organisation on which the stability of the State was dependent. However, this did not stop Enault, Alesson or other critics like *Le Figaro's* Albert Wolff, who was publicly hostile to political feminism, from being supportive of the separate women's exhibitions.[22] It was perhaps in their encouragement of women's exhibitions that critics like Wolff could demonstrate their 'fair mindedness' (without conceding any political rights) in an arena which, when entered into at a suitable level, could be regarded as appropriately feminine. For some of those who were sympathetic to women's plight, it was precisely as artists that women could fulfill their duties as wives and mothers, express their innate feminine natures, and fulfill their newly pressing professional aspirations. A contemporary impassioned defence of the woman composer began with the familiar assertion that the writer was no supporter of 'the emancipation of women'. This was an impossible Utopian dream, but it did not mean that women should not excel in the arts, an arena which was compatible with their natural concerns and talents.[23] In the words of the Christian commentator, the Abbé de Sertillanges, what needed to be encouraged in women was 'maternity and its appendages' and art could be perceived as one of these.[24]

It is apparent, therefore, that the *Union's* exhibitions and reform campaigns cannot be claimed simply as feminist intitiatives, without some explanation of what that meant in its nineteenth-century context. Indeed, the contemporary reading of the insititution was as complex and contradictory as the discourse on 'Woman' itself. As we saw in the discussion surrounding Mme Bertaux's candidature to the *Académie des Beaux-Arts*, it was as easy to divorce women's campaigns in the arts from broader political questions, as it was to see them as part of a feminist 'master plan'. But the tendency to separate issues related to the woman artist from wider political ones, outraged those who were committed to women's social and political advancement. Not everyone agreed with Jean Alesson's cautious strategy of reform. Indeed, his simultaneous hostility to political change and support of the woman artist provoked an infuriated response from a writer for the Republican feminist *L'Avenir des femmes*, angered by his disparaging remarks about women's professional aspirations in more controversial areas than the arts.[25] For this writer, Mme Jeanne Mercoeur, a pseudonym for the paper's founder and editor Léon

Richer, the campaign for reform of women's position within art institutions was valid only in as much as it was part of a much wider struggle for reform. These could not be divorced from one another. There were, in fact, critics who framed their support of the exhibitions of the *Union* in terms of the role that they could play in the improvement of women's lot. Emile Cardon defended his interest in the *Union*'s activities by asserting that: 'everything that can contribute to the emancipation of woman, to the improvement of her position, in a society which treats her like a slave, deserves to be seriously encouraged'.[26]

It was in these terms that the newly founded women's suffrage journal *La Citoyenne* had welcomed the initiative in 1882, hailing the first exhibition of the *Union* as responding to a need for the development of women's intellect which the writer contended had been compromised for far too long.[27] The critic of the 1885 show saw the initiative of the *Union* as one step on the road to political emancipation, and welcomed the new collective spirit among women which she saw it as heralding.[28] However, very few of the supporters of the *Union* shared the radical politics and commitment to female suffrage of *La Citoyenne*. The exhibitions and the endeavours of the woman artist as an independent professional could be championed from a number of political perspectives, all of which were committed to the amelioration of women's position in society. For example, some commentators saw the exhibitions of the *Union* as concrete manifestations of women's intellectual and creative capacities and potential, and they were used to counter contemporary beliefs in women's innate intellectual and artistic inferiority. They could be cited as evidence to support various and divergent claims for women's rights, or even simply for their dignity. A case in point is Charles Bigot, who, writing for *La Revue politique et littéraire*, used his review of the first exhibition to declare his sympathy for any initiative which would 'free women and permit them to earn an honest living'. He then added a condition that would have alienated the militant readers of *La Citoyenne*: that 'women did not stop being women and did not lose their charming qualities'.[29] Many women were tired of having the problematic formulated in this way. Bigot's opinion, however, represented those of a large number of sympathetic supporters, and was to become almost a cliché in the years following the formation of the *Union*. As long as the campaigns remained restricted to areas that were regarded as suitably womanly, and in many quarters art was seen as one of those, then even the reviewer for the highly conservative, anti-emancipatory *La Famille* could welcome the exhibitions because of their demonstration of women's capacities and potential.[30]

*La Famille* went as far as to feature the work of women artists on its covers, sometimes depicting the woman professional at her easel (fig. 17). An interesting *frisson* is set up between the title of the journal, framed by its two traditionally allegorical female profiles, and the image of the assertive woman artist gazing directly out of the picture. This uncompromising and defiant assertion of self-as-professional provides a somewhat unlikely image on the cover of this cautiously conservative publication, and points to the notion that the woman artist could represent the acceptable side of modern women's assertiveness in some contexts. The skills of the woman artist could also be harnessed to the idealisation of maternity and the celebration of the traditional family that this publication endorsed. A cover for an 1889 issue used a painting by Virginie Demont-Breton celebrating traditional feminine roles through the transpositon of the Madonna

17. AVANT LA SÉANCE, tableau de M<sup>me</sup> M. Carpentier (Phot. Roux).

LE BAIN : Tableau de M<sup>me</sup> Demont-Breton.

17. Cover of *La Famille* (11 January 1891); Bibliothèque Nationale, Paris.

18. Cover of *La Famille* (6 January 1889); Bibliothèque Nationale, Paris.

onto a modern *maternité* (fig. 18). Women's professionalism is marshalled here to the defence of women's role in the family. Female authorship functions as an alibi to women's maternal mission. The skilled and publicly acclaimed woman artist is seen, here, to endorse conservative social values. Her work both asserts women's skill and inscribes women's role. Small wonder that this would appeal to some of the Third Republic's most traditional patriarchs.

Jules Claretie of *Le Temps* even compared what he saw as the different strategies for female emancipation exemplified by, on the one hand, Hubertine Auclert and her organisation *Suffrage des femmes* with its outspoken newspaper *La Citoyenne*, which he characterised as 'public haranguing', with, on the other hand, that of the exhibitions of the *Union*, which he half mockingly claimed as a more substantial form of campaigning for women's rights. As he put it:

> I know women who, for their liberation, have more than words to be listened to; they have works to show. On this very day at the *Palais des Champs-Elysées*, the second exhibition of the Union of Women Painters and Sculptors is opening.[31]

Claretie went on to satirise the women's achievements, but having put his comments in the above context, the source of his anxiety is apparent. The exhibitions of the *Union* were

linked with feminist agitation in general. The shows' strengths, if they were acknowledged to exist, could be used to point up the weaknesses of women's wider political struggles, while their fallibility could be linked to women's inherent failings and made to demonstrate their unworthiness for a more elevated social status.

As we have seen, the impetus for the exhibitions came from a growing awareness among a group of women artists that the institutions available for the display of their work were inadequate, and from the strongly held belief that women were discriminated against, not only at the level of exhibition opportunity, but in terms of education, acknowledgement of achievement, and public honours. That such a consciousness was not always accompanied by an allegiance to a radical political feminism, is accounted for by the complex splittings and multiple variations in feminist politics of the time. Indeed, the expectation that it should be is an anachronistic projection, which does not take account of the heterogeneity of the debate over women's role and mission, at its height in late nineteenth-century French society. What is as interesting as the reluctance of certain supporters of the woman artist, and indeed many of the artists themselves, to identify with organised political feminism, is the realisation that the exhibitions of the *Union* and similar initiatives could be championed by supporters working from the most diverse political positions. The fact is, that the exhibitions in general, and the campaigns of the woman artist in particular, become a focus of interest and attention from feminists of varying persuasions and allegiances. While for some critics they were hailed as part of a larger political struggle, for some they could represent the acceptable face of a rather unpleasant but nevertheless pressing set of contemporary concerns, whilst for others they could be welcomed as the forum which would facilitate the flowering of a truly female culture, one which was beyond the vagaries of temporal political power. All of these claims could be made in the name of 'feminism', but it is by no means a univocal or monolithic concept which can be reduced to one set of ideas or strategies. Feminist culture in late nineteenth-century France was too heterogenous and complex to be reduced in this way.

The word *féminisme* itself was rarely used in the first two decades of the Third Republic. It is interesting that it does not appear as a separate entry in either Pierre Larousse's *Grand Dictionnaire Universel*, compiled between 1865 and 1876, or in *La Grand Encyclopédie*, compiled between 1887 and 1902. Yet the word is reputed to have been invented by Charles Fourier as early as 1808, but was not widely used until the 1890s when it could be employed in a variety of ways.[32] The suffragist, Hubertine Auclert, first used the word or its derivative in a letter to the *Préfecture de la Seine* in 1882.[33] She had, in the 1870s, described a group she joined as a *comité féministe*. It was she who, through a series of articles in *Le Temps* in the early 1880s, introduced the word *féminisme* to a wide French public. The first women's rights congress to use the word *féministe* was in 1892. By 1893, there existed a *Fédération des Sociétés Féministes*, and in 1895 a *Syndicat de la Presse Féministe* was formed under the presidency of Clotilde Dissard. By the late 1890s, at least two journals used the word in their titles: *La Revue féministe* (1895 to 1897), founded by Dissard, and *Le Féminisme chrétienne* (1896 to 1899), founded by Marie Maugeret.[34]

There was still little consensus about how the word should be used. In 1886, the critic known as Hermel described Degas as a feminist because of his ability to see and define

'Woman' in the manner which most characterises her.[35] Here the word is used, perhaps ironically, to mean a discerning appreciation of woman, and is far removed from the context of political struggles in the name of women with which it was already associated in some quarters. For one high ranking civil servant, speaking at a banquet hosted by the *Union*, 'most great artists have had, at the time of their finest creations, moments of feminism', that is moments when the allegedly feminine attributes of refinement, delicacy and perceptiveness are deployed.[36] Feminism is here conflated with feminisation, and the artist is constructed as a masculine subject infused with feminine sensibilities. Sometimes this infusion is attributed to men's 'affection for women', which is seen to induce in them, especially artists with their particularly refined sensibilities, the attributes culturally associated with the 'feminine'. It was in this sense that it was used by Virginie Demont-Breton, in an attempt to avoid what she saw as an unfortunate polarisation between feminists and non-feminists: 'Are not all men essentially feminists? Their most tender and most virile artistic aspirations, the very form of their ideal, are these not born of their love for Woman?[37]

Most late nineteenth-century men were prepared to admit to a 'love of women', and if 'feminism' could be appropriated to such ends they were prepared to be devotees. But the issue did not rest with the word and its multiple significations alone. Within those groups established in order to ameliorate the position of women, many competing definitions, not only of the terminology but of the project at hand, its ultimate goals and strategies for achieving these, existed simultaneously. And the field was to become more complex and divisive as time went on. In nineteenth-century France there was never a unified women's movement with clearly defined and shared aims. There were always passionate subgroups, splits and differences, which made concerted action impossible.

This was already true in 1881, the year of the formation of the *Union*. This was an important year for Republican, and therefore for feminist, history. In the 1870s, most active feminists in Paris had supported the Republic and were willing to believe that when the Republic was securely established, women's issues would be placed firmly on the political agenda and given priority. The Republican victory in the 1877 election in the Chamber of Deputies had facilitated the organisation of feminist meetings when the restrictions on public gatherings were lifted. The 1879 elections for the Senate brought in a large majority for the Republicans, and established the presidency of Jules Grévy after the resignation of Patrice de Mac-Mahon.[38] In 1881, once the Republican government was firmly in control, deputies felt able to pass a law which guaranteed the freedom of assembly, the law of 30 June 1881, and some weeks later another law was passed which guaranteed freedom of the press. For feminist organisations, some of which had been shut down in the more conservative 1870s, especially during Mac-Mahon's presidency, this augured well. The late 1870s and early 1880s was therefore a period of expansion and relative optimism. It seemed, for a time, that some of the oldest feminist demands – the re-introduction of divorce, reforms in girls' and women's education, the right to file paternity suits, the access of women to the liberal professions – were, at last, to be seriously debated.[39] It was economics as much as anything that had put most of these issues onto the agenda, and it was necessity which was to lead to the gradual opening up of the professions to women. Although Republican rhetoric, for the most part, endorsed the

dominant *femme au foyer* doctrine so dear to Catholic conservatives and Proudhonian socialists alike, women would have to enter the workforce, and not only at the level of unskilled labour, if France was to re-establish itself as a dominant economic power after the political and military disasters of the early 1870s, and the financial burden which the loss of Alsace-Lorraine and the paying off of indemnities to the Germans had involved.[40] This, together with a profound anti-clericalism and a will to control the influence of the Church, which had been instrumental in supporting anti-Republican factions in the 1870s, led to concerted efforts to secularise education, especially that of girls, and moves to open up the liberal professions to women.

The women's movement was already irreparably split at this point, however, and even the alliances which had cemented Republican feminism in the 1860s and 1870s threatened to break up. For as long as the Republic had been a Utopian fantasy or even a fragile, ever-threatened reality, Republican feminists were united against a common enemy, the protagonists of political reaction. The so-called 'architects of the new feminism' (the phrase is Patrick Bidelman's), fiercely Republican and anti-clerical in nature, were the indefatigable Léon Richer and Maria Deraismes.[41] In the 1860s, they had been able to work to some extent with socialist activists and were united with them against the Empire, but after the destruction of the commune and the exile of important figures like Louise Michel, André Léo and Paule Minck, such alliances broke up.[42] Huge differences began to appear between Republicans who supported the new *régime* and who were prepared to work for it in the belief that this was the party with women's interests at heart, and the revolutionary socialists who were prepared to put off the moment of women's emanciaption to a time when socialism had been established and the proletariat was liberated.[43]

However, there were fundamental differences amongst the Republican feminists themselves. Their own philosphies had been founded on a combination of the theories of influential thinkers like John Stuart Mill, and of previous generations of feminists. This had culminated in the early 1860s in a veritable '*querelle des femmes*' as Claire Goldberg Moses has called it, comprising a series of important publications which set out, in the context of the rampant anti-feminism which characterised both the left and right during the Second Empire, to dispute the influential theories of Jules Michelet and Pierre-Joseph Proudhon. Under the censorship laws of the Second Empire, the concerted feminist action which had characterised the heady days of the Second Republic had been squashed, and the flurry of feminist publishing which had picked up on ideas first formulated within the context of the Saint Simonian idealism of the 1830s, had disappeared.[44] But in the 1860s a number of individuals set out to challenge dominant gender assumptions, and systematically to refute current beliefs in women's innate inferiority and concomitant social roles. The most important publications were *Idées anti-proudhoniennes sur l'amour, la femme et le mariage* of 1858, by Juliet Lamber, later Adam, and Jenny d'Hericourt's *La Femme affranchie* of 1860. Among others was Olympe Audouard's *Guerre aux hommes* of 1866, which was a scathing attack on women's legal position prompted by legislation which had prevented the author, as a woman and therefore not a full citizen, from publishing in 1862 *La Revue cosmopolite*, a political journal which was both anti-government and anti-church. As a response, Audouard founded her literary review, *Le Papillon*, which was to champion women's causes in the arts (see figs. 1, 2).

With the gradual liberalisation of laws of public assembly and the easing of censorship laws in the last years of the Empire, the setting up of forums for public debate surrounding political and philosophical issues became possible. It was in this context that the young Maria Deraismes, encouraged by Léon Richer, made her debut as a public speaker at the *Conférences libre-penseuses à la Salle du Grand-Orient*.[45] Deraismes had, also, been stimulated into action by the publication of a misogynist text, this time Barbey d'Aurevilly's bitter attack on intellectual women, *Les Bas-Bleus* of 1867. Her lectures from this period were subsequently published as *Eve dans l'humanité*. Like d'Hericourt and Adam, Deraismes joined a defence of women's rights to a defence of the family and the rights of married women. She denounced the double standard in sexual morality which created two classes of women, one the married woman enslaved within the home, the other the prostitute, the victim of male sexual appetite. It was through the reform of marriage into an institution of enlightened equals, which could be brought about by the education of women and their improved legal status, that social harmony and the prosperity of the Republic could be assured. Without intelligent companionship in the home, men would continue to seek out '*le cabaret, le café ou le cercle*' at the expense of the family. These themes set the tone for the majority of feminist campaigning in the later part of the century. It was reform via the sacred institution of the family that most feminists sought, and it was the establishment of equality within the family in the context of a traditional monogomous sexual relationship, without double standards of morality, in which most women thought that their interests lay. The most widely supported feminist campaigns of the late nineteenth century, therefore, centred on the preservation and reform of traditional social institutions, through the establishment of financial independence and full legal status for wives, jurisidiction for mothers over their own children, and the deregulation of prostitution. (The latter was simultaneously perceived as oppressive to working women whose meagre wages necessitated the sale of their bodies, and the licensing of the double standard which led to the erosion of the family and the exploitation of married women.) Only very few late nineteenth-century feminists like Madeleine Pelletier believed in free sexual union, legalised contraception and abortion.[46] It is not difficult to see, therefore, that many aspects of bourgeois 'reformist' feminism could be allied with some of the most conservative social movements of the late nineteenth century, and Republican though much of it was, it was not, in parts, dissimilar in rhetoric to the social philanthropy of liberal Catholicism.

Uniting all feminists during this period and throughout the nineteenth century was a hostility to the Napoleonic Code, the legislative system by which France had been governed since 1804 and which enshrined masculine privilege, both in the home and in the public domain. Feminists in the nineteenth century, and subsequently, agreed that the Code legitimised a form of female servitude which surpassed that of the Ancien Régime and the Middle Ages. As Sue Goliber has noted, even women who were not active supporters of feminist organisations found the Code difficult to accept.[47] The family structure, as inscribed in the Code, mirrored that of the Empire with the father as the undisputed figure of authority. The obedience of the wife to her husband was decreed by law. She remained a legal minor and had no jurisidiction over her own movements, her money, her property or her children.[48] Reform of the Code became the focus of much

feminist campaigning in the second half of the nineteenth century. In 1870, figures with as different political sympathies as Richer, Deraismes, Michel, Mink, Léo and M. and Mme Jules Simon could identify with the newly formed 'Association pour les Droits des Femmes' (linked to the journal, edited and mostly written by Léon Richer, Le Droit des femmes, later to become known as L'Avenir des femmes), united in the belief that it was the Code which was at the core of women's oppression. In 1883, Richer was to write his Le Code des femmes in which he demanded changes to, or elimination of, sixty-five provisions.[49] In addition to revising the Code, Le Droit's programme involved the improvement of girls' education, the increase of women's wages as a means of fighting prostitution, the freedom for women to dispose of their own wealth, the spreading of the idea of a single moral standard, equal pay for equal work, and, importantly for our purposes, the establishment of the right of women to gain access to the liberal professions.

What was clearly not on the platform of Richer and Deraismes's collaborative efforts in the 1870s was a demand for the vote for women, and it was on this issue that Republican feminism was to become split. The strategy that Richer and Deraismes had adopted in the 1870s was to press for full civil equality and the protection by law of women, believing that political rights would follow. This was accompanied by the fear shared by many Republicans that women were too attached to the Church and that their enfranchisement would give power to politically reactionary forces. The politique de la brèche, to which Richer and Deraismes adhered, was based on the idea that piecemeal breaches in the patriarchal edifice would be more effective than a head-on assault on the issue of democracy and the right to the vote, the politique de l'assaut.[50] Strong protagonists for the latter were soon to emerge. 1876 saw the arrival of a more militant wing of the organisation under the leadership of France's first suffragette, Hubertine Auclert. She formed her own organisation (called at first, confusingly, Le Droit des Femmes), after she was forbidden by Richer and Deraismes from raising the issue of female suffrage at the first Congrès International des Droits des Femmes, organised to coincide with the Exposition Universelle of 1878.[51] By the early 1880s, Deraismes herself had become to some extent converted to the issue of female suffrage, and she and Richer were to split up on this issue. In response to Deraismes's changed position, Richer founded the Ligue Française pour le Droit des Femmes in 1882. In 1883, Auclert renamed her group the Société de Suffrage des Femmes to avoid confusion. By this stage she was publishing a rival newspaper, La Citoyenne, which was to remain the single paper committed to female suffrage during this period.

The political differences which had surfaced between these groups by the early 1880s were vast, but that does not mean that they had nothing in common. Differences were, to a large extent, ones of strategy. All three remained profoundly anti-clerical, committed to reforms in women's civic and legal status, and convinced that improvement of women's education and access to professions were crucial to women's emancipation. All these organisations remained essentially bourgeois in their membership, despite attempts to recruit poorer and working class members, and urban in focus. All created important forums for feminist publishing, and opened up spaces for the discussion of women's social and political position which had not existed in this way before. What characterised all the publications produced or edited by these three central figures of French feminism was a

commitment to the affirmation of women's endeavours, and an encouragement of women's intellectual and creative capacities. It is interesting to note here that Maria Deraismes wrote art criticism in the 1870s, publishing, for example, a long defence of the painter Eva Gonzalès as a woman and a 'realist', and criticising the Salon jury for rejecting her works in 1874. This was followed two years later with three long essays on the position of the woman artist in France, in the context of a discussion of women artists at the Salon.[52] Writers made careful records of women's advancements in the liberal professions. Newly qualified doctors, successful artists, philanthropists and teachers were congratulated. Important commissions received by women artists were noted. Advertisements for private art lessons appeared. Histories of successful women of the past were chronicled, and current publications on women's position in the present and the past were reviewed. When Deraismes set out to dispute the misogynist theories of Proudhon, she called the achievements of women in art, literature, industry and commerce to her defence.[53] A critic for *La Citoyenne* called on feminists and protagonists of women's emancipation to take heart at the sight of good, young women artists at the annual Salon.[54] It was in this context that the endeavours of the woman artist could be claimed for feminism. Even the anti-feminist Madeleine Lemaire's appointment as a painting teacher at the Natural History Museum in Paris was described by one reviewer as 'a feminist victory'.[55] In keeping with the affirmation by feminist leaders of women's achievements across a broad spectrum, Hubertine Auclert attended Rosa Bonheur's funeral as a homage to the artist and the woman.[56] The practice of reviewing the exhibitions of the *Union des Femmes Peintres et Sculpteurs* or appraising the successes of women at the *Salons*, or supporting the professional campaigns of access to male institutions, was a logical extension of a policy of active encouragement of women to which such organisations were committed. It was in such publications, too, that many inexperienced women writers could try their hands at art criticism, and the position of woman as viewer as well as artist could be legitimised.

A case in point is that of Marie Bashkirtseff, one of the few women during this period to become involved in women's organisations as artist, feminist and critic (fig. 19). A much respected member of the *Union des Femmes Peintres et Sculpteurs* (her premature death was marked by a one-person retrospective accompanying the 1885 exhibition), Bashkirtseff also showed an interest in radical feminist politics, albeit under the assumed name of Pauline Orelle. She visited Hubertine Auclert, whom she greatly admired, attended meetings of her organisation, in disguise, and paid her subscriptions. It was under the name of Pauline Orell (*sic*) that she wrote art criticism for *La Citoyenne*, publishing, in 1881, a heated defence of women's rights to a State-sponsored art education, and also a number of reviews of the Salon. In the multiple identities and disguises which Bashkirtseff assumed lies a clue to the duress under which she and other assertive women lived. It was not easy to claim the persona of an independent woman, or of a successful intellectual, political or creative figure, and still be seen as reassuringly feminine. While Bashkirtseff played out these conflicts in a number of conscious and unconscious ways, taking on different identities on the one hand and mimicing the mores of femininity in costume and demeanour on the other, other figures like Rosa Bonheur and the doctor, Madeleine Pelletier, eschewed traditionally feminine costume and assumed a

19.   Photograph of Marie Bash-
kirtseff; photographer unknown.

20 (facing page). Photograph
of Rosa Bonheur; photographer
unknown, Bibliothèque Nat-
ionale, Paris.

sobriety of dress and hairstyle which was more closely related to the uniform of modern masculinity.[57] Bashkirtseff, in her display of excessive 'femininity', and Bonheur in its denial, can be seen as occupying opposite sides of the same representational coin (fig. 20).

It was, of course, not only the politically radical or reformist journals which provided a space for the fostering of female achievement. In the expanding publishing industry which characterised this period, journals of every type and representing every shade of opinion were formed. Central to this expansion was the growth of a female audience for journals, corresponding to the growth of women as consumers in general, and countless papers were aimed at an exclusively female readership. Most popular among these were publications like the highly conservative and anti-feminist *Petit Echo de la mode* which originated in 1871 and had achieved, by 1891, a run of 210,000; the older *Moniteur de la mode* which had been in existence since 1843 and had a run of 200,000 in 1890; and the *Journal des demoiselles* which went back to 1833.[58] None of these publications

challenged dominant notions of sexual roles. According to one feminist historian of the press, they were financed by the dominant class to promote dominant values and were openly hostile to feminist campaigns.[59] For the most part, the only woman artist that could be accommodated in such pages was the accomplished amateur. The acceptable woman artist was the refined dabbler, the acceptable studio an appropriate setting for the

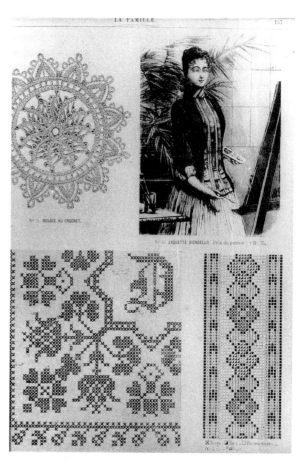

21. Cover for *La Gazette des femmes* (10 November 1886); Bibliothèque Nationale, Paris.

22. Page from *La Famille* (1880).

display of fashion. The prestigious *Gazette des femmes* featured an appropriately amateur woman artist on its cover, ensuring the domesticity of the activity by the insertion, on the one hand, of a child with her alphabet book in the painter's space, and, on the other, of a fashionable lady inspecting plates from the *Histoire de la Mode* (fig. 21). The act of painting is further contained by its juxtaposition with fashionable pastimes, such as going to the theatre and playing the piano. In a similar vein, *La Famille* featured a woman artist at the easel as a model for a new design of bodice, rendering her as a sort of animated mannequin rather than a professional woman (fig. 22). The aspiring professional was, very often, seen to be a figure of fun.

There was, however, a quantity of publishing, aimed at women, which set out to counteract the trivialising tendencies of so many women's publications with their obsession with fashion and physical appearance, their gossip columns and lightweight fiction. In addition to journals like the didactic *La Vie domestique* of 1875 to 1893 or the moralising *Les Causeries familières* of 1880 to 1900, which took their message of women's moral mission and responsibility to the family very seriously while not trivialising women's intellectual aspirations, there were publications like *La Mode Illustrée* which, while catering for the *femme du monde*, offered a stronger image of women and their professional aspirations than a journal like *Petit Echo de la mode*. Also

there were conservative journals, as we have seen, like *La Famille*, who, while anti-feminist in politics, could find ways of promoting the woman artist as an acceptable social figure. In this context, it is not surprising that a journal like *La Grande Dame*, founded in 1893 and subtitled 'Revue de l'élégance', would give ample coverage to the arts, and even include a lengthy tribute to Mme Demont-Breton with a detailed report of the banquet given in her honour by the *Union* on the occasion of her being awarded the *Légion d' honneur* in 1894.[60]

Amongst this glut of publishing emerged a space for the formation of small circulation serious women's magazines, which were edited and produced by people committed to women's social advancement, but with diverse views as to women's political role. Impatient with the trite attitude of the big circulation women's journals, and yet not as domestic in focus as the sober publications intended for the dutiful *femme d'intérieur*, these publications took up discussions of women's position in the broad social sense, arguing the case for women's civic rights and access to the professions, and debating women's role in general, but without advocating full political enfranchisement of women. The range and diversity of these publications was to grow as debates on 'the woman question' became more multifarious and divergent towards and into the 1890s. Examples included the conservative *La Tribune des femmes*, founded in 1881, which, whilst not having much time for the successful woman artist, was prepared to see the artist who had fallen on hard times as taking her place amongst the worthy poor represented by the 'honest woman bent under the weight of deprivation' and 'the talented teacher dying of hunger'.[61] More affirming of the ambitious professional was *La Femme dans la famille et dans la société*, edited by Louise Koppe, which started out as a moderately feminist educational paper campaigning for the re-introduction of divorce, revision of the search for paternity laws and improved conditions for women workers.[62] Amongst the articles were a number of discussions of women and art, displaying a clear understanding of the disadvantages to women which their exclusion from prestigious institutions implied.[63] In the early years Jules Gerbaud, later to be editor of the *Journal des femmes artistes*, contributed some articles on women's legal, educational and economic problems, and was one of a number of men who were involved in the running of the journal at this time. In 1882, it was to change its name to *La Femme et l'enfant* and became, like many women's organisations, committed to the philosophy that women's moral influence should extend from the family to society at large. In 1885, an organisation and a journal entitled *La Fédération des Femmes* was formed to protect women's work and to fight for their civil rights.

In the 1870s and 1880s a number of small circulation publications existed which were devoted entirely to promoting women's involvement in the arts, affirming their intellectual aspirations and congratulating their achievements. Usually politically conservative journals (such as the confusingly named *Le Bas-Bleu*, subtitled *Moniteur mensuel des productions artistiques et littéraires des femmes*, founded in 1873 and directed by Jean Alesson) nevertheless made it their business to challenge misogynist stereotypes and to publicise women's achievements.[64] A similar policy was undertaken by *Les Gauloises*, founded in 1878, and *La Gazette des femmes*, founded in 1882, also by Jean Alesson. At the moment of the formation of the *Union*, therefore, there was a growing consciousness of the plight

of women in general, and of the problems faced by the woman artist in particular. Such activities were paralleled by initiatives in other disciplines. In May 1888, for example, the *Revue scientifique des femmes* was formed to generate a feminised form of science, and to elevate women's status in society and at home via the reform of this masculine domain. A similar rhetoric informed much of the writing in the *Journal des femmes artistes* founded just over two years later.

One did not need to be committed to female suffrage or be an avid Republican to be exposed to discussions about women's changing role in society. By the early 1890s, no-one could avoid taking a stand on the 'woman question'. What was more, there were now organisations and publications to cater for every permutation of argument. Even the small group of socialist feminists was split at this point. Some followed the lead of Eugénie Potonié-Pierre, representative of *La Solidarité des Femmes*, a group who fought for the improvement in women's position through socialist revolution, and worked to gain political rights through socialist channels by trying to persuade them to support female candidates in elections. She was also active in broader feminist politics and organised two congresses, one in 1892 and another in 1896, which were instrumental in bringing together diverse republican and socialist groups.[65] Others agitated for the formation of a socialist women's party, like Aline Valette, secretary of the diverse *Fédération des Sociétés Féministes* founded in 1892 by Maria Deraismes, and follower of Jules Guesde. (They were opposed by women like Potonié-Pierre who were against segregated campaigns for women's rights.) Valette, like many of her contemporaries, was committed to the promotion of women's interests in a number of spheres, and her socialist views did not prevent her from supporting the professional campaigns of bourgeois women, including artists. The journal that she edited, *L'Harmonie sociale*, therefore gave ample coverage to such issues. Hubertine Auclert's *La Citoyenne* had by this stage collapsed. Auclert had married and gone to live in Algeria in 1888, leaving Maria Martin as editor, but after a series of disputes Martin left *La Citoyenne* to found her own *Journal des femmes* (1891 to 1911) which was to take over as the only journal seriously committed to female suffrage. Richer's *Le Droit des femmes* had suspended publication in 1891 due to his ill health. However, these publications were already accompanied by a number of other small publishing initiatives. In 1888, Eliska Vincent had founded the journal *L'Egalité* and Jeanne Deflou formed a small society, the *Groupe Francais d'Études Féministe*, to concentrate on winning civil rights.[66] Moderate feminists gathered around the new, reformist *L'Avant Courrière*, founded in 1893 by Jeanne Schmahl, which campaigned vigorously for the rights of women to act as witnesses in civic acts and for married women to have the right to dispose of their own incomes, but was hostile to more radical feminist claims.[67] Among the central members of this organisation was the sculptor and future third president of the *Union des Femmes Peintres et Sculpteurs*, the glamorous Duchesse d'Uzès, featured on the cover of *L'Art français* in September 1890 (fig. 23).[68] At the same time, Marya Chéliga-Loevy, a Polish dramatist and lecturer who lived in France, formed *L'Union Universelle des Femmes* which counted among its founders Clémence Royer, the philosopher and scientist, Eugénie Potonié-Pierre, the socialist feminist, and the radical Maria Martin, and published its own *Bulletin*. In 1897, Chéliga-Loevy was to start her own *Théâtre féministe* in Paris.[69] By 1893 the *Fédération Féministe* constituted at least

Quatrième année. — N° 179.        LE NUMÉRO : **25** CENTIMES        SAMEDI 27 SEPTEMBRE 1890

# L'ART FRANÇAIS

### Revue Artistique Hebdomadaire

Directeur littéraire :

**FIRMIN JAVEL**

*Bureaux : 97, rue Oberkampf, à Paris*

Directeurs artistiques :

SILVESTRE & Cⁱᵉ

ABONNEMENTS. — Paris & Départements : un an, 12 francs ; six mois, 7 francs. — Union Postale : un an, 15 francs ; six mois, 8 francs.

JACQUET. — *Portrait de Mᵐᵉ la duchesse d'Uzès.*

23.   Cover of *L'Art français* (27 September 1890).

24. Jules Cayron,
*Marguerite Durand*
(1897); Biblio-
thèque Marguerite
Durand, Paris.

thirty-seven different affiliated societies.[70] Two years later Clotilde Dissard founded *La Revue féministe* (1895 to 1897) which was to pick up and report on many of these campaigns, and to publish long articles on women's position in the arts and the possibilities for the creation of a 'feminine aesthetic'.[71]

Feminist publishing initiatives were to culminate in the formation of the first women's daily newspaper in Paris in 1897, *La Fronde*, edited by the charismatic and elegant Marguerite Durand and written, typeset and produced entirely by women (fig. 24). About 12,000 copies of the paper were sold daily.[72] The creation of *La Fronde* was announced by a propaganda poster designed by the painter Hélène Dufau, representing 'the peasant, the artist, the businesswoman, the nun, etc. – symbolising women's effort and work – lead

25.   Hélène Dufau, poster for *La Fronde* (1897); Bibliothèque Marguerite Durand, Paris.

by an intellectual towards the light of a future city' (fig. 25).[73] *La Fronde* covered issues of general interest as well as women's affairs. Journalists were hampered in their political and economic reportage as women were not permitted into the stock exchange, the Chamber of Deputies or the Senate, but coverage was still maintained with a regular 'Au Parlement' column, daily political commentary and a financial column. Parisian events were amply reported. There was a regular 'Carnet Artistique', articles on women workers and labour relations, foreign affairs, sport, education, theatre reviews, a round up of other newspapers, interviews with famous personalities, fiction, and discussions of women's achievements in the past and present. Campaigns for the improvement of women's education, working conditions, access to careers and elligibility for public honours were strongly supported. At first, Durand attempted to accommodate the diversity of view-points which characterised Parisian feminism within the journal. Contributors included people with as wide-ranging views as Séverine (Caroline Rémy), capable of writing articles which were very hostile to feminism; Maria Pognon, a radical free-thinker; Aline Valette, who contributed twenty-five articles on the position of women in industry; Clémence Royer; and moderates like Jeanne Schmahl and Jane Misme. Séverine, the most famous contemporary woman journalist, was paid a large sum for her regular daily column, was a much talked about figure, and was a powerful symbol for professional women during the period. Her portrait, by the *sociétaire*, Mme Beaury-Saurel, was exhibited at the Salon

26. Mme Beaury-Saurel, *Portrait de Mme Séverine* (Salon 1893); whereabouts unknown.

of 1893 (fig. 26). Despite her own strongly secular, Republican sympathies, Durand even gave space in the early years to the newly emerging Catholic feminist movement which had gathered around Marie Maugeret's *La Société du Féminisme Chrétien* with its publications *Le Féminisme chrétien* and *L'Echo littéraire de France*, both founded in 1896.[74] However, the political scandal surrounding the Jewish officer Albert Dreyfus split Catholic feminists away from *La Fronde* and the milieu that it represented. *La Fronde* became one of the most active defenders of Dreyfus, offering public support to Zola's *J'Accuse*, and of the right of Mme Dreyfus to join her husband in exile. Marie Maugeret and her society were, like most Catholic organisations, committed anti-Dreyfussards.[75]

In the mid 1890s, many Catholics were expressing their anxieties concerning the hold that feminist ideas were having on women, often seeing these as part of a wider anti-

clerical plot. As an unclassified document, dated 5 February 1896, in the *Archives de la Préfecture de Police* put it:

> The Catholics are following the French feminist movement attentively. They are quite disturbed to see the feminine element escape, step by step, from them. They have found out that more and more attempts are being made to attract women to freemasonry and they, themselves, want to form women's groups with the mission of checking this movement.[76]

Catholic disquiet over changes in women's roles did not, however, originate in this decade. Already in the 1860s, the proposed creation of public secondary courses for young women by the liberal minister of public instruction, Victor Duruy, had been the catalyst for a huge debate among Catholics, who had traditionally controlled most girls' education, on the role of women in society. The most vociferous opponent was the Bishop of Orleans, Félix Dupanloup, who attacked the minister and his initiative, which was eventually shelved.[77] The exclusive hold of the Church over State education for girls was finally broken with the introduction of the controversial *loi Camille Sée* in 1880, which introduced state controlled *lycées* and colleges for young women, and was seen by Republican supporters as a major victory in the struggle against the Catholic monopoly over the secondary education of middle and upper class women. Opposition to the bill by Catholics was very strong. It was essential to the Church that women and girls remained under their tutelage, as it was through their influence within the home that the Church could assure the endurance of Catholic morality for future generations. The secularisation of education implied, they believed, a crucial cutting off of influence, and a potential erosion of religious morality as the foundation of French society.[78]

Women, in Christian teaching, had an important role to play as the moral educators and civilising influence in society. Woman was potentially both the destroyer and the bedrock of social stability. Her 'destructiveness' could be curtailed through marriage and subjugation to the doctrines of the Church. As home-maker, wife and 'mother-educator', she could fulfill her mission of saving civilisation from corruption and moral decay. As the performer of charitable deeds, she could spread her virtue, fulfill her public mission and put pay to the notion of woman as a charming, passive creature, created only for the pleasure of men. Christianity, claimed its protagonists, could restore to women the dignity which they deserved. If this was what was meant by 'feminism', then the Church itself claimed the right to be at its frontiers.[79] Catholics, though, had by no means the monopoly on the construction of 'Woman' as moral regenerator and as the conscience of the nation. Even a Republican and free-thinker like Maria Deraismes argued that woman was an *agent moral*, a pacifying agent, naturally conservative and preserving in her instincts. Such ideas, promoted across the board in the Third Republic, were rooted in nineteenth-century philosophy from Catholic doctrine to Comtian positivism, and were used by people of all political persuasions to support the notion that women's role in the family was, as its moral centre and in public life, that of the performer of *bonnes œuvres*.[80]

Catholic and Protestant women had long been involved in philanthropic projects, charity work and campaigns for social reform. This was, in the nineteenth century, the one area of public life in which it was perfectly acceptable for women to be active, and it was

these organisations which, as James McMillan has argued, were to become an important recruiting ground for future feminists roused by pressing social issues. Catholic charitable organisations provided occupations for lay women.[81] Protestant philanthropists had, since 1879, identified with *La Femme*, the anti-emancipatory journal which reported on, motivated and encouraged 'good works' among women as well as publishing literary, moral and religious material. Causes championed by women's groups ranged from pacifism to anti-vivisection, from vegetarianism to temperance. Charities were set up, orphanages and shelters for the homeless or infirm were created, a system of crèches for working women was founded and the poor were visited in their homes. Together these initiatives constituted an important collective effort at social reform. By the mid 1890s, one of the major campaigns of philanthropic reformism was the deregulation of prostitution, organised by Avril de Saint-Croix who was to become a committed feminist via her contacts with Josephine Butler, the English deregulationist, and her experiences with the movement.[82]

It was in this context that Catholic feminists wanted to seize the initiative and claim their rights as women from their position as Catholics. Observing the preponderance of 'free-thinkers' and socialists at the 1896 International Feminist Congress held in Paris, Marie Maugeret resolved to form a society which would draw on the energies of the 'true' Frenchwoman, the vast majority of whom were Catholic, and to initiate what she believed was the only form of feminism which would suit the 'national temperament'. It was, claimed Maugeret, women's Christian duty to enter into the fray of public life, since men had abdicated their responsibilities as guardians of the moral and spiritual values of the nation. As minors in the eyes of the law, however, women could not do this effectively. They demanded the respect, equal pay for equal work and economic independence which was due to them as Christian women. They demanded to be viewed as intelligent beings, to have the right to enter all the careers which were suited to their physical and moral faculties, to have access to educational institutions and to be partners in marriages in which duties and responsibilities were equally shared and honoured.[83] It was in terms of this broad vision of the emancipation of women, while affirming those aspects of their traditional roles which were seen as sacred and natural, that *Le Féminisme chrétien* could join other feminist organisations in the championing of the woman artist and her professional campaigns.

One of the instances in which art and philanthropy came together during this period was in the establishment of the *Orphelinat des Arts*, founded by Marie Laurent in 1880, to cater for the orphaned daughters of artists (painters, sculptors, actors, musicians, writers) who had died poor. In 1882, the *Moniteur des arts* praised this institution founded by 'the women artists of Paris', and reported that it housed twenty-five children at that date.[84] By 1891, eighty-four children had gone through the orphanage. Funds were raised by the committee of prestigious artists, including Sarah Bernhardt and Louise Abbéma, through organising tombolas and other activities. Marie Laurent's initiative earned universal praise. Artists like Meissonier, Baudry, Moreau and Manet were prepared to donate works to the tombola. The press encouraged her activities, and praised the inventiveness of the idea and the suitability of the project. Here was a case of a woman's energy which was truly well directed.[85] When *L'Art français* featured a *Portrait*

*de Mme la duchesse d'Uzès*, the future third president of the *Union*, on its cover in September 1891, she was praised as a woman who stood for the living synthesis of '*Le Bien, l'Art, la Charité*' (fig. 23).[86] To each of these 'missions', she had devoted a part of her life. It was in the measured balancing of these that her womanliness and her ambition as a public person were reconciled.

The Republican government itself nurtured the idea of women's philanthropic mission, and was happy to encourage women's charitable deeds as suitable outlets for their reforming zeal and public spiritedness. Indeed, they were much happier when women's energies were channelled in these directions than into agitation for political reform. The State had always, therefore, been wary of feminist congresses, and when Richer and Deraismes had organised their first *Congrès International des Droits des Femmes* to coincide with the *Exposition Universelle* of 1878, it had existed outside of any official celebrations. For the centenary celebrations of 1889, though, the State was ready to sponsor a women's congress, but one which was to be far removed from all political agitation and talk of 'rights', affirming instead women's philanthropic role and charitable deeds. One reporter described its aims as the exhibiting of initiatives and projects originated and directed by women.[87]

The people to spearhead the move for an official congress were the deputy Yves Guyot and Mme Emilie de Morsier, a woman interested in moral reform and the alleviation of misery through philanthropy. The *Congrès International des Œuvres et Institutions Féminines* was to be presided over by Jules Simon, a committed Christian, who had a reputation in Republican circles as both a sympathiser with women's lot and supporter of women's endeavours, while not being in any way a radical. Simon's 'tribute' to French women, made at the congress, illustrates his political conservatism in a not unusual combination with traditional gallantry. Aimed at discounting the myth of the superficiality of the modern *Parisienne*, at which earnest moralisors and patriots took great exception, he spoke of 'the enormous quantity of French women . . . devoted to their duties as mothers of families, ardent in their emotions, faithful to their God, their honour and their fatherland.'[88] The tone of the conference and the parameters of discussion were clearly set. Isabelle Bogelot, the director of the *Œuvre des libérées de Saint-Lazare*, who called herself a 'philanthropic feminist', became vice-president of the congress. All political, sectarian and divisive talk was forbidden from the congress agenda, and Simon made it clear in his opening address that the issue of woman's suffrage would be ruled out of order.[89] The congress was to be divided into four sections: philanthropy and morality; arts, sciences and literature; education; and civil legislation. More than 550 delegates attended. The broader issues which were debated at the congress included a discussion on the working conditions of domestic servants and shop assistants, the fate of women released from prison, the issue of co-education, the rights of mothers over their children, women's commercial rights, the abolition of the death penalty, and animal rights.[90]

The organising committee was composed of thirty members, comprising seventeen women and thirteen men. Among the women were well-known conservatives like Mme Koechlin-Schwartz, president of *L'Union des Femmes de France*; Sarah Monod of *La Femme*; Marie Laurent in her capacity as founder of the *Orphelinat des Arts*; and Mme Léon Bertaux as president of the *Union des Femmes Peintres et Sculpteurs*. When justify-

ing the presence of a women artists' society in this context, Mme Bertaux claimed an affinity between her organisation and the others represented: 'I see here a common trait', she declared, 'I feel that our institution is the sister of yours, being equally a daughter of progress and fraternity'.[91] It is not surprising, therefore, that among the more than 550 delegates who attended were a number of prominent women artists including Mmes Fernhaber, Fould, Gardner, Houssay, Huillard, Nallet-Poussin, Réal des Sarte and Salles-Wagner. With the exception of Elizabeth Gardner, all of these were members of the *Union des Femmes Peintres et Sculpteurs*. Prominent male supporters of the *Union* who attended included Léon Bertaux and Felix Herbet.[92] Art and philanthropy fitted neatly together in the conception of this conference. Both could affirm women's dignity, and could assert their 'seriousness' in the face of current constructions of women's superficiality and amateurism without appearing to threaten the power relations on which the social order was based. In this context, to create *bonnes œuvres* could have a double resonance, conferring virtue onto the creation of worthy objects and raising women's apparent selflessness and innate charitability to the status of 'Art'. It was this happy conjunction of art and morality which would make this forum, as we shall see in chapter four, the perfect launching pad for the public campaign for women's entry into the *Ecole des Beaux-Arts*. It is in the context of this public embracing of the arts as compatible with women's mission, that Jules Simon's support of Mme Bertaux's candidacy for the Institut can best be understood.

It is not surprising that the form of State-fostered philanthropic feminism represented by the *Congrès des Œuvres et Institutions Féminines* would not satisfy the more radical activists in Paris. Maria Deraismes's anti-clericalism, for one thing, made it impossible for her to envisage working with Jules Simon. More generally, if Simon's 'feminist' credentials had been credible in the 1860s, they were less obviously so in the late 1880s. Not that his cautious position on civic or social reform was very different from the majority of moderate campaigners for women's 'dignity' and 'equality in difference', but it was very removed from the far-reaching reforms demanded by Deraismes, Richer and the small but committed group of radical feminists which had emerged by this stage.[93] The longstanding feminist leadership did not believe that the State-sponsored congress represented feminist aspirations adequately, and Richer's *Ligue Française pour le Droit des Femmes* and Deraismes's *Société pour l'Amélioration du Sort de la Femme* united to organise a rival conference, the *Congrès Français et International du Droit des Femmes*, obtaining sponsorship from the Paris Municipal Council and scheduling it to open three weeks before the official congress.[94] The major difference between the Richer/Deraismes conference and the State-sponsored one, was the inclusion of three explicitly political sections in addition to the 'section historique' which chronicled women's achievements in a manner more in keeping with Simon's forum. These sections included one on economics, one on morality, and a legislative section at which calls were made to revise the Napoleonic Code and to permit the pursuit of paternity suits. Skilful management on the part of Richer and Deraismes ensured that the suffrage issue was not raised, and a momentary reaffirmation of *la brèche* over *l'assaut* was achieved. Importantly though, the two congresses were not constructed as opposing one another and many delegates attended both of them. No-one at the International Congress was going to eschew the importance of philanthropic work,

even if, for some people, this was not enough and the focus of feminist agitation had to be elsewhere.

The successor to this conference, held in May 1892, was the first congress to use the word *féministe* in its title. Here delegates fiercely demanded the extension of women's civil rights, professional opportunities, and the improvement of their social position. Among the items on the agenda were the opening of professional careers to women, and equality for the sexes in scientific and artistic studies. Yet the issue of suffrage and political rights was not evident.[95] It was left to the 1896 *Congrès Féministe* to be the first to publicise this issue, on a conference agenda far more radical than any previous feminist gathering in France. Among the issues discussed were abortion rights, the status of 'free union' as opposed to marriage, and the suffrage question.[96] The conference marked a crucial moment in the history of French feminism, for despite the radical programme, the two hundred delegates represented very diverse positions including bourgeois, socialist, conservative and radical feminists alike. Among the participants were women distinguished in the arts and sciences as well as humanitarian causes. It was here that both Maugeret and Durand resolved to start their respective journals, and it was from this time on that French feminism was to begin to shift from being a small movement which had made a lot of noise to one which was to grow in number. As Hause and Kenney have shown, in 1896 the combined membership of feminist leagues in Paris numbered under 1000. After 1901, when the *Conseil National des Femmes Françaises*, a catholic coalition of women's organisations, was formed, there were about 20,000 to 25,000 members.[97]

How then does the *Union des Femmes Peintres et Sculpteurs* fit in to this diverse and multifarious field? That the *Union* was involved in campaigns for women's professional advancement, both individually and collectively, is clear. That initiatives like that of Mme Bertaux's candidacy to the Institut were associated in the public mind with what came to be known as *féminisme* has been demonstrated. It is also clear that the unprecedented campaign for professional status and legitimacy for women which characterised this period was widely perceived to be part of a collective feminist initiative, even while real change, when it occurred, was most often economically motivated. The struggle for the rights of the woman artist, as we have seen, took place within the context of parallel campaigns in other areas. The State itself made the professionalisation of women possible through the slow but steady changes in educational access (even though women's *lycée* education was still designed so that they could not sit the vital *baccalauréat*) and the gradual opening up of the liberal careers to women. If anything, it was the professional bodies themselves, and artists were no exception, that stalled, hostile to the competition that women would offer and anxious to maintain their privileged positions. Many male professionals closed ranks by instituting formal training procedures, rigorous standards, entry requirements and licencing in careers like medicine, law and education which made it very difficult for women to gain access. Other forms of outmoded legislation hampered women's professional competence. While women could train as doctors, for example, they were barred from signing birth and death certificates as they were still regarded as legal minors. These were the sorts of barriers that aspiring professional women confronted. The institutional barriers to the woman artist were not dissimilar, although the practice of making art was not dependent on legal sanction in the same way and it was subsequently

possible to chart a professional practice without certification. The fact that the demands on a career in the field of art, especially at a time when autonomy from institutional protection had become a virtue in some quarters, were different than those of other forms of work, does not displace these professional campaigns from this broader context. Nor does it get us away from the fact that it was in the context of a general move towards women's professionalisation that the institutional struggles of the woman artist could be articulated, indeed that it was even possible to think them. Whether or not the members of the *Union* liked to think of themselves as feminists, it is possible to argue that it was feminism, in this guise at least, which made their collective endeavours possible and gave them meaning.

What is clear, though, is that the context of women's professionalisation in which the *Union* can be placed does not presuppose a broader platform of demands for political or even civic rights. There were, as we have seen, many ways in which women could assert their power and improve their status in the name of feminism in the early Third Republic. It is interesting that women's achievements in the arts and the institutional impediments to their success were not marginal to feminists in general but were consistantly present as a theme in feminist publications of all types. Here was an area on which all feminists could agree. Examples of famous women writers and artists from George Sand to Rosa Bonheur (and even occasionally Mme Léon Bertaux) were consistantly used to invert current constructions of women's intellectual and creative weaknesses, to show up the discrimination of a system of public honours which either ignored them, in the case of Sand, or isolated them as exceptional freak instances in the case of Bonheur, and to assert women's claims to rights as citizens. Whatever feminists might think about the larger issues of political reform, they could all endorse the campaigns of the woman artist. For some this might be an issue of professional rights which paralleled the campaigns of doctors and lawyers to open educational institutions and professional bodies to female practitioners. For others, 'Art' was a special case and could catalyse the unique aspects of the female imagination for the glory of France.

It is obvious, then, that the *Union* provided a very good cause for feminists to champion. And they did so, as we have seen, across the board. Among the members of the *Union* itself, though, opinions on feminism must surely have reflected the diversity of the feminist community at large. There were certainly people like Marie Bashkirtseff who could join the small group of feminists who supported the campaign for female suffrage, but these must have been in the minority. If there was any aspect of feminism with which most of the members would have identified, it was with the philanthropic feminism of the Christian conservatives. There was much in the *Union*'s rhetoric which tried to join the practice of art to the performance of good deeds. The progress of the *Orphelinat des Arts*, for example, was conscienciously charted in the pages of the *Journal des femmes artistes*. Predictably, the *Union*'s journal never became an organ of political propagandising in the broad sense, and its interests remained, for the msot part, partisan and parochial. However, Jules Gerbaud, the editor of the journal in its early years, was active in feminist forums, being present, in his offical capacity, at the organisation committee for the 1892 feminist congress which was attended by figures like Richer, Maria Martin, Maria Deraismes and Aline Valette.[98] In 1894, Gerbaud was made a member of the commission

set up to erect a monument in Maria Deraismes's honour.[99] He was also the only man present at a central committee meeting of the *Fédération Française des Sociétés Féministes* in 1896, but was no longer editor of the journal at this point.[100] Under his editorship, the journal had carried regular anouncements of feminist meetings in Paris with reports of general assemblies and coverage of the issues discussed. Yet these were often cautiously announced, as if too enthusiastic an identification with political agitation would offend the readership. On one occasion, Gerbaud took the liberty of using the paper to announce the formation of the *Cercle de la solidarité des femmes*, by Maria Martin and Eugénie Potonié-Pierre, as a forum which would facilitate an exchange of ideas on the *question féministe*, and he offered this gathering his cautious support. But, stated Gerbaud, as if covering his tracks, he knew that there were many members who would not agree with the ideas of this particular group.[101] After Gerbaud's withdrawal from the journal, there was little coverage of the broader context of women's campaigns, and the journal became more insular and domestic in its concerns. By the time of the feminist congress of 1896 when *tout Paris* was talking about feminism, the journal had become a short newsletter and there is little indication of any real wish to be identified with this forum.

The *Union*'s position within this history is therefore complex. Although dependent on what became known as feminism for its very existence, its position within feminist history is not straightforward. It is only through a broad and inclusive historical understanding of feminism itself that we can chart its course. While it was at home with the philanthropic societies endorsed by the Republican administration, the *Union* still confronted that administration head-on on the issue of women's rights to education and professional equality. Tapping in to some of the most conservative thinking of its time in the construction of its own self-narratives, the *Union* was nevertheless at the forefront of a vigorous campaign of institutional reform. Nowhere was this more evident than in the campaign for the entry of women into the *Ecole des Beaux-Arts*. The principles on which the campaign was fought, however, were not always the most predictable ones, and nor were the responses which resulted in the political and artistic communities. It is to these that we must now turn in order to get a fuller understanding of the institutional and discursive field within which the *Union* operated.

# Chapter 4

# Reason and Resistance: Women's Entry into the *Ecole des Beaux-Arts*

IT WAS AT THE *Congrès International des Œuvres et Institutions Féminines*, held in July 1889 at the town hall of the 6ᵉ *arrondissement* in the Place Saint-Sulpice, that the issue of women's access to State-funded, and administered, fine art education was first raised at an official, government–sponsored event and placed firmly on the public agenda. As we saw in chapter three, Mme Léon Bertaux, 'founder-president of the Union des Femmes Peintres et Sculpteurs', as she was described in the official proceedings, was among the members of the organising committee of the congress. She took the opportunity of the platform offered to her in this capacity to publicise the work of the *Union*, and to make the first formal, public appeal in its name for women's access to the exclusively male *Ecole des Beaux-Arts* and for their eligiblity to compete for the prestigious *Prix de Rome*.[1]

To make such a demand at one of the officially sanctioned forums, convened to coincide with the *Exposition Universelle*, and designed to function as *the* representation of Republican stability, prosperity and power, was tactically shrewd. For a number of years before the centenary celebrations, the Republicans had set up a network of publications and provincial committees aimed at fostering research and popularising a coherent, sanitised history of the Revolution, designed to produce secular Republicanism as its natural heir. These were to culminate in the extensive centenary celebrations, and in the *Exposition Universelle* itself, which would function both as a statement to the world to which it was host, and as a self-affirming narrative to the thousands of French citizens who participated in the spectacle. By 1889, the Revolution, for the Republican state and its apologists, functioned less as an event than as the evocation of an origin. The triumph of Republicanism was decreed by evolution itself. Frenchmen stood at the pinnacle of human evolution, and a Republican democracy represented that form of government which best embodied Darwinian principles of natural selection. France's claims to exemplory justice and equality in the social order were not the result of chance. It was France, after all, who had first proclaimed these values to the world, and it was the Republican State which was capable of translating these into the institutional fabric of everyday life.[2]

The claims made by French women, therefore, that equality and justice were not always extended to them, were destined to touch a raw nerve. The official congresses, at which many foreign delegates were present, were not convened to provide a forum for domestic grievances, let alone for the building of international subversive alliances of the type that feminists formed.[3] Although 'universalism' was the reigning catchphrase – apparently represented by the diversity of goods and peoples on display – it was really the national

interest, dressed up as beneficence, friendly co-operation and healthy competition, which was at stake. In his opening address at the *Congrès des Œuvres*, Jules Simon, president of the congress, alluded to the dissident *Congrès Français et International du Droit des femmes* at which discussion of women's political rights had been raised. These, he was keen to establish from the start, were not to be the concern of the present congress. What he would not tolerate was women provoking discord among the delegates. They owed it to themselves and others to conduct themselves responsibly and to provide a spectacle of calm, peaceful discussion to the world at large. After all, as women they were destined to be peacemakers and unifiers, and they had gathered together to celebrate and affirm the work women did, in public life through their philanthropic deeds and good works and in the home as natural 'mother-educators,' and thereby as the source of moral regeneration for the nation. In this context, women's educational campaigns and artistic mission could find their place on the agenda. It was as natural teachers in the home, the school or society that women could fulfil their mission, and their demands for training and professional status in this area were in keeping with their destiny. The discussion of political rights or over-ambitious reforms, however, would only be divisive and inflame passions. They, in the name of harmony, dignity and even the health of the nation, were to be avoided.[4]

When Mme Bertaux made her demands, therefore, they were couched in the terms of the dominant discourse. It was not by chance that Mme Bertaux was on the organising committee of this congress and had not been present at the smaller, more radical one held earlier in the same year. On that occasion it had been up to Mme Elisa Bloch, a sculptor and regular exhibitor at the *Union*, to make a personal plea for women's entry to the *Ecole* in the context of a general discussion of women's achievements, past and present, and a demand for equality for women in the eyes of the law.[5] But neither Mme Bertaux nor any official representative of the *Union* was to be found at such a forum. It was at the *Congrès des Œuvres* that she would surely have felt more comfortable, and it was in the context of this officially sanctioned platform that the demand, made on behalf of the organisation that she represented and backed by the upright and respectable delegates with whom she associated, would carry most weight. Indeed, Mme Bertaux spoke the language of the congress, but she knew how to manipulate it to effect.

Drawing on the wider context of the *Exposition Universelle*, she spoke of improving the human condition, of internationalism as a means of sharing without erasing difference, of a 'universal society where the invention of each becomes the property of all'.[6] What they all had in common, she alleged, was an attachment to progress, and it was this idea which was at the origin of the founding of the *Union*, an international organisation which included many foreigners among its members. Not only was the *Union* itself making great strides in number, quality and status, it had been recognised as an organisation which provided a force for *le bien* in the community at large, inspiring women who studied art at all levels and in a number of different institutions with that passion to emulate which was always at the root of progress. Yet, in this context, it was not only progress that needed to be invoked. The rhetoric of the moment demanded that a belief in universal progress be matched with a patriotic concern for national advancement. Mme Bertaux was politically astute enough to know that her demands for women's rights needed to be

linked to a broader patriotic interest for them to make an impact in the wider context. There were, after all, no rights without duties, as many contemporary commentators hastened to remind women.[7] Sensitive to the issues of the moment, and pre-empting much of the discussion of the next decade, Mme Bertaux predicted that women would occupy an increasingly important place in the industrial and decorative arts. Economic progress and competition demanded this. For France to retain its undisputed cultural and aesthetic supremacy, care needed to be taken that standards did not fall. It was here, Mme Bertaux was convinced, that the *Union* could play a crucial role. As women entered into these professions, there was the risk that they would be carried away by their marvellous and fecund innate skill, and that because they were generally less equipped with solid studies and training than men, they would allow themselves to be misled by the fantasies and whims of the day, and would, through their ignorance, sacrifice those precious traditions of ornamentation and decoration in which France had demonstrated itself to be the master since the Renaissance. What was at risk was the national heritage, and it was to fine art education that women needed to turn to counter the erosion of traditional skills. Left to themselves and without the tuition of the State and the tempering influence of organisations like the *Union*, which saw itself as a zealous guardian of traditional standards of taste, France's very aesthetic traditions, national pride and industrial competitiveness were at risk.

At this point Mme Bertaux built up to her climax. Hers was not the disposition of a complainer. Instead, she constructed a vision and invoked its realisation, carrying her audience with her without ever having seemed to accuse or to point a finger. That there was little tangible legislative foundation on which to base her optimism did not matter. This was rhetoric, and above all Mme Bertaux could not afford to alienate either her immediate audience or the men in power to whom she was indirectly appealing. And so Mme Bertaux adopted the rhetorical strategy of idealisation, even of collective flattery. In the context of the *Exposition*, it would have been churlish to object to the optimistic and egalitarian fantasies which were encoded in the very signs and structures of the moment. To talk of a new age was almost obligatory, and Mme Bertaux like everyone else was happy to use this rhetoric to her own ends. She talked without embarrassment, therefore, of a new era which had appeared for the artistic neophyte, one in which women would no longer be confronted by systematic obstacles. No longer would they be denied the educational protection of the State. The day had come when women would be allowed the State support and advantages which had hitherto been the exclusive domain of men, when finally the doors of the revered *Ecole des Beaux-Arts* would be open to them. At this point caution was needed. Mme Bertaux anticipated the anxiety which the prospect of mixed tuition would provoke. It was not for this that she was campaigning, although the congress itself would, on another occasion, vote overwhelmingly in favour of co-education.[8] She envisaged a separate class at the *Ecole*, in which women painters and sculptors would be offered the same educational programme as men. This would equip them to be admitted to the regular drawing competitions and to participate fully in the course of studies, culminating even in their eligibility to compete for the *Prix de Rome*, still the highest award for any artist. Dedicated to that elevated practice known as *le grand art*, she declared:

To be the *Prix de Rome*! besides being evidence of an aptitude for *le grand art* this means that one is protected henceforth against all terrible eventualities, it is to have, in the *Ecole des Beaux-Arts*, a family who takes you under their wing, who lavishes on you, without cost, the greatest education with the most illustrious teachers, supports you at first, encourages you afterwards and protects you always.[9]

It was this ideal community of which women wanted to feel a part. No matter how much talent, how much genius had been bestowed upon her, no woman artist could compete in the arena of *le grand art*. This, Mme Bertaux intoned, was soon to change. Today, when all the barriers of ignorance and prejudice were collapsing in the face of the appearance of a type of woman who was more steady and balanced by education than the women of previous generations, she was able, in the name of the *Union des Femmes Peintres et Sculpteurs*, to submit a proposition to the vote of the congress:

> The Congress proposes that there be created at the *Ecole des Beaux-Arts* a special class, separate from the men, where women can, without injuring propriety, receive the same education as men, with the right under the conditions which exist in this school to be admitted into all the drawing competitions leading to the award of the *Prix de Rome*.[10]

Such a proposal was designed to meet the demands of both justice and propriety. Mme Bertaux formalised a wish that had been articulated by many women artists and their supporters for at least a decade. That she had chosen her moment well and formulated her proposal in a manner designed to inspire rather than alienate the wider community, was demonstrated by the unprecedented publicity which the proposal, supported unanimously at the congress, stimulated. It is important to remember, however, that Mme Bertaux did not 'invent' the idea of women's entry to the *Ecole*. Indeed, her speech at the congress was, itself, preceded by a short presentation by a Mlle Basset, who called both for women's entry into the *Ecole* and for their representation on exhibition juries, contextualising her demands with reference to the struggles of other professional women, in particular doctors and musicians.[11] The debate on the *Ecole* was in no way an isolated intervention at the congress. It formed part of a general concern for women's training and status in artistic, scientific and pedagogic areas which had been expressed through feminist forums for some time. Mme Bertaux herself participated in more general educational debates at the congress, and was part of a group of delegates to propose a motion concerning the admission of young women, as students and teachers, to all the *écoles publiques* with the same rights and privileges as their male counterparts.[12]

A consciousness of the injustice of women's exclusion from State-funded fine art education had been articulated for some time. Historians of the struggle for women's entry into the *Ecole* have painstakingly chronicled the various initiatives of both Mme Bertaux and the younger Mme Demont-Breton to penetrate this male bastion. Yet these attempts have been conceived exclusively as heroic individual struggles rather than as initiatives which are best understood within the context of wider feminist politics, on the one hand, and a changing art institutional fabric on the other.[13] The most recent account of the campaign for entry into the *Ecole* relies, almost exclusively, on one archival source, and so while escaping the biographical biases of most accounts it lacks the broader contextualisation which helps to situate and make sense of the various initiatives and

debates.[14] Depending on the sources used, different moments in the struggle, isolated from the wider political context, have been highlighted. Diane Radycki, writing in 1982, and using as her prime source Mme Demont-Breton's memoirs witten in 1926, weaves a narrative in which it is the second president of the *Union* who occupies the central role. Here the crucial event is a private conversation which took place in 1884, betweeen the young painter, recently awarded the status of *hors concours* at the Salon, and the Republican politician, Jules Ferry, with whom she is alleged to have raised the issue. It is this meeting which Demont-Breton herself had constructed as a pivotal moment in the campaign, and she reported in her memoirs, apparently verbatim, Ferry's response to her challenge: 'It will happen one day because justice always comes sooner or later'.[15] Mme Demont-Breton was not present at the *Congrès des Œuvres* and her autobiographical account of the struggle completely bypasses this crucial moment.[16]

Charlotte Yeldham, following carefully in the footsteps of Edouard Lepage, Mme Bertaux's biographer, traces the narrative back long before the formation of the *Union*, to Mme Bertaux's early interest in women's art education and the formation of her own sculpture course for women in 1873, which moved in 1879 to special premises on the avenue de Villiers. In 1878, according to Lepage and later Yeldham, she had initiated her long campaign for women's entry into the *Ecole* by making a direct appeal to the director, Guillaume, for the creation of a special school for women in the rue Bonaparte.[17] The response at this point was equivocal. The administration was not prepared for such an expense but would take note of the request and put it forward if an opportune moment arose.[18] This, together with the Demont-Breton encounter with Ferry, constitutes, apocryphally, the two major initiatives prior to 1889.[19] It was not until after the events of 1889 that the *Conseil Supérieur* of the *Ecole* engaged in any serious discussion of the idea.

These isolated 'events', magnified out of all proportion by their respective chroniclers, could not have singlehandedly created the climate which had, by 1890, made it impossible to evade a formal discussion of women's entry to the *Ecole*. The fact that the real public debate on the issue was only to begin then, was a function of the wider discursive framework into which the campaign can be situated as well as the institutional support which it now enjoyed, backed as it was by a thriving and officially recognised *Union* that could act as a pressure group. What was more, the consolidation of philanthropic feminism gave a context to the demands made by Mme Bertaux and adopted enthusiastically by a government-sponsored forum, and could not, therefore, be dismissed by the authorities as the lunatic ravings of extreme feminists. Indeed, Mme Bertaux disavowed any such associations, declaring firmly that she should not be accused of being a supporter of feminist demands. That would be to misundertand her intentions. She, more than anyone, was an enemy of 'the emancipation of women in the political and in certain social senses'. She simply desired that 'a gifted young woman be able to receive, like any young man, an elevated artistic education, and give free reign to her ambitions if these were justified'.[20]

As mentioned in chapter three, December 1880 had seen the passing of the controversial *loi Camille Sée*, stimulating a debate on women's education the intensity of which had not been seen since the Duruy affair of the late 1860s. While conservatives and Catholics saw the reforms as a fatal blow to the morality and social stability of France, feminists were

concerned that they would not equip women for careers and access to institutions of higher learning, but would turn them into exemplary wives and mothers, into the ideal Republican woman as the perfect spouse for the enlightened Republican man and a fitting mother-teacher for his sons.[21] A focus for debate was the fact that, although most of the university faculties were technically open to women (the Sorbonne had opened in 1880), the Republican reforms and the new curricula in the *lycées* in no way made women eligible to compete for entry to institutions of higher learning. This debarred them, from the start, from access to all the liberal professions and government careers. Feminists embarked on campaigns to counter such exclusion. In November 1881, for example, Hubertine Auclert responded to the creation of two new ministeries, that of agriculture and fine arts, by writing to Gambetta to remind him that as the budget which facilitated these inititives was drawn from both women and men's taxes, women deserved to benefit from it as much as men and should be offered employment under the same conditions as men and in proportion to their numbers.[22] Campaigns for entry to institutions of higher learning and professional bodies were waged by individual women who had, through their own efforts or the wealth of their families, managed to gain private tuition so that they could meet entry requirements. By 1893, the *Revue Encyclopédique* could report that women had benefited from study in 'the faculties of *sciences et lettres*, and that they had forced open the doors of the schools of medicine and law'. However, this was more as a result of the lack of interference on behalf of the authorities rather than from any legislative changes: 'women's courage and perseverence have done the rest'.[23] Most publicised were the campaigns of women doctors and lawyers. Even the conservative *La Femme* had to acknowledge, in 1889, that the question of women's access to professions was being discussed everywhere, and resolved to devote one article a month to this subject.[24] Actual figures of women graduates vary from source to source, but the fact remains that women were qualifying for professions in unprecedented numbers. It was, however, for the most part foreign women who took advantage of the non-intervention of the authorities. Of the two women who qualified in law during this period, one was Romanian and the other was the pioneer French woman lawyer Jeanne Chauvin, who was awarded her diploma in 1892 after submitting her thesis on *The Professions open to Women and the Historical Evolution of the Economic Function of Women in Society*. She was, though, unable to enter the bar, one of the strongest bastions of male exclusivity, and became instead a teacher of political economy at a girl's *lycée*.[25] Of the first eighty women doctors qualifying in the *Faculté de Paris* only four were French. But a precedent had been set, and the example of the Paris medical faculties was to be invoked again and again in the discussions on the *Ecole des Beaux-Arts*, not only because it provided an instance of a previously all-male community which had been penetrated by women, but because of the delicate question of nudity and mixed tuition. More than any other institution, the case of medicine raised the difficult problems of the body, nudity and propriety which were to haunt discussions of the *Ecole*. If the anatomy class in the medical schools had managed to overcome the problem of mixed classes and naked cadavers, why could not the same happen in the life-class at the *Ecole*?

Such an issue leads us to the specifics of the debates around the *Ecole* which raged in the 1890s. Before these are mapped out, however, it is necessary to give an account of the

available art educational facilities in Paris for women, in comparison with their male counterparts, so that the demands women were making in this area are adequately contextualised. To some extent, budget allocations give an indication of priorities. The 1889 fine arts budget offers a representative example of spending allocations by the French State during this period. Out of a total budget of 12,063.905 francs for *beaux-arts*, the following allocations, in francs, were made for art education:

> *Ecole des Beaux-Arts*: 358, 210
> *Ecole Nationale des Arts Décoratifs*: 106,000
> *Académie de France à Rome*: 152,000
> *Ecole Spéciale d'Architecture à Paris et écoles des beaux-arts dans les départements*: 63,000
> *Ecole spéciale des beaux-arts et de dessin dans les départements*: 333, 450
> *Ecole Nationale de Dessin pour les Jeunes Filles*: 40,200[26]

The overwhelming preference given to male art and design education by the State, mirrored the contemporary dispensation for public secondary education for boys and girls. In the same year, the allocation in francs for the *lycées nationaux des garçons*, boys' secondary schools, amounted to 8,329,000, and that for *enseignement secondaire des jeunes filles*, secondary education for young girls, was 1,578,000.[27] Even in a climate when female education was the focus of attention in an unprecedented way, and when Republicans claimed for themselves the label of its champion, there was comparatively little injection of capital to facilitate reform and turn rhetoric into action. In the area of art education, State priorities were clear. There was no provision whatsoever for fine art education for women. When money was spent on women in the area of the visual arts, it was in design, a sphere to which women like Mme Bertaux were not content to be relegated.

It was the *Ecole Nationale de Dessin pour les Jeunes Filles*, the National School of Drawing for Young Women, founded in 1802, which constituted the only State-funded art school for women in Paris.[28] Support for the school extended beyond the financial to official and public endorsement, ritualised through the elaborate annual prize-giving ceremonies attended by State officials (the much more solubrious surroundings of the hemicycle of the *Ecole des Beaux-Arts* were borrowed for the ocasion), and designed to match the showy award ceremonies at equivalent male institutions. Officials also promised maintenance grants to some students.[29] The rhetoric of Republican Utopianism, however, which characterised these public occasions, hid the paucity of provision and the mean environment in which the students had to work.[30] The speeches at the prize-giving ceremonies, always published in full in the art press, gave no indication of the overcrowding, of the cramped accommodation and of the obvious contempt in which the authorities held these young women of the lower classes. Addressing themselves as much to the world at large, to their audience via the art press, as to the young women themselves, they sketched a world of ideal bourgeois morality in which the young female worker would have her place. The rhetoric served to underline the division between the fine and decorative arts, the public and the domestic sphere (a rhetoric which flew in the face of the actual employment conditions of the small industries into which many of the graduates

would go), and to encode the gendering of these divisions. At the 1879 award ceremony, for example, de Ronchaud, a high-ranking government official, assured the recipients that their education was aimed at regulating their imaginations and disciplining their fantasies:

> We are not aiming at all in kindling in you an elevated ambition for high art which could lead you away from your true path; we will restrict ourselves to developing in you a taste for beauty, arming you, for a more modest task, with the means to realise yourselves according to your faculties and your needs ... The pencil which we put in your hand here must not be an instrument of vanity and fame but of modest facility and domestic happiness; it should give independence and dignity to your life and charm and embellish it. You will transmit it to your children like a family heritage, aimed at procuring for them the same profits and the same joys which you have drawn from it yourselves ... for art, disengaged from the preoccupations of vanity, is essentially edifying, and, like all work, it gives to those who practice it in a disinterested manner or for a moral purpose, the satisfaction and pride of the soul.[31]

In the end, what was to be praised, intoned de Ronchaud, was the lack of self-aggrandisement which the school promoted, concentrating more appropriately on 'the propagation of beauty in the works of industry, for the ennobling of domestic life and the education of public taste'.[32] What everyone expected from these women students, he assured them, was their selfless commitment to making anonymous works, contributing thereby to the preservation of France's acknowledged superiority in art and taste, in the full knowledge that the more modest their personal success, the greater their capacity to serve their country. What was at stake here was the health of the nation and it required an appropriately humble and devoted 'femininity' as its guarantor.

In 1881, the *Ecole Nationale de Dessin pour les Jeunes Filles* had been re-organised, to reinforce its vocational orientation and to rationalise a curriculum with drawing as its basis. This was in keeping with the Republican commitment to drawing as a means of inculcating rational perception and the ordering of the visual and conceptual world. Special training in specific areas of industrial design and craft, and history of art for the refining of aesthetic sensibility were also included. No amount of 'restructuring', however, could suppress the continuing tension between the fine art aspirations of many women, inspired by the successes of erstwhile teachers at the school such as Rosa Bonheur, and the official encouragement of the decorative and industrial arts as their proper sphere. Several graduates from the school exhibited at the Salon in the 1880s, for example.[33] Yet in 1889, Gustave Larroumet was still insisting that the aim of the school was not to produce artists. At the prize-giving of that year, he warned the audience that despite the aspirations of certain graduates to become artists, it was important to remember that the aim of the school was to prepare young women for practical and vocational skills, not for the world of fine art.[34] So anxious were the authorities about the increasing number of graduates who had aspirations to be artists rather than designers or craftswomen, that they resolved soon after to close down the school and attach it to the *Ecole Nationale des Arts Décoratifs*. In a letter written by Léon Bourgeois, Minister of Fine Arts and Education, to the president, the action was explained as the outcome of the deviation of the school from the intentions of its founder, whose aim had allegedly been to equip poor young women

with the capacity to earn a living by teaching them the basics of the decorative arts. The channelling of women's 'natural talents' and the development of them through appropriate instruction would, she believed, equip them for work in certain of the artistic industries. She had been, according to Bourgeois, less interested therefore in creating artists than artisans.[35] For a long time the school had remained faithful to these ideals, and many of its students, who had come primarily from the working classes, found employment in the applied arts, such as painting on porcelain, enamel or *faience*, the decoration of fans, designing for embroidery and fabric, engraving and casting. Unfortunately, continued Bourgeois, the character of the school had changed:

> Future women workers have become, every year, less numerous and make place for a type of student for whom drawing is only an accomplishment art or who only take their studies seriously in the hope of becoming artists . . . today, despite its modest title, this is in reality a school of fine arts where artists, above all, are formed, with all the ambitions which this label implies.[36]

A bone of contention for the authorities was the school's institution of life-classes, indispensible, in their view, for students of 'academic art', but positively counter-productive in the context of the decorative arts.[37] These would be replaced by classes for drawing and watercolour painting from flowers, and lessons on ornamental composition. Once lodged in special quarters in the *Ecole Nationale des Arts Décoratifs*, the focus of education would be exclusively vocational.[38] Those women who wanted to become artists would have to go to the *académies libres*, private academies, for their training.

Critics like Emile Cardon of the *Moniteur des arts* were incensed by these proposals. Turning Republican rhetoric against itself, they defended drawing as the basis of all aesthetic education, whether its final use was for fine or decorative arts. What was lacking in French industry, proclaimed Cardon, were artists, and reinforcing these false polarities would only harm French standards and ability to compete. What was really at issue here were deeply entrenched oppositions in terms of both class and gender. By encouraging women with aspirations as artists to attend the expensive *académies libres*, Bourgeois had reinforced the notion that such aspirations, when legitimate in women at all, were only appropriate for the wealthy. In the context of the middle and upper classes, the operative opposition was that which distinguished accomplishment art from that of professional practice. What needed to be assured in the context of the decorative and industrial arts, however, was the continuation of a substructure of workers in light industries and mass-produced ornaments, women who would be skilled enough to produce quality goods but neither too individualistic nor ambitious for the drudgery of mass-production. The idea that some of these women might want to become artists, flew in the face of necessity and good sense. In the years to come, women of the upper classes were also to be encouraged in the direction of the decorative arts, but in this context they would be offered the aristocratic traditions of eighteenth-century luxury craft production as their model.

For the aspiring woman artist of the type who joined the *Union*, the *Ecole Nationale de Dessin pour les Jeunes Filles* was unlikely to function, therefore, as an appropriate training ground. Most of these women were much more likely to have paid their fees and attended one of the many private academies to which Bourgeois had alluded. Nor were the

mushrooming *écoles professionnelles*, vocational schools, likely to serve most of the potential exhibitors at the *Union*. Together with the *Ecoles Elisa Lemonnier*, first established in 1862 under the auspices of the *Société pour l'Enseingnement Professionnel des Femmes*, the Society for the Professional Education of Women founded by Mme Lemonnier, these schools offered post-primary technical training to young women of the lower classes. Drawing was now compulsory for both boys and girls in all primary schools.[39] The first *école professionelle*, financed by the *Ville de Paris* and devoted to providing apprenticeships for young working-class women in the *métiers de la femme* or women's crafts, opened in 1880. By 1888 there were already five operating in Paris, giving some indication of the priority being given to industrial apprenticeship and training by the authorities.[40] Skills taught in the schools included dressmaking, corsetry, lingerie, embroidery, millinery, as well as training to be a florist and a porcelain, fan or glass painter. All students were taught housekeeping and cooking.[41] All the vocational schools placed a strong emphasis on drawing, regarded as the basis of all design. While Mme Bertaux served as a member of the *Commission d'Inspection des Arts Industriels*, the Inspection Committee for the Industrial Arts, for the *Ecoles Elisa Lemonnier*, she railed against the circumscribing of women's ambitions which the Republican establishment's art education policies endorsed:

> Young girls are encouraged to learn drawing when we teach it to them in the primary schools, but from the moment they want to push their artistic education further, a thousand difficulties are placed before them and the door on which they could knock remains obstinately closed to them. It's almost as if the Fine Arts administration is saying: We very much want women artists, but we want to incarcerate them in the most humble mediocrity; they will be permitted to make industrial art, fans, screens, small pots of flowers and portraits of cats, but we bar to them the route which leads to honours and to glory. These we reserve for ourselves alone.[42]

Mme Bertaux's views were in the minority. Both central government and local administration were keen to establish a skilled workforce, and set out to harness women's skills to this end. In keeping with its policy of encouraging industrial training and countering foreign competition, the City of Paris itself was ready to finance independent, free drawing schools which had proven their worth like those run by Mlle Destigny, in the rue des Archives, and Mme de Chatillon, in the rue d'Anjou.[43] It is possible that some students in these institutions developed aspirations towards public exhibition of their works, especially in the decorative arts, but this was more likely the case in the independent drawing schools and the *Ecoles Elisa Lemonnier* than in the *écoles professionelles* which were exclusively vocational in orientation. Indeed, the *Ecoles Elisa Lemonnier* proudly announced the admission of a small percentage of their students to *expositions des beaux-arts*, fine art exhibitions which were usually in the areas of painting on porcelain or glass.[44] However, it is probable that the vast majority of students destined for industrial training never expressed such aspirations, and were more likely to have measured themselves against the expectations of the authorities that they become skilled workers as well as conscientious spouses and mothers.

The phenomenon of the *académies payantes*, the paying academies which Bourgeois alleged were sufficient to cater for the fine art aspirations of women, had grown through-

out the late nineteenth century and it was by no means only women who took advantage of their facilities. Run by well-known artists, these studios offered both the advantage of providing tuition by an acknowledged *maître* (master), often himself a teacher at the *Ecole des Beaux-Arts*, together with those of the *académie libre*, like the Académie Suisse, which functioned more as a life-drawing studio providing the facilities of space and model for a modest fee. By 1899, the number of students attending the *académies payantes* far outnumbered those in the controversial *ateliers*, the studios run by individual artists, independent from, but attached to, the *Ecole des Beaux-Arts*.[45]

Many of the male painters who ran private studios accepted women students. In 1876, Maria Deraismes was full of praise for the *atelier* run by Léon Cogniet. In 1882, Ernest Hoschédé described the studio of the fashionable portraitist Charles Chaplin as 'the oldest women's studio'. Other teachers whom he described as fashionable during this period were Cogniet, Stevens, Carolus Duran, Henner and Robert-Fleury.[46] An article in the *Journal des artistes* in 1890 listed the studios of Chaplin, Carolus Duran, Bonnat, Dubufe and Cabanel as among the most popular.[47] Also known to take in women students during this period were Barrias, Boulanger, Lefebvre, Giacomotti and Flandrin. In 1893, *L'Art*

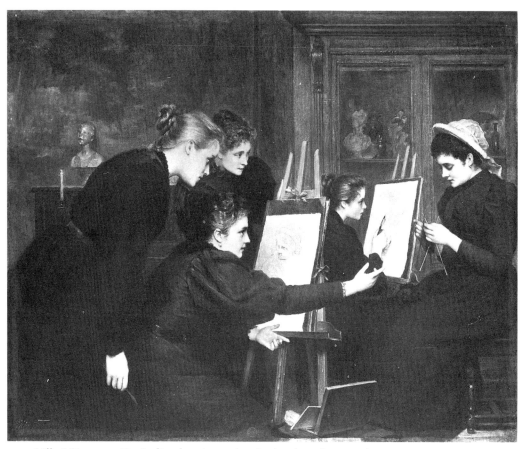

27.   Mlle J Houssay, *Un Atelier de peinture* (*c* 1895); whereabouts unknown.

*français* recommended the *atelier* of Henri Gervex, and mentioned those run by Le Roux and Krug, declaring that 'these studios are precious resources for interested women students, all the more because the *Ecole des Beaux-Arts* remains ruthlessly closed to them.'[48]

As fashionable male artists cashed in on the demand for fine art tuition for women, so the prices in many of these studios became prohibitively high and only the most wealthy women, many of them foreign, could afford to enrol in them. Mme Bertaux was scathing about the kind of students who frequented these:

> Without doubt, a certain number of *ateliers* exist in Paris. But some, at an exhorbitant price, are the meeting places of elegant society women and *demi-mondaines* who can be found there out of '*snobisme*'. These form the exclusive clientele of certain fashionable painters. Others accept the young women of the bourgeoisie who learn painting as they learn the piano, because it looks good, because it's *très comme il faut* and altogether in good taste.[49]

On the other hand, the *Acadèmie Julian*, founded by Rodolphe Julian in 1868 and by no means cheap, offered serious women students a learning situation which most closely resembled the *ateliers* at the *Ecole des Beaux-Arts* at a reasonable price. But even here women's fees were double those of their male counterparts.[50] The segregated *ateliers* (facilities for women were completely separated from those for men) were very informally run and gave ample opportunity for study from the figure, both draped and naked. This was one of the very few places where women had the option to study from the nude if they chose to. While the oportunity to draw the whole figure could in itself be a novelty for women, it was especially important to be able to study the nude. Traditionally, in most life-drawing classes for women, it was only parts of the body that were drawn. In the words of Maria Deraismes, writing in 1876: 'One studies the head, the arms, the feet, but rarely the nude torso, and the whole figure is absolutely prohibited'.[51] In Mlle Houssay's much admired *Un Atelier de peinture, c* 1895, a typical scene is represented (fig. 27). A demure and fully clothed young female model poses before a group of woman artists who are engaged with portrait drawings. The theme of women artists engaged in an activity like this one would have been regarded as highly appropriate, and the subject of such a woman's studio offered a useful setting for a figure study by a woman artist. When the whole figure was required, most *ateliers* offered the nude for male students only and the draped, fully or partially clothed figure for women. Elaborate costumes could be worn or theatrical postures might be struck. Study from the naked or lightly draped figure as was offered at the Académie Julian was highly sought after. Here instruction took the form of regulated competitions, judged and tutored by respected male painters who made weekly visits to the studios.[52] The most famous contemporary image of the studio was the painting exhibited by Marie Bashkirtseff in 1881, under the name Mlle Andrey, which showed a life-painting class in the women's studio, with a boy posing as a shepherd, suitably draped and evocative of historical or religious subject painting (fig. 28). It is interesting that, although the naked model was permitted in the women's studio at the *Académie Julian*, Bashkirtseff chose not to focus on the potentially *risqué* juxtaposition of

Septième année. — N° 318.    LE NUMERO : **40** CENTIMES    SAMEDI 27 MAI 1893

# L'ART FRANÇAIS

### REVUE ILLUSTRÉE HEBDOMADAIRE

Directeur :    Rédacteur en chef :

H. GALLI    *Bureaux : 76, Passage Choiseul, à Paris*    FIRMIN JAVEL

ABONNEMENTS. — PARIS & DÉPARTEMENTS : un an, **20** francs ; six mois, **10** francs. — UNION POSTALE : un an, **24** francs, six mois, **12** fra

## Les ateliers de Femmes

Le tableau de la regrettée Marie Bashkirtseff : *A l'atelier Julian*, que nous publions aujourd'hui, a figuré au Salon de 1881. Il était signé « *Andrey* ». En effet, la charmante artiste, si prématurément enlevée à l'affection des siens, n'a abordé le Salon sous son vrai nom qu'en 1883 avec un tableau : *Jean et Jacques*, et deux portraits au pastel.

Cet *Atelier Julian* a son histoire, que Marie Bashkirtseff a contée elle-même dans son *Journal*.

« *Vendredi 24 décembre 1880.* — Ayant fait de mauvais rêves, je vais à l'atelier où Julian me fait l'offre suivante : Promettez-moi que le tableau sera à moi et je vous indiquerai un sujet qui vous donnera la célébrité ou au moins la notoriété de six jours, après l'ouverture du Salon. »

Naturellement, je promets. Il tient le même langage à A., et après nous avoir fait écrire et signer l'engagement, avec Magnan et Madeleine pour témoins, moitié riant, moitié sérieux, il nous emmène dans son cabinet et nous offre, à moi, de faire un coin de notre atelier avec trois personnes sur le premier plan, grandeur nature et d'autres comme accessoires, et à A., tout l'atelier de la rue Vivienne, 55, en petit.... Quant au sujet il ne me dit pas beaucoup, mais ça peut être très amusant, et puis Julian est si empoigné, si convaincu : il m'a cité tant d'exemples qui ont réussi — jamais un atelier de femmes n'a été fait... Du reste, comme ce serait une réclame pour lui, il ferait tout au monde pour me donner cette fameuse notoriété dont il parle. Ce n'est pas facile un grand machin comme ça... Enfin, nous verrons ».

C'est sur ce ton familier que la pauvre enfant dira, au jour le jour, ses joies et ses angoisses, selon un mot encourageant ou une critique de ses professeurs MM. Tony Robert-Fleury et Julian, et l'on constatera avec regret

A L'ATELIER JULIAN

» Julian trouve qu'il a énormément gagné depuis huit jours, que c'est maintenant.

» Tony n'a pas vu le changement du centre ; les trois principales fig quoique au second plan sont repeintes, changées, et puis d'autres, e mains.

» Je sens moi-même que c'est mieux à présent, nous verrons ce que demain Tony

» Il y a en seize personn le squelette, fait dix-sept..

Le lendem les maîtres ne pas satisfaits Marie Bashkir s'écrie :

« Ah ! je drais qu'il crevé, ce tal pour ne pas forcé de l'exp Et il y a là démie du m un petit bor me de dix Non, si j'av. ça comme de la sen j'aurais gratt c'est mal c tout d'un commun, sa ractère et a ment indig moi ; c'est l mauvais de bleaux. »

*A l'atelier* obtint au co au Salon, u joli succès d'

et c'est ce qui décida la jeune artiste à adopter, dès l'année suivante, sa ture patronymique. A l'époque où cette toile intéressante révélait au publ térieur d'un atelier de femmes, il n'y avait guère, à Paris, outre l'Aca Julian, que l'atelier fondé par MM. Carolus Duran et Henner où les fe peintres fussent assurées de recevoir les leçons les plus sérieuses. Cette d'annexe à l'école de beaux arts était située quai Voltaire, à deux l'autre. De là sont sorties, notamment, Mme Lee Robbins, dont on a succès au Champ-de-Mars, et Mlle Forget, la seule artiste femme qui ait une commande pour la décoration de l'Hôtel de Ville. Aujourd'hui l Carolus Duran et Henner n'existe plus, mais les femmes trouvent enco excellent enseignement à l'atelier Henri Gerves, dont la surveillance e fiée à Mlle Valentino, à l'atelier Hector Le Roux, à l'atelier Krug, et ateliers sont de précieuses ressources pour ces intéressantes élèves, d mieux que l'école des Beaux-Arts leur reste impitoyablement fermée.

**28.** Cover of *L'Art français* (27 May 1893).

naked body and clothed women artists in her Salon painting. Here the model is an 'innocent' young boy, and the presence of naked models is invoked only from the life-drawings which hang discreetly on the back wall. It was this painting which formed the fitting centrepiece for coverage by *L'Art français* of the many *ateliers des femmes* functioning in Paris by 1893. When women students were confronted with the naked body as a whole, it was almost always the female model that was used and there were, by the 1890s, a number of women artists who made the female nude their speciality. Mlle Houssay, while boldly tackling the nude herself in her *Un Atelier de peinture*, exhibited at the *Salon des femmes* in 1891, still has the demure women students whom she pictures confining themselves to the heads and shoulders of the model (fig. 29). It was rare for women artists to tackle the male nude. Such a possibility functioned more as the material of fantasy than

as actual experience, and many caricatures plus at least one salacious short story dwelt on the inversions at stake in such a situation (see figs. 30, 31).[53]

There were a number of successful women painters who were in a position, by the mid 1880s, to open their own private studios to women students. Mme Bertaux had of course been providing one of the only places where women could study sculpture since 1873, and by the 1880s was running a thriving establishment.[54] The sculptor Mme Elisa Bloch drew attention to the special difficulties of aspiring women sculptors in the speech she gave at the *Congrès Français et International du Droit des Femmes* in 1889, pointing to the *Ecole Nationale de Dessin* as offering minimal State-sponsored art education to prospective painters, whilst no such provision existed for sculptors.[55] By 1882, both men and women were allowed to compete for the diploma in drawing instruction, and many women were trained to teach in primary and secondary schools.[56] In addition, a number of women offered private tuition and advertised their classes in the art and feminist press. One

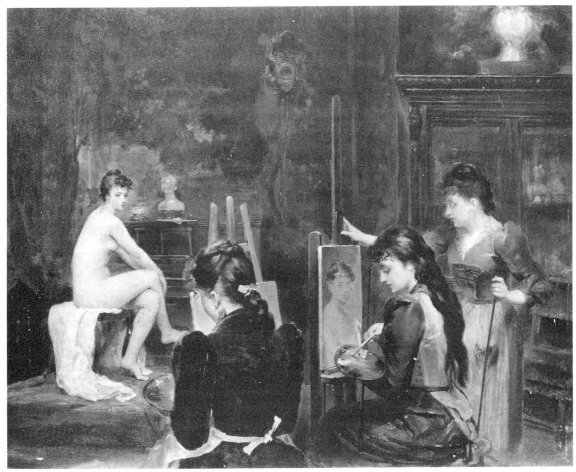

29.   Mlle J Houssay, *Un Atelier de peinture*, Exposition des Femmes Peintres et Sculpteurs, 1891; whereabouts unknown.

woman even started an *Ecole de Peinture pour les Jeunes Filles à Rome* (Painting School for Young Women in Rome), to parallel the provision given by the State in the Villa Médicis.[57]

The privatisation of art education which characterised this period created a diverse artistic field for aspiring men and women artists. Men had the choice of opting for the subsidised and traditionally high status training of the *Ecole* or taking advantage of the *académie payant* or the *académie libre*. The *Ecole* itself, it must be remembered, was divided between the *ateliers* run by individual artists for which there were no rigorous entry requirements, and the *cours*, the courses organised around the examinations, leading to prizes, the entry to which was by competition. Indeed, it was possible at this point for men to get a free education in the *ateliers* without ever being an official student at the *Ecole*. The methods of teaching in the *académies payants* differed little from those in these *ateliers* of the *Ecole*. As Pierre Vaisse has shown, the teachers often overlapped, and the kinds of aesthetic principles which were promoted in these institutions varied much less than modernist accounts have led us to believe.[58] The contemporary perception of these institutions, though, did differ. For those individuals who had embraced the identity of the independent artist, the idea of State-controlled or centralised education was anathema. It meant the crushing of the individual spirit on which great art was based. Artists of this type could not see the point of women's struggle to enter what they saw as a stultifying and anachronistic institution. Rodin, who, perhaps more than anyone else, had internalised the *fin de siècle* construction of the artist as the unfettered individual and as the embodiment of the free spirit, exclaimed: 'Women artists have their liberty. Let them profit from it. To what end do they strive for the condition of the students at the *Ecole*!'[59] The modern-life painter Jean Beraud was equally cynical about the involvement of the State in artistic affairs:

> I am inclined to admit neither women nor men to the *Ecole des Beaux-Arts*, which I regard as an absolutely useless, if not dangerous, institution. If the intervention of the State is indefensible in any situation then it is really in the matter of art. Art, in actual fact, cannot develop except through the independence, not only of its students but of its teachers as well, and this official fabric of artists, which is in any case a fairly recent creation, only serves to clutter up exhibitions with works which are without interest.[60]

What these artists could not possibly have understood was that the unfettered masculine subjectivity to which they clung, and to which their identity as artists and men was linked, was not an available subject position for the bourgeois woman artist. The freewheeling individualism, the belief in the autonomy of genius, the freedom to possess the city and its urban spaces, both symbolically and physically, were exclusively male prerogatives.[61] In a culture in which women were not meant to possess 'genius', feminists were not duped into thinking that this was a masculine birthright. They understood that achievement was the result of education and hard work, and it was not in their interests to collude with a construction of artistic prowess in which they could have no stake. A self-imposed marginality, as politics and pose, was born of the right of access and the concomitant resistance to State paternalism. For many women the cultural field was experienced differently. They could not revel in the pleasures of diversity when they were excluded

from the seat of power. Even at the point when power was shifting and old hierarchies were crumbling, the exigencies of the market now usurping the role of the beneficent State, the institutional fabric which continued to keep women out, was still perceived as a bastion to be stormed. Women wanted to be taken seriously; they wanted their cultural and professional aspirations legitimised. In an artistic field in which their role was constructed as either that of skilled anonymous craftswoman or accomplished wealthy amateur, access to state institutions seemed to offer the security of a career structure, a path to be traversed which would be marked by the public honours which had always been denied them, a stake in the most elevated of the culture's aspirations and the promise of the status, dignity and social sanction which they craved.

The demands for entry to the *Ecole* were not always made with the whole package in mind. For the feminists of the early Third Republic who supported their artist contemporaries, it was nothing less than justice that was at stake. These campaigners were not so much concerned with the state of contemporary culture or with freedom as a necessary condition for the fostering of genius, as with penetrating the structures of male privilege and exclusiveness. In this there was certainly the promise of freedom. Without it, women were imprisoned in their own ignorance, confined to the sphere which had been relegated to them. Long before Mme Bertaux made her famous speech at the *Congrès International des Œuvres et Institutions Féminines*, therefore, feminist journals were publishing demands for the entry of women into the *Ecole* and for the right to compete for the *Prix de Rome*. In the words of Pauline Orell, alias Marie Bashkirtseff, writing in *La Citoyenne*:

> You who loudly proclaim yourselves, to be stronger, more intelligent, more gifted than us, you monopolise for yourselves alone one of the best schools in the world where all the encouragements are plentiful for you . . . As for women whom you call frail, weak, limited, and many of whom are deprived even of the mundane liberty of coming and going by the word 'propriety', you give them, by contrast, neither encouragement nor protection.[62]

In the name of equality and justice, feminists were to include the struggle for access to the *Ecole* in their more general educational campaigns. They well understood how women's paltry training was used as a means to proclaim their innate inferiority. Fighting against the lack of logic, reason and fair-mindedness in current arguments about women's weaknesses, they sought to expose the blind prejudice on which common-sense was based. Writing in 1882, Camille alleged that in placing women at a disadvantage in society, men provided themselves with a basis on which to proclaim women's 'original inferiority'.[63] Convinced that it was only education and opportunity that held women back, feminists firmly located women's lack of achievement, where they acknowledged it existed, in the social fabric which inhibited their development, and defiantly proclaimed women's successes where they could. As Pauline Orell put it in 1881: 'We are asked with an indulgent irony how many great women artists there have been. Ah, gentlemen, there have been some and that is surprising given the enormous difficulties that they have encountered.'[64]

They invoked the arguments of precedence (if women were admitted into the schools of medicine, why not into the schools of Fine Art?), made comparisons with art educational

provision in other countries, predicted typical objections and argued against them, challenging the dominant notion of the *femme au foyer*.[65] They confronted head-on the question of propriety. Some had no patience with hypocritical invocations of women's modesty (Camille, 1882), or exposed the absurdity of a culture which saw no harm in women observing paintings of the nude but forbade them the opportunity to draw from actual live naked models (Olympe Audouard, 1882).[66] Some gave practical suggestions, proposing the opening of the *Ecole* itself with the segregation of life-drawing classes (Orell, 1881), others advocated the creation of days or even hours when women would be permitted to follow specific courses and be advised by the teachers (Jacques, 1883).[67] Camille did not care how it was done. Whether classes were mixed or segregated, held at the same time or were staggered, was immaterial. What was important was the will to reform the school and give women their due.[68]

It is not surprising that by 1889, when Mme Bertaux got unanimous support for her proposal, the debate was to move outside of the small but vociferous context of feminist publishing and to impinge on the art establishment itself. The time was right, the context perfect. Not only was Republican policy on art education in flux and women's education on the agenda, feminists had declared that education reforms were too modest, and economics had demanded that women work and that they be trained to do so. When the government-sponsored *Congrès International des Œuvres et Institutions Féminines* endorsed women's rights to professionalism and training in the name of their feminine natures and philanthropic spirit, the authorities had to sit up and pay attention.

Mme Bertaux was not prepared to leave things to chance or conscience. At the general assembly of the *Union* in December 1889, a full report of the congress was given, and the resolution read out and endorsed by the *sociétaires* who resolved to send it directly to the *Beaux-Arts* administration.[69] On 29 January 1890, Mme Bertaux sent the resolution to the Minister who in turn submitted it to the *Conseil Supérieur des Beaux-Arts*, thus precipitating the first official discussion on the question at the *Ecole* itself.[70] The matter came up at the meeting of 25 March 1890, and was duly documented in the minutes.[71]

Our evidence for the substance of the debates over women's entry into the *Ecole* in the 1890s is varied. In addition to the personal recollections and memoirs already mentioned, there were the official debates held in the *Conseil Supérieur* or the Chamber, 'recorded' in the official minutes of these institutions, hand-written in the case of the former, printed and bound in large volumes in the case of the latter. A cursory glimpse behind the scenes at the *Ecole* itself is provided by the fragments, letters and notes preserved in the school's own archives.[72] Then there was the more public debate that raged in the pages of the press, partial, opinionated, journalistic in character and inflected by the newspaper or journal's wider commitments to feminism, education, Republicanism, the state of contemporary culture, and so on.

It is with the official records, initially the minutes of the *Conseil Supérieur des Beaux-Arts*, that this account of the debates of the 1890s will begin. For it is through them that one can both chart the course of events, and trace the operations of official ideology as it is encoded in discourse. The structure of the minutes evokes the formality of the meeting, with its hierarchies, niceties, and its procedures. From the records of these

meetings, the impression received is one of calm deliberation, rational planning and reasoned debate, but such decorum and politeness can serve to mask some of the real anxieties which the proposals provoked. To explore these we will have to look beyond the official records themselves. To understand the resistance to the reforms, we will need, at times, to delve beneath the reasoned exterior which public discourse marshals to its defence.

At the meeting of 25 March 1890, the precedent for future prevarications was already set. The difficulty of admitting women, according to the director of the *Ecole*, Paul Dubois, was practical. After reading the petition which had been sent on to the *Conseil* and before any discussion was allowed, he declared that in the present condition of the *Ecole's* premises it would be absolutely impossible to organise the separate courses demanded by the *Congrès des Œuvres*, and that this would require a financial outlay that the school's budget would not allow.[73] A brief mention was made of the arrangements for the entry of women to courses at the Sorbonne and the *Ecole de Médecine*. These, it was reported, had been implemented with no disturbance to order. The concept of order was to appear again and again as a consideration in these discussions. At the request of Bailly, it was decided that a commission composed of two painters, Lenepveu and Gérôme, two sculptors, Cavelier and Guillaume, and two architects, Garnier and Bailly, would be set up, under the authority of the *Conseil*, to study the question.[74]

The special commission met on 10 May 1890 at the *Ecole*. Present at the meeting were Mmes Bertaux and Demont-Breton who had been invited to put forward the case for women artists. They were faced with a committee which included one of the most vehement opposers to women's entry into the *Ecole*, Gérôme, and one of its staunch supporters, Guillaume. Mme Bertaux was the spokesperson for the resolution.[75] It was Guillaume who reported back to the *Conseil Supérieur* on the 13th May, at a meeting which was attended by all the members of the special commission. On the 12th May a petition signed by 121 *sociétaires* had been sent to Paul Dubois, asking for the subcommittee to look favourably on their demand which they claimed was in both the public and the national interest.[76] According to the minutes of the subcommittee, what women were demanding was an analogous education to their male counterparts and the organisation of competitions which would equip them to compete for the *Prix de Rome*. Mme Bertaux is represented as the picture of reasonableness. According to Guillaume, she recognised the impossibility, given the current accommodation at the *Ecole* and the resources which it had at its disposal, of creating a special section for young women.[77] The special commission, however, endorsed unanimously women's rights to an equivalent art education to men but on an 'independent site' which would have its own 'special budget' (the school was keen that the initiative be centrally funded), where 'analogous studios to those which exist would be organised and for which the teaching staff could be the same as that at the *Ecole des Beaux-Arts*'.[78] The majority of oral courses, with the notable exception of anatomy, on the other hand, could be open to both men and women. On the subject of the *Prix de Rome*, the commission had decided that it was not competent to judge. This would have to be referred to the Academy and the Director of Fine Arts. It was in this context that the much publicised statement on the willingness of the *Ecole* to endorse an equal art education for men and women was made:

The *Conseil Supérieur* sharing the opinion of the subcommittee, by eight votes against two, puts forward the view that 'young women may, with the aid of the State, be afforded, for their artistic education, the same facilities as young men'.[79]

There is much left unsaid in the official records as summarised here. What is not articulated in this truncated account, is that which, on the one hand, 'went without saying', or on the other could not be dwelled on. Yet it was the great 'unsaids' in this case which constituted some of the major issues informing subsequent debates of both the official and less formal types. Mme Bertaux's alleged reasonableness rested on her apparent recognition that whatever the cost, male education must be ensured before female education could be considered. If an 'injustice' is recognised, which seems from these records to be the case, it cannot be rectified by a more equitable arrangement if the provision that exists for men is to be challenged. Justice involves women getting something of what men already have but without any cost to men. Small wonder that neither the budget nor facilities were going to stretch that far. There were some commentators who would recognise such rationalisations as stemming from bad faith. During the same period as these initial meetings were taking place, the *Ecole* was to acquire the Hôtel de Chimay, at a cost of four million francs, as an extension to the school. It was decided that it would be used for the study of decorative composition and the simultaneous study of the three arts, part of the Republican inspired curriculum reforms which the *Ecole* was undergoing during this period. As one commentator in *Le Temps* asked: 'Could one not make a little place there for women? If we allow this occasion to pass without making use of it, we will give proof of a lack of goodwill.'[80]

Even more occluded in these records than the implicit understanding that male education came first, whatever the cost to women, is the anxiety already alluded to by earlier feminist writers, but here left veiled, over mixed education. This went to the heart of the problem for it impinged on the institution of the life-class, still regarded as the basis of serious art education, official or otherwise. The authority of the life-class, within academic circles, depended for its sobriety on the capacity of art to transcend the material, base associations of the body. The 'ideal' itself figured in academic mythology, as represented by the influential theorist and arts administrator Charles Blanc, as the redemption for which men strove, after 'Woman', in the form of Eve, had destroyed the primal beauty of the Garden of Eden. To compensate for the ills that Woman had caused, since it was she who had provoked the conflict between the 'real' and the 'ideal' in the first place, men struggled perpetually to attain this ideal which was always under threat.[81] Woman's physicality, her rootedness in her own biology and sexuality, was itself a threat to the quest for the ideal. It was hard enough to transcend women's physicality in the transformation of female models into respectable nudes, containing their fleshy bodies in the discipline of the line, polishing their soft flesh with the smooth veneer of finish, disciplining their flushed skin with the palour of tonal modelling.[82] It required a male hand to exercise such control, and an all-male environment to ensure the sobriety of the enterprise and the integrity of the project. As long as all-male communities could conspire to keep sexual difference at bay, taking their own sexuality for granted so that it went unremarked if not unnoticed, then the naked body of the model could more easily be transformed into

the disciplined body of the mind rather than the sexualised body so threateningly invoked by the discourses of 'realism'. The presence of women as *artists* in the life-class, or even the anatomy lesson, would induce a degree of self-consciousness which could expose the repression on which the institution of the life-class was premised. In their presence, neither the sex of the artist nor the bodily identity of the model could be overlooked. Both threatened to assert themselves. Such an assertion would hit at the heart not only of propriety, accepted morals and decency, but at the institution of the nude and thereby at the beleaguered traditions of *le grand art* which the *Ecole* was so anxious to defend. Even segregated classes posed the problem of the male model, still most often used for the competitions for the *Prix de Rome*, whose difference from his female audience could not be overlooked. While the male artist, with all his intellectual powers, had the capacity to transform physicality into spirituality, women artists were not so endowed. In their company, the body was the body. Conversely, in this assertively heterosexist discourse, while male models could be guaranteed to parade a lack of self-consciousness in the company of male artists, they could not be relied upon to do so when being surveyed by young women. The gaze of women artists, like the gaze of the Medusa, threatened to petrify its male objects. And in this context, fear, masquerading as desire, could only mean trouble.

The tension between the physical, or more to the point, sexual, connotations of the body and the rhetoric of idealism in which academic discourse shrouded it, had been articulated in criticism for some time. The sexualisation of the body which 'realism' had entailed could be construed as an attack on traditional forms of representation, traditional hierarchies of genre and traditional social relations. It stood for 'modernity', a term which connoted the rejection of the past and the sacrifice of its social forms and institutional structures. Encoded in debates about the nude, therefore, were larger issues about tradition versus modernity, the ideal versus the real, the old versus the new.

That the issue of the nude was one of the central concerns in the debate over women's entry to the *Ecole*, was revealed in an interview with Gérôme published in the *Moniteur des arts* a few months after the meeting of the *Conseil Supérieur*. Gérôme assured his interviewer that the whole question of women's entry into the *Ecole* was premature, and that there was little real possiblity of the *Ecole* opening its doors. The resolution of the *Conseil Supérieur* had simply been passed as a way of curtailing discussion and so that the *Ecole* would not appear to be hostile to liberal and emancipatory ideas. Not only was the *Ecole* too small for the students it already had, but it was 'impossible to admit women to the same courses as men'. This was not a matter of morals, protested the eminent teacher, but had to do with the fact that work would suffer. Proof of this was the fact that when the art students had, approximately once a month, to work from a female model they worked much less well. The power of Woman to provoke disorder is invoked even when the actual women in question are the hired workers completely subjugated to the stringent routines which modelling required. It followed that the presence of women students in the class would produce a situation in which concentrated work was impossible.[83]

Many commentators saw the entry of women into the life-drawing class, therefore, as threatening, both on the level of public morals and in terms of the disruption of the notion

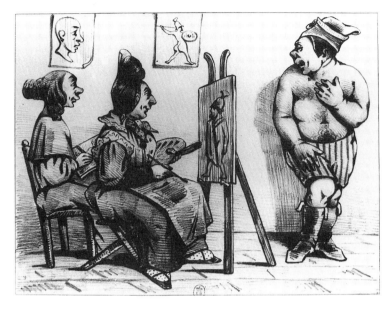

30. 'Allons Daroncourt, gros indécent...'
('Come on, Darancourt, you gross slob, remember that you are no longer at the baths; you represent Achilles and you are posing in front of your wife and your daughter Clara.') Lithograph from *Pièces sur les arts*, Cabinet d'Estampes, Bibliothèque Nationale, Paris.

31. 'Songez que vous peignez l'histoire'
('Remember that you are painting History.') Lithograph from *Pièces sur les arts*, Cabinet d'Estampes, Bibliothèque Nationale, Paris.

of art as transcendent. A mid-century caricature played on the ridiculous, much talked about *caleçon*, the trunks which it was suggested that male models could wear in the presence of women artists (fig. 30). Here, the tradition of history painting is undermined by the unlikeliness of the gender identity of the artists, caricatured as old shrew and ugly spinster daughter, and the far from ideal proportions of the model, made more ridiculous by his mock heroic attire, gross expression, and pathetic underpants. The inability of women to appreciate the sobriety and transcendent qualities of history painting was a continuous theme, both in these debates and, as we shall see in chapter five, in the

discussion of the exhibits at the *Salons des femmes*. In a much earlier caricature, the young female artist is reminded by her lecherous teacher, in the face of the less than perfect body of the model who must be transformed into the embodiment of ideal beauty, that she is painting 'history' (fig. 31). Both her capacity to transcend the physical, and the life-class's institutionalised containment of an always threatening sexuality, is put into question. There are many 'sexualities' on display here: the chaste femininity of the artist, the gross, almost caricatural attitude of the model with the chimney stack rising provocatively from between his legs, and the lascivious leanings of the teacher. Conventional morality threatens to be overturned by a sexuality that lurks beneath the surface. The edifice of 'Art' could be easily disrupted. The danger of this was palpable.

The debates of 1890 to 1891 were to set the tone for the discussions of the next decade. Jules Antoine, of *Art et critique*, saw the public objections to men and women drawing side by side from the naked model as tied up with notions of bourgeois morality with which he would have no truck:

> The people who are upset by the meeting of men and women in front of a nude model have never been in a drawing studio; the presence of forty or fifty students gives a sort of impersonality to the model, who becomes no more than an object to be drawn. In addition, the nude is not obscene: it is often very ugly but much less bawdy than low-cut clothing or a hitched-up garment.[84]

Art transformed the naked into the nude and thereby repressed its sexual connotations. If the body of the model did not signify sex, what was the danger of men and women drawing it together? But whilst the model did not immediately parade his sexual differ-ence, being effectively neutered by the institution of the life-class, this was not true for the artists, and it was their identity which was potentially dangerous. Unconvinced by the assurances of the likes of M. Antoine, there were those commentators who feared for the *sangfroid* of the male model in the presence of the 'faces, blonde hair and laughing eyes of the young women artists'.[85] And if the male model was to become aroused, who could then testify to the transcendence of the nude over the naked?

In the context of these concerns, a very enlightening perspective on the meeting of the subcommission at which the two women artists were invited to speak is given in Mme Demont-Breton's memoirs. What emerges as equally pertinent as the ability of art to transcend sex, is the question of male virility and rivalry. The balance between the necessity for the masculine capacity to abstract, on which the academic tradition de-pended, and male potency, on which current myths of the artist were based, is a fragile one. In a graphic reconstruction of the meeting, Mme Demont-Breton recounted that while she was addressing the meeting, she noticed the mobile expression on the face of Charles Garnier, who suddenly, unable to contain himself, is reported to have cried out that it was absolutely impossible to put men and women under the same roof at all: this would be like placing fire near to gun-powder and would produce an explosion in which 'Art' would be destroyed altogether.[86] This was allegedly too much for the generally calm Guillaume, who turned to him and cried:

> You childish ignoramous! You don't know what you're saying. When an artist works, does he think of any thing other than the study which concerns him, over which he

struggles? In such a school, with the realisation of legitimate progress, there will no longer be men or women but artists, animated by a noble and pure desire to emulate![87]

Garnier was not content with this answer:

It's possible that you, oh great sculptor, you're made of marble or wood like your statues, but as for me, at twenty years of age, had I seen a nice young feminine face next to my easel, to hell with my drawing! Oh Guillaume! You are not a man![88]

To which Guillaume is said to have responded:

Oh! Garnier! You are not an artist![89]

Artist and man are, momentarily, in conflict here. It was allegedly Cavelier, in the interests of conciliation, who proposed the creation of a separate school. Gérôme it seems, true to his beliefs, complained of the unnecessary expense this would involve.

Notwithstanding all the objections, the *Ecole*, whether it had used it as a delaying tactic as Gérôme had maintained or not, was now publicly committed to seeking a solution to the problem of a State-funded women's art education, and Mme Bertaux and the members of the *Union* were not going to allow them to forget it. There followed a campaign of letters and reminders.[90] According to the *Journal des artistes* of 28 September 1890, Mme Bertaux made a visit to Gustave Larroumet, one of the members of the *Conseil Supérieur* who had voted in favour of the statement issued by this body, to remind him of the promise made a few months earlier. Larroumet responded to her challenge by equivocating and stressing the practical difficulties that the proposal entailed. Despite Mme Bertaux's allusions to the mixed education at the *Sorbonne* and the *Ecole de Médecine*, Larroumet could not, like his colleagues, see the possibility of 'admitting pupils of the weaker sex into the studios frequented by the stronger sex'.[91] The difficulties, he stressed, were practical and financial. The building of separate facilities for women would entail great administrative upheaval and costs. What was more, there was the problem of the Villa Médicis to consider. If women could compete in the competitions they would be in a position to win the *Prix de Rome*. There was no question of women being in residence in this all-male environment. (The only women permitted to enter the *Ecole de France* at Rome were the director's wife, washerwomen and servants. Winners of the *Prix de Rome* had always to be single as there was no accommodation for wives). The dangers would be too great. Once again practical difficulties functioned as a screen behind which prejudice could hide. For women artists like Louise Abbéma there was an easy way around such a problem. Instead of sending women to the Villa Médicis, why could they not be awarded a travel bursary which would be just as useful to them as a number of years spent in Rome?[92] For this type of imaginative solution to be entertained, however, there needed to be a willingness to question the sanctity of tradition and its institutions and the acknowledgement that if things were to change they could not, simultaneously, stay the same.

Mme Bertaux was apparently impressed by the practical difficulties which the earlier request had presented, and, always the political tactition, she was ready to simplify her demands. In a letter to the *Ministre de l'Instruction Publique et des Beaux-Arts*, dated 8 October 1890 and reprinted in the *Journal des femmes artistes*, she, in the interests of

speed and feasibility and in recognition of the objections that had been raised, issued a modified request:

> That the *Ecole* be opened to women, from the beginning of the next academic year, not through the creation of new studios, but in according women the right to count for a fraction of the number of admissions reserved until now for men, and in placing this group of admitted women under the supervision of one of the *Ecole*'s teachers in one of the studios in the school itself, which would be specially given over to them.[93]

But the *Conseil Supérieur*, to whom this letter was referred, saw no possibility of revising their statement of 13 May 1890 in which they had stressed the impossibility of the entry of women to the *Ecole*, thus affirming that the responsibility lay with the State to provide women with an analogous education elsewhere.[94]

The public initiative was now in the hands of central government rather than the administration of the *Ecole*. In March 1891, Léon Bourgeois, Minister of Fine Arts, nominated a commission of senior government officials, 'men of letters', and artists, to study the question. The commission consisted of Eugène Spuller, member of parliament; the senators, Jules Ferry and Berthelot; the director of civic buildings, Jules Comte; the *président de section du Conseil d'Etat*, Tétreau; Viscount Henri Delaborde, the permanent secretary of the *Académie des Beaux-Arts*; the writer, political commentator, and member of the *Académie française*, Alexandre Dumas; the director of the *Ecole Nationale des Arts Décoratifs*, Louvrier de Lajolas; the painter, Jules Breton; the engraver, Flameng; and the art critic, Louis Gonse.[95]

The *Journal des femmes artistes* was quick to notice the absurdity of the fact that not one woman had been invited to be part of the commission. Once again this was the case of a committee of male authorities making decisions about women in their absence. Women artists and their supporters registered their protest. They insisted that it was women artists themselves who should defend their cause in front of this all-male jury. Public figures like Bourgeois, Ferry, Berthelot and Dumas had already damaged their public profile by being perceived as too 'femininst'. Were they going to stick their necks out for women in this case?[96]

The commission made its formal report to the *Conseil Supérieur* on 25 June 1891. As was to be expected, the finding of the commission was to be the same as that of the *Conseil Supérieur* itself. Whilst they acknowledged the reponsibility of the State to give an equal art education to women, on no account could this be done within the walls of the *Ecole* itself. However, some different issues to those heard at previous meetings were mobilised in the discussion. The fears expressed by Louvrier de Lajolais echoed those of the Republican administration's concerns over the *Ecole Nationale de Dessin pour les Jeunes Filles*. He worried over a potential dropping of standards in the *Ecole* due to the presence of young women, more suited to expressing their mediocre talents through industrial arts, and deluded into thinking that they had been called 'to higher things'. He urged that entry procedures should remain strict to prevent this.[97]

Another crucial point was the matter of international competition and national pride. When Mme Bertaux had written her reminder letter of October 1890, she had ended with a reference to the provision of art education for women in Russia, England, Switzerland

and Holland, stating that she hoped that France would soon do for her women what these countries already did for theirs.[98] The knowledge that France lagged considerably behind other European nations and the United States, was to be used repeatedly in debates in the following years.[99] That this sometimes lead to distortion and an over-romanticised view of provision elsewhere is clear, but it was certainly tactically and rhetorically effective.[100] At this meeting it was Tétreau who brought it up:

> France . . . should not refuse to women that which is accorded them in England, in Germany, in Sweden, in America, where it has been observed, besides, that the opening of common courses to both sexes has not given rise to any criticism, and to any concern that propriety has been offended. It is sufficient to speak of the South Kensington Museum, where common drawing courses after the antique and the live model are regularly frequented by a large presence of men and women, without the modesty of England being moved towards an allegedly dreadful promiscuity.[101]

For many, this might have seemed like a conclusive argument, but Alexandre Dumas was to bring up a subsequently widely reported objection which went to the heart of the late nineteenth-century French conception of self. For him, what counted was the fact that 'the character, the temperament and the customs of French women' could not be compared with those of the English or Americans.[102] If one accepted this, one could see why it would never be possible to open to women the studios or the competitions of the *Ecole*, where men had always behaved with utmost liberty. The notion of a 'national character', and its links to 'temperament' seen as stemming from a hereditary constitution and essential ethnic traits, was entrenched in common parlance. Although anthropolgists and sociologists would speculate about the origins of 'national characteristics' and dispute the relative claims of essentialists and evolutionists, few people, if any, disputed the 'fact' that they existed and that they were important marks of difference.[103] The French had long regarded English and American women as more 'masculine' than their French sisters, who were thought to represent the quintessentially 'feminine'. That Anglo-Saxon women were safe in mixed life-drawing classes guaranteed nothing in the face of the passion of the French male and the vulnerability of the French woman. For the rabid anti-feminist, England was in any case seen as a land with an unhealthy number of 'spinsters' and blue stockings, forming a notorious 'third sex' of celibate unnatural beings who would contribute eventually to general social decline.[104] French 'femininity' was already under attack from feminists who sought, it was feared, to turn women into men. The prospect of women inhabiting the potentially sexualised space of the studio prompted fears on a number of levels. In addition to the threat posed to the institution of art there were social dangers which needed to be guarded against. At risk was both the 'liberty' of men, a necessary condition for the expression of masculinity, creativity and the energy which fuelled progress, and the 'character' of women, who might be morally corrupted, or, worse still, transformed into men's colleagues rather than their partners and thereby become desexed.

These objections were to strengthen some critics' convictions that the solution to the problem was the creation of a separate school for women, where they would be protected whilst masculine liberty would be unimpinged. As Auguste Vacquerie mockingly put it:

If France is more prudish than England and if the deputies feel a blush mounting their cheeks at the thought of men and women working together, they could vote for an additional school and women's studios where solid doors and strong bolts separate them from the male studios.[105]

This required an injection of money. At the meeting of June 1891, Paul Dubois, as director of the *Ecole*, was invited by the commission to set up a working party to look into the organisation and budget required to implement the findings shared by both the *Ecole* and the *Conseil Supérieur*.[106] The *Ecole* itself had, at this point, abdicated all responsibility for finding a solution within its own walls. At a meeting of the *Conseil Supérieur*, held in December 1890, MM. Gérôme, Garnier and Lenepveau, all staunch conservatives, had stressed that the 'commission and the special committee had always thought that the new provision would be absolutely independent of the *Ecole des Beaux-Arts*'. Backtracking on the sense of the earlier resolution of the commission, the dangers of which they could now see, they stressed that the admission of women into the *Ecole* itself would create such serious inconveniences that had the commission suspected the real intentions of the petitioners (Mme Bertaux and her associates), they would not have issued so favourable a statement in the first place. The only reason that they had come out in favour of women's art education was because they had believed that it was up to the State to provide it. Affirming in general their original finding, they now wanted to stress that it was 'absolutely impossible to provide this education for women at the *Ecole des Beaux-Arts*'.[107] If the *Ecole* was not to be the home of women's State-funded art education, then it could continue as normal. This was now a matter for central government and its infrastructure of Fine Arts administration.

What followed was a period of immense frustration for the members of the *Union*. By all accounts they had triumphed, having obtained official support for the worthiness of their cause. Despite the arguments against it and the opposition of powerful men, their case had, theoretically, been won, yet nothing was to happen in the following year to put the resolutions into practice. The *Union* stepped up its campaign. In virtually every issue of its journal, the question was raised and the matter debated. What angered women artists more than most things were the repeated claims that they did not need the *Ecole*. Artists with talent, they were told, would triumph regardless. In that case, asked the women, why not scrap the school all together?[108] In a series of articles published in March 1892, Jules Gerbaud detailed the achievements of the campaign so far. Expressing his frustration, he demanded a way out of the vicious circle of, on the one hand, theoretical support, but on the other, endless practical impediments. If there was not enough money to create a new school, then the old one would have to be enlarged. If foreign students were eligible for free tuition in France, then why not French women? One by one the often raised objections were mentioned and dismantled. If logic and reason were to win the theoretical battle, then they were going to be marshalled tirelessly.[109]

Understanding that the provision of art education by the State was a legislative matter, the *Union* began to lobby support among members of parliament. If the various commissions had been sincere in their support, they argued, then they would have to find the money to finance their convictions. Feminists were in a familiar position here. With no

representation of their own in government they had to rely on sympathetic deputies to argue their case. As if to demonstrate the strength of their organisation at this crucial time, the *Union* invited the deputy Gerville-Réache to address their sumptuous eleventh anniversary banquet, attended by five hundred people, mostly women. At the banquet, the talk was all about the achievements and aspirations of the woman artist. Gerville-Réache rose to the occasion and assured the gathering of his support for their 'artistic emancipation'. Most importantly, he promised to defend their interests publicly in the name of patriotism and justice.[110]

Mme Bertaux was not prepared, however, just to leave matters with him. A month after the banquet, she addressed a public letter to members of parliament giving them a brief history of the campaign to date and constructing a three-point argument for her case. She rejected claims that a career in art was not compatible with the duties of a mother or wife, she refused the popular conception of women as incapable of great artistic achievement, and she rebelled against the injustices of a system which bestowed favours and support on one group at the total expense of another. At this stage, she asserted, she did not mind how the State chose to organise it, whether at the *Ecole* itself or in a separate school, what she demanded was free and equal art education for women.[111] In the subsequent months, support for the case of women artists was to appear in major newspapers. In November 1892, an impassioned defence of women in art and public life appeared on the front page of *Le Temps*, and another in *Le Rappel*.[112]

Everything depended now on the willingness of the State to provide the necessary funds for the realisation of the project. This was a matter which only the Chamber could decide. After over a year of official silence, the debate now moved into parliament itself, taking place within the context of discussions of the annual budget for fine arts. The form of the discussions at this point was, therefore, conditioned by parliamentary procedure, and proposals usually took the form of amendments to bills. In the interests of stimulating debate, raising awareness or hindering the smooth passing of resolutions, apparently minor changes could be proposed, precipitating long speeches and little alteration in legislation. The issue did, in this halting way, however, get debated and was covered in the regular reportage of the budget which appeared in the press. If there were still Parisian newspaper readers who were unaware of this issue, they could not remain so for long.

The debates in the Chamber over the next seven years (the issue was debated in 1893, 1895, 1896, 1899 and 1900) were to re-state and expand many of the arguments that we have heard before. Crucial issues remained: the gendering of the fine and decorative arts, a concern over the excessive number of artists whose work was not harnessed to industry, wider questions on the social role of women and the compatibility of art and domesticity, the ever-recurring anxiety over propriety, life-drawing and co-education, France's claims as the originator of Republican justice and her relative conservatism in relation to women's rights, the anomalous relation of the present dispensation for women artists with France's own record in pre-Republican days, the changing economic position of women, and their need for training. In the name of equality, justice and progress the Republicans were presented with campaigns, of which the struggle for art education was only one, for the improvement of women's status and rights. As these were the values that they liked to attach to their own political credo, they had some difficulty in refuting their validity. Yet even those who argued for reform were never to accord priority to equality in preference

to difference. It was via the acceptance of women's and men's natural constitution and social function as fundamentally different but equal, that Republicans could satisfy their demand to be seen to be both just and responsible. If women's domestic mission could be seen to be in both her interests and that of the nation's, then the arguments for equal rights and priviliges would have been addressed without changing the fundamental social structure.

Progress was, therefore, slow and halting. True to his word, Gerville-Réache presented an amendment to the fine arts budget of 1893 to raise the allowance for personnel and materials of the Ecole by 1000 francs each, in order to facilitate the entry of women into the school in the following year.[113] The figure was entirely arbitrary. Putting forward such an amendment was a ploy to provide the proposer with a platform from which to present his case. In a long, detailed and well-researched speech, Gerville-Réache defended the rights of the woman artist in the name of both the traditions of France (he included a detailed history of the position of women under the old Académie Royale) and the customs of modern nation states, with a summary of his findings on the position of women art students in other countries.[114] He outlined the history of the campaign so far, challenging the Chamber to find a means of putting into practice the resolutions of earlier commissions. He scorned the objections of people like Alexandre Dumas, claiming that his assessment of French women and men was tantamount to a national insult. There was, in his view, nothing dangerous about men and women working together. They did so in the schools of medicine and law, and in the hospitals as interns, as a result of battles which had been hard won. Art, he claimed, following the lines of reasoning of Mme Bertaux, was not incompatible with women's social and domestic duties. From the point of view of equality and justice, he declared, the government could not refuse to grant women artists what they wanted.

It was up to Charles Dupuy, *Ministre de l'Instruction Publique, des Beaux-Arts et des Cultes*, to respond for the government. Predictably, in the light of Republican concerns, he had no sympathy with a proposal which might serve to augment the already inflated numbers of artists which France possessed. He was adamantly opposed to the idea of co-educational fine arts education. Re-invoking Dumas's premises, he was not concerned with 'the Slavic race' nor 'the Anglo-Saxon race' but with French women, who, although they might be safe when they shared their classes at the schools of medicine or law, would certainly not be at the *Ecole des Beaux-Arts* where the pranks of the young male art students were well known. But it was not primarily the corruption of women in a mixed school which concerned Dupuy. He had his own vision of women's education and social role, which could never be fulfilled through fine art education. Dupuy supported, uncon-ditionally, the creation of an entirely new school for women, but one which would not duplicate the teaching at the *Ecole*. Rather, it would be especially designed to cater for women's aptitudes and propensities.

To the sound of multiple 'hear, hears' and much applause, he elaborated his ideas:

It seems to me that women's artistic tendencies would be orientated in a more appro-priate, a more useful and a more practical manner, both for her and for us, if they were directed, not towards that which is called the fine arts but towards the decorative arts which have not yet, in this country, developed to a desirable standard [*hear, hear*].

What women needed, Dupuy intoned, was:

> a programme of study after which each artisan could be, simultaneously, a kind of
> artist (*hear, hear*), that is to say the kind of education which is never separated, even
> in its preoccupations with the most useful, the most functional of objects, from that
> notion of art, that feeling for distinction and elegance which is one of the characteristics
> of French genius. (*Applause.*)

Preferring to see women orientate themselves in this direction, he claimed that they would
have everything to gain from it, as would society, because once they had finished the
aesthetic training which he had outlined they would become mothers, and they would find
in this education ('which is no less artistic, but more practical and much more open to
application' than a fine art training) the means to remain artists at the same time. What
was more, they would bring to their domestic *foyers* a wealth of resources which they
would not have had to the same extent if they had devoted themselves totally to 'Art'. This
assertion was met with loud applause.[115]

What Dupuy expressed was, as we have seen, at the heart of the Republican conception
of femininity. Social order and prosperity were dependent on the existence of the patriar-
chal family structure. Anything that challenged women's role as wife and mother was a
threat. No claims could supersede the fundamental structural principle on which natural
relationships were based. It was an unthreatening engagement with the decorative arts
(much more than a serious commitment to the fine arts with its connotations of individu-
alism, professionalism, careerism and public display), which could be seen to fit into the
domestic vision of womanhood still at the heart of Republican fantasy, and to contribute
to the Republican project of rejuvenating the decorative arts at the same time.[116] The
warm response which Dupuy received throughout his speech testified to the fact that he
spoke a language which was generally understood. It was precisely this argument that
Mme Bertaux had long confronted and rejected, but she was not present here to defend
her position. Few people, not even Mme Bertaux, would have argued against popular
wisdom as it was encoded here. What Mme Bertaux might have sought to do, as she had
done on many occasions, was to convince these gentlemen that neither the fabric of the
family nor the sancity of the home would be threatened by women's fine art education. In
the event, Gerville-Réache could only make a lukewarm attempt at establishing this point,
and suggested that Dupuy was not addressing the question that had been put to him, that
of women's aspirations in the fine arts. After seeking assurances that proposals for a
separate school would find their place on the budget for 1894, he withdrew his amend-
ment, and the budget was passed without ensuring any provision at all for women's art
education.[117]

Response to the proposals was mixed, but few seemed to have greeted them enthusias-
tically, least of all women artists. It was Gustave Geffroy, writing in *Le Figaro*, who
poured scorn on this Utopian vision of the flowering of the decorative arts. He made some
salutory and hard-hitting points about the contemporary condition of light industry,
stressing the difficulty women would find in making a living during this time of increasing
mass-production and price-cutting. He mentioned the conditions under which people in
small industries worked, the competition that men would offer women, and their inevi-
table resentment at an invasion of craftswomen into their domain. This was, according to

him, no solution to women's problems. That lay, he not very helpfully added, in them not working at all.[118] Other commentators could not see any point in building a new school of decorative arts for women. Such a school for men already existed and it was not clear why women could not be admitted into that one.[119] Moreover, the solution offered by the deputy did not answer the challenge put to him by women artists. As the writer for *Le Temps* put it:

> Women say 'Fine Arts' to you and you respond to them in an inviting manner with 'Decorative Arts' ... By what right do you presume to push towards decorative arts those subjects (men or women) who believe themselves to have a vocation for the fine arts?[120]

It was left for feminists to refute the entire premise on which the proposal had been based. The writer for *L'Harmonie sociale*, for example, rejected entirely the notion that women's capacities were either fixed, or known, or that their innate propensities were evident. As women had always been restricted in the scope of their self-development, how could anyone know their capabilities and legislate accordingly? This writer had nothing against the decorative arts, but could not support the policy of pushing women towards them regardless. The point was, she claimed, to allow both men and women to realise their potential in all these fields and without prejudice.[121]

*L'Art français* was inspired by the debate in parliament to conduct a survey of the opinions of contemporary artists, men and women, on the issue. From these responses it is possible to glean how very conservative, at least on the question of women's rights, most male artists were during this period. It was not on the majority of their male colleagues that women artists would be able to depend for support. Very few came out forcefully in favour of women's rights to art education. Younger painters like Georges Rochegrosse, Lucien Doucet, Félix Boucher, and Gueldry, to whom Mme Bertaux had written for their views, expressed their lack of interest in the issue with caustic irony and some disdain.[122] Carrière saw no problems in women entering the *Ecole*, but feared for their entry into an already overcrowded profession.[123] There were those like Henner, Raffaëlli, Béraud and Rodin, who questioned the relevance of this education at all, and Dalou advocated the closing of the school which he regarded as an 'artistic calamity' for everybody. Puvis de Chavannes was non-committal and Dagnan-Bouveret was completely uninterested in the issue.[124] There were others like Bonnat, a teacher at the *Ecole*, and Chartran, a winner of the *Prix de Rome*, who were adamantly opposed, and questioned whether women had either the physical or intellectual force necessary for the task. Gérôme claimed that there were already too many failed artists around to risk encouraging more. Moreover, he contended, women artists had an impossible choice to make: either they chose art and celibacy, as art required undivided attention, or they chose marriage and motherhood and gave up their ideas of art. The two were incompatible.[125] Carolus Duran, whose own wife was an artist, was one of the few to take the issue seriously and argue for separate studios for women.[126] In this he took a similar position to Rosa Bonheur, who, while adamantly supporting women's rights to enter the *Ecole*, could not foresee them working in the same studios as men. For Louise Abbéma, there was no sense in letting women into the schools of medicine when they were not allowed into the schools of fine art for which they were much better suited.[127]

Despite the huge public interest and the support of a small handful of prominent politicians, no immediate changes were to be effected by the parliamentary debate. *La Femme* reported in May 1893 that there was talk of opening the separate women's school in a section of the *Pavillon de Flore*, recently vacated by the administration of the *Préfecture de la Seine*.[128] The plans were halted by the transfer of the *Minstère des Colonies* into these buildings. In a retrospective analysis given to the *Chambre des Deputés* in 1896, Maurice Faure accounted for the failure of the establishment of the separate school by referring to the practical impediments to its realisation. Instead, he recounted that the ministry was contemplating allowing women partial entry into the *Ecole* itself.[129] In May 1893, *L'Art français* reported that Dupuy had come round to offering women a special section in the rue Bonaparte. This, it seemed, was the simplest and most financially feasible option.[130] In February of that year, Dupuy had invited Dutort, Inspector of Drawing Education and a member of the *Conseil Supérieur*, to investigate how the admission of women into the existing school, without the intermixing of the sexes, could be achieved. The *Ecole* was given no choice but to co-operate with this initiative. In a strongly-worded letter to the director of the school, Roujon as the then *Ministre de l'Instruction Publique*, instructed him to give Dutort his full co-operation.[131] However, progress towards the integration of women into the school was to be halted by upheaval in the ministry and rapid changes in personnel. Before any changes could be effected, Dupuy was replaced by Poincarré, an allegedly careful man who liked to balance the books.[132] At the same time, the administration of the *Union* was itself in crisis, for it was during this period that the controversy over Mme Bertaux's leadership emerged and she was succeeded by Mme Demont-Breton. The *Journal des femmes artistes* which, up to this point had monitored developments in the struggle, publishing polemics from members and reprinting articles from the general press, was from now on to change into an uncontroversial news-sheet. It ceased, therefore, to function as an instrument of propaganda or pressure within the Paris art world. Its coverage of the campaign was now limited to the publishing of speeches at official functions which may have included allusions to the continuing struggle of women to enter the *Ecole* or the occasional printing of official letters. But the aim of the journal was to keep the membership informed of developments rather than to encourage debate within the *Union*.

Reform in women's fine art education, it seemed, was unlikely to be initiated by the *Beaux-Arts* administration itself.[133] The officials would only respond to pressure groups, whether they were organisations of women artists, feminist educational reformists or radical deputies, prepared to take up women's causes. It was the socialist deputy René Viviani, one of the few parliamentary socialists committed to feminist campaigns, who was to bring up the issue again in the debate on the fine arts budget of 1895.[134] Like his predecessor Gerville-Réache, Viviani proposed an amendment to the budget, calling, in the name of justice, for an increase of 1000 francs to facilitate the entry of women into the *Ecole* itself. From the answer given to Viviani by the *Ministre de l'Instruction Publique et des Beaux-Arts*, it was clear that the government was at this point no nearer a solution than it had been two years before. Finances remained, according to the minister, the major stumbling block and he was prepared to promise nothing. All he could do was to undertake to study the issue once again. The nominal increase of 1000 francs was adopted

to facilitate this. Although this was not a large sum, it was the first time that parliament had voted money for the fine art education of women.[135]

In Viviani's impassioned speech, the familiar arguments were marshalled, comparisons drawn and precedents invoked. More than anyone else, Viviani exposed the inconsistencies in legislation which by this time allowed women to enter almost all professional training institutions (even if professional bodies often blocked their ability to practice) and schools of higher learning administered by the State, including the school of music, except for the *Ecole des Beaux-Arts*. Not only that, but the *Salons* were open to women artists and the State even acquired women's works for its national collections.

If it was logic alone that was at stake, there would, of course have been no contest. To examine the continued resistance to women's entry into art schools, especially by artists and arts administrators, however, is to open up to question the construction of 'Art' itself which was operative in the culture. Of course there were the familiar objections which were brought to bear on all campaigns for women's professionalisation and training. Yet in these struggles, there must have been more at stake than the preservation of the family, the domestic role of women or the authority of the father. We have already seen how *le grand art* was separated from the industrial or decorative arts, and how much easier it was for men to conceive of women's involvement in the latter fields, despite anxieties about competition. Indeed, women could be found a legitimate place in the regeneration of the decorative arts so dear to Republican politicians and arts administrators. The place of the nude in academic circles as guarantor of a serious involvement with 'Art', and the threat that the presence of the woman artist posed to such traditions, has also been discussed. The capacity to create great art was conceived of as a function of the operation of the highest powers of intellect and imagination. It was improbable, in the light of contemporary medical and psychological understanding, that women could possess the characteristics needed for such an elevated practice.

Perhaps what was most threatening about the entry of women into the *Ecole* was a fear of a loss of status for art as a whole. No longer the exclusive property of the most evolved of human beings, how could it continue to be seen to embody the greatest of human aspirations? What was at risk from women's entry was the very capacity of *le grand art*, already under attack from all sides, to sustain the myth of its own importance and its position as the repository of traditional values, when threatened by the onslaught of modernity. Women threatened not only to upset the organisational infrastructure and spoil the fun of the art students, but to reveal the academic tradition as no more elevated than any other artistic or professional practice. If women were capable of 'mastering' it, then, already in its dying throes, it would be completely vanquished, and with it the hope of a regeneration of French culture.

However, the conservatives were not going to be able to withstand the pressure for change much longer. With much of the press behind the campaign, it was only a matter of time before the *Ecole* was open to women. In January 1896, assurances had been given to women that the oral courses would soon be open to them.[136] The costing of the full entry of women had already been done in a private letter from the director of the *Ecole* to the Director of Fine Arts, dated January 2nd, in which he estimated that an extra 26,300 francs should be added to the annual budget.[137] In a further letter of 28th January,

the director spelled out the conditions under which women would be admitted, making much of the inconvenience and difficulties this would cause. Women students would take the same entry exams as prospective male students. On admission, they would be able to work in the drawing and sculpture studios between 8.00 and 10.00 am every morning, where they would receive tuition that was separate from male students but identical to that received by them. In the afternoons, they would be able to attend the oral courses in perspective, literature, archeology, history of art, general history and anatomy. They would be eligible to compete in the trimestrial competitions on the figure, the competitions for painted sketches (*esquisse*), and special semestral competitions around which tuition was structured. Their tuition would take place in the same amphitheatres that the male students used, and they would have access to the same models. Their work would be judged together with that of the men, but the number of awards given to women would be independent from that given to men. Space, complained the director, would be a huge problem, as would be the need for extra surveillance as the prospect of the proximity of men and women in this environment could bring many unforeseen difficulties.[138] The *ateliers* were not mentioned, and it was obvious that there was no intention of opening these to women, a fact that was to cause much consternation among women artists.

Clearly, the *Ecole* was by no means a willing partner in the admission of women. From the start it had opposed such a change, and when it came, it was imposed rather than embraced. By March 1896, the current *Ministre de l'Instruction Publique et des Beaux-Arts*, having met with Mme Demont-Breton, promised that women would be admitted to the *Ecole* by Easter 1897. Under the now stable leadership of Mme Demont-Breton, the *Union* had once more stepped up its pressure, writing letters and making public demands.[139] At the 1896 annual banquet of the *Union*, held in May, Mme Demont-Breton attacked the authorities in their own terms. Confronting popular assumptions about women's capacities and aspirations, Demont-Breton argued passionately for women's intrinsic suitablity for the highest forms of art, and their rights to an education which would equip them to harness their intuitive talents to a skilled practice. The fear, expressed by so many of the authorities, that the profession would be swamped by women artists was unfounded, she claimed. Few would have the tenacity and perseverence to aspire to the greatest heights of artistic achievements. Those that did should not be penalised because they were women. Claiming the language of the threatened academic apologists for women, she refused to accept the limitations which society placed on herself and her colleagues. In one of the most effective forms of subversion, Demont-Breton spoke the language of the dominant discourse but charted a new and unexpected path through it, turning women's apparent weaknesses into strengths. Change, she predicted, was to happen very soon.[140]

It was now up to parliament to legislate accordingly. In November 1896, in the debate on the budget in the Chamber, Maurice Faure for the first time proposed an amendment which would augment the allowance for the *Ecole* by a figure (13,500 francs) which, although way below the inflated amount demanded by the reluctant *Ecole*, was designed to cover the actual cost of the proposed changes.[141] Faure reported on the gradual acceptance by the *Conseil Supérieur* of the inevitablity of having to provide for women's art education, and outlined their plans to accommodate them. These, he assured the

Chamber, far outweighed earlier proposals in financial and practical terms, and, he claimed, anticipating the objections which were to come, would also maintain standards. Faure assured the Chamber that the arrangements would be easily made, and that any fears for disorder or protest would be unfounded.

The historic amendment was duly passed, but the reservations of the Chamber, articulated by the deputy, Georges Berger, were encoded in the words: 'It's a question, of course . . . in assuring for women a superior education in art, of only admitting to this education a carefully chosen élite (*hear, hear*).'[142] All precautions would be taken to assure that the *Ecole* was neither 'overrun' by women, nor subject to a drop in standards.[143] Despite the restrictive terms in which women would be admitted to the *Ecole*, the resolution, passed in a year which had witnessed the third international feminist congress in Paris, was hailed as a 'victory for feminism'.[144] From Hubertine Auclert writing in the socialist *Le Radical*, to Paule Georges contributing to *Le Féminisme chrétien*, the decision was welcomed and applauded.[145] Whether committed to a regeneration of French society through its infusion with Christian morality, via women's deeds and example, or to true 'universal suffrage' in a socialist context, feminists affirmed women's rights to claim for themselves that which was regarded, by those who occupied the seats of power, as the height of cultural achievement. For them *le grand art* did not necessarily signify political reaction or a nostalgia for a past golden age. Rather, it hailed a time when privileges and rights, long taken for granted by men, many of whom were now ready to discard them, would at last be open to women.

The most visceral protest against women's entry to the *Ecole*, however, was yet to come. On the 14th May 1897, a number of male students organised a public protest against the presence of women in the school. Under the pretext of objections to the introduction of stricter discipline, which women's presence had allegedly precipitated, the men banded together and hounded them out of the school with cries of 'Down with women'. When interviewed by *L'Eclair*, the extent of the male students' hostility to women's presence, their resentment at the erosion of their old privileges, the invasion of their space, and especially the potentially increased competition for medals, the winning of which entitled men to military exemption, was revealed.[146] The public was scandalised by the lack of hospitality and gallantry which the cream of French manhood had shown to its women. Some even noticed that, more than gallantry, it was equality that was at stake.[147]

In a state of great consternation, the authorities decided to close the school temporarily. When it re-opened one month later, women were to be permitted to attend the oral courses which were mixed, were to be provided with their own segregated anatomy class, and could participate in the competitions and drawing courses, separately from men, as had been outlined in January of 1896. All students would work from the same models.[148] However, unfair entry procedures and strict judging meant that, in the first year that they were eligible, only two women were accepted into the *Ecole* proper, and this after the intervention of Maurice Faure, who took up the case of the two women who were initially only accepted as temporary students despite the fact that they had gained higher scores in the entrance exams than male students who had been fully accepted.[149] It would still be some time before the *ateliers* themselves would be open. It was to take two more

parliamentary debates, with amendements proposed by René Viviani and much agitating on the part of the women students at the *Ecole*, to effect that reform. In January 1900, however, the Chamber voted the necessary funds and women were, at last, to be given an equal State-funded art education to men.[150]

The struggle for women's entry into the *Ecole* had raised issues which went to the heart of contemporary constructions of femininity and art. What was at risk were the traditional social and sexual relationships which feminist campaigns threatened in all fields. These were inflected here in a particularly powerful way because they impinged, not only on questions of professionalism and women's social role, but on a fluid and rather insecure art institutional fabric, fragmented and diversified beyond recognition. Faced with unprecedented competition from abroad, especially in the production of luxury goods, ornaments and household objects, the Republicans were desperate to infuse their own industrial infrastructure with new energy. One of the ways in which they believed they could do this was in harnessing women's talents to the decorative arts, where they felt they were really needed. To this end, as we have seen, they dreamed of a suitably design-orientated education for women. They also organised elaborate exhibitions, the *Expositions des arts de la femme*, ostensibly to celebrate women as both consumers and producers of decorative objects, and elicited the support of women like Mme Léon Bertaux and Rosa Bonheur on the organising committees. From the vantage point of the Republican authorities, faced with France's dwindling export market on the one hand and an overcrowded artistic profession on the other, the aspirations of a group of women to produce *le grand art* could be construed as at best awkward, at worst positively perverse.

For the protagonists of *le grand art*, the idea that women could aspire to the heights of history painting threatened to diminish the exclusivity associated with the highest artistic aspirations, already undermined, as they saw it, from all sides. There was no more support from allegedly 'advanced' artists. For those who had rejected what they saw as the conservative attitudes of the *Ecole*, the battle was a pointless one anyway, but the Republicans were committed to supporting the State art school and to defending its value. As it turned out, some of its most vociferous supporters in these times were those who were excluded from its doors.

Ironically, by the time they were admitted as full students, the *Ecole*, at least as far as painting was concerned, had relinquished much of its power and importance in the Paris art world. By this time, in the avowedly free market economy in which 'independence', 'individuality' and 'originality' had become the catchwords of the moment, the focus had well and truly shifted elsewhere.

# Chapter 5

# The Sex of Art: In Search of *le génie féminin*

WHEN THE CRITIC FOR *Le Temps* reviewed the 1888 *Salon des femmes*, he hoped to find the exhibition infused with a feminine spirit, meaning, for him, a physical manifestation of a female essence transported to the objects on show. For him 'feminine genius' was something which could exist then and there. It involved women being faithful to their natures. When the far sighted feminist critic, 'Lorgnette', writing for the suffragist *La Citoyenne*, reviewed the posthumous retrospective of her fellow feminist and critic, Marie Bashkirtseff at the *Salon des femmes* of 1885, she too invoked the notion of feminine genius, but as a Utopian fantasy, a future moment when women's talent could flourish unfettered by the ideological and institutional constraints of contemporary culture. Both these critics were prepared to use the concept of *le génie féminin*, but whereas for the man it connoted a known set of properties linked to accepted notions of behaviour which were biologically and socially determined, for the woman it was an unknown quality, a fantasy of a femininity fulfilled and free.[1] Between feminist Utopianism and Republican determinism there is a world of difference, despite the mobilisation of an ostensibly shared language drawn from the common-sense culture of the *fin de siècle* with its apparent cohesiveness and yet palpable underlying tensions.

The language generated by the *Salons des femmes* is both abundant and revealing. The shows operated as a focus for debates of a particular kind, debates which centred on the interaction of notions of gender, creativity, culture and national identity. These specialised exhibitions provided a forum for intense speculation on the fraught relationship between women and art, precipitating the first major public debate on this subject. To read the criticism of the *Salons des femmes*, therefore, is to uncover a complex set of assumptions about gendered subjectivity, to witness the explicit and implicit gendering of that which humanist scholarship has traditionally represented as a sexually indifferent terrain, and to gain an insight into the discursive field through which the woman artist was constructed and within which she operated. The art works shown at the *Salons des femmes* were as much the projection of language as the stimulus to it. Their very recognisability as works of 'art' was dependent on the meanings attributed to this term, and their capacity to signify differently to different audiences indicates how their identity was both socially constituted and ideologically contested. Art criticism drew its languages from utterances formulated in other sites, and owed its intelligibility to its ability to voice or contest the naturalised assumptions of the culture. The aesthetic was by no means a hermetic or self-enclosed category. Where reviews of the *Salons des femmes* differed from 'ordinary' reviews, though, was in their explicit mobilisation of gender as an evaluative category. General observations were regularly interspersed with speculations on the femininity of

the artist and the suitability to her and her sisters of the activity at hand, the medium used or the subject adopted. The gendering of criticism is not only evident in the explicit pronouncements of the critic, however. It was encoded in the imagery invoked, the reader assumed, the tone adopted and the language used. While works by male artists were not generally understood as symptomatic of their author's masculinity (it went without saying), those by women could not escape the determining origin of their producer's femininity. The sex of art was crucial. Rarely conceived of as neutral, art works could be made to stand either for an invisible but all pervasive masculinity, or as a sign of difference. As such, they could potentially provide a testimony to the difference on which the social order was based. Those who wished to threaten or undermine such difference risked destroying the very bedrock of civilisation.

Most serious newspapers and journals which covered the visual arts during the period reviewed the *Salons des femmes*. After the mixed *Salon des artistes français* and *Salon de Champs de Mars* it was the most regularly reviewed annual exhibition in Paris, receiving much more coverage than the now famous *Salon des Indépendants*.[2] The interest generated by the *Salons des femmes* can be traced to its value as spectacle (the prospect of viewing women's work on show was almost as exciting as the prospect of looking at women themselves) and to the political urgency that surrounded the quest for a stable 'femininity' potentially on display here. Whilst the formation of the *Salon des Indépendants* did not constitute a spectacular event since it represented yet another forum for the display of disparate works, the advent of a women-only exhibition was really news. Its importance stretched far beyond the world of art, and brought into focus the broader assumptions of the culture, assumptions which, as we have seen, were under threat at this moment. If 'the woman question' was widely discussed, then the question of a women's exhibition forum could only excite interest. Its curiosity value alone guaranteed it coverage. Sceptics, enthusiasts, and the merely inquisitive, would all have something to look for. What was more, the *sociétaires* of the *Union* were determined to make the exhibition a major event, and embarked on a tireless publicity campaign. Members of the press were invited either to special press viewings or to the openings, and printed invitations were sent out to potential reviewers. On occasion, Mme Bertaux even sent out personal, handwritten messages on her visiting card to eminent critics to encourage them to publicise and review the shows. At other times, she enclosed a note to the potential reviewers explaining the aims of the shows and asking them to include among their comments words of encouragement and advice which would be helpful to the artists.[3] Mme Bertaux's need for control, it seems, went beyond the organisation of the exhibitions themselves, and encompassed the responses they could potentially generate. Few critics felt able to decline the invitation, and most went along out of genuine interest, a sense of duty or sheer curiosity.

The format of the reviews ranged between a number of set formulae. Some critics followed an alphabetical structure customary for Salon reviews, others used subheadings of genre or medium around which to order their observations, whilst others singled out favourites for comment. There were the usual lists of artists and titles, followed by brief descriptive statements in which words are used to give a verbal analogue to a visual experience. These, in themselves, construct interpretive frameworks. Certain details are

selected for comment, stories are woven, narratives produced. Most reviews began with a paragraph or two of general comment on the phenomenon of an all-women's exhibition (very few took this fact for granted), often contextualising it in relation to other exhibition initiatives and contemporary debates on women's rights.[4] The spectre of feminism was never far from the surface. It haunted perceptions and conditioned responses. There were those who mused in general about the role of women in life or art, giving scant attention to the works on show, others waxed gallant or chivalric (invitations could be likened to love-letters, for example, which if refused, would cause offence), or offered indulgent exegeses on the difficulties experienced by the male critic when faced with the task of criticising women's work.[5] There were those critics who invoked the image of feminist revolution. One was reminded of the spectacle of Louise Michel campaigning for a women's strike, and mockingly asked whether men had become so gross that women had now to separate themselves from them completely.[6] The same critic later implied that women had grouped themselves together because they could not bear the suspense of acceptance or refusal from the annual mixed Salon.[7] Responses ranged from outright expressions of hostility and assertions such as 'women have not made any masterpieces in any genre', to patronisation and fatuous flattery, sometimes in the same article, and from gentle encouragement to wholehearted praise.[8] Very few reviewers were able to stand outside of the dominant ideological constructions of femininity and masculinity. It was how they negotiated these that differed.

There was no pattern of support or lack of it on broad political lines, and it does not make any sense to divide the criticism up in this way. Left-wing journals were, in general, no more sympathetic to the aspirations of the urban, middle-class, professional woman than were Catholic or secular Republican ones. In fact, as we saw in chapter three, it was around a traditional notion of the family, and the position of women within it, that vastly different political programmes could find some meeting point. In keeping with the conservative tradition of much socialist thought in nineteenth-century France, dominated as it was by Proudhonian social theory, some of the most hostile coverage of the women's exhibitions could come from anarchist and socialist critics. One such critic referred to the 1889 exhibition as '*l'eau de vaisselle de la cuisine artistique*', the dishwater of artistic cuisine, mustering the most scornful domestic metaphor available.[9] Where significant differences in the criticism emerge is when feminists introduce into the mainstream press some of the new criteria for the evaluation and valourisation of women's work, formulated within feminist circles and popularised by feminists writing in the general and feminist press. Such writers included Hubertine Auclert contributing to the socialist *Le Radical*, Olympe Audouard in her own *Le Papillon*, or sympathisers like Emile Cardon (described as a supporter of the 'feminine artistic school') writing in the *Moniteur des arts*.[10] It is the dialogue set up between ideas formulated in this context and their challenge to more traditional views, increasingly on the defensive during this period, which animates the debate on the woman artist. Yet supporters of the woman artist, no less than anyone else, regularly couched their appraisals of the shows in the essentialist language of the dominant discourse. Only very rarely, and most often in the more radical sectors of the feminist press, did a critic use the shows as the focus for a call for a wholesale revision of the social order.

Views on the exhibitions and the works themselves depended, therefore, more on the writer and journal's position in relation to contemporary debates on the 'woman question' than on any other political affiliation. However, as seen in chapter three, there were many ways in which an amelioration of women's position could be conceived, and the field of feminist activists and sympathisers was a complex one. It did not follow that a hostility to political feminism necessitated a hostility to the endeavours of the woman artist. Indeed, as we have seen, certain serious but conservative women's magazines could be openly hostile to political feminism and simultaneously sympathetic to the endeavours of the woman artist, seen as the relatively unthreatening representative of modern women's aspirations. It is not surprising, then, that support for the formation of the exhibitions and mildly patronising flattery could emanate from men who were generally unsympathetic to political feminism like *Le Figaro*'s Albert Wolff.[11]

Paradoxically, it was in terms of its evocation of, and compatibility with, women's domestic role, her primary duty, that many critics could see a virtue in the exhibitions of the *Union*. They sought signs of domesticity in the works on display and the installation itself, complimenting the organisers on having managed to evoke the atmosphere of a private domestic *salon*, restrained but elegant, rather than a public exhibition space. But this could just as easily be turned against the artists. There were those critics who used this putative skill in domestic and personal adornment as a yardstick by which to measure an apparent lack of achievement in fine art:

> French women, and in particular the *Parisiennes* have plenty of taste in their dress, they are such colourists in the arrangement of their *toilettes*, such true artists in the skill with which they furnish houses, that one would expect to find more fantasy, grace and spirit in their artistic productions - all of this slips away when they have a palette in their hands. They paint in a dull way, and practically everything falls apart in the composition. They have skill but no intelligence.[12]

The rhetorical domestication of the exhibitions had many permutations. Most often it served to deflate women's pretensions. Some critics even praised what they saw as the mediocrity of the exhibits, as this was in keeping with the tame domesticity of the environment. With mock flattery they lauded the *sociétaires*' achievement of changing a public space into a private one, transforming the masculine world of competition and commerce into a suitably feminine extension of the family. Here *Salon* and *cercle* were reconciled. Women's capacity for house-keeping triumphed.[13] The practice of harmonious placement of works, the stress on collectivism as opposed to individualism, the absence of an entry fee and the overall decor of the installations could only have fed into the prejudices of the critics. These practices could easily be seen as evidence of the artists' amateurism, either testifying to the illegitimacy of their aspirations as artists or to the appropriateness of this alternative 'feminine' culture, one more in keeping with the home than the public gallery. The domestication of what was obviously an incursion into public space, the re-inscription of it as private, and as womanly, could deflect attention away from the potential threat of the endeavour. The exhibitors themselves had understood the advantage of being seen to harness their 'feminine' taste, so admired in the context of the home, into the public arena. The danger was that their work, which varied in its scope and

ambition, threatened to be subsumed under the rubric of interior decoration and amateur dabbling, and to be trivialised thereby. The very space that they had created as an extension of their culturally endorsed skills could be used against them as a reminder of the limits of their legitimate aspirations.

There were times when conservative women's journals were used as a forum for discouraging their readers from aspirations beyond their station. They served to control and manage young women's ambitions. In this context, the exhibition could be constructed as counterproductive for women. For the writer of the stylish *Journal des des,noiselles*, in 1889, for example, who detected the odd interesting work amongst the 'mediocrity of the whole', the entire endeavour was misplaced:

> This women's *Salon* is a mistake because it allows people to establish a general fault which apparently belongs to the sex: a lack of creative genius, an almost general absence of character. Why not simply enter into the mixture of the big annual Salon, where the good stuff is accepted, sometimes even a bit of the weaker stuff with it, and where the rare *peintresses* with a robust talent, will doubly triumph, side by side with their bearded colleagues?[14].

In this commentator's view, women should submit themselves to unbiased criticism in the context of mixed exhibitions, and if they consistently received negative comments, return to that for which they were really suited, the more modest tasks of needlework or artificial flower-making. The fault with contemporary culture was that everyone had pretensions beyond their abilities, thereby neglecting that which they could do well: 'Let us not force our talent, we will do nothing with grace. And grace is the first duty, the compulsory science for a woman'.[15] What was unbecoming and unfeminine in this writer's opinion, was the public struggle and clumsy aspirations of women who together would reveal shortcomings which would come to be identified as belonging to women in general. He/she appeared not to understand that what might have structured the choice of exhibits at the *Salons des femmes*, and characterised the endeavour at large, were aims far outside the accepted notion of an exhibition as a showcase for exceptional works. Rather than encourage their readers to aspire beyond that which was normally expected of them, and to take advantage of a forum whose avowed policy was one of inclusiveness, it must have inhibited them from doing so.

Such a notion was more easily understood within the context of the feminist press, which provided unconditional support, if only of the exhibitors' intentions rather than the quality of all the works on show. Because of their generally affirmative stance, these writers were able on many occasions to make value judgements, relative assessments and critical comments without recourse to misogynist jeering, often delicately balancing a sympathetic appreciation of the project itself with a discriminating assessment of the exhibits (based on fairly conventional aesthetic criteria) and encouraging remarks for newcomers and unknowns.[16]

When critics reviewed the *Salons des femmes*, they were doing more than assessing an exhibition of art works. They were measuring the works on display, the installation, even the artists themselves, against a notion of appropriate feminine behaviour and its effects. There were those critics who, when called upon to review the exhibitions, could not resist

the temptation to comment on the physical appearance of the artists themselves. Some reassured their readers that they were not all ugly, others lamented the fact that the ugliness of the works on display reflected a similar quality in the appearance of the artists themselves.[17] In a culture in which the trappings of femininity were associated with physical adornment and in which the *toilette* was widely thought to be the most appropriate arena for women's creative expression, critics needed to be assured that a professional usurping of the brush or the chisel did not necessarily involve a renunciation of women's primary function as spectacle. As Octave Uzanne put it:

> Fashion is women's literature. Dress is the expression of her personal style. By dress she conveys the outward expression of her taste, of her skill, and even of her aesthetic individuality . . . Dress is, therefore, for women, the highest of the arts, the art containing all others. It is not only the expression of characteristic style . . . but it is her palette, her poem, her theatrical setting, her song of triumph . . . If a man has the right only to clothe himself, woman has the right to ornament, to embellish herself, and, in the natural adornment of her grace and beauty, to introduce a little brilliance into the dullness of our modern life.[18]

If women's professionalisation meant the sacrifice of their function as decorative objects, as canvases on which their own desirability could be inscribed, then this was an aberration and a preventable diversion from women's true role. One critic facetiously lamented the fact that the unfortunate consequence of the decoration of women with public honours was that they had to wear medals which destroyed the effect of their *toilettes*, especially as many of them wore black, the colour more generally associated with the uniform of modern masculinity.[19] Another used women's putative skill at self-adornment to belittle their artistic aspirations: 'There is a distance between the putting together of a bodice and the composition of a painting, between the toilette and a work of art, that cannot be overcome by these women's brains – essentially inferior or faulty in education.'[20]

It was standard practice for critics to dwell, with a morbid fascination, on the costume and carriage of the artists. For them, the glamorous *vernisagges* or openings offered the opportunity to survey and assess the women themselves, rather than their art. One critic went so far as to claim that the presence of so many fashionable gentlemen who did not usually attend such events was prompted by the prospect of being able to survey so many women.[21]

If it was not always the women themselves who were on show, this did not necessarily imply that it was the works that were the attraction here. For many critics the occasion was to be valued more as a means of penetrating the mysteries of femininity, conceived of as something that all women shared and kept hidden from men, than for looking at individual paintings. In the words of one critic:

> That which makes this exhibition particularly attractive for the truly curious, is not the inspection of some hundreds of metres of painted canvas with which the women artists have hung the walls of the *Palais de l'Industrie*; no, it is the unique occasion which it offers us to enter into *le génie féminin*, to find out something of the secret feelings of the daughters of Eve.[22]

An encounter with the exhibition offered the possibility of an encounter with 'Woman', that mythic discursive construction which, according to the contemporary commentator, Octave Uzanne, had always eluded representation.[23] Here its traces could potentially be found, as much in the image of 'Woman' or the actual bodies of women as in the inevitable, but intangible, imprint of their presence as makers in the works on show. The works could potentially be gendered 'feminine' in displaying an essence which flowed in an unmediated way from artist to product. What critics wanted was not a show of 'women painters', but a demonstration of 'paintings by women', that is 'paintings which express their peculiar views, which show the feminine spirit'.[24] In men's art, quality and uniqueness were what was at stake. At the *Salons des femmes*, what was most important was that the overall effect was evocative of the 'feminine'. Individual works were judged by many, therefore, not only in relation to current stylistic notions of good drawing, design, imaginative composition and so on, but according to a more particular test of adequacy, their capacity to express an essential femininity, to encapsulate Woman. An art which was seen not to fulfill each of these criteria could be regarded as both weak in terms of quality, and mendacious in nature. An art which might demonstrate certain skills, for example in draughtsmanship (regarded as the most rational and intellectual of artistic skills, and appropriately 'masculine'), could simultaneously be seen as reneging on women's innate and necessary incapacity to draw, their skills being more intuitive, and thereby be constituted as transgressing its natural boundaries.[25] This was clearly summed up by one contemporary commentator who resented what he saw as women artists' 'hatred for feminine visions', which, he asserted, they made every effort to efface:

> Many even succeed in assimilating our habits of vision; they know marvellously well the secrets of design and of colours, and one could consider them as artists, if it were not for the artificial impression which we receive in regarding their pictures. One feels that it is not natural that they should see the world in the way in which they paint, and that while they execute pictures with clever hands they should see with masculine eyes.[26]

The slippage from representing to seeing is easily made. While vision is fleetingly acknowledged to be habitual and in that sense cultural, the critic quickly moves on to the conflation, common among his peers, of seeing with rendering. The frightening implication of a 'masculine' technique was that it seemed to stem from a 'masculine' way of seeing. In a woman, this could not be regarded as 'good' by any standards. Notions of quality had to be adjusted to the necessary expression of 'sex', and women were to find themselves judged, often in contradictory or mutually exclusive ways, in terms of their ability as artists and their destiny as women. It was only rarely that anyone argued emphatically that art had nothing to do with the sex of the artist and criticised the purpose of the shows in these terms. In 1876 in the heyday of Republican feminist optimism, Maria Deraismes had boldly stated that art need not have a sex. 'Art', she declared, 'is androgynous'. It could potentially 'reproduce the qualities of humanity in its entirety'.[27] Almost twenty years later, similar sentiments were expressed by a woman artist following a call from a woman critic for all women artists to exhibit with the *Union*. Her response was to declare: 'A work of art cannot have a determined sex; there is no feminine or

masculine art, there are only people with talent and genius, and there are good and bad works.'[28]

In the conservative 1890s few would have agreed with her, both from within the *Union*'s leadership and in the art world at large. For the most part, difference between the sexes was seen as both inevitable and valuable. Opponents of women's art looked to women's 'difference' as causal, and cautioned them not to strive beyond their legitimate aspirations or distort their true natures. Most supporters of the aspirations and endeavours of the women artist adhered to the 'equality in difference' doctrine.[29] It was, of course, only women who were required to display this difference in their art and thereby distinguish it from art in general. Women were asked, and asked themselves, to occupy the space of the fantasised 'Other'. This did not allow for the elaboration or discovery of difference outside of dominant ideology. For some nineteenth-century feminists, although difference certainly existed, it was impossible to determine what constituted it as women had never been given the chance to find out. According to one contemporary commentator, men fatuously declared that they understood women's difference while women themselves did not have the liberty to enter into their own journeys of self discovery.[30] But few like 'Lorgnette' could dream of a future time when genuine difference might emerge, when *le génie féminin* could move from the realm of fantasy to realisation. Most commentators were content to imagine an art in which current constructions of difference were adequately expressed.

'Femininity' was one of the terms which was most struggled over in late nineteenth-century Paris. There was general consensus that it existed, that women possessed it, and that much of what they said or did could be seen to originate in their 'feminine' natures. But it was more difficult to agree on what caused it. Whether people believed that sexual characteristics were the result of centuries of adaptation and evolution like the followers of Darwin, or the result of 'evolutionary transformism' (an eighteenth-century doctrine revived in the mid-nineteenth century believing that the species survived and adapted itself to changing environmental conditions by learning behaviour which established an 'equilibrium' between itself and its new environment) or whether they believed that they were biologically determined inherent and pre-ordained characteristics, for the most part there was agreement about what constituted appropriate 'masculine' and 'feminine' behaviour.[31] Men and women behaved, thought and felt differently because their entire constitution and physical make-up was, at this historical juncture, necessarily different. For some, such difference was the mark of an advanced and civilised society. In the words of Carl Vogt, a prominent and influential anthropologist, 'the inequality of the sexes increases with the progress of civilisation . . . the lower the state of the culture, the more similar are the occupations of the two sexes.'[32] Any deviation from normative gender roles or blurring of difference was a threat to the social order, a form of racial and cultural regression and a perversion of the natural.

It was primarily during the second half of the nineteenth century that the scientific and medical establishments in Paris focused their minds on the empirical analysis of sexual difference, seeking to find evidence in the laboratories which would confirm existent beliefs in difference based on sex and race.[33] Where the nineteenth century differed from previous centuries was in its attempts to understand difference through science, to prove

it empirically and use such proofs as the basis for social theory. What had been the stuff of religion, philosophy and common sense became increasingly a matter for medicine, the new discipline of psychology and social policy. In the face of feminist agitation and the frightening spectre of *la femme nouvelle*, the findings of science were used by the conservative medical and anthropological establishments to corroborate the belief in the natural hierarchy of the sexes and the concomitant social roles of men and women.[34]

Sexual difference resided for scientists and social theorists in all aspects of intellectual and affective life, and reflected both external and internal physical differences. Whilst white French men were shown to be intellectually advanced, women, it was held, were not fully equipped to deal with the superior mental functions, especially for abstract thought. It was in organising thoughts, synthesising material and making judgements based on evidence, that women and people from 'inferior races' were particularly stunted. Such inferiority was, it was widely believed, physically determined and depended on the different structure, size and weight of the human brain. Although there was much dispute within the academic scientific world as to the relevance of these factors in determining mental capacities, and the findings of the experiments were often hotly contested, the discoveries of 'craniology' (as the science of comparative brain measurement came to be called) generally endorsed the contemporary view of men and women. What was controversial was the craniologist's conviction that the intellectual superiority of European males could be proven through measurement and quantification, not the belief itself. As each form of comparative analysis was shown to be inadequate because it failed to prove the 'facts' which were already known, new and more complicated instruments and procedures were developed. Some contemporary commentators warned people of the dangers of establishing an equality between the sexes. This would go against the laws of nature and result in the inevitable lowering of the intellectual level of human beings in general.[35] Others argued that it would take many centuries for 'heredity to produce the missing five ounces of the female brain', during which time men themselves would evolve so rapidly that they would still outstrip women considerably.[36]

The findings of 'science' by no means remained the preserve of the experts. As Robert Nye has shown, medical theories pervaded everyday life in late nineteenth-century France, and doctors became credible as mediators between the experiments of the laboratories and problems of society. Research findings were widely disseminated, often with the finer points of dispute and doubt eradicated, in popular scientific and general journals, sometimes the very ones, like the *Revue des deux mondes* (a periodical which was standard reading for educated Frenchmen) that ran long articles on women and art. A general reference book like the *Grande Encyclopédie*, for example, drew heavily on current 'scientific knowledge', particularly on the highly reactionary work of the criminologist Cesare Lombroso, for its entry for 'femme' defined as 'the female of man'.[37] Differences between men and women, could be explained, held Henry de Varigny, the writer of the entry, not by mysterious or transcendent causes, but by anatomical and physiological factors. The origin of women's mental weakness was to be found in the physical structure of her brain, with its meagre creases, less beautiful forms and lower relief than the masculine brain. In men, 'the frontal lobes – those where it is agreed that the organs of intellectual operations and superior psychic functions are placed' are more preponderant.

He added that, 'they are even more beautiful and voluminous where the most civilised races are concerned'. Men, he claimed, were endowed with greater blood irrigation to the brain than women and this was said to help their capacity for thought.[38] In a later article published in the *Revue des revues*, de Varigny was to challenge the craniologists by claiming that it was not the 'inferiority of woman' which was the issue but her 'difference', which he described as natural, inevitable and necessary.[39] In this claim he was simply mouthing a truism. Whilst not everyone was willing to champion male superiority, most, as we have seen, were willing protagonists of difference. In such a scenario, men were superior to women in some areas and inferior in others. What was needed to create 'equality' was a wholesale revision of the values placed on these qualities, not the access of men and women to those qualities deemed outside of their realm.

Such views were widely endorsed by the Republican establishment. The influential Alfred Fouillée, favourite of Republican politicians, underlined the belief in men's superior capacities for rational and abstract thought. Distancing himself from the evidence used by the likes of extreme conservatives like Gustave Le Bon and Cesare Lombroso, well-known defenders of masculine superiority, he nevertheless endorsed the belief in woman's intellectual inferiority, attributing this to her laudable role in the family and the inevitable mental regression which pregnancy and menstruation induced.[40] The idea that women's mental capacities were necessarily stunted so that they could fulfil their maternal role was widespread. Pregnancy and menstruation were widely thought to lead to mental regression, and women's generative capacities were regarded as responsible for their innate nervousness and irritability. Women were thought to stop developing intellectually at the onset of puberty, when their constitutions became consumed with their reproductive functions. The development of their intellectual capacities, it was feared, would lead to the deterioration of their capacity to breed and to mother effectively. The professionalisation of women, therefore, could be said to threaten the future of the nation.[41]

Women's intellectual deficiencies were compensated by other capacities which were, allegedly, more highly developed in them than in men. According to de Varigny, in women it is 'the occipital lobes [of the brain] which are the most developed and have the most significance and it is in those that physiology places the emotional and sensitive centres'.[42] Some commentators thought women had a relatively larger visceral nerve expansion than men and hence were endowed with greater visceral feeling. This allowed them to experience the world more directly through their senses, leading to a tendency to act upon the impulse of the moment.[43] Whereas in European men responses to sensory impulses were delayed, complex and deliberate, the result of cerebral reflection, in women, children and 'uncivilised races' responses were direct and immediate. Peripheral stimuli led, in these groups, to relatively unmediated reactions. They shared a similar psychological make-up: they had short concentration spans, were attracted indiscriminately by passing impressions, were essentially imitative, their mental actions were dependent upon external stimuli, and they were extremely 'emotional' and 'impulsive'.[44] Women's strengths lay in their highly developed powers of observation and perception.

Although women were intellectually weak, most commentators alleged that they possessed greater *sensibilité* and capacity for *sentiment* than men. Some even thought that they were endowed with greater 'aesthetic emotions' than men, but it was generally felt that this was more appropriately and successfully expressed in the unambitious arena of

domestic and personal decoration that in the world of fine art. In the words of George Romanes:

> All the aesthetic emotions are, as a rule, more strongly marked in women than in men – or perhaps, I should say, they are much more generally present in women. This remark applies especially to the aesthetic emotions which depend upon refinement of perception. Here feminine 'taste' is proverbially good in regard to the smaller matters of everyday life, although it becomes, as a rule, untrustworthy in proportion to the necessity for intellectual judgement. In the arrangement of flowers, the furnishing of rooms, the choice of combinations in apparel, and so forth, we generally find that we may be most safely guided by the taste of women; while in matters of artistic or literary criticism we turn instinctively to the judgement of men.[45]

Women's 'natural' talents, like their abundance of feeling, could easily be turned against them. Extrapolating from Jules Lemaître's views on women's incapacity to create great literature, the critic for *La Femme* attributed their mediocrity in the sphere of fine art to the very fact that they were more *sentimentales*, more *passionnées* then men. These qualities allegedly made them unable to distance themselves from their work: 'They are too moved at the moment of writing'. This lack of distance led to the absence of calm, critical self-appraisal: 'women have hardly ever the self control, the necessary *sang-froid* for this operation'.[46] There were those confirmed believers in women's generic inferiority, like Lombroso, who would not even concede women a developed *sensibilité*, and argued that what women had in abundance was *irritabilité* as their poor artistic achievements demonstrated.[47]

The notion that the sexes were different, and that nature required this to be so, was so entrenched in late nineteenth-century parlance that it informed discussion at all levels. There was no escaping it. It permeated social critiques, psychological investigations, aesthetic theory and literary debates alike. Cutting across these various discursive sites was an underlying set of assumptions about sexual difference which often formed the underpinning of their rhetoric, providing the imagery for their metaphoric and symbolic languages, as well as the material for their more banal prescriptive admonishments and exhortations.

It was not, as must by now be clear, only the conservative male establishment that saw the *Salons des femmes* through the filter of sexual difference. Women's essential qualities could be turned to their advantage, and some feminists saw the point in elaborating an affirmative feminine aesthetic which would valourise women's traditional attributes rather than demean them.[48] Rather than berate women for what they did not possess, writers like Clotilde Dissard constructed an elaborate argument for a distinct feminine aesthetic, based on women's capacities to feel emotion, their intrinsic sensitivity to colour, its delicacies, nuances and harmonies, their heightened sense of smell, the quickness of their perceptions and their attraction to mystery. Summing up the differences between men and women, she wrote, 'The masculine aesthetic is an aesthetic of form, the feminine aesthetic is an aesthetic of movement'.[49] Olympe Audouard used her review of the second exhibition of the *Union* as a platform for a discussion on art and sexual difference, drawing on widely held biological and psychological theories. Women and men, she argued, had been created differently and had, therefore, different roles to play. Neither

one nor the other was the more important. Humanity, she claimed, had been created both male and female, and this was as true in the realm of the intellect as in reproductive life. The fact that women's brains were endowed with creative power just like men's proved that divine will wished them to be productive. It was precisely because their works were different from men's that it was important that they produce. Nature had been created both male and female, and it followed that works of art, literature and science would not reach their height, would not be complete, unless this law was followed. Instead of stifling *le génie feminin*, its flourishing and development should be fostered in the same way that *le génie masculin* was fostered. But, warned Audouard, woman must be careful not to masculinise herself. She must remain a woman. She must retain her difference. And her work should be judged, not by comparing it with that of men, but from a special point of view, one which although different need not be inferior.[50]

Audouard's views fitted into the large 'separate but equal' camp of critics, who wanted the exhibitions to provide concrete evidence of the artists' 'femininity', to celebrate it in fact, rather than fulfil an abstract, sexually indifferent notion of quality. However, whereas Audouard, like many others, recognised the obstacles which the culture erected to prevent women's success, and praised what women had achieved in spite of their obvious disadvantages, some critics traced what they saw as the inferiority of women's artistic and intellectual work to essential flaws in their character and psychological and physical constitutions. In the words of Victor Joze, writing in the avant-garde literary magazine, *La Plume*:

> Most women's works carry an obvious mark of weakness and intellectual inferiority. ... This is because the role of woman is not to guide people but rather to guide children. She, herself, is a sort of large, nervous child incapable of judging things coldly, with fairness and good sense. This is why the writings of most 'blue stockings' are full of so many exaggerations, of useless bursts of enthusiasm, of empty and overblown sentences.[51]

The fluctuations in the criticism of the *Courrier de l'art*'s Georges Dargenty, with his elaboration of a rhetoric of difference, demonstrates some of the permutations which a call for a sexually differentiated art could involve. In his review of the exhibition in 1884, he was cynical and flippant. As art had no sex, he proclaimed, he could not see the point of special women's shows except as a forum for the expression of the vanity of those women who liked to see their names in print and to be part of a small clique. Here it was not a question of serious painting but rather of elegant trifles, charming but insignificant. Only a year before though, he had lamented the fact that the works in the *Salon des femmes* so closely resembled those in the mixed *cercles*:

> I hoped, on entering the hall of the *Palais de l'Industrie*, to feel a special impact, a small shock, something in fact which corresponded to the *odor di femina* of Don Juan. I didn't go to look for good or bad; I didn't hope to find masterpieces and it didn't concern me that I would encounter daubs, but I believed that at least I would have the right to *féminisme*. I allowed myself to expect that from the bosom of this exclusive exhibition would emanate an artistic perfume *sui generis*, a particular flavour deriving

neither from knowledge nor from genius, but from that complex entity, so subtle, so fine, so fleeting, so interesting, feminine emotion. Bitter disappointment. There is nothing like it there. All these works, quite mediocre for the most part, smack of the masculine force which has dominated the minds of their authors ... Not one has known how to avoid the coarseness of *masculinisation*.[52]

Whereas a feminist like Olympe Audouard had located the reason for any weaknesses she perceived in women's lack of education, it was precisely there that Dargenty identified the source of the problem. It was an over-dependence on taught skills which ruined the expression of sincerity and the innocence which he expected from women's work. Everything smacked, for him, of the 'crushing finger of education', to which women responded with characteristic servility, and which destroyed the sincerity and spontaneity of their true selves. By 1885 he was giving full unbridled expression to a theory of art as sexually differentiated: the shows were a failure because women did not give 'free expression to their temperaments'. Much more than any abstract notion of 'quality', what was needed was that women should discover the 'gracious and delicate qualities with which they were gifted – that 'je ne sais quoi' which distinguishes them from us [the implied reader is male], that sort of formula which corresponds to their constitution'. Where, wondered Dargenty, were the marks of feeling transported, of nervousness, which characterised women? He saw no trace of them here. Women's painting, he complained, 'had no sex', and this was what he had against it.[53]

A year later he claimed that women were competing amongst themselves over who could become more masculine.[54] Both Audouard and Dargenty, from their different perspectives, evoked masculinisation as a potential threat, and they were by no means the only ones to do so. Masculinisation of women was the potential result of their reneging on difference. For most men and women alike, the advent of *la femme nouvelle* invoked the horrific possibility of the arrival of a mutant, unnatural being, an *hommesse* who threatened to destroy the natural divisions of society by the formation of what was described, literally, as a 'third sex', a cadre of celibate professionals who could by no standards be called women.[55] Variations on such creatures became the focus of much caricature in the 1890s, identifiable by their culottes, bicycles, cigarettes, intellectual aspirations, and, sometimes, the emasculated husbands and neglected children which they left in their wake (fig. 32). Feminists, or 'manly women', were also associated with the depopulation crisis representing one type of modern women who had rejected maternity (fig. 33). Constantly present in the nation's imagination, they or the threat of social disintegration for which they stood, would haunt all assessments of women's work. In art they were invoked when difference did not display itself immediately and overtly. If women's work did not look different from men's, it must be because women were acting as men.

The most famous figure in the art world on whom the issue of 'masculinisation' turned was Rosa Bonheur, renowned not only for her vigorous animal paintings but for her transgressive adoption of masculine working attire, for which she had to receive police permission. For some critics, Bonheur became the caricature of the professional female artist who had in all ways reneged on her natural attributes and laid claim to gestures and

# REVENDICATIONS FÉMININES

**-- Je vais au Congrès féministe ! tu prépareras le dîner pour huit heures précises, tu m'entends ? et surtout, que rien ne cloche !...**

32. 'Revendications féminines', *Le Grelot* (19 April 1896); Bibliothèque Nationale, Paris.

## LA DÉPOPULATION

Le Clergé, lui, réagit autant qu'il peut!...

33. 'La Dépopulation', *Le Grelot* (27 December 1896); Bibliothèque Nationale, Paris.

34. Rosa Bonheur, *Le Marché aux chevaux* (1853); Metropolitan Museum of Art, New York. Gift of Cornelius Vanderbilt, 1887.

modes of behaviour which were beyond her sphere. Her case was used as a warning of the potential dangers which all women artists faced. Bonheur, it was alleged, 'painted like a man', with her large canvases of almost life-size horses (fig. 34). What was even worse, she looked and acted like a man, with her short hair, male working attire and habit of smoking a pipe. How, wondered one critic, could she be called a woman artist at all? In which way did she remain a woman? She neglected all delicate feelings only to produce huge pictures which demonstrated a kind of false and pretentious power.[56]

Although Bonheur was often the butt of malicious humour, the embodiment of a women 'unsexed', not all critics arraigned her in this way. There were those like Albert Wolff who could not help admiring her work, and indulged her personal whims by dwelling on their eccentricity, their very oddness.[57] However, the possibility that many women should model themselves on her example, abandoning their domestic duties and maternal vocation and devoting themselves to a life of ambitious painting and aggressive marketing, was a different matter. For the leadership of the *Union* and feminists of all sorts, however, Bonheur's achievements as an artist were exemplary. She was repeatedly used by them to counteract beliefs in women's innate inferiority. In her work, a 'feminine intelligence', which was both fine and powerful, revealed itself and attracted the viewer. Here was work which could put pay to assumptions of women's intellectual and artistic weaknesses. There was no question that this was the work of an artist and a woman. Professionalism and femininity were not, argued feminists and women artists alike, mutually contradictory.[58]

When Mme Achille Fould, a staunch supporter of the *Union* and regular exhibitor at the *Salon des femmes*, showed her *Portrait de Rosa Bonheur* at the Salon of 1893 there could be no doubt that it was as a professional that she was being represented (fig. 35). None of the conventional trappings of femininity are present. She is shown complete in working gear and in the context of her own studio, filled with allusions to hunting and

35. Mme Achille Fould, *Portrait de Rosa Bonheur* (Salon 1893); whereabouts unknown.

wild animals deemed far beyond the domestic concerns to which women were destined.[59] Yet, when Virginie Demont-Breton paid tribute to her mentor in an obituary published in the *Revue des revues* in 1898, she was anxious to assure her readers that Bonheur had fulfilled both her ambitions as an artist and her true female destiny. Despite her masculine costume and even though she had never married or had any children of her own, Bonheur, claimed Demont-Breton, viewed her animals with the tenderness of maternal love and would have made an outstanding mother and wife because of the profundity of her feelings. She was like a mother to her animals, and in turn became like a mother to women artists. She was a feminist, claimed Demont-Breton, in that she wanted, 'the development of women's artistic faculties to be as complete as possible' but she was not a feminist in the manner of some who:

> under the pretext of making woman happy and of delivering her from what is called the 'yoke of the husband', would like to deprive her of a beneficent protection and of all that gives her joy; who with the aim of realising vain chimeras, seek to smother in her all instinctive impulse, all natural attraction.[60]

Having fully domesticated this unconventional and independent woman's life, Demont-Breton was free to proclaim and endorse her professional achievements.

Though such verbal acrobatics and the laundering of Bonheur's biography might have satisfied Mme Demont-Breton, enabling her to transform her deviant mentor into a suitably womanly woman, they were hardly to compensate for the widespread demands made by the critics for a 'feminine' art which would give expression to women's 'special gifts': their 'capacity to assimilate', their 'adroitness' and their 'undeniable original grace'.[61] The example of Bonheur's work and lifestyle could offer no solace to lamenters of a lost feminine charm, nor compensate them for their longing for an art which would fulfil their fantasies of femininity. They looked for traces of what they saw as women's particular manner of seeing and feeling in the works on show. The least the exhibitions should do was to show off women's special talents to advantage, thereby offsetting their innate weaknesses. At best they could offer men a glimpse into the enigma of Woman, into 'the mysteries of virginity or maternity' expressed through the qualities of 'grace, tenderness, love, pity'. Here was an opportunity for women to express their intuitive understanding of 'the child, of man, of themselves, of nature'. This was the place to reveal what their hearts felt and what their eyes saw. Such a display of sincerity could only earn men's admiration and respect.[62] Even if women revealed their faults in their work, this would not matter because at least they would be revealing their true selves.[63] What was not to be tolerated was an ungainly pastiche of masculine modes, a self-conscious aspiration after 'style'. Any attempts by women at engaging with the accepted conventions of representation or stylistic formulae which had been taught and passed down in the teaching academies could be interpreted as the submersion of innocence into a tainted and stultifying régime, destroying women's purity and teaching them a sterile conformity to masculine principles. If learning was identified with the masculine, and a necessary *naïveté* with the feminine, then any indications shown by women of an employment of methods of representation which were culturally shared and endorsed could be seen as a betrayal of self, a perverse suppression of nature. Raoul Sertat of *Le Public* issued a typical complaint when he accused women of 'too great a respect for established rules, through a servile admiration for masculine talents'. It was the resultant 'lack of initiative' which forced the critic to temper his praise for the works on show: 'With natural generosity . . . the woman artist seems to doubt herself; she carries an exaggerated deference towards her masters who influence her to the point of becoming dangerous for her independence and her development.'[64]

Sertat, like Dargenty, could not help but link his observations to what he saw as women's lamentable pursuit of education. Entry to the *Ecole des Beaux-Arts*, he argued, would make an already bad situation utterly hopeless.[65] However, Sertat's complaints were mild compared to the diatribe issued forth by Dargenty in the same year. Gone was the polite pleading of his earlier admonishments. Now a full-scale assault on women's derivativeness was mounted. At fault was their 'blind obedience', their 'servility utterly denuded of ideas', 'their passivity which poisons originality', and their 'religious' and utterly 'irrational admiration for the teacher' whom they desired to resemble completely, in the false belief that they would thereby become stronger artists.[66] For Dargenty, women's paralysing humility and inhibiting subservience crushed all that constituted their difference. How, he asked, could these beings who were so 'nervous, impressionable, sensitive, spontaneous, perhaps even a little irritable', allow themselves to be so

hypnotised by their teachers? If they were only interested in imitating the likes of Bouguereau, Tony Robery-Fleury, Carolus Duran, and so on, why bother to construct an exclusively female exhibition at all? What must really have galled someone like Dargenty was the tendency among some women to exhibit actual copies of the works of their teachers. In 1889, for example, Anne-Marie Cortet showed a copy after Henner's *Fabiola*, Blanche Louppe showed a porcelain copy after Bouguereau's *L'Amour rebelle*, Louise Malortigue showed a porcelain copy of a head after Hébert and Augusta Beaumont showed the only copy after a woman artist, Elizabeth Gardner's *Deux mères de famille* (fig. 62).[67]

Ironically, the logical extension of discussions on women's essential imitativeness was to argue for this as the ultimate fulfilment of their 'difference'. After all, a lack of originality and the tendency to slavish imitation were part of what distinguished them from men, and excluded them, by nature, from the pantheon of the greats. In the words of Octave Uzanne, women's 'imitative sense is highly developed', but 'the gift of imitation develops at the expense of originality, which is one of the characteristics of genius'.[68] Women are caught here in an impossible rhetorical bind. Although possessed of distinct qualities which could potentially be harnessed to their artistic project, these are suppressed by their overriding and essential weakness, a tendency to imitativeness. In acknowledging this, critics unconsciously voiced the impossibility of the demand that women both demonstrate their difference and create significant art.[69] One perceptive critic went as far as to say that it was the very qualities which were the most socially admired and necessary in (bourgeois) women which worked against them in the sphere of fine art.[70]

Not everyone restricted their comments to complaints. There were those critics who were prepared to accompany their complaints against the shows with the elaboration of a vision of an appropriately feminine art. The critic for *Le Temps* put it as follows:

> It does not seem impossible to me that they will manage to achieve an art of their own, one where the subtleties of their fine impressions will make them recognisable right away. They should, therefore, treat the elegant things of life and familiar scenes. They could bring an incomparable taste to these and as they are very quick at perfecting their craft, they would add an exquisite note to the documentary works of these times.[71]

The qualities endorsed here have to do with women's alleged refined and quick perceptions, their powers of observation and documentation, their impressionability, intuitive decorative skills and understanding of elegance and taste. It was because of their possession of these qualities that many critics thought that it was through a loosely defined notion of Impressionism that women artists could best express themselves. It was the contemporary view of Impressionism which saw it as at once viscerally rich but cerebrally and imaginitively deficient, which was to make it appear an appropriately 'feminine' style in the late 1880s and 1890s. Academics had remained hostile to Impressionism because of its purported rejection of the crucial principle of academicism, the cerebral and intellectual underpinning of art, while the new symbolist artists and apologists were keen to define themselves against its putative sacrifice of the imagination and rejection of anything which was not to be found in the world of immediate experience. Whilst academics saw the Impressionists' renuncuation of idealism as a sign of moral bankruptcy, symbolists saw

the result of its attempts to rid itself of the burden of idealism as a lapsing into crass materialism.[72] Yet the very qualities which were to lead to a wholesale rejection of Impressionism, its alleged attachment to surface, its celebration of sensory experience born of the rapid perception and notation of fleeting impressions, were the exact qualities which were to make it widely regarded as a practice most suited to women's temperament and character. While men, contemporary rhetoric had it, were drawn to a consideration of essences and endowed with a penetrating intellect or imagination which could delve beneath the surface of things, women were innately superficial and therefore intuitively *Impressionnistes*. They would not be selling themselves short by adhering to its tenets. One critic put it as follows:

> Men's genius provides them with a tendency to go beyond themselves, a desire to enter into a direct connection with things, to seize them to oneself, in their truth, in their reality, in their character. They suspect, outside of themselves, the existence of a world of forms and ideas which they are forced to apprehend and understand. To these two exercises of the mind, they bring more curiosity, more impartiality than passion. It is not the same with women who never know anything but themselves, who exist in an adorable childish incapacity to ever go beyond themselves, from their prejudices, from their impressions, from their hates, from their loves . . . They have no idea of logical order, of sequence, of the absolute value of ideas; they substitute all of this with the order and sequence which pleases them most, they recognise no value in events or ideas except in so far as they affect them: they are Impressionists, I tell you, in history, in morality, in literature, in grammar, in logical analysis, in mathematics, in chemistry and, consequently in painting.[73]

The Parisian critic de Soissons put it even more bluntly, effectively prohibiting men from painting Impressionist pictures:

> Strictly speaking woman only has the right to practise the system of the Impressionists: she alone can limit her efforts and translate her impressions and recompense the superficial by her incomparable charm, by her fine grace and sweetness.[74]

Roger Marx saw in the very term *Impressionism*, 'a manner of observing and of noting which well suited the hyperaesthesia and the nervousness of women'.[75]

However, it was not at the *Salons des femmes* that the critics were to find many women who identified with Impressionism as such. Few, if any, of the painters who belonged to the *Union* were interested in so transgressive a technique and contentious an aesthetic identity as the movement still entailed. And there were certainly critics who congratulated them for not being tempted by the glamour of the new or the corruption of the modern.[76] Not all the supporters of Impressionism as a woman's style necessarily wanted women to mimic the more outrageous experiments of composition or risqué subjects which were associated with the most infamous protagonists of the style. For many, it was a much tamer version of Impressionism which was invoked here, one in which women could turn their very imitativeness and cerebral deficiencies to advantage by adopting the credo of faithfully recording everyday life: 'Because woman is a spontaneous being, impressionable and nervous, one should not ask her to search for thoughts, but only the notation of the

# LA FAMILLE

**Voyages, Romans, Modes, Musique, Beaux-Arts, Actualités, etc.**

DÉPOT LÉGAL
Seine
1889

| GRAVURES | 11ᵉ ANNÉE. — 27 JANVIER 1889. — Nᵒ 486 | TEXTE |
|---|---|---|
| UN MEETING : Tableau de M. Bashkirtseff. — LA NEU-VAINE DE COLETTE. — UN CANDIDAT : Tableau de Ar-turo Michelena. — Gravures de modes. — Dessins des ouvrages. | Le numéro : **15** centimes<br>**Abonnement : un an, 8 fr.; six mois, 4 fr.**<br>*avec une gravure coloriée chaque mois*<br>**Un an, 10 fr.; — Six mois, 5 fr.**<br>5, — RUE DE LA PERLE, — 5 | LA NEUVAINE DE COLETTE. — LES COLONS DE LA FRESIL par Abel Combes. — Chronique. — Courrier de la mode. — Petite Correspondance. — Description des gravures de modes. — Nos gravures. — Menu. — Recettes et Procédés. — Passe-Temps. — Semaine financière. |

36. Cover of *La Famille* (27 January 1889); Bibliothèque Nationale, Paris.

impressions and sensations which she feels'.[77] It was a freedom of facture, an attention to surface, and a delicacy of handling, qualities which in men's art could easily be called lack of finish and carelessness, in an art which purported to give a humble reflection of the outside world, which many commentators labelled 'Impressionist'. At the *Salons des femmes*, these qualities were more often detected in the abundant watercolours and pastels than in the oil paintings, most of which aspired after, to the disappointment of the likes of Dargenty, the relative tightness of surface typical of Salon naturalists like Jules Bastien-Lapage. It was works which came closer to demonstrating conventional notions of finish which the *sociétaires* themselves were to endorse, as shown by their admiration for Bashkirtseff's *Le Meeting*, exhibited in 1885 and featured on the cover of *La Famille* in 1889, or their award of the *Prix d'honneur* for Mme Delacroix-Garnier's *Loin de Paris*,

exhibited in 1896 (figs. 36 and 37).[78]

It was to be beyond the sphere of the *Salon des femmes* that some critics were to find their answer to the problem of the search for a 'feminine' painting. Some of the very critics who lamented the absence of the marks of 'sex' in the works shown here, found in the paintings and drawings of Berthe Morisot a fulfilment of their fantasy of femininity (see fig. 61). Raoul Sertat, who had so condemned the works on show at the exhibition of the *Union* for their derivativeness and lamented women's aspirations towards an education in fine art, praised Morisot for the appropriateness of her ambitions which, unlike that of other would-be women painters, propelled her towards an art which was 'totally impregnated with the essential virtues of her sex and which only sought to provide a "feminine" painting'.[79] Thadée Natanson, in the same year that he had condemned the efforts of the *sociétaires* of the *Union* in the most misogynist terms, was overcome with admiration for Morisot's work.[80] Influential critics like Théodore Duret praised her work for managing to escape what he called the dryness and affectation which was typical of women's workmanship.[81] Georges Lecomte welcomed what he saw as her sincerity and immediacy

37.   Mme Delacroix-Garnier, *Loin de Paris*, Exposition des Femmes Peintres et Sculpteurs, 1896; whereabouts unknown.

which allowed her 'delicate woman's temperament which no influence either corrupts or alters' to be expressed. Unlike most other artists of her sex, Morisot managed, in his view, to guard against creating 'an artificial nature, a man's vision'.[82] By being an Impressionist, Morisot was being truly herself. A number of critics had, over the years, lamented Morisot's absence from the *Salons des femmes*, and one critic suggested, on her death, that the *Société des Femmes Artistes* organise a posthumous exhibition of her work, or erect a modest monument or fountain in her honour.[83] Nothing, of course, came of this. Morisot's work may have fulfilled the desires of its professional admirers, but it did not stand for the aspirations of the leadership of the *Union*, whose goals went beyond fulfilling current expectations through the perfecting of a technique deemed suited to women alone. If Impressionism was not good enough for men, it was certainly not good enough for women. Whilst they were by no means averse to harnessing their feminine strengths to their artistic projects, they were determined to do this by embracing the most ambitious, and hitherto exclusively masculine, means.

The discussion on difference was by no means to centre on the issue of style alone. It was to be articulated in the discussions on genre, subject matter and medium as well. Most critics took comfort in the gendering of the genres and media, and claimed that it was through these that a crucial distinction between men and women's art would be expressed. Interestingly, this issue was very often raised in the context of a defence of the very idea of the exhibitions and of women's rights to enter the artistic profession at all. What needed to be allayed were men's fears about the potential competition that women's entry into the profession provoked. The intrinsic difference of men and women's sensibilities and aptitudes could be brought in, to demonstrate that misgivings about the threat which women artists could present to an already overcrowded art world were unfounded. No male artist worth his salt had anything to fear. In the words of Pierre Borel:

> You [women artists] can do no harm to true artists, to those who are sincere; they will preserve intact the monopoly on powerful works and the gift of creative power; with you, *troupe légère*, rests the domain in which they would always remain inferior, the more delicate arts, the more intimate and gentle notes; to you the watercolour and the pastel, the landscape, the flower and the child.[84]

Borel was giving voice to what had become, by 1889, a commonplace view. Some feminist critics and a handful of women artists were ready to threaten men with the potential rivalry of women artists, and to admonish them for their selfish monopolisation of resources, but few mainstream critics took such threats seriously. Already, in 1860, Léon Lagrange had given voice to an argument which was to become a cliché in the rhetoric of the 1880s and 1890s. Lagrange defended women's right to become artists by the reassuring assertion that 'male genius has nothing to fear from feminine taste'.[85] What was being compared, according to Lagrange, were two unlike quantities, almost two different species. There would be no competition, as men and women operated in different arenas. Some twenty years later, the critic for *Le Papillon* predicted that far from competing with each other, men and women's art would compliment one another. Women would leave to men 'tortures, battles, and butcherings', and would concentrate

instead on 'the beauties of nature, flowers . . . and women and children'.[86] The apparent equality in difference suggested here however, was spurious. Most often a hierarchy of aptitudes was implicit in their deliniation. When Charles Bigot welcomed the first *Salon des femmes* in 1882, he, like Henry Havard of *Le Siècle*, had no fears about potential competition. Women were not destined to produce great mathemeticians, intellectuals, philosophers, politicians, orators, or generals. Nor, he was sure, did they seek such glory. It was in literature and art that women could prove themselves. The qualities that the woman artist needed to harness to her project were such that competition was not a problem. For one thing, for a woman to be both a true artist and a woman, she had to make sure that she did not lose her feminine qualities and neglect her responsibilities as housewife and mother. Being an artist could, in fact, enhance the quality of mothering which a woman could provide, and mothers who were artists inspired the most noble sentiments in their children. Art was highly suited to the domestic responsibilities of women who could paint instead of spinning cotton or sewing. It is clear that Bigot's vision of the woman artist is far from the dominant cultural construction of the independent male professional engaged in serious work in his studio. Such a creature could indeed offer little threat. Competition was not an issue here.[87]

Bigot endorsed domesticity as women's true vocation, but saw art as a route towards enshrining it. There were others who defended women's involvement in art as a means of earning a living, but this remained a contentious position. What constituted a legitimate professional engagement for women remained open to debate. For some, nothing short of full professional access to institutions and the entire range of artistic practices was adequate. Some, like Jean Alesson, saw no realistic possibility of the thousands of women artists in Paris at that time earning a living from their work.[88] Others argued that it was in the more manual and artisanal aspects of the profession that women could excel and should be encouraged. It was here that women's aspirations should be channelled. The need to work could be explained as an economic necessity, lamentable but unavoidable for many. An engagement with certain forms of art seemed one of the most suitable and unthreatening areas of women's work. Consequently, there were those critics who saw painting as a means of earning a living for poor, lower middle-class women, and defended the exhibitions as a forum for selling their work. Jules Claretie, who likened the overall impression of the 1882 show to an exhibition of work of a provincial artists' society, endorsed any activity which would allow women to earn a living. 'The brush', he alleged, was 'for the woman of the *petite bourgeoisie* the equivalent of the needle for the *fille du peuple*'. Such women, argued Claretie, would do well to paint fans, flowers or portraits on porcelain. Not everyone could be a great artist but most people, even women, could learn a *métier*. And painting, continued Claretie, was becoming, more and more, a craft like any other. There was no reason why women should not profit from this. He therefore applauded the first exhibition of the *Union* as he would have done an interesting exhibition of industrial art.[89]

Claretie had moved from a lamentation at the beginning of his review on the demise of serious museum art, conceived of as masculine and now usurped by the context of the billiard or card room, to an endorsement of women's access to art as *métier*. The commercialisation of great art was deplorable, but the access of women to the domain of

commerce in the lesser genres was to be encouraged. Although amateur domestic production was still considered the most desirable form of women's art, especially for the wealthy, since women were deemed naturally self-sacrificing and humble and were urged not to be overambitious in their aspirations, there were those commentators who supported women's suitability as craft producers. This could be more easily reconciled with the ideology of domesticity than most forms of paid work: it could be done at home, was purportedly compatible with maternal duties, being easily picked up and put down again, and would not necessitate personal display as did acting or music, for example. Such sentiments were often accompanied with the familiar assertion that women were unsuited to the higher genres. Nor was it necessarily desirable that they aspire to them. In the words of Emile Cardon, 'many have talent, not all for making portraits, or history painting, but for earning a large part of their livings in different branches of industrial art, which is preferable'.[90] Professionalism could be endorsed when it was as skilled craftswoman, industrial worker, or 'lady novelist'-cum-flower painter, that a woman might want to make some money. Indeed, France's prosperity might even depend on the harnessing of women's natural taste to the regeneration of the decorative arts. For a woman to aspire to *le grand art*, however, with all the intellectual skills and physical strength which that required, was quite another thing.

The actual distribution of genres at the *Salons des femmes* seemed to bear out all the critics' expectations, and was used repeatedly as concrete evidence of women's propensity and skill in certain types of art and as tangible demonstration of their unsuitability for others. Throughout the first two decades of the *Salons des femmes* there was little change in the proportionate distribution of genres. Portraits were by far the most plentiful, followed by flowers, landscapes, still-lifes, genre scenes and animal scenes. A typical overview of an exhibition is given by Henry Havard in 1882: 'Very few large works, hardly any history paintings, a few genre scenes, numerous portraits, some flowers, some fruits, a few landscapes, a single full-length portrait'.[91] In 1899, the critic for the *Journal des artistes* was still able to claim that women, through 'temperament', 'fashion' and 'taste', confined themselves to those genres in which 'their predelictions for elegance and *coquetterie*' were most easily expressed, that is to say flowers, portraits and decorative landscapes.[92]

The predominance of works in the lower genres was accompanied by the abundance of works in the less elevated media. Most of the two-dimensional works on show were drawings, watercolours and pastels, alleged to be the most suited to women's temperament and level of skill. It was, after all, 'grace' which was women's greatest quality, and which was construed as the opposite to 'force', its masculine equivalent.[93] Whilst the former was more easily expressed in fragile works on paper, executed in media thought to require a refined sensibility and delicate touch, the latter was necessary for ambitious, large-scale works.[94] It is hardly surprising, then, that the *Salons des femmes* showed unusual quantities of sketches in pencil and charcoal, fewer oil paintings than would generally be expected in an exhibition of this type, and a sprinkling of miniatures, fans and pieces in porcelain.

Works in two dimensions far outnumbered sculptures, the majority of which, when they were exhibited, being portraits and busts. Sculpture was generally thought of as a

38. Mme Léon Bertaux,
*Psyché sous l'empire du
mystère*; reproduced in
*L'Art français* (3 March
1888), photograph: Biblio-
thèque Nationale, Paris.
This figure is seen to the
far right of fig. 39.

masculine art, and the women who became professionals in this field were widely thought
of as having transcended normative expectations. Not only did the practice of sculpture
require physical force and a willingness to get dirty, it was also regarded as less compatible
with domestic life and would certainly not have formed part of the standard education of
most *haute bourgeois* women.[95] The boundary between professional and amateur produc-
tion was much more blurred in two-dimensional work, and while many lady amateurs
whose education had required that they become proficient in painting might have wished
to exhibit their work publicly and used the *Salon des femmes* for this purpose, this was less
likely to happen in the case of sculpture. A serious engagement with this medium was most
likely to stem from a commitment to seeking training outside the home (unless, as in the
case of the young Mme Léon Bertaux, the artist was her father's pupil) and the assumption
of a professional identity. Partisans of women's art were therefore lavish in their praise
when women succeeded in showing an ambitious piece of sculpture, like Mme Bertaux's
*Psyché sous l'empire du mystère*, featured on the cover of *L'Art français*, which both

conformed to accepted standards of taste, and could be read as infused with a suitably feminine grace and elegance or even a certain spirituality (fig. 38).[96] This work was chosen for exhibition at the 1889 *Exposition Universelle* where it took its place amongst other idealised renderings of the human body (fig. 39). More than one critic went so far as to claim that it was Mme Bertaux's work, more than any other, which would force viewers to reassess their theories about 'the inferiority of women's genius in questions of art'.[97]

What was almost entirely absent from the exhibitions, according to the critic from *Voltaire*, was *le grand art*, including the nude, history painting, 'dramatic subjects', 'mythological legends', 'decoration of municipal buildings'; in sum, 'large works'. Women gave preference instead 'to flowers, to fruits, to insects, to scenes with children', those subjects in which they, with their 'more penetrating eyes', found poignant manifestations of life and love, and which men, with their narrow and restricted vision, failed to notice or to value. At stake here is the standard set of suppositions about gendered vision and cerebration. Whilst women's acumen lies in their acute powers of observation and eye for detail, at the expense of a more mediated general understanding of principles, men are endowed with the capacity for elevated general conceptions which allows them to see beyond the particular to the grand scheme of things. What they have to sacrifice en route

39.   Photograph of installation in sculpture hall, *Exposition Universelle*, Paris, 1889, photograph: Roger Viollet.

is an attention to detail, which in any case was seen as distracting in a painting of noble conception. Women's eye for detail and capacity to focus on the minute, on the other hand, could transform even a humble bowl of flowers into a full-blown drama equivalent to the 'Marriage of Cana' or the 'Apotheosis of Homer'.[98] On the surface, this could be construed as a matter of equality in difference, with occasional digs at men's blindness, but there was no question which of these capacities was more highly valued, discursively and institutionally. Small wonder that the gendering of the genres seemed, for the vast majority of commentators, to mirror the natural order of things.

It was not only the scale and ambition associated with *le grand art* that made it appear to its defendants as beyond the scope of women artists. Under attack from the forces of modernity, a special case had to be made for its superior ambitions and the elevated faculties which it required. It was impossible to both assert the specialness of these and make it seem probable that women could accomplish them. That would have been a contradiction in terms. According to its protagonists, *le grand art* required both arduous technical training and the most intellectual of all artistic capacities, the ability to idealise which, according to Charles Blanc, required that the artist:

> go for synthesis in searching for unity; annihilate all anatomical detail which is detrimental to the whole, is unnecessary to the movement of a figure; correct all ugliness, suppress all triviality; above all choose beautiful lines, beautiful forms, and never copy, always interpret.[99]

All women's so-called special talents would be counterproductive in this context. What was more, the 'mastery' over nature which *le grand art* required was, itself, conceived of in gendered terms. 'Nature', constructed as feminine, represented the unbridled abundance and undisciplined plethora of sensations and experiences which needed to be given form and turned into 'Art' by 'Man'. 'Woman' constituted part of that material of nature which needed to be controlled and formed, if order was to be achieved and civilisation was to reach its heights.[100] If women were symbolically placed as part of the matter of nature, they could not easily be seen to occupy the transcendent sphere of the mind to which nature was subject. Nor were they equipped to do so. It was precisely the qualities of intellectual disinterestedness, discipline and the capacity to abstract, necessary to forge order out of chaos, which were held to be beyond women's reach. If women could be seen to be capable of creating *le grand art*, either it could not be as difficult or elevated as it was purported to be or else women were less limited than society demanded. Neither of these was a happy prospect and many critics preferred to keep their preconceptions intact, keeping a suitably elevated regard for ambitious art and encouraging women's humbler ambitions with affectionate tolerance. When Laurent Just, for example, noticed at the 1892 exhibition that some women were venturing outside of their traditional terrain, he became nervous. He detected that they were beginning to try their hands at '*la grande peinture*, academic figures, landscape, outdoor painting'. This could only lead to ruin, in his view. Predictably, he complained that women's art would be spoiled by becoming a base imitation of men's. The result of this could only be 'vulgar pastiche'.[101]

Laurent Just had little to fear. Despite assertions that the range of women's practice was expanding, the actual distribution of genre and medium at the exhibitions did not change

40. Mlle Marie Perrier, *Eveil* (Salon 1895); whereabouts unknown.

41. Mme Lucy Lee-Robbins, *Le Repos* (Salon 1895); whereabouts unknown.

noticeably over time. The number of history paintings or nudes shown at the *Salons des femmes* continued to be small, although by the 1890s there was a handful of women who, having attended the private academies at which life-drawing was taught, turned to representing the idealised female nude, sometimes in traditional remote settings, occasionally in a modern-life context, and always according to traditional conventions of representation. Works like Mlle Marie Perrier's *Eveil*, Mme Lucy Lee-Robbins' *Le Repos*, both exhibited at the *Salon* of 1895, or Mme Esther Huillard's *Fait-il aimer?* of the *Salon* of 1892, were typical of the kinds of nudes produced by women artists (figs. 40, 41, 42). Among those exhibited at the *Salon des femmes* in 1895 was the small study by Mlle Carié

43.  Mlle Carié Langlois, *Etude de nu*, Exposition des Femmes Peintres et Sculpteurs, 1895; whereabouts unknown.

42.  Mme Esther Huillard, *Fait-il aimer?* (Salon 1892); whereabouts unknown, photograph: Bibliothèque Nationale, Paris.

Langlois (fig. 43). Two years earlier Mme Firnhaber had exhibited the curious *Le Valet de Cœurs*, all the more strange, commented the critic from *L'Art français*, because of the 'scarcity of nudes at the exhibitions of the *Union des Femmes Peintres et Sculpteurs*'[102] (fig. 44). For the most part, women artists who painted the female nude (it was virtually impossible to get access to a naked male model) functioned within the standard erotic economy of their time.[103] It was tradition that spoke through their works and which conditioned their mode of representation. It was to traditional accolades that women artists aspired, and their rendering of the nude is consequently entirely predictable.

The exhibition of nudes was neither abundant nor distinctive enough to change the

44. Mme Firnhaber, *Le Valet de Cœurs*, Exposition des Femmes Peintres et Sculpteurs, 1893; reproduced in *L'Art français*, photograph: Bibliothèque Nationale, Paris.

dominant view that women were unable to produce significant figure paintings. Nor did most commentators think they should. Although many people commented on the abundance of works in the lower genres, only committed supporters of women's emancipation like 'Lorgnette' of *La Citoyenne*, who was disappointed at not finding one history painting at the first *Salon des femmes*, seriously lamented the fact.[104] In 1896, feminists were still railing against the limitations imposed on women's intellectual aspirations. How could it be, asked Virginie Demont-Breton in a speech reprinted in and endorsed by *Le Féminisme chrètien*, that history had produced as many heroines as heroes, but that women were proscribed from producing history paintings?[105] She herself was determined to paint

heroic women, whether that heroism was conceived of in traditional terms or not. In keeping with her belief in infusing heroic subjects with a special feminine tenderness and understanding, she turned to images of female mystics, figures representing maternal devotion, and saints (figs. 45, 46, 47). She also did her fair share of genre paintings, following in her father's footsteps as a painter of idealised peasant scenes (fig. 48). She was one of the few late nineteenth-century women painters who did not shy away from ambitious historical scenes, as paintings like *Jean Bart*, shown at the 1894 Salon, demonstrate (see fig. 11).

There were some commentators who saw the nature and standard of women's art production as indicative of the restrictions of education and socialisation under which women laboured. Painting ambitious figure paintings, as everyone knew, required an ease and familiarity with the representation of the nude. As the controversy over women's entry to the life-class at the *Ecole des Beaux-Arts* revealed, this raised enormous issues

45.   Mme Virginie Demont-Breton, *Le Gui* (Salon 1895); whereabouts unknown.

46. Mme Virginie Demont-Breton, *L'Homme est en mer* (Salon 1889); present whereabouts unknown, formerly in the Walker Art Gallery, Minneapolis.

47. Mme Virginie
Demont-Breton, *Jeanne à
Domremy* (Salon 1893);
whereabouts unknown.

which went to the heart of contemporary constructions of art and sexuality. For some, the
issues it provoked were too difficult to resolve and were best left alone. Raffaëlli, for
example, saw no point in women attempting the nude, as the draping and covering of the
model that their modesty necessitated meant that they could never experience the 'mag-
nificent emotion' which true artists felt in front of a totally naked body. Their attempts,
therefore, at tackling this genre were doomed to failure from the start. It was better left
alone.[106] There was doubt anyway of women's capacity to conceive of drawing in a
necessarily abstract way so that the deficiencies of nature could be compensated for by a
suitably elevated notion of the 'Ideal', and thereby transform the naked into the nude. At
the other extreme there were those who thought the genre overrated in the first place, and
women's abstinence from it both laudable and exemplarary.[107] However, not everyone
was quite as negative as this. There were those who saw the scarcity of paintings of the
nude at the *Salons des femmes* as a primary cause of the *Union*'s campaign for women's
entry to the *Ecole*.[108] Some entertained hopes that with social change, women's access to,

and skill in, the higher genres was an inevitable and welcome possibility. Olympe Audouard, no friend of hypocritical double standards of sexual morality, in her review of the 1883 exhibition discerned good taste as the overwhelming criterion for the present choice of subjects. Like 'Lorgnette' of *La Citoyenne*, she preferred to regard the exhibition in a diagnostic way, a chance to glimpse what women's art could potentially be like in a future, more just world.[109] But such a world was a long time coming. Some fourteen years later, the critic for the *Journal des artistes* was convinced that it was not an inherent weakness in women that still made them unwilling to tackle the higher genres, but a lack of confidence and education which he was sure their admission to the *Ecole des Beaux-Arts* would remedy.[110]

   The more typical critical response to the types of works on show at the exhibitions was that of the writer for *La Lanterne*, in 1890, who discouraged women from engaging with *la grande peinture* in which they inevitably showed, in his opinion, irreparable weakness.[111] The critic for *L'Artiste*, a self-proclaimed 'partisan' of women's art, spoke for many in his assessment of the 1886 exhibition, in which he praised the preponderance of works in the least elevated genres and mediums. Waxing lyrical, he invoked a soft focus world characterised by blossoming flowers and sweet scents, delicate hands, and tender,

48.   Mme Virginie Demont-Breton, *Le Foyer* (Salon 1893); whereabouts unknown, photograph: Bibliothèque Nationale, Paris.

Mᵐᵉ FRÉDÉRIQUE VALLET. — *Coquetterie.*

Mᵐᵉ CLAIRE LEMAITRE. — *Fleurs d'automne.*

Mᵐᵉ DEMONT-BRETON. — *Tête d'étude.*

Mᵐᵉ BOYER-BRETON. — *Femme qui rit.*

L'ART FRANÇAIS

49.   Full-page spread from *L'Art français* (15 March 1890).

bashful emotions. It was in the arena of these gentle pleasures which, in his view, feminine art at its best could flourish and to which it should testify. Like many of his colleagues, this critic constructed an entirely separate set of criteria for the evaluation of women's work. In this arena it was the expression of 'heart', 'tenderness', even *maternité* or *virginité* which needed to be witnessed.[112] Other critics proffered more pedestrian explanations of the preponderance of works in the lower genres. Dargenty, for example, set out to explain the abundance of still-lifes at the exhibitions by attributing this to women's enduring patience. Patient women, he alleged, far outnumbered hot-headed ones. Still-lifes were, therefore, the most attractive subject for women who with calm, patience and serenity could contemplate the motif. They had, afterall, learned this capacity through years devoted to the 'joys of tapestry'.[113]

Not everyone, however, was quite as banal in their reasoning. Some were not supporters of the high-flown ambitions of academic art in the first place, and thought that women's dependence on nature, born of their inherent loyalty and good sense, made them eminently suited to realising the essentially plastic nature of fine art. They knew, instinctively, not to mix painting with 'literary declamation by searching for profound ideas, whether moving or moralising'.[114] Ironically, in its relation to subsequent history, women are constructed here as quintessential and intuitive modernists. It was in this context that this convert to the cause of women's art welcomed the absence of 'romantic subjects' in preference for the 'studies, which were most often sincere', detected at the 1891 exhibition. Women's concentration on the lesser genres could also be praised from a feminist perspective. A writer for *La Citoyenne* proclaimed women very wise to stick to painting flowers, as this both belied their opponents' allegations that they had reneged on their femininity and freed them from the burden of having to execute contrived, large-scale pictures, devoid of true sentiment. In this way women's achievements are affirmed by turning the traditional hierarchy of the genres on its head:

> At least one cannot say that the brush has masculinised woman to the point of making her renounce the taste which suits her so well . . . For myself, I admit . . . I much prefer Mme de Gaussaincourt's *Pantier de lilas blancs et violets*, for example, or any other bunch of common roses or the most vulgar daisies, to any of the allegedly historic *grande machines*, which we have seen in other places. These show a great amount of effort with less feeling and above all, fewer results.[115]

Whether the same inversion of traditional status would have been attributed to flower paintings by men is questionable. The association of women with flowers ran very deep, and it was not surprising that most of the still-life paintings exhibited at the *Salons* were of flowers. A typical example is that by Mme Claire Lemaitre, featured in a full-page spread published by *L'Art français* in one of its special features on the *Union* (fig. 49). Flowers were thought to provide a soothing influence on women's jangled nerves and Michelet, that widely acclaimed authority on 'Woman', went as far as to argue that a female child could be taught all it needed to know in life by having studied a flower. Flower arranging was regarded as an essential feminine accomplishment, and thought by many amply to express women's aesthetic ambitions and propensities.[116] To represent women together with flowers was standard practice at this time (see, for example, fig. 16).

Mme Frédérique Vallet's pastels, which often juxtaposed women with flowers, were highly acclaimed because of their suitable subject matter.[117] At the 1896 *Salon des femmes* she showed a much admired work depicting a young woman, dressed in floral *décollatage*, arranging flowers in a vase. The conflation of women themselves with flowers, needing to be cultivated and carefully handled, was a naturalised part of the language. Men, on the other hand, could be compared to gardeners (artists), whose mission it was to tame Nature and render her managable.

Small wonder then that it was as flower painters that so many women defined their practice, and in which they were acknowledged to have excelled. Feminist critics sometimes greeted the abundance of flower paintings with impatience, and urged the exhibitors to be more ambitious and try their hands at larger works. 'You have too many flowers . . . Your *Salons* are truly gardens', wrote the reviewer from *La Citoyenne* in 1889.[118] But, as we have seen, ambition beyond this realm was more often greeted with disquiet. Even landscape and seascape, which for some commentators could harness the same faithful imitative qualities as flowers and still-lifes and were therefore to be welcomed at the *Salons des femmes*, were regarded as beyond women's sphere by others. There were relatively few pure landscapists among the *sociétaires* of the *Union*, and an exceptional figure like the marine artist, Elodie La Villette, was generally highly acclaimed (fig. 50). Most often paintings and drawings of the outdoors were representations of

50.   Elodie La Villette, *Marine*; part of full-page spread from *L'Art français* (2 March 1889).

EXPOSITION DES FEMMES PEINTRES ET SCULPTEURS

M<sup>me</sup> RÉAL-DEL-SARTE — *La défroque de ma grand'mère.*

M<sup>lle</sup> KLUMPKE. — *Une paysanne.*

M<sup>me</sup> COTTON. — *Portrait.*

M<sup>me</sup> LAURE-MARTIN COUTANT. — *Farniente* (statuette).

51. Full-page spread from *L'Art français* (22 March 1890).

gardens, some bordering on genre scenes, others on outdoor still-lifes (fig. 37). There was the odd critic who understood that it was women's social position which made *plein air* work an awkward affair. Custom did not allow women to romp about in the country and the forests in search of 'nature'. Yet, alleged this critic, when they did 'look at nature with the eyes of a woman' they infused it with 'tenderness'. This critic went on to praise the suitably inhabited farm scenes of Mme Annaly and domestic landscapes of Mme Anais Beauvais.[119]

Second to flowers and still-lifes, it was portraiture which was relatively plentiful at the exhibitions. The frequent features on the *Salons de femmes* published by *L'Art français* showed an abundance of portraits and single figure studies (figs. 51, 52). There was, however, some dispute over women's skill in this genre. Whilst 'portraits' of domestic

M<sup>me</sup> RÉAL DEL SARTE. — *Manon Lescaut.*

M<sup>lle</sup> MARGUERITE TURNER. — *Premeditazione.*

M<sup>lle</sup> KLUMPKE. — *Portrait de ma mère.*

Huillard. — *Etude,* — pastel.

52.   Full-page spread from *L'Art français* (8 March 1890).

animals were widely regarded as well within women's grasp, and practitioners of this genre like the Belgian animalier, Henriette Ronner, were much praised, portraits of people provoked more controversy (fig. 53). Olympe Audoard, for example, complimented women on their insight into character, and identified a particular liveliness in the gaze of their sitters: 'It is the wonderful way that women have of rendering the look, the eyes are alive, expressive, eyes which speak!'[120] Others thought they brought a special understanding to the representation of *la femme nouvelle*, breaking out of the traditional manner of depicting women surrounded with the accoutrements of 'femininity' and replacing these with the attributes of their profession.[121] A comparison between Manet's earlier portrait of Eva Gonzalès, in which the presence of artistic paraphernalia operates more as so many fashion accessories than as signs of the professional engagement of the artist depicted, with the portraits of Rosa Bonheur by either Mme Achille Fould or Anna Klumpke, is an interesting case in point (figs. 35, 54, 55). In the representation of the new woman it was 'character', traditionally regarded as a manly attribute, rather than 'beauty' that had to be

53.   Henriette Ronner, *Autour d'un panier* (1892); whereabouts unknown.

54. Edouard Manet, *Portrait of Eva Gonzalès* (1870); National Gallery, London, Lane Bequest, reproduced by permission of the Trustees.

55. Anna Klumpke, *Portrait of Rosa Bonheur* (1898); oil on canvas, Metropolitan Museum of Art, New York. In Memory of Rosa Bonheur, gift of the artist.

captured. Achievements of this sort were amply rewarded by the *Union*. In 1896, for example, Mlle Jeanne Tournay was awarded the second prize of the *Union* for her conventionally composed but confrontational *Portrait de Mme Clovis Hughes* (fig. 56).[122] A portrait of Mme Demont-Breton herself was much admired by the critic of *L'Art français* for its evocation of the intellectual and professional identity of the sitter (fig. 57). 'It is less the woman than the artist which she captures', he declared approvingly, indicating that a new critical language was developing for the discussion of images of the 'new woman'.[123] *L'Art français* published reproductions of the much admired portraits of her daughters by Virginie Demont-Breton, describing their intense gazes as intelligent, the

56. Mlle J Tournay, *Portrait de Mme Clovis Hughes*, Exposition des Femmes Peintres et Sculpteurs, reproduced in *L'Art français* (March 1896).

57 (facing page). J-V. Salgado, *Portrait de Mme Demont-Breton*, reproduced in *L'Art français* (2 March 1895).

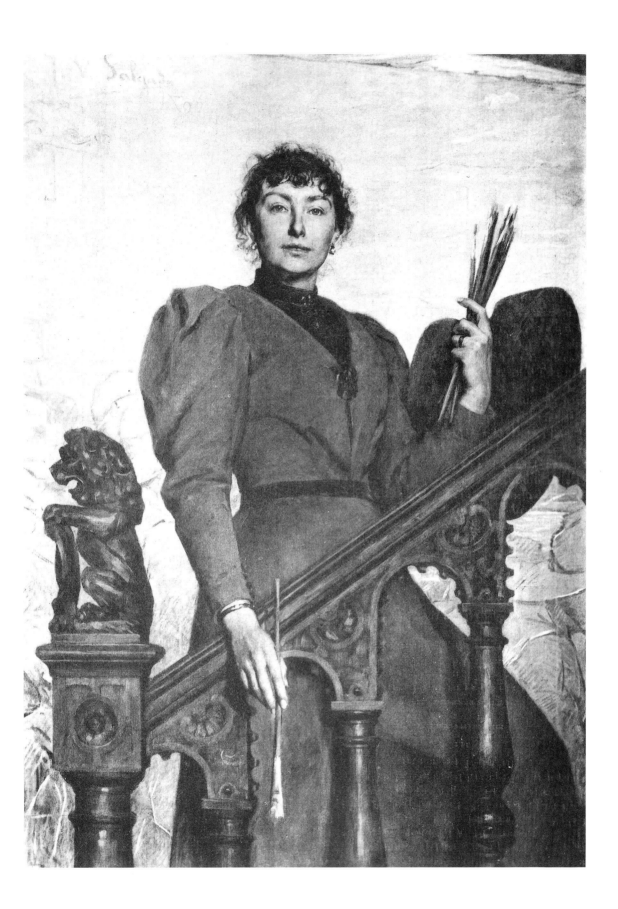

one dreamy, the other strong and purposeful (fig. 58).[124] The margin between portraiture and genre scenes was often blurred, and portraits of social types, especially idealised representations of the poor like Mme Cadilhon-Venat's *Une Béarnaise*, were fairly common at the exhibitions (fig. 59). Virginie Demont-Breton's genre portraits often depicted fisher folk (fig. 60).

58.   Mme Virginie Demont-Breton, *Portrait de mes filles Louise et Adrienne*; whereabouts unknown.

There were those critics who simply asserted women's skill at portaiture without finding it necessary to give any reasons for this.[125] The critic for *Le Temps*, on the other hand, thought women innately unsuited to portraiture, particularly in the painting of men, because of their insurmountable subjectivity and their incapacity to see beyond themselves. In his view, all male portraits by women looked the same, resembling an ideal man. It was as if women artists did not take the trouble to look at their male sitters, he complained.[126] But some sympathisers understood the difficulties women had, both in finding male sitters, and in brazenly confronting them in a manner so transgressive of accepted conventions of looking. One commentator, noticing a portrait of Strindberg by Mme de Frumerie at the 1896 exhibition, marvelled at the fact that such a misogynist had condescended to be painted by a woman at all.[127]

As is apparent from the above permutations of argument, virtually any essentialist argument about 'Woman' could be brought in to play, to defend or condemn her practice. In some cases her subjectivity could be used as a positive factor, providing a resource of feeling which would fill her portraits with empathy and understanding, in others, that very quality could be seen to mitigate against her possession of the cool and objective distance necessary to 'capture' character. At stake was a struggle over power. Art was only one of a number of sites in which the battle was fought, and logic and reason could be manipulated to serve any ideological position. A similar inversion of accepted forms of reasoning was to be used by defenders of women's right to aspire to the highest expression of art,

59.   Mme Cadilhon-Venat, *Une Béarnaise*, Exposition des Femmes Peintres et Sculpteurs 1891;
whereabouts unknown.

60. Mme Virginie Demont-Breton, *Tête de marin* (1895); whereabouts unknown.

from which rhetoric, custom and institutional structures excluded them. It was against the conventional, circumscribed notion of a 'feminine' art, haunted by the ever-present terror of 'masculinisation', that the counter rhetoric of *l'art féminin* was elaborated by the leaders of the *Union*.

Having analysed the critical reception of the works that women showed at their *Salons*, it is to the rhetorical riposte to certain aspects of conventional wisdom, revealed in the criticism as much as anywhere else, that we must now turn in order to get a fuller picture of the mission that the leadership of the *Union* believed that they had to fulfil.

# Chapter 6

## *L'Art féminin*: a Utopian Vision

IN AN ARTICLE PUBLISHED in February 1893 in the *Journal des femmes artistes*, Mme Bertaux pointed to what she saw as the two major charges which critics levelled against the works on show at the *Salons des femmes*.[1] The first was a lack of ability in handling the figure, the second was the absence of originality. Women, she wrote, were reputed to copy their masters too visibly. Yet copying the style of the master, she claimed, was a natural tendency for both men and women. Pupils chose their teachers, became absorbed in contemplating their works, and thereby learned technical processes and forms of interpretation. The most powerful guard against an over servile attitude to the master was to turn to 'tradition', the only force strong enough to resist both the biases of the teacher and the attractions of passing fashions. Tradition functions here as a corrective to more transient forms of seduction. It constitutes a solid core of irrefutable principles which guarantees both quality and integrity. The authority who should be remembered, alleged Mme Bertaux, was Ingres, who had proclaimed drawing as the basis of all art.[2] It was via a return to traditional drawing skills that quality could be guaranteed. Mme Bertaux managed in her statement to juxtapose the two criticisms, and to turn the correction of one into the panacea for the other. The implication of her response is that if women were enabled to draw well by being given access to State-run institutions of fine art education, and thereby to traditional skills, they would be equipped to withstand both the influence of their teachers and the allure of transitory styles. As such, they would be able to participate in a project which went far beyond their need for personal success. Mme Bertaux was on difficult territory here, however, for in making demands for women's access to male institutions she risked threatening existing social relations and being identified with extreme feminist agitation. Tradition would have to be called forth on a number of fronts to be both politically effective and able to speak for the aspirations of the majority of women.

This was not the first time that 'tradition' had been invoked in the defence of women's art. In 1892, a *sociétaire* writing in the *Journal des femmes artistes* used just these terms at the posthumous retrospective hosted by the *Union* to honour Mme Peyrol-Bonheur, sister to Rosa Bonheur and also an *animalier*. Mme Peyrol-Bonheur's exhibition was seen as the successul expression of a new art based on the solidity of old principles, and an important connection was made between tradition in art and traditional female roles. In the light of the confusion and troubled atmosphere of the present, this writer maintained that progress in art could only be founded on 'individual research based on tradition'. To go forward, one had to look backward. Nothing modern could compete with the certainties of past masterpieces which should act as guides to the future:

Is there one modern exhibition ending with an *ant* or *iste* which is, in its entirety, worth the value of one work by a master? When the fundamental knowledge of Art is seen to be observed, whether it be in a sketch or in a study, then you have a real work, perhaps a masterpiece.[3]

Mme Peyrol-Bonheur's exemplary status was further endorsed by her success in reconciling the task of being an artist with the pleasures of being a woman, wife and mother. In fact, argued this writer in a not unfamiliar way, it was her situation as a woman artist which helped her to concentrate on the family and allowed her to share with it the gifts of a spirit which was totally enamoured of the 'Ideal', a quality which had the power to uplift both art and family life. In a speech made shortly after her death, Gambart, the art dealer, had praised this artist in similar terms. Mme Peyrol-Bonheur, 'whilst passionately cultivating *le grand art*, does not neglect any of the duties of family or society. A devoted wife, an admirable mother of a family' was how he described her.[4] Mme Peyrol-Bonheur's involvement in art is offset by her fulfilment of womanly duties. She can be seen to infuse the family hearth with the elevated aspirations of her art. Conversely, her womanly reverence for harmony, beauty, love and the search for perfection are seen to serve her well in an art world in which such values are threatened by the triumph of the new.

The compatibility of traditional social relationships and traditional skills in art was stressed by the leadership of the *Union*. The development of women's intellectual and artistic capacities, for which the *Union* campaigned so tirelessly, was defended in terms of what they could contribute to domestic harmony and thereby to society as a whole. According to Mme Demont Breton, the development of women's faculties, their necessary 'intellectual emancipation', far from turning them from their duties, would serve to complete their unions with their husbands through the exchange of ideas. It was not for women's happiness alone that they wished to participate in progress, but in order to be worthy confidantes for their husbands, and to ensure the future of their children. It was, in her words, 'to enrich the fatherland as much as to develop the forces that we feel inside ourselves and which we have for too long neglected to cultivate', that women sought emancipation.[5] What was at risk was the health of the nation, and women were biologically determined and psychologically equipped to preserve it. They did so in society through their charitable works and philanthropic endeavours. Given the means, they would do so in art through their 'feminine' sensibilities, innate conservatism and natural caution. Drawing parallels between their intuitive capacity for good works in society and the striving for the 'Ideal' in art, she invoked the residue of feeling which women possessed and which made them eminently suited to becoming artists. Was not, she asked, a woman, rather than a man, better equipped to understand both the tenderness and the anxieties of life and to feel its poignant sadnesses? 'She who penetrated into garrets and cottages to bring charity to the unfortunate, she who listened to their confidences, she who helped and consoled them', who better than she to be the guardian of sentiment and value in an increasingly hostile and meretricious world?[6]

For Mme Demont-Breton, it was the 'maternal tenderness' possessed instinctively by all women which would provide the basis of a redemptive 'feminine art', necessary not only to provide an outlet for female creativity, but to help to hold back the morass into which contemporary French culture was sinking:

The more that woman finds herself in the desirable conditions of existence for penetrating those human emotions which most strongly attract her, the more her work will be interesting and strong and the more she will continue to contribute a particular element which has the capacity to complete and enrich the art of her country.[7]

It was in their traditional roles that women's difference was expressed, and it was from the emotions generated in this arena that they would be able to infuse an ailing culture with a purity and idealism which it now lacked. Without adequate training in traditional skills, they would have no productive outlet for the expression of their profound 'sentiments' and intellectual aspirations. They would not be equipped to marshall their intuitions to the public good.

Traditional skills were not only seen to be present in the most elevated of genres. Whilst these undoubtedly represented the pinnacle of women's aspirations, and neither Mme Bertaux nor Mme Demont-Breton made any bones about declaring this, they were anxious not to alienate their colleagues by undermining their achievements in the lesser genres, or even the decorative arts into which women were increasingly being coaxed for the benefit of the nation.[8] Very few women, as we have seen, were producers of *la grande peinture*, in the traditional sense, but even Mme Peyrol-Bonheur was praised as a practitioner of *le grand art* although she was no history painter. This points to a fairly loose application of the term by supporters of women's art, to indicate a practice in which traditional skills are seen to be present. The *Journal des artistes* reported an incident which occurred at the *Union*'s general assembly of 1889 which graphically illustrates this point. While Mme Bertaux was eulogising the merits of *le grand art*, a *sociétaire*, described as 'an intransigent, or if you prefer, an Impressionist' is said to have called out, provocatively, for a definition of this term. Off the cuff, Mme Bertaux is alleged to have produced what was regarded as a brilliant and heated response which was greeted with enthusiastic bravos. The substance of it was summed up as follows:

> '*le grand art*'; which can be sought and found in the smallest canvas . . . is the result of acquired knowledge and elevated personal inspiration. Genius cannot develop without culture; it is this high culture which the State refuses to women and which it owes them.[9]

Mme Bertaux seems reluctant to commit herself to any precise definition in this forum. Always conscious of eschewing exclusivity, she opts for a vague and inclusive explanation around which all women artists can rally. To have opted for any narrower definition would have been to exclude most women from what she saw as the main arena of battle. In so doing, she would have been collaborating with those critics who doubted women's capacities for *le grand art* in the first place, and such a view was intolerable to both Mme Bertaux and Mme Demont-Breton.[10] What Mme Bertaux deftly manages is to use the dominant rhetoric, but to manipulate it so that it can serve the cause that she champions. *Le grand art*, in the way she defines it on this occasion, has little to do with scale or subject matter. Rather it is an abstract quality which is the product of personal inspiration and knowledge, derived from training and an immersion in 'high culture'. Mme Bertaux's comments are vague enough to represent the interest of the majority of *sociétaires*, and at the same time to form the basis of an important political point. Her views were consistent

61. Berthe Morisot, *Nourrice et bébé* (1880); Ny Carlsberg Glyptotek, Copenhagen.

with those of other *sociétaires* anxious not to alienate or undermine those women whose work did not aspire to rendering the elevated world of the gods, and who were content to capture the reality of a carrot or a bunch of onions. It was not what women painted that determined whether they were true artists or not, argued one *sociétaire*. It was the skilful application of light and shade, good, solid draughtsmanship and overall compositional understanding which could transform a humble subject into a masterpiece.[11] What was crucial to most of the articulate spokespeople for the *Union* was the sanctity of traditional skills and values, whether they manifested themselves in the most elevated genres or not. But some special problems arose when it was in this arena that they wished to compete. To artists like Mmes Bertaux and Demont-Breton, who tirelessly defended women's rights to aspire to the higher genres and their innate suitability for these, the inability to draw figures to which critics alluded precluded women from succeeding in these traditionally masculine genres, and stood for their lamentable lack of understanding of traditional

62.   Elizabeth Gardner, *Deux
mères de famille* (Salon of
1888); whereabouts unknown.

principles without which they could not fulfil the mission for which they, as women
artists, were destined. Most importantly, it prevented them from engaging effectively in
what they saw as the mainstream of artistic debate, and defending that which was most
threatened by the forces of modernity.

The leadership of the *Union* saw the tendencies of the new schools of painting as
profoundly threatening. These came to represent the passing of the old order identified
with the great French cultural tradition, symbolic of France's historic power and standing
in the world. Like most defenders of academic principles, they would have had little
difficulty choosing between a painting by an artist such as Berthe Morisot and one by the
American, Elizabeth Jane Gardner, who was to become an honorary Frenchwoman
through her marriage with the much acclaimed, and favourite of *Union* members, Will-
iam-Adolphe Bouguereau.[12] While Morisot's *Nourrice et bébé* of 1880 (fig. 61) would
have been seen as lacking finish and skill in drawing, a mere *étude*, Gardner's *Deux mères*

*de famille*, exhibited at the Salon of 1888 (fig. 62) and a procelain copy of which was shown at the *Salon des femmes* in 1889, would have fulfilled the demands for a highly contrived, well delineated and convincingly illusionistic pictorial space, with its skilful draughtsmanship and creation of volume through appropriately subtle tonal modelling.[13] What is more, the Gardner would have been seen to be making a moral statement about the healthy young mother's instinctive and entirely wholesome attitude to her child, inscribed as natural by finding its echo in the hen and her chicks. The moral overtones of the Gardner would not have been resticted to the overt 'message' in the work, however. It was the way in which it was encoded in traditional pictorial means that conferred upon it the status of representing the 'good' and the 'true'. Indeed, despite its apparently secular theme, the Morisot too could have been read as an interpretation of the modern Madonna, particularly in late nineteenth-century Catholic France. Even though the work is a representation of Morisot's daughter Julie and her nurse, its format suggests Madonna imagery through the subtle promotion of the 'natural' closeness of woman and infant.[14] The apparent disregard, though, for traditional skills sets up a tension between the putative morality of the message and the alleged decadence of the means.

It was not, therefore, only the overt nature of the moral encoded in the Gardner which made it praiseworthy. It was the formal elements themselves which became tinged with moral associations, signifying purity, a striving for the ideal, a belief in the power of beauty, and a respect for tradition and enduring values. These characteristics had come, in certain circles, to be associated with the finest attributes of French culture. Their absence was lamented as the sign of a degenerating national spirit.[15] On the other hand, the apparent formlessness of a painting like Morisot's could signify materialism for its detractors, a devotion to this world at the expense of a more spiritual one, an attachment to the present at the expense of the past and with no due regard to the future, and a capacity for being seduced by surface pleasures rather than being uplifted by enduring moral values. Of course, as discussed in chapter five, for some critics Morisot's 'style' could represent the ultimate expression of femininity with its inevitable superficiality, but for others, especially women like Mme Bertaux, it constituted a surrender to the forces of modernity which threatened to undermine all that was valuable in French culture.

For conservative forces within the art world the rise in popularity of the new schools of 'naturalism' and 'realism' (in the wake of the revolutionary movements of the mid-century during a period just after France's traumatic military humiliation and a period of great political and economic instability) made them come to represent much that was ailing about modern France. They were identified with the rise of secularism and positivism, and were seen as emblematic of national degeneration and spiritual decline.[16] Among the leadership of the *Union*, as amongst the die-hard academics who still administered the ailing *Prix de Rome* and lamented their loss of control over the *Ecole des Beaux-Arts*, it was feared that this growth of naturalism and realism would lead to the destruction of the nobility of the French tradition, which, in their view, had always been based on a reverence for the 'Ideal', the world behind appearances associated with purity and truth. In keeping with such views, writing about art, both contemporary and of the past published in the *Journal des femmes artistes*, broadly reflected the most conservative elements of late nineteenth-century French criticism. The furious debate, for example,

which raged over the Caillebotte donation of Impressionist and naturalist paintings to the State, was recorded in the journal with support given to artists like Gérôme, that fierce campaigner for women's exclusion from the *Ecole des Beaux-Arts*, who issued a vehement attack against the bequest. For Gérôme, the acceptance by the State of paintings by the likes of Manet and Pissarro was evidence of a great moral decline. In his words, it meant 'anarchy', 'decadence' and ultimately 'the end of the nation, the end of France'.[17] Despite the occasional comments in the art press lamenting the absence of Berthe Morisot and the other 'women impressionists' from the *Salons des femmes*, no similar views were expressed in the *Journal des femmes artistes*. Events like Morisot's 1892 exhibition at Boussod and Valadon, or her posthumous retrospective of 1896, went unnoticed in this publication and were certainly not hailed as a triumph for women. It was not in this context that Morisot was to be proclaimed as the paragon of femininity. Many of the *sociétaires* feared that too strong an adherence to naturalism, whether by male or female artists, would lead to a sacrifice of the rational and imaginative elements of 'style', 'taste' and 'sentiment', all of which were essential for the 'high aesthetic concern' which was the hallmark of France's historic cultural superiority, now under threat. Far from feeling that these qualities were beyond women's reach, they felt that they, as women, were particularly suited to preserving them. As an anonymous *sociétaire* put it in 1892:

> We are living through a time of doubt which has cast its shadow over the artistic and literary ideal of all nations . . . Stronger and more devoted to our art, let us re-establish a sense of ourselves in the face of all these new sects: decadents, intransigents, incoherents, independents, etc., and let us thank them for teaching us what should be avoided.[18]

'To be of one's time', argued this *sociétaire*, could also mean to reflect its prejudices, to be a slave to fashion and to drift with the current rather than to elevate it. To be truly of one's time was to know what to preserve, and to work towards progress through the cherishing of valuable customs and traditions. The true artist was one who guarded himself (*sic.*) against the vagaries of fortune and did not traffic with the demands of his faith: 'He did not place the care of the body above the pure pleasures of the ideal, he dreaded the prospect of his work becoming reduced to a consumable object rather than remaining the manifestation of an idea'.[19] Art and religion occupy the same arena here. It is a world of spiritual values, of salvation through transcendence. This is the rhetoric of the religious revivalists of the *fin de siècle*, a rhetoric which, curiously, fitted most comfortably with the idealist aesthetics of many women artists. Art, like religion, offered women the space to imagine their own transcendence, to fantasise their communion with something beyond their own infantilised existence. The commodification of art signified the demise of the realm of the spiritual, and pointed to the materialism and decadence of contemporary culture.

The *sociétaires* were not alone in fearing the moral and spiritual collapse of the nation. The idea of national degeneration, which by the late nineteenth century had entered into popular parlance and become a cultural catchphrase in the 1890s, originated in the theories of *transformisme* of the eighteenth-century naturalist Jean-Baptiste Lamarck and had been revived in mid-nineteenth century France. For Neo-Lamarckians, the species

survived and adapted itself to changing environmental conditions by learning behaviour which established an 'equilibrium' between itself and its new environment. This resulted in the transformed internal organisation of the organism which could then be passed on to its offspring. Degeneration theory centres on the notion that the short-term adaptive functions of the organism can be those which will become ultimately dysfunctional to the organism itself. So the organism develops a 'pathology' which can be said to be hereditary. In the words of William Schneider, the 'environment can stimulate physical changes which are passed to subsequent generations'.[20] As Robert Nye has shown, neo-Lamarckian heredity and degeneration theory functioned paradigmatically in *fin de siècle* Paris, providing an ostensibly scientific range of concepts with which to explain all France's contemporary 'social ills', ranging from the depopulation crisis to alcoholism, from the 'decline' in moral standards as exemplified in the pornography trade and licensed prostitution to the potential dangers of feminism and the behavioural patterns of the working classes.[21] So whilst the defenders of France's traditional artistic practices and institutions might not have been consciously drawing on biological theory in their attack on 'modernity' and its representatives, they operated within a discursive field in which a fear of national degeneration had currency, and provided the framework for a counter attack.[22]

Although anxiety about the 'new tendencies' was widespread, there were not many critics in the general press who argued that the threat to academic standards and traditional skills, posed by avant-garde tendencies and what was seen in such circles as an overdependence on 'naturalism', could be assuaged by the collective efforts of women artists. Yet it was to women that members of the *Union* and their supporters ascribed the salvation of French culture. In the words of Mme Bertaux: 'it is not perhaps foolish to suppose that the feminine ideal will give back to art that which the world has demanded of it since its origin'.[23] In an article published in the *Journal des femmes artistes* she issued forth a call to women artists:

> Let us fight, my friends, . . . this outburst of modern peculiarities. Through us, women, through the character of our works, let Art become again a civilising force, so that it gives back to the world that which has been demanded of it from the beginning, that which it has given: the forgetting of realities, the dazzle of pure light in place of the dark night. Art is invention. Let us invent that which consoles the heart, charms the mind and appeals to the eye. That is certainly a truly feminine mission. Yes, let us, women, create, we must do it and we can do it, this new art which is ahead of us, *l'Art féminin*.[24]

For Mme Bertaux this new art comprised the careful balancing of tradition with the serious study of nature, and crucially, the inspiration of the heart. 'It is up to women to bring about the manifestation of this *art nouveau*', she continued. According to the editors of the *Journal des femmes artistes*, if women truly followed their feelings and instincts they would never be men's competitors or their imitators: 'they would have found *l'art féminin*'.[25] Women's innate capacity for sentiment, their imaginations, their aspirations towards the ideal and their instinctive wish to conserve that which was valuable, were produced as the corrective to the cry '*il faut être de son temps*', characterised as mere opportunism, passing fashion, or ignorance.[26]

Such a cry could hardly have made sense in the world of fine art alone. It could only make sense in the context of the naturalised gender assumptions of the culture. In addition to their fertile imaginations, their intense emotions necessary to their social roles as mothers and nurturers, and untainted idealism, women were thought to be capable of profound intuitive understanding, and, importantly, to possess an innate conservatism necessary to the survival of the species.[27] Such ideas, widely promoted in the Third Republic, with dissension from only a tiny group of anti-essentialist feminists, were rooted in nineteenth-century philosophy from Catholic doctrine to Comtian positivism. It was women who were responsible for the preservation and generation of the race. As the *Grand Dictionnaire universel du XIXe siècle* put it: 'The degeneration like the improvement of races always begins with the feminine sex'.[28] It was women's bodies which had been adapted to bear and rear children, and their natures which were formed to conserve that which was 'good' and necessary for the survival of the species.[29]

While man's innovativeness was seen as crucial for progress, woman's conservatism made her the custodian of the past: prudent, old fashioned, and suspicious of change. And while modernity, which was man-made, was seen to be threatening the moral fibre of the nation, it was these very qualities which would make women, more than ever, the guardians of an endangered morality.

The languages of art critics and social theory intersect in interesting ways. Women's psychological characteristics, their capacity to experience profound 'sentiments' defined in the *Grande Encyclopédie* as intuitive and instinctive intellectual phenomena, sometimes associated with a deep and direct appreciation of the 'beautiful', the 'spiritual' and the 'good', were, it was believed, adapted to suit their role in the family as its affective centre and in society as its moral conscience.[30] The family itself was regarded as the social institution which could stave off the 'moral peril' with which France was threatened.[31] An understanding of '*du vrai et du bien*' (truth and goodness), so dear to defenders of tradition in art, were among the crucial qualities which women could marshall in the defence of home and hearth and thereby counter the decadence of French culture and society. Mme Demont-Breton even alleged that '*le Beau*' was the artistic form of '*du Bien*'. An understanding of the one was tantamount to a quest for the other.[32]

Woman's conservative mission in society was reflected for many by her moral responsibility in affairs of the mind. A writer for *La Femme* was in no doubt as to the type of writing which women were, by nature, equipped to support. Decrying recent literary tendencies, she welcomed their widespread repudiation which she witnessed around her and outlined women's responsibilities in this regard:

> Many of those who were raised on this shocking so-called naturalist literature now condemn it with distaste; many of our young men are now energetically rejecting these humiliating labels of 'decadents' and '*fin de siècle*' . . . We, women of France, mothers, sisters, friends of these young men, let us help them in this new path with all our wishes, with all our prayers, with all our ardent sympathy.[33]

There were those women who were not content to leave such an important task to chance and who joined together under the leadership of Mme Roger de Nesle to form a *Société de l'Union des Femmes Poètes* in the late 1880s, defining their task as that of 'vanquishing

the tendencies towards materialism, favouring moral progress towards that which is the most grand, the most elevated; . . . working for . . . the regeneration of humanity'.[34] Calling themselves 'a cenacle of sincere idealists', they took on the role of the guardians of morality who needed to bring their wayward mentors, who had lost their way in materialist excess and the seductions of the flesh, back to the path of virtue. Not only would art be saved by such efforts, but society at large: 'It is the purification through idealism of all human societies; it is universal peace the advent of which is written in the book of God'.[35]

Such a redemptive vision also permeated the newly founded and much welcomed *Revue scientifique des femmes*.[36] A glance at the editorial of June 1888, written by the editor Céline Renooz and entitled *Régéneration morale par la science*', outlines a programme in terms which are similar to those of the *Union des Femmes Poètes*. Science, claimed Mme Renooz, had lost its way. Society was in a state of disorder, morality had become depraved, women were humiliated in the family and in society, the lower classes had become brutalised and criminalised, men were on a relentless path to wickedness and would take women and civilisation with them if women did not band together to counteract these tendencies. Science would have to be remade in order to reveal to men the implications of their actions and to show them a better path:

> It is on woman that this task is incumbant. It is she, with the aid of that faculty, *intuition*, for which men, even the most unjust, recognise her, who should give back to the world the light that will regenerate intellectual life which has gone away, morality which has disappeared, faith in supreme truth, enthusiasm for great and holy causes.[37]

It was women's regeneration of science which could potentially return a life of morality and serenity to men. Yet women had been silenced, by the mockery of men, the closure of institutions of learning and the difficulty of getting publishers to publish their works. Old values had perished and men were relentlessly destroying all that had been most valued in the past. Science, like art, had become corrupted into a means of making money, a tool of industry, of new forms of production. Its true role, claimed Mme Renooz, was not to flatter the ego of selfish man, delivering him with 'the luxury which corrupts him'; rather it was to elevate his spirits and instill in him a renewed integrity. It was up to women to harness science to their mission 'to revive in humanity a love for truth, for the cult of the good, the horror of vice, the spurning of all venalities'.[38]

Such sentiments echo those expressed by the leadership of the *Union des Femmes Peintres et Sculptures* in their formulation of the Utopian dream of an *art féminin*. Nothing was beyond the realm of women's influence for the good, they argued. At one point Mme Bertaux imagined the *Union* at the centre of a vast women's organisation which would set itself the task of redeeming French society and culture via the uplifting effects of an *art nouveau* infused with 'feminine' values:

> All the forms of Art, the most elevated as well as the most modest, could find their place here. Women authors, poets, critics, who knows? All those who think and work should do as we do; all should unite, and all together, we should form a vast and proud association of which, naturally, the centre will be our beloved Society, which is today flourishing and prosperous.[39]

It is not surprising that Mme Renooz and Mme Bertaux followed each other's projects with interest, even entering into a correspondence at one point.[40] Their words occupied the same dialogical field and negotiated it from a similar perspective. Their language is the language of messianism, filled as it is with personal pronouns, formulations set in the future and exhortations to improvement. As such it is a counter language, one which addresses itself to the secular world of literary and artistic production by invoking the tone and substance of the sermon.

The sense that we get from the rhetoric of many of the redemptive women's societies is that they are offered in response both to the dominant claims of the culture and to those which would seek to challenge them. The parallel discourse on women's mission in art, *l'art féminin*, generated by the members of the *Union des Femmes Peintres et Sculpteurs* can be seen as a response to current debates within the art world, as a riposte to the prevailing notion that a professional woman was a desexed woman, as a rejoinder to the demands of radical feminists that women fight publicly for their political rights, as a refusal to accept women's alleged intellectual incapacities and as an answer to critics who demanded that women infuse their art with all their 'femininity'. It is in the intricate negotiation of these positions that the complexity of the category *l'art féminin* can be traced.

That Mme Bertaux had a Utopian dream is already evident from her early claims for the *Union*. She had never seen it as a facilitating institution alone, but had always regarded it as a force through which women's intrinsic powers for 'the good' could be channelled in the name of an ailing and threatened French culture. As she put it in a speech to a group of women on the founding of the *Union* in 1881: 'Is it a dream *mesdames*, is it a Utopia to believe that our role in the future of the State is immense?'[41] For Mme Bertaux, this role involved fighting the forces of corruption which would lead art, following in the steps of literature, to an 'epoch of decadence', in which its true goals would be forgotten. In her words, art's primitive goal was to 'charm the heart through the sight of beautiful forms and at the same time to develop the most noble sentiments through the representation of heroic or tender actions.'[42]

If the redemption of French culture was to be achieved by 'women who remained women', who 'were themselves', 'who remained true to their natures', it had to be achieved without upsetting the sanctity of the discourse of the separate spheres, which divided sexual roles in terms of the public arena of masculinity and the private, or domestic, domain of femininity. So the *sociétaires* of the *Union* had to answer in their rhetoric to the claims that professionalism would take women away from their domestic duties, would necessitate their entry into the public domain, would result in the neglect of their personal responsibilities and the destruction of the natural order. Art had to be produced within this discourse as compatible with women's domain without thereby becoming trivialised. One of the ways in which this was done was to challenge the terms of feminist rhetoric by reinvesting traditional social roles with value, insisting on the compatibility of ambitious art with women's nature and function within society and indeed on proclaiming this as necessary if women artists were to fulfil their roles as people and as artists faced with the threat of the collapse of traditional values. As Mme Bertaux put it in one speech to the members of the *Union*:

You see, *mesdames*, our domain has no limits. Let us be great artists; we will still remain within our roles, perfectly in accord with the laws which nature, society, the family impose on us. The cult of art leaves us in our sphere; men make the laws and when neccessary make war to defend them; public life belongs to them, they guard it.

Certain of being in our places, let us enrol all our living force, all our beautiful passions in the divine cult of art. There we will find bread, sometimes fortune, and, according to our destinies, joys and consolations. Woman will gain by it and all of society with her.[43]

Mme Bertaux sought to turn the 'separate spheres' argument to her own advantage by accepting its validity but changing its parameters. Art is seen to belong legitimately to the sphere of 'Woman', the conserver, both socially – that is in the preservation of family and traditional structures – and artistically, in the promotion of traditional skills and subjects. It was in the name of women's mission that the institutional campaigns of the *Union* were conducted. Responding to current fears that professionalism would take women away from their traditional roles, they argued that women had been impeded from living out their truly womanly destinies by educational disadvantage. If women had not fulfilled their mission, it was because they had never been given the opportunity to develop their skills. If the flowering of *l'art féminin* remained a Utopian vision, it was because women were not yet equipped to realise it. At the time that the struggle for women's entry into the *Ecole des Beaux-Arts* became most concentrated, so a rhetoric evolved which sought to fight the campaign within the terms of the dominant order. It was as women who wished to remain women that the *sociétaires* canvassed support.

In a typical speech made at the banquet of the tenth anniversary of the *Union*, Mme Bertaux appealed to her 'sisters of the brush' in terms of their womanliness, conceived as essence, as social role and as artistic mission:

Let us remain women in society, in the family; let us show that one can be an artist, and even a great artist, without ceasing to fulfil the sum of duties which is our glory and our honour. Let us remain women: from an artistic point of view as well; let us not imitate our masters, let us create in accordance with our own feelings. Even with the intention of equalling them, let us not copy masterpieces, let us give birth to an art which will carry the mark of the genius of our sex; let us remain woman, let us remain artists, let us remain united.[44]

In this invocation, we have come full circle to the fear of imitation, the dread of derivativeness, by which ambitious woman artists were haunted and with which this chapter began. Many of them, like their critics, believed that it was their mission to express their difference in their art. How that difference was defined and valued was open to dispute. There is no trace of women arguing for an untutored naturalness as their greatest strength. Most who had ever tried to make art knew that they were dealing with a system of signs, techniques and conventions which had to be learned. They never underestimated this task and the records that they left frequently allude to the patience and stamina which was demanded for excellence to be achieved.[45] Nor were they content to be relegated to the realm of amateurish dabbling, domestic production and the circu-

lation of their work in the domestic sphere alone.[46] The identity of artist entailed public exhibition, acknowledged rites of passage and as many sales as possible. To this world of professionalism and perserverence, women, they maintained, could bring some special qualities, qualities which they valued not only as suitable 'feminine' attributes, but as virtues which society had disparaged and demeaned at its peril. The flowering of an *art féminin* was not, in their view, an overblown and impossible fantasy of female egoism, but a Utopian vision which entailed the valourising of women's talent and the flowering of a feminine culture long stifled by men's selfish monopolisation of resources and arrogant self-aggrandisement.

In the name of patriotism, history, and progress, the leaders of the *Union des Femmes Peintres et Sculpteurs* conducted their campaigns and formulated their rhetoric, convinced of the belief that they had in their power the means to save both women and France. Paradoxically, it was through a sorority of creative artists that the fatherland would be both preserved and improved. United as 'sisters of the brush', they could fight their battles, withstand hostility and dream of the promised land.

# Notes

## INTRODUCTION

1. For feminist critiques of this account of Paris, see
Adler (1989); Pollock (1988); Wolff (1985).

## CHAPTER 1: VISION AND DIVISION IN THE SISTERHOOD OF ARTISTS

1. Quoted in Lepage (1911), p. 47.
*Note*: This book is a revised version of my doctoral
dissertation: '"Sœurs de pinceau": The Formation
of a Separate Women's Art World in Paris, 1881–
1897', University of London, 1991.
2. See letter from Rosa Bonheur to the *Union* quoted
in Charles de Feir, 'Banquet des femmes peintres &
sculpteurs', *Moniteur des arts* (1895), p. 110.
3. See *Journal des artistes*, no. 5 (2 February 1883),
p. 3, and V. Demont-Breton, 'La Femme dans
l'Art', *Journal des artistes*, no. 28 (12 July 1896),
p. 1513. See also the catalogue for the 1896 exhi-
bition.
4. See the police authorisation of 13 December 1888,
as published in the *Journal des femmes artistes*, no.
1 (December 1890), p. 3. For regulations relating
to societies and clubs, see the dossier D/B 228,
Archives de la Préfecture de Police.
5. See 'Union des Femmes Peintres et Sculpteurs au
Palais des Champs-Elysées', *Moniteur des arts*, no.
1627 (11 December 1885), p. 378; *Moniteur des
arts*, no. 1688 (17 December 1886), p. 406;
*Chronique des arts*, no. 14 (2 April 1892); *Jour-
nal des femmes artistes*, no. 30 (18 June 1892),
p. 1.
6. *Journal des artistes*, no. 23 (8 June 1883), p. 5.
7. See J. Gerbaud, 'La Bibliothèque de l'Union', *Jour-
nal des femmes artistes*, no. 18 (15 November
1891), p. 1.
8. *Statuts: Société de L'Union des Femmes Peintres et
Sculpteurs*, (aûtorisée par décret du 13 décembre
1888), p. 6.
9. See Lami (1914), pp. 108–11; Lepage (1911), pp.
21–38.
10. Lepage (1911), p. 46.
11. Quoted in *Moniteur des arts*, no. 1627 (11 Decem-
ber 1885), p. 378. This idea was reaffirmed by
Jules Gerbaud in his review of the tenth exhibition.
He commented on Mme Bertaux's assertion that
not all exhibits would be immortal, as the aim of

the *Union* was to be 'une œuvre de duration et de
solidarité en même temps que de rénovation
sociale et artistique', 'L'Art de la femme', *Journal
des femmes artistes*, no. 9 (1 April 1891), p. 3.
12. 'les progrès des anciennes et l'éclosion des jeunes.'
*Journal des femmes artistes*, no. 13 (June 1891),
p. 2.
13. See Charles de Feir, 'Exposition de l'Union des
Femmes Peintres et Sculpteurs', *Moniteur des arts*,
no. 1579, (27 February 1885), p. 61.
14. Lepage (1911), pp. 67–8, lists the expenses in 1888
as 1,400 francs for installation, 1,867 francs for
the tapestry maker, 1,1867 francs for joinery, 200
francs for a turnstyle and 575 francs for two
large partitions. It is clear that no expense was
spared.
15. Although the transformation of a public exhibition
space into one that resembled an elegant domestic
interior became common practice for private exhi-
bitions in the 1880s, critics did not hesitate to link
the domestication of these spaces with the 'femi-
ninity' of the artists whose work was on display.
For some this was a suitable extension of their
femininity, for others an indication of their true
vocation as tasteful homemakers rather than pub-
lic professionals. For a discussion of the
privatisation of public exhibition spaces in general
in this period, see Ward (1991), pp. 599–600. For
specific comments on the domestication of the
*Union* exhibitions, see Franck-Lhubert, 'Exposi-
tion de l'Union des Femmes', *L'Artiste* (5 February
1882), p. 219.
16. 'Chez les femmes artistes, les bonnes places ne
sont pas accaparées par les membres du jury. Il n'y
a pas d'intrigues d'atelier, pas d'escamotages de
médailles. La cimaise est aux belles œuvres sans
distinction de signature, et le succès est au talent,
d'où qu'il vienne. Les Débutantes ne sont pas
exclues, mais encouragées, et après avoir exposé
d'abord des essais souvent médiocres, elles
travaillent avec plus d'ardeur et on les voit bientôt
apporter des œuvres sérieuses qui prennent rang
parmi celles de leurs aînées.' 'Les Femmes peintres
et sculpteurs', *L'Art français*, no. 95 (16 February
1889), p. 1.
17. For a wide-ranging discussion on the politics of
display during this period, see Ward (1991).
18. F. Fertiault, 'IXe Exposition des femmes peintres et
sculpteurs', *Moniteur des arts*, no. 1879 (28 Febru-
ary 1890), p. 65. Directives on display were writ-
ten into the exhibition rules. See 'Société de

l'Union des Femmes Peintres et Sculpteurs, 4e Exposition annuelle [1885] Reglement', Article 4, *Moniteur des arts*, no. 1574 (23 January 1885), p. 27. The early hanging policy is described by Lepage (1911), p. 64. The idea of harmonious placement rather than strict alphabetical grouping of exhibits was later picked up by the *Société Nationale des Beaux-Arts* at its annual *Salon*. See Aquelino (1989).

19. Mme Alice Guyard-Charvey, 'Causerie sur le placement des œuvres d'art dans une exposition', *Journal des femmes artistes*, no. 44 (January 1894), p. 7.

20. See, for example, F. Fertiault, 'Union des Femmes Peintres et Sculpteurs', *Moniteur des arts*, no. 2005 (4 March 1892), p. 73.

21. F. Fertiault, 'Union des Femmes Peintres et Sculpteurs', *Moniteur des arts*, no. 2221 (7 February 1896), p. 53.

22. See the statutes published in the *Journal des artistes*, no. 5 (2 February 1883), p. 2. Membership fees were adjusted periodically in the early years. See the *Gazette des femmes*, no. 2 (23 January 1882), p. 1; *Journal des artistes*, no. 46 (20 November 1887), p. 363; C. Yriarte, 'Beaux-Arts', *Le Figaro* (27 February 1893), p. 2. The fee for membership of the *Union* was relatively low. The annual fee for the *Cercle artistique et littéraire*, of the rue de Volney, founded in March 1881, was set at 100 francs per annum. See 'Cercle artistique et littéraire', *Annuaire de 1894–1895*, p. 22. The *Cercle des arts libéraux* charged the same fee. See V. Champier, *L'Année artistique (1880–1881)*, Section VII 'Sociétés diverses des beaux-arts'.

23. See the 'Règlement de l'Exposition des femmes peintres et sculpteurs', Article 8, *La Citoyenne*, no. 93 (February 1885), p. 4; 'Règlement de l'exposition de 1887', Article, 7, *Moniteur des arts*, no. 1693 (21 January 1887), p. 19.

24. See *Journal des artistes*, no. 5 (2 February 1883), p. 2; 'Statuts', *Journal des femmes artistes*, no. 1 (December 1890), p. 1. Lepage (1911), p. 62, stressed what he saw as the friendship and solidarity among women's organisations as compared with the rivalry and disputes among men.

25. E. Cardon, 'Causerie', *Moniteur des arts*, no. 1818 (22 February 1889), p. 57.

26. J. Alesson, 'La Troisième Exposition de l'Union des Femmes Peintres et Sculpteurs', *Gazette des femmes*, no. 5 (10 March 1884), p. 35.

27. A. Wolff, 'L'Union des Femmes Peintres et Sculpteurs', *Le Figaro* (24 February 1885), p. 1.

28. C. Bigot, 'Les Petits Salons artistiques', *La Revue politique et littéraire*, no. 9 (4 March 1882), pp. 280–1.

29. The *Journal des artistes* wrote of 'a strict selection' in the exhibition of 1884. See no. 19 (9 May 1884), p. 2.

30. Langley, 'Exposition des femmes peintres et sculpteurs', *Journal des artistes*, no. 8 (21 February 1886), p. 57; E. Cardon, 'Septième Exposition de l'Union des Femmes Peintres et Sculpteurs', *Moniteur des arts*, no. 1759 (March 1888), p. 65.

31. 'Statuts', Article 16, *Journal des femmes artistes*, no. 5 (1 February 1891), p. 1.

32. *Journal des femmes artistes*, no. 5 (1 February 1891), p. 1.

33. *Journal des femmes artistes*, no. 5 (1 February 1891), p. 1.

34. See Demont (1927) *passim*; Yeldham (1980) pp. 370–2; Demont-Breton (1926) *passim*.

35. These debates are covered in numerous articles in the *Journal des femmes artistes* in 1893 and 1894. See specifically no. 3 (21 January 1894), p. 445.

36. Mme Demont-Breton's letter of resignation was published in the *Journal des femmes artistes*, no. 44 (January 1894), p. 1. She had initially published it in a newspaper which was generally hostile to the *Union*'s aims, an event which upset many *sociétaires* who believed that the controversy was a domestic matter and that it was not in the interests of women's art to have it widely publicised. It is clear, though, that Mme Demont-Breton perceived of the wider art world rather than the members of the *Union* as her primary audience. The correspondence between Mme Demont-Breton and the *Union* was published in *L'Art français*, no. 349 (30 December 1893), and *L'Art français*, no. 351 (31 January 1894).

37. *Journal des femmes artistes*, no. 44 (January 1894), p. 1.

38. *Journal des femmes artistes*, no. 44 (January 1894), p. 4. This argument had been countered by Mme Aron-Caën in an earlier article when she asserted that the inclusion of prize-winners and those who had exhibited five times assured the standard of the jury. *Journal des femmes artistes*, no. 43 (December 1893), p. 3.

39. 'L'Exposition des femmes artistes à la Galerie Georges Petit', *Journal des artistes*, no. 5 (29 January 1893), p. 37; 'Exposition de femmes artistes', *Moniteur des arts* (1895), p. 470.

40. *Journal des femmes artistes*, no. 51 (December 1894), p. 1.

41. *Journal des femmes artistes*, no. 50 (November 1894), p. 2.

42. Mme Demont-Breton's speech was printed in full in the *Journal des femmes artistes*, no. 51 (December 1894), p. 1.

43. *Journal des femmes artistes*, no. 74 (November 1896), p. 2.

44. *Journal des femmes artistes*, no. 65 (February 1896), p. 2.

## CHAPTER 2: AMIDST 'A VERITABLE FLOOD OF PAINTING'

1. Substantial parts of this chapter were first published in Garb (Spring 1989).

2. A. Bagnières, 'Première Exposition de la Société Internationale des Peintres et Sculpteurs', *Gazette des beaux-arts*, vol. 27 (1883), p. 187.

3. *Journal des artistes*, no. 1 (10 May 1882), p. 1.

4. See Angrand (1965), p. 34. The 'Indépendants' eliminated jury selection at their exhibitions. Women held no membership of the organisation

until 1895, when Mme Philibert became one of the fourteen members. There were no women on the committee or the '*commission de placement*'. In 1899, there were two women amongst its members. See Yeldham (1984), vol. 1, p. 86.

5. The familiar art historical construction which would create a neat division of the institutional network of the early years of the Third Republic into the heroic avant-garde, with its innovative pictorial practices and independent exhibition forums on the one hand, and the repressive State with its academic aesthetic prescriptions and subsidised institutions on the other, has been repeatedly shown to be a misrepresentation of the complexity of the artistic field during this period. Such a characterisation which is typical of modernist accounts like that of John Rewald (1973), rests on too monolithic a construction of State power on the one hand, and too loose a reading of the autonomy of independent art practices on the other. Critiques of the modernist perspective include Boime (1971); Genet-Delacroix (1985); Genet-Delacroix (1986); Bouillon (1986); Vaisse (1980) pp. 258–346; Orwicz (1991).

6. See Orwicz (1991), pp. 572–4.

7. The traditional modernist narratives construct a linear progression from the heroic *Salon des Réfuses*, through the Impressionist exhibitions to the *Salon des Indépendants*, seeing these as beacons of light in an otherwise murky and regressive artistic field. Even a cursory glance at the catalogues for these exhibitions indicates that this is a falsely homogeneous picture. See Wildenstein (1965), p. 133. For a discussion of the diversity of works on show at the 'Impressionist' exhibitions, see Adler (1989). For a characteristic reading of the *Salon des Réfuses* as forerunner to subsequent independent exhibition initiatives, see Boime (1969), pp. 411–23. For alternative readings of the *Salon des Réfuses* see Green (1986), pp. 312–47; Vaisse (1980) pp. 258–346. For contemporary press speculation on the relationship between the 'Indépendants' and the 'Réfuses', see Angrand (1965) pp. 43–4.

8. Genet-Delacroix (1985), pp. 106–8.

9. Pierre Vaisse (1980), pp. 4–48, anxious to redeem the leaders of the Third Republic from what he presented as the unfair tendency to see them as philistine and doctrinaire in their arts policies, drew attention to the Republican fostering of a diversity of practice and preference, and exposed the oversimplification and distortion of the view of the period as characterised by an heroic avant-garde battling against an inflexible establishment. Identifying with contemporary Republican rhetoric, Vaisse reads the encouragement of independence of artists by the State as emblematic of the liberal and facilitating attitude of the *régime*, which in his view, fostered a heterogenous art community. For more critical analyses of the relationship between bourgeois individualism and the Republican State, see Green (1987), pp. 71–84 and Genet-Delacroix (1985), pp. 105–120.

10. See Vaisse (1980), p. 172.

11. See Levin (1986); Genet-Delacroix (1985) and Vaisse in Haskell (1981); Green (1987), pp. 71–3. Orwicz (1991). For a discussion of the rituals and representations of Republicanism see Nora (1984); Musée du Petit Palais (1986); Musée du Petit Palais (1989).

12. 'L'Etat a besoin de l'art pour travailler avec lui à l'éducation du goût et de l'esprit public, pour faire pénétrer dans le sein des masses, avec le sentiment du beau un esprit de paix, d'ordre et de progrès.' L. de Ronchaud, 'De l'encouragement des beaux-arts par l'Etat', *La Nouvelle Revue* (1 March 1885), p. 132.

13. See Jules Ferry's ideas for a public art extolling the virtues of a post revolutionary art, in Orwicz (1991), p. 581.

14. For a discussion of the varying views within Republican circles as to how this should be achieved, see Orwicz (1991), pp. 574–83.

15. See Vaisse (1980), p. 172. For a detailed account of the 1863 reforms of the *Ecole des Beaux-Arts*, see Boime (1977), pp. 1–39.

16. L. de Ronchaud, 'De l'encouragement des beaux-arts par l'Etat', *La Nouvelle Revue* (1 March 1885), p. 138. For a discussion of these reforms, see M. Orwicz (1991) p. 578–584.

17. See Proust (1892), p. 11.

18. Arguments for drawing as a core element in education were widespread. See, for example, Say and Chailley (1891), p. 178. See also Levin (1986), pp. 77–92; Vaisse (1980), pp. 169–257.

19. On the gendering of the project to create 'petits musées d'art scolaire' in the nation's classrooms, see Orwicz (1991), pp. 576–7. For an explicit statement on the gendering of 'l'art industriel', see de Ronchaud (1885), p. 134. For a discussion of the way in which the image of 'Marianne' can be used as an indicator of shifting positions within Republicanism, see Agulhon (1979). For a critique of the sexual politics of this text, see Rifkin (1983), pp. 368–73. For a brief discussion on the Republican discourse on 'femininity' see Bellet (1979), pp. 19–28. For the gendering of Republican art educational practice, see Nesbit (1992).

20. For a summary of these debates from the point of view of someone who believed that the State should retain control over some exhibitions, see Boussu (1877), pp. 94–100. Although sympathetic to the arguments of the anti-monopolists who were against State control on any front, Boussu believed that the competition which was set up between State-sponsored exhibitions, whose awards were highly prized, and other private societies and organisations, would be beneficial for standards. (See p. 100.) He therefore encouraged the co-existance of exhibitions sponsored and organised by the State with other private initiatives. (See p. 119.)

21. The State made annual purchases, and a special viewing day for State officials was held prior to the opening of the Salon to the public. The purchasing of works for the national collection of modern art housed in the Luxembourg Museum was thought of as one of the prime responsibilities of the State

in its task of forging a new identity for the secular Republic. The visual arts were regarded as one of the key sites for the formation and consolidation of the notion of a national culture. In the interests of the preservation of what came to be regarded as a key constituent in the construction of a national heritage, the fine art budget always comprised a sum for acquisitions. The process of State purchasing is described in Larroumet (1895), pp. 11–20.

22. 'Le rôle de gouvernement n'est pas d'ouvrir des bazars à la vente de tableaux et de statues, mais de contribuer à la prospérité de l'art, d'en enlever le niveau et de faire par lui l'éducation du goût public', wrote L. de Ronchaud, 'De l'encouragement des beaux-arts par l'Etat', *La Nouvelle Revue* (1 March 1885), p. 146.

23. See Vaisse (1980), p. 294. The conflict between the Salon as a site for the display of merchandise on the one hand, and objects of great national glory on the other, was evident in debates in the 1870s and throughout the 1880s. A critic by the name of Perignon had already identified this conflict in 1866. See Vaisse (1980), p. 292. To assure that both aspects of art-exhibiting could be catered for, the administration proposed that the two kinds of exhibition should co-exist: the one would be open annually to artists, the other, a more retrospective form of exhibition, would be more strongly directed by the State and would only take place every three years. For the rules of the triennial exhibition, see *Moniteur des arts*, no. 1276 (January–April 1879), p. 1. The first and only triennial exhibition opened on 15 September 1883. The following one was cancelled because of the protests of artists who felt that it offered unfair competition to the *Salon* of the *Société des Artistes Français*. See Vaisse (1980), pp. 331–2.

24. By a ministerial decree of 27 December 1880, all artists who had exhibited at least once at the Salon were asked to attend a meeting to be held on 12 January 1881 where they would elect a committee of 90 members to collaborate with the *Beaux-Arts* administration in the organisation of the 1881 Salon. On 17 January, an official announcement was made to the members of the committee that the State would hand over the organisation of the Salon to them as the elected representatives of contemporary artists. See Vaisse (1980), pp. 277–9. For a detailed history of the formation of the *Société des Artistes Français* from the point of view of the Republican administration, see *Annuaire de la Société des Artistes Français (1887)*, pp. 3–11. See also Mainardi (1992), published since submission of the 'Sisters of the Brush' manuscript.

25. The official history of the *Société* put it: 'pour donner satisfaction au voeu du Conseil Supérieur, l'administration n'interviendrait plus dans les Salons annuels, mais qu'elle en remettrait la gestion libre et complète, la gestion matérielle et artistique, à tous les artistes français, l'expérience ayant suffisamment démontré ... qu'il n'y avait pas de transaction possible entre la gestion complète de l'Etat ou la gestion libre par les artistes'. *Annuaire de la Société des Artistes Français (1887)*, p. 5.

26. This was tempered by the protectionism implicit in the priority given to State purchases; although on the surface this was antithetical to professed Republican claims for the self-regulating functions of a free market economy, it was nevertheless consistent with its policies in other industries. Although avowedly anti-monopolist, the State saw its role as a regulating body, balancing the needs of capitalists with protection of the national interest and the rights of the individual. The debates over monopolism and the eventual move towards the embracing of the interests of monopoly capitalists which came to be identified with the national good is charted in Elwitt (1975), pp. 123–65.

27. It was the elected *Conseil Supérieur des Beaux-Arts* who decided on awards whilst the Academy still had jurisdiction over the *Prix de Rome*. See Ferreol, 'Causerie – l'art officiel', *L'Art français*, no. 425 (15 June 1895), p. 1.

28. The immediate issue on which the split focused was the status given to awards at the recently held *Exposition Universelle*. Meissonier and his supporters believed that, in the name of patriotism (the exhibition having been organised by the State), those artists, including foreigners, who had been honoured at this exhibition should be given the status of *hors concours* at the Salon itself. This was opposed by the organising committee of the *Société des Artistes Français* and led to the resignation of Meissonier, Puvis des Chavannes, Carolus Duran, Cazin, Dagnan-Bouveret, Duez, Gervex, Roll, Waltner and others, who constituted some of the most well-known and prestigious members of the artistic community. For Meissonier's letter of resignation, see 'La Société des Artistes Français', *L'Art français*, no. 141 (4 January 1890). For a discussion of the formation of the new exhibiting society, see Hungerford (1989), pp. 71–7.

29. See Vaisse (1980), pp. 339–43.

30. 'La légende de l'artiste au paletot râpé, le chapeau défoncé, les souliers éculés, est une bonne histoire qui ne tient plus debout ... Dans notre société, les artistes sont gâtés, honorés et largement rétribués. Qu'il y en ait qui meurent de faim, hélas! c'est bien possible. Mme Boucicaut était une riche commerçante qui a ramassé des millions; a coté d'elle, riche marchande d'étoffes, il y a la marchande de mouron. Elles sont toutes deux commerçantes ... Entre Meissonier qui vend son tableaux 100,000 francs et un pauvre rapin qui fait de la peinture au mètre courant, il y a la même différence que nous trouvons entre la marchande de mouron et la riche marchande de tissus.' Un artiste, 'Le Salon', *La Citoyenne*, no. 132 (May 1888), p. 2.

31. See Ward (1991) p. 599.

32. For information on the art market in the nineteenth century see Green (1987); H. and C. White (1965); Moulin (1972); Vaisse (1983).

33. M. Deraismes, 'Les Femmes au Salon', *L'Avenir des femmes*, no. 142, (3 September 1876), p. 135.

34. 'Le Salon', *Moniteur des arts*, no. 1319 (23 April 1880), p. 2.

35. For detailed statistics see J. Alesson, 'Salon de

1882', *Gazette des femmes*, no. 9 (10 May 1882), p. 65.

36. The rewards were recorded by J. Alesson. See for example, 'Salon de 1877', *Les Gauloises*, no. 32 (18 May 1877), p. 2 and 'Salon de 1882', *Gazette des femmes*, no. 9 (10 May 1882), p. 65.

37. J. Alesson, 'Salon de 1882', *Gazette des femmes*, no. 10 (25 May 1882), p. 73. Hoschedé (1882), p. 9, commented on the effect that the strict admissions policy in 1882 had on women: 'le nombre des œuvres à accepter, fixé par la commission des artistes, étant plus restreint que jamais. Cette décision sévère . . . sera surtout cruelle pour les femmes, dont les envois sont toujours nombreux dans la section des dessins, fusains, aquarelles, peintures sur porcelaine et émaux.'

38. J. Alesson, 'Salon de 1883', *Gazette des femmes*, no. 9 (10 May 1883), p. 67

39. Un artiste, 'Les Femmes au Salon', *La Citoyenne*, no. 146 (July 1889), p. 1

40. Un artiste, 'L'Art féminin en 1894', *Journal des Femmes*, no. 36 (December 1894), p. 3.

41. 'L'Art féminin en 1895', *Journal des femmes*, no. 43 (July 1895), p. 1.

42. J. Alesson, 'La Seconde Exposition de l'Union des Femmes Peintres et Sculpteurs', *Gazette des femmes*, no. 4 (25 February 1883), p. 26.

43. This point is made by J. François, 'Après le Salon', *La Citoyenne*, no. 74 (5 August 1883), p. 2.

44. 'A tort ou à raison, elles ont jugé qu'au Salon les artistes hommes s'arrogent la part du lion et traitent les travaux de femmes avec trop de dédain.' 'Union des Femmes Peintres et Sculpteurs', *Gazette des femmes*, no. 2 (25 January 1882), p. 1.

45. 'Ces dames ont bien raison, elles qui sont exclues de l'Ecole des Beaux-Arts; elles qui ne font pas partie du jury chargé d'apprécier les œuvres du Salon doivent faire une exposition des œuvres de leur sexe à part de celle des hommes.' 'Echos', *La Citoyenne*, no. 47 (2–8 January 1882), p. 3.

46. 'Les femmes ont raison de se coaliser de la sorte, car on les sacrifie vraiment trop dans les Salons organisés par les hommes.' A. Wolff, 'Peinture et peintres', *Le Figaro* (16 February 1883), p. 1. For a contemporary feminist account of Wolff's views on women see Louis Koppe, 'La Femme et M. Albert Wolff', *La Femme dans la famille et dans la société*, no. 22 (26 September–3 October 1880), p. 2.

47. Franck-Lhubert, 'Chronique des lettres et des arts', *L'Artiste* (February 1883), p. 147.

48. 'Ce qui échappe au public, c'est le mode qui préside à la distribution des récompenses: la camaraderie, la coterie y sont le plus souvent en faveur. Aussi, tel membre du jury donnera sa voix pour telle œuvre, sous condition que son collègue lui rendra la réciprocité, et alors comme généralement ces pauvres femmes n'ont ni le bonheur ni l'honneur de travailler sous la direction d'un maître, elles se trouvent délaissées . . . suffit-il d'avoir une œuvre bien étudiée, bien rendue pour obtenir une récompense? Assurément non: il faut davantage, il faut qu'une voix s'élève en votre

faveur, vous désigne à l'attention, vous défende devant le jury'. Jacques, 'Aux Beaux-Arts', *La Citoyenne*, no. 78 (5 November–2 December 1883), p. 3.

49. 'Le Jury du Salon', *Moniteur des arts*, no. 1524 (21 March 1884), p. 89.

50. *Journal des artistes*, no. 49 (21 December 1890), p. 392.

51. For a summary of these developments, see *Journal des femmes artistes*, no. 9 (1 April 1891), p. 2; *Journal des femmes artistes*, no. 10 (15 April 1891), p. 2.

52. *Le Féminisme chrètien* (1897), p. 64.

53. For a documentation of the gradual changes in the laws regarding '*réunions publiques*', see Archives de la Préfecture de Police, dossier D. B/228.

54. For information on Baron Taylor's organisation, see Maingot (1963). For information on the *Société nationale des Beaux-Arts*, see M. de Seigneur 'L'Art et les artistes au Salon de 1882', *L'Artiste*, vol. 1 (1882), p. 551. De Seigneur chronicles the history of small exhibitions from the late eighteenth to the late nineteenth centuries. For a brief discussion on Martinet and Baron Taylor, see Bouillon (1986), p. 93.

55. See Ward (1991). For the various exhibitions held at Durand Ruel's premises, see M. du Seigneur, 'L'Art et les artistes au Salon de 1882', *L'Artiste*, vol. 1 (1882), pp. 552–5. Georges Petit's exhibition space was equally sought after. See A. Baignères, 'Société d'Aquarellistes Français', *Gazette des beaux-arts*, vol. 25 (April 1882), p. 434.

56. *Moniteur des arts*, no. 1304 (9 January 1880), p. 2.

57. Agulhon (1977), pp. 17–18.

58. Agulhon (1977), pp. 47–57. In Agulhon's words, 'le cercle s'oppose . . . au salon comme une sociabilité purement masculine à une sociabilité incluant hommes et femmes.'

59. Agulhon (1977), p. 52.

60. Entry for 'cercle', *La Grande Encyclopédie*, p. 16.

61. Dame Pluche, 'Chronique', *Gazette des femmes*, no. 21 (10 November 1883), pp. 161–2.

62. 'Notre programme', *Le Moniteur des cercles*, no. 1 (December 1879), p. 1.

63. 'Les dames ne fréquentent pas les cercles, et cela est fort heureux pour elles: car, si elles y étaient admises, elles y contracteraient sans doute les habitudes déplorables que nous y prenons; elles joueraient aux cartes certainement fumeraient peut-être de gros cigares aussi chers que détestables'. H. Gourdon de Genouillac, 'Les Cercles des dames', *Gazette des femmes*, no. 19 (10 October 1882), p. 148.

64. *Moniteur des arts*, no. 1301 (19 December 1879), p. 1.

65. 'une réunion aristocratique de gens qui s'ennuient dans leurs familles et qui veulent en sortir sans se mêler à la foule, au peuple, dont tous les lieux publics sont aujourd'hui encombrés.' Larousse, *Grand Dictionnaire du dix-neuvième siècle*, p. 754.

66. For a detailed discussion of this *cercle*, see Yriarte (1864), pp. 9–55.

67. *Moniteur des cercles*, no. 3 (23 December 1879),

p. 1.

68. 'Assurément, l'habitude introduite par les cercles de quitter sa femme et sa famille, pour aller passer, avec des indifférents ou autour d'une table de jeu les seuls moments dont on dispose, est une habitude qu'on peut qualifier d'immorale; mais il faut reconnaître qu'à côté de la facilité qu'offre le cercle aux gens de plaisir de s'absenter trop souvent de chez eux, il a aussi un but utile; outre qu'il met à même de se voir et de s'apprécier des hommes qui ont des opinions et des aspirations très diverses et qu'il contribue ainsi à soustraire les idées à l'horizon trop étroit des intérêts de la famille, c'est au cercle que le commerçant peut rencontrer les renseignements dont il a besoin sur la solubilité d'un acheteur, sur le prix de certaines marchandises.' Larousse, *Grand Dictionnaire du dix-neuvième siècle*, p. 753. For a discussion of the dictionary as a site for the formation of Republican ideology, see Ory (1984) pp. 229–46.

69. M. d'Orcagne, 'Les Petits Salons de peinture', *La Nouvelle Revue*, vol. 15 (March–April 1882), p. 421.

70. R. Ménard, 'Le Cercle des beaux-arts', *Gazette des beaux-arts*, vol. 5 (May 1872), p. 438.

71. L. Enault, 'Exposition des aquarellistes', *Moniteur des arts*, no. 1312 (5 March 1880), p. 1.

72. C. Yriarte, 'L'Exposition du Cercle Volney', *Le Figaro* (26 January 1892). For an interesting discussion of diverse exhibition venues during this period, see Ward (1991).

73. For representative views see *La Nouvelle Revue*, vol. 15 (1882), pp. 421–3; *Bulletin hebdomadaire de l'artiste*, no. 2 (19 March 1882); *Revue des deux-mondes*, vol. 38 (1880), pp. 193–202; *Le Figaro* (6 February 1882), p. 1; *Chronique des arts*, no. 48 (November 1882), p. 569; *Gazette des beaux-arts*, vol. 31 (May 1885), pp. 437–49; *Journal des artistes*, no. 20 (1 December 1882), p. 1; See also the decidedly negative views of H. Havard in 'L'Exposition des aquarellistes', *Le Siècle* (21 February 1883), p. 2. He was still expressing disapproval almost ten years later; see *Le Siècle* (1 February 1892).

74. See A. Wolff, 'Les Expositions dans les cercles', *Le Figaro* (6 February 1882), p. 27. For a similar view, see G. Dargenty, 'Exposition de peinture du cercle artistique de la Seine', *Chronique des arts*, no. 48 (November 1882), p. 569.

75. de Thauriès, 'L'Exposition du cercle des arts libéraux', *Bulletin hebdomadaire de l'artiste*, no. 2 (19 March 1882).

76. For the rules and principles of this organisation, see *Moniteur des arts*, no. 1987 (27 November 1891), pp. 859–60.

77. *Moniteur des Arts*, no. 1390 (16 December 1881), p. 220.

78. For Morisot's exhibition and sales history see Lindsay in Edelstein (1990), pp. 79–90. See also Garb (1986); Mathews (1984).

79. Gonzalès showed the pastel *Une Modiste*. For a review including the names of many of the women who showed at the rue de Volney, see 'L'Exposition des Femmes Artistes', *Moniteur des*

arts, no. 1404 (24 March 1882), pp. 2–3. The exhibition included some of the most famous women artists of the time, such as Madeleine Lemaire, Rosa Bonheur and Louise Abbéma.

80. 'Je ne comprends pas que les femmes aient leurs expositions à elles, car c'est vouloir dire: Nous ne sentons pas le courage de concourir avec les hommes', *L'Eclair*. Republished in F. Herbet, 'Louise Abbéma et la solidarité féminine', *Journal des femmes artistes*, no. 12 (15 May 1891), p. 2. For Abbéma's response, see *Journal des femmes artistes*, no. 13 (June 1891), p. 4.

81. 'Presque tous les peintres, presque tous les sculpteurs de quelque talent, font partie d'un ou deux grands cercles, fort bien posés, très en vue, et organisent chaque année une ou plusieurs expositions, où se pressent la foule des amateurs et dilettantes, et l'élite des gens du monde. Mais les règlements de la plupart de ces cercles n'admettent à figurer dans leurs expositions si recherchées que les œuvres de leurs membres, et comme les femmes ne peuvent en faire partie, leurs œuvres sont fatalement exclues de ces expositions. 'L. Enault, Henry IV (7 August 1881), reprinted *in Journal des femmes artistes*, no. 1 (December 1890), p. 2.

82. 'je trouve que la position faite aux femmes est vraiment rigoureuse ... les expositions officielles tomberont bientôt dans une sorte de discrédit que plusieurs causes rendent inévitable. Les expositions particulières deviendront donc de jour en jour plus intéressantes et plus avantageuses, et n'en pouvoir profiter sera une cause d'infériorité réelle pour les victimes de cet ostracisme sans raison. Et ces victimes ce sont les femmes.' *ibid*.

83. 'Ces expositions particulières, qui généralement précèdent de quelques semaines l'exposition officielle et publique des Champs-Elysées, sont comme une carte de visite que nos sculpteurs et nos peintres à la mode mettent à la portée du public; ils attirent ainsi une première fois l'attention sur leurs œuvres, et on les revoit avec plus de plaisir quand on les retrouve au Salon.' L. Enault, 'Le Monde et les arts', *Le Papillon*, no. 27 (23 October 1881), p. 210.

84. 'Tout y fusionne: les grands artistes, les grands seigneurs, les gens d'esprit. La plupart des peintres en renom font partie du Mirliton, ce qui permet d'y organiser des expositions qui, pour être moins officielles que celle du Palais de l'Industrie, n'en ont pas moins de succès.' *Gazette des femmes*, no. 21 (10 November 1883), p. 162.

85. C. Yriarte, 'Douzième Exposition de l'Union des Femmes Peintres et Sculpteurs', *Le Figaro* (27 February 1893), p. 2.

86. 'ces messieurs qui formés en petits groupes, organisent de petites mais fortes interessantes expositions dont nous sommes généralement exclues.' Reported in the *Journal des artistes*, no. 49 (7 December 1883), p. 2.

87. 'Une force ignorée, méconnue, retardée dans son essor est celle de la femme artiste! Une espèce de préjugé social pèse sur elle, et, cependant, chaque année, le nombre des femmes qui se vouent à l'art, va grossissant, avec une rapidité effrayante: je dis

effrayante parce que nos institutions ne faisant rien encore pour la grande culture de ces intelligences en ardent travail, les résultats de tant d'efforts sont souvent impuissants ou ridicules . . . Doit-on en tirer, la conclusion que les femmes doit s'abstenir ou se résigner à occuper parmi les artistes une place inférieure? Ce n'est pas ma pensée. Là où il y a sentiment et volonté de l'exprimer, il y a une force vive qu'un pays ami du progrès n'a pas le droit de méconnaître ou de laisser inactive. Nous sommes cette force, et, pour la démontrer jusqu'à l'évidence, nous allons nous grouper. Les hommes ont imaginé, pour se faire valoir, de se mettre en société, quelquefois en coterie, d'où naguère, nous étions systématiquement exclues. Rassemblons-nous, afin de nous compter de nous défendre! Soyons unies pour la loyale lutte! Appelons-nous 'L'Union des Femmes Peintres et Sculpteurs.' Speech reprinted in Lepage (1911), pp. 47–50.

## CHAPTER 3: FEMINISM, PHILANTHROPY AND THE FEMME ARTISTE

1. For an analysis of the changing institutional structure of the *Institut*, see Aucoc (1889). For a brief history of the *Institut* from a Republican perspective, see the entry for *Institut de France*, Larousse *Grande Dictionnaire du dix-neuvième siécle*, p. 724. For the *Académie des Beaux-Arts*, see Larousse, vol. 1, p. 44. For a history of Mme Bertaux's previous attempt at being elected to the *Institut*, see Lepage (1911), p. 207 and pp. 216–8.

2. E. Cardon, 'Les Femmes à l'Institut', *Moniteur des arts*, no. 2027 (24 June 1892), p. 227. For Cardon's views on the appropriateness of art as a career for women, see Jenan de Court (pseudonym for Cardon) 'En Belgique', *Moniteur des arts*, reprinted in *Journal des femmes artistes*, no. 24 (1 March 1892), p. 3.

3. 'Il est incontestable que si l'éminent sculpteur eût été un homme, sa nomination serait déja un fait accompli. Nous demandons aux artistes, pour qui l'idéal doit être chose sacrée, de s'élever au-dessus des distinctions de sexe comme ils se sont déjà placés au-dessus des préjugés de classe et d'honorer le ciseau qui produit des chefs-d'œuvres sans regarder si la main qui le guide est celui d'un homme ou d'une femme.' 'A l'Académie', *Journal des femmes*, no. 8 (July 1892), p. 1. The *Journal des femmes* was founded by Maria Martin after a dispute between her and the founder of *La Citoyenne*, Hubertine Auclert, in November 1891. Auclert had left Martin in charge of *La Citoyenne* while she was in Algeria. See Hause (1987), p. 147.

4. 'Quand on pense à la somme d'efforts qu'il faut à une femme artiste, médecin, avocat, littérateur ou journaliste, pour parvenir là où les hommes arrivent sans peine, ayant la route toute frayée devant eux, on se demande si elles ne méritaient plutôt une recompense double.' *ibid*. p. 1.

5. A. Marty, 'Revendications féminines', *Journal des artistes*, no. 25 (27 June 1892), p. 189. Although women had been admitted to the Académie Royale, suppressed in 1793, this institution was nothing like the *Académie des Beaux-Arts* which formed one of the five classes of the *Institut de France*. No one class was authorised to make a decision to admit women alone. This needed to go before the *Institut* as a whole. The academician William Bouguereau urged patience. There were many steps which needed to be taken before Mme Bertaux's candidacy became a crucial issue. First this had to be approved by the commission on sculpture and only if they approved would it be referred to the *Institut*. See 'L'Art et la presse', *Journal des artistes*, no. 25 (27 June 1892), p. 190.

6. The obviously privileged were wealthy aristocratic women. For a more general statement on the relative freedom which working-class women had prior to the Revolution, see de Beauvoir, (1949, English edition 1983), pp. 139–41.

7. E. Cardon, 'Les Femmes à l'Institut', *Moniteur des arts*, no. 2027 (24 June 1892), p. 227.

8. Fidière (1885).

9. 'Les Femmes artistes à l'Académie Royale de Peinture et de Sculpture', *Moniteur des arts*, no. 1619 (16 October 1885), pp. 318–9; *Moniteur des arts*, no. 1620 (23 October 1885), pp. 326–7. In 1888, *L'Art* printed a similar history but listed only fourteen 'académiciennes': *L'Art*, vol. XLV (1888), pp. 121–2. The history of women in the old Académie Royale was of great interest to the members of the *Union*. On 14 December 1890, M. Herbet delivered an address to the general assembly on this topic. This was subsequently written up in the *Journal des femmes artistes*. The theme of the relative liberalness of the Ancien Régime to women artists was continued in a subsequent article, see *Journal des femmes artistes*, no. 4 (15 January 1891), p. 1.

10. Simon's letter was printed in *Le Temps* (25 June 1892), and reprinted in *Journal des femmes artistes*, no. 29 (July 1892), p. 4.

11. For a discussion of Jules Simon's political position, see Bertocci (1978). For Simon's views on women's role, see his *La Femme du vingtième siècle* (1892). See also his 'Il faut rester femme', *La Revue*, vol. XVIII (15 July 1896), pp. 134–41 and the many editorials he wrote in the journal that he edited between 1888 and 1893, *La Revue de famille*.

12. 'A l'Académie', *Journal des femmes*, no. 8 (July 1892), p. 1.

13. 'Mme Bertaux ne veut pas d'hommes dans son exposition, mais, en revanche, elle veut au moins une femme à l'Institut, et, pour être logique jusqu'au bout, elle désire que cette femme ne soit autre qu'elle-même. C'est d'une discutable logique'. Quoted in 'L'Art et La presse', *Journal des artistes*, no. 25 (27 June 1892), p. 190.

14. Quoted in *Journal des artistes*, no. 28 (25 July 1892), p. 214.

15. See survey of women artists published in *Le*

*Monde illustré* in special dossier at the Bibliothèque Marguerite Durand. For Louise Abbéma and Madeleine Lemaire's opinions on feminism see their responses to a questionnaire published in *Moniteur des arts* (24 April 1896), pp. 193–4. Both Lemaire and Abbéma were cautious about women's demands for civic rights. Surprisingly for a single professional woman, Abbéma states: 'je ne vois pas la nécessité pour la femme d'obtenir des droits politiques ou civils. La femme a une mission différente, une mission suffisamment belle et grande à remplir en restant simplement mère de famille sans se créer d'inutile et oiseuses préoccupations.' Neither Lemaire nor Abbéma recognised any difficulties for women artists. Lemaire was convinced that women could, without difficulty, fulfil their roles as both artists and mothers.

16. Quoted in 'L'Art et la presse', *Journal des artistes*, no. 28 (25 July 1892), p. 214.

17. V. M. Crawford, 'Feminism in France', *Fortnightly Review*, vol. 61 (April 1897), p. 531.

18. 'On parle beaucoup des droits de la femme depuis que Mlle Jeanne Chauvin a conquis le titre de docteur en droit. Nous saurons bientôt si la cause de l'émancipation femme a fait autant de progrès qu'on veut bien le dire, quand l'Académie des Beaux-Arts se sera prononcée sur la candidature de Mme Léon Bertaux.' Quoted in *Journal des artistes*, no. 28 (25 July 1892), p. 214.

19. 'Il est probable que ceux qui ont parlé légèrement des femmes artistes ne les ont jamais fréquentées. Il est vraiment temps de mettre fin à des calomnies dénuées de fondement. Pour nous, l'admission des femmes dans le domaine des sciences, sa progression notoire dans l'art, nous sont une garantie de réforme des moeurs dans l'avenir.' M. Deraismes, 'Les Femmes au Salon', *L'Avenir des femmes*, no. 142 (3 September 1876), p. 135.

20. In 1872 Alesson founded *Le Bas-Bleu*. In one of the first issues, Jeanne (presumably a pseudonym for Alesson), distances her construction of the 'bas-bleu' from Molière's. She wishes to appropriate the term with its usual negative connotations, and to use it to affirm women's artistic and intellectual aspirations. Alesson also founded and edited the *Gazette des femmes*, a periodical dedicated to the promotion of women's intellectual and artistic endeavours. The first issue appeared in 1882. His involvement with it lasted until 1885, after which it became a less serious journal.

21. 'aux services sublimes qu'elle peut rendre par son intelligence délicate, son adresse patiente, son tact exquis, son inaltérable tendresse'. J. Alesson, 'Le Jury ouvert aux femmes', *Journal des femmes artistes*, no. 10 (15 April 1891), p. 1. By 1889, Alesson believed that women's emancipation had gone far enough. In his publication of that year, *Le Monde est aux femmes*, he argued that it was up to men to save women from the ludicrous *mascarade* which extreme feminist claims had driven them to: 'La plupart des Françaises sont d'accord: elles ne veulent ni ridicule, ni grotesque, ni mascarade'. Quoted in Decaux, (1972), vol. 2,

p. 917.

22. Albert Wolff wrote a number of articles in *Le Figaro* which demonstrate his hostility to modern feminism, arguing that whereas women did not have the the same rights as men, they also did not have the same responsibilities. For a critical account of Wolff's anti-feminism, see L. Koppe, 'La Femme et M. Albert Wolff', *La Femme dans la famille est dans la société*, no. 22 (26 September–3 October 1880), p. 2.

23. de Solenière (1985), p. 7.

24. 'maternité et ses annexes', Abbé de Sertillanges (1908) p. 110.

25. For a summary of the debate and a statement distancing the editorial board of the *Journal des femmes artistes* and the president of the *Union* from Alesson's article, see *Journal des femmes artistes*, no. 12 (15 May 1891), p. 1.

26. 'tout ce qui peut contribuer à l'émancipation de la femme, à l'amélioration de son sort, dans une société qui la considère comme une îlote, mérite d'être serieusement encouragé.' E. Cardon, 'Exposition de l'Union des Femmes Peintres et Sculpteurs', *Moniteur des arts*, no. 1819 (1 March 1889), p. 65.

27. Anon. *La Citoyenne*, no. 49 (16–22 January 1882).

28. 'Les femmes peintres et sculpteurs', *La Citoyenne*, no. 94 (March 1885), pp. 2–3.

29. C. Bigot, 'Exposition des femmes', *La Revue politique et littéraire*, vol. 3, no. 9 (4 March 1882), p. 280.

30. M. de F. 'L'Exposition annuelle de l'Association des Femmes Artistes'. *La Famille*, no. 545 (16 March 1890), p. 167.

31. 'je sais les femmes qui, pour leur affranchissement, ont mieux encore que des paroles à faire entendre; elles ont des œuvres à montré. Aujourd'hui même s'ouvre, au Palais des Champs-Elysées, la seconde Exposition de l'Union des Femmes Peintres et Sculpteurs.' J. Claretie, 'La vie à Paris', *Le Temps* (10 February 1883).

32. This point is made by Mary Cheliga in 'Les Hommes féministes', *Revue encyclopédique*, no. 169 (1896), pp. 825–31. See also Bell and Offen (1983), vol. 1, p. 38; Turgéon (1906), p. 10; Leclère (1929), pp. 46–8; Moses (1984), pp. 90–8; Moses (1982), pp. 240–67.

33. Taieb (1982), p. 9.

34. See 'La Femme et les féministes', *Revue encyclopédique*, no. 169 (28 November 1896), p. 865. See also Langlois (1979), pp. 208–10 and Hause and Kenney (1981), pp. 11–30.

35. Hermel, 'L'Exposition de peinture de la rue Lafitte', *La France libre* (27 May 1886), p. 453.

36. Quoted in full: 'car il n'est pas possible de s'adresser à l'art . . . sans avoir à ce moment-là une disposition d'esprit en quelque sorte féminine par la délicatesse de l'observation, par la ténacité de la perception, et en même temps par quelque chose de délicat, de sensible, qui se trouve surtout chez la femme; je dis que la plupart des grands artistes ont eu au moment de leurs créations les

plus belles des moments de féminisme'. *Journal des femmes artistes*, no. 77 (May 1898), p. 2.

37. 'Les hommes ne sont-ils tous essentiellement féministes? Leur aspirations artistiques les plus tendres et les plus viriles, la forme même de leur idéal ne sont-elle pas nées de leur amour pour la femme?' From a speech delivered by Mme Demont-Breton on 16 May 1898, published in the *Journal des femmes artistes*, no. 77 (May 1898), p. 2.

38. According to Klejman and Rochefort (1989), p. 57, the hopes of feminists were significantly raised by these events.

39. For discussions on feminism in the context of Republicanism, see Moses (1984), pp. 197–227; Bidelman (1975); Bidelman (1976); McMillan (1981).

40. For the economic consequences of the war see Magraw (1983), pp. 210–11. For a comparative analysis of women in public employment in Europe, see Louis Frank's comprehensive survey (1893), pp. 46–69.

41. Bidelman (1975), p. 187.

42. See Thomas (1967).

43. Throughout the century, few socialists were to place 'the woman question' as a top priority. Many socialist thinkers followed the Proudhonian model of a gendered division of labour, with women staying at home and having exclusive responsibility for performing domestic tasks. In the 1870s, women's questions were consistantly on the agenda at socialist conferences, but in 1876, for example, the resolution of the congress remained that women had the right to work provided that they did this work at home. See Boxer (1978), p. 52. Hubertine Auclert conducted concerted campaigns to put feminism onto the socialist agenda, managing in 1879 to persuade the Marseilles Congress of the *Parti Ouvrier Français* to adopt a resolution in favour of political rights for French women and complete equality of the sexes in public and private life. This established, at least temporarily, the basis for an alliance for feminism and socialism. However, the Havre congress of 1880 voted to return to the policy of the party of 1876–8, which maintained that women belonged to the home. For the relationship between socialism and feminism, see Bidelman (1982); Boxer (1977); Boxer (1978); Hause (1987); Sowerwine (1982).

44. See Moses (1982), pp. 240–67.

45. For an example of Deraismes' views on Proudhon and the early work of Alexandre Dumas, see 'Deux misogynes', *L'Avenir des femmes*, no. 132 (November 1875). For Richer's views on Proudhon, see 'Une insanité', *L'Avenir des femmes*, no. 131 (October 1875).

46. See Boxer (1981) and Gordon (1990).

47. It was not until the 1960s that the last vestiges of the legislation about women laid down in the Code were amended. (In 1904, 800 people protested at the centennial celebrations of the Code. In November of that year the government appointed a committee to study the possibility of revising the Code. But the committee consisted of sixty male members with a consulting committee of twenty-six male lawyers. Marguerite Durand who, via her feminist daily newspaper *La Fronde* had mounted a consistant attack against the Code, protested, together with Jeanne Hellé, secretary of *L'Union Fraternelle des Femmes* and Maurice Sembat, a deputy. This was to no avail. When the committee met in February of the following year, there were no women present.) See Goliber (1975), pp. 36–42.

48. For information on the Code and its implications for women see Bidelman (1975), pp. 10–11. Stanton (1910), pp. 239–61, quotes it at length to back up his contention that the Code restricted women's lives in a more extensive form than had been the case in the previous three hundred years. For a discussion of the Code as representative of the views of a class rather than those of Napoleon himself, see Albitsur and Armogathe (1977), vol. 2, p. 360.

49. For a discussion of Richer's organisation in relation to other contemporary developments, see Bidelman (1975), pp. 172–9. For a discussion of the *Code des femmes*, see *ibid*. p. 95.

50. Bidelman (1976), p. 93.

51. See Bidelman (1975), pp. 172–9, and 190–217. For a detailed discussion on the question of female suffrage during this period see Hause and Kenney (1984), pp. 1–28. For a study of Auclert's position within French feminism and her campaigns for civil disobedience, see Hause (1987).

52. See M. Deraismes, 'Une exposition particulière de l'école réaliste', *L'Avenir des femmes*, no. 116 (5 July 1874), p. 1; 'Les Femmes au Salon', *L'Avenir des femmes*, no. 140 (2 July 1876), pp. 101–3; no. 141 (6 August 1876), pp. 115–7; no. 142 (3 September 1876), pp. 132–5.

53. M. Deraismes, 'Deux misogynes', *L'Avenir des femmes*, no. 132 (November 1875).

54. 'Lorgnette', 'Exposition de Peinture et Sculpture', *La Citoyenne*, no. 13 (June 1881), p. 3.

55. She was appointed to teach flower painting, the first woman to hold a teaching position in the Museum. See Marie-Louise Néron, 'Chez Madeleine Lemaire', *La Fronde* (22 February 1898), p. 1.

56. Marie-Louise Néron, 'L'Enterrement de By', *La Fronde* (May 1899), cutting in the B.M.D., (ref: DOS BON). Among the wreaths at the cemetery was one from the feminist daily, *La Fronde*.

57. For representative press coverage of the Bashkirtseff retrospective, which was generally very favourably received, see: 'Lorgnette', 'Exposition de Peinture et Sculpture, 1885', *La Citoyenne*, no. 96 (March 1885), pp. 1–2; Jules Claretie, 'La Vie à Paris', *Le Temps* (17 February 1885); Charles de Feir, 'Exposition de l'Union des Femmes Peintres et Sculpteurs', *Moniteur des arts*, no. 1579 (27 February 1885), p. 61; A. Wolff, 'L'Union des Femmes Peintres et Sculpteurs', *Le Figaro* (24 February 1885), p. 1. An extensive collection of press criticism of her work from 1881–4 was published in the catalogue for her

retrospective, 1885. For Bashkirtseff's art criticism, see P. Orell, 'Les Femmes artistes', *La Citoyenne*, no. 4 (6 March 1881), pp. 3–4; 'Le Salon de 1881', no. 14 (16 May 1881), pp. 2–3, 'Le Salon de 1881', no. 17 (5 June 1881). For Bashkirtseff's description of Auclert and her home, see *The Journal of Marie Bashkirtseff* (1887, new edition 1985), pp. 439–41. For a discussion of Bashkirtseff's position and her strategies of self-narration, see Garb (1987–8). For a discussion of the dress practices of radical feminists in the 1890s and early twentieth century see Gordon (1990). See also Perrot (1984).

58. See Langlois (1979), pp. 187–92.

59. Flamant-Paparatti (1984), p. 20.

60. 'Virginie Demont-Breton', *La Grande Dame*, vol. 3 (1895), pp. 17–22.

61. Cheminat, 'Nos Droits', *La Tribune des femmes* (5 February 1881), p. 1.

62. For a representative statement of the position of *La Femme dans la famille et dans la société*, see no. 7 (May–June 1880); E. Cheminat, 'Notre programme sur la féodalité moderne', no. 28 (7–14 November), p. 3.

63. See for example, L. Muller, 'Chronique de l'Art, *La Femme dans la famille et dans la société*, no. 46 (26 December 1880–2 January 1881), p. 5.

64. See for example, O. Audouard, 'Les Bas Bleus', *Le Bas Bleu*, no. 1 (November 1873). Works exhibited by women artists were reviewed by the journal's critics and discussed. See no. 25 (1 April 1876), p. 1. Art schools for women were advertised, and important women's submissions to exhibitions were listed.

65. See Boxer (1975), pp. 157–81; Moses (1984), pp. 224–5.

66. See Hause (1987), p. 153.

67. For a detailed discussion of the formation and achievements of the group from the point of view of its founder, see Schmahl (1896), pp. 88–9.

68. For a contemporary view of her attraction to Schmahl's organisation, see J. Misme 'Madame La Duchesse d'Uzès', *Revue Bleu*, vol. 8 (August 1897), pp. 178–81. The Duchesse d'Uzès was to become president of the *Union* in 1900 after an initally negative response to the organisation. See her *Le Suffrage féminin au point de vue historique (1914)*, for a summary of her views.

69. See Wilkins (1975), p. 12.

70. Goliber (1975), p. 50.

71. See, for example, J. Chanteloze 'Essai historique sur les femmes peintres', *La Revue féministe*, no months in binding (1895), pp. 272–6; C. Dissard, 'Essai esthétique féminine', *La Revue féministe (1895)*, pp. 10–12; R. Sugères, 'La Femme dans l'art', *La Revue féministe* (1897), pp. 214–21.

72. See Goliber (1975), pp. 2–13.

73. 'la paysanne, l'artiste, la commerçante, la soeur de charité, etc. – symbolisant l'effort et le travail des femmes – conduites par une intellectuelle vers la lumière de la cité future', Dzeh-Djen (1939), p. 87.

74. *L'Echo littéraire de France* was subtitled 'Organe des intérêts des femmes de lettres et des femmes

artistes'. See Archives de la Préfecture de Police, dossier BA/1651, no. 90772. For a discussion on Catholic feminist journals, see Langlois (1979), pp. 208–10.

75. Marie Maugeret made her appeal to French women against Zola and Dreyfus in the name of a patriotism 'qui n'a pas de sexe'. Her arguments are couched in bald anti-Semetic terms. See 'Zola contre l'Armée française'. *Le Féminisme chrétien*, no vol. no. (25 March 1898), pp. 33–41.

76. 'Les catholiques suivent attentivement le mouvement féministe de France. Ils sont assez inquiets de voir leur échapper, petit à petit, l'élément feminin. Ils ont appris que l'on faisait des efforts pour attirer de plus en plus les femmes dans la franc-maçonnerie et ils vont de leur côté former des groupes de femmes qui auront pour mission d'enrayer ce mouvement.' Archives de la Préfecture de Police, dossier BA/1651, no. 90772.

77. For a detailed discussion of the affair, see Horvarth (1975), pp. 83–104. For a history of the relationship between the Church and girls' education from the point of view of a liberal Catholic historian, see Phillips (1936), *passim*. For a detailed analysis of the Catholic debates on women's role during this period, see Waugh (1977).

78. On the similarities between the Republican and Catholic vision of women's role, see McMillan (1981), pp. 361–76. For a response to McMillan, see Evans (1982), pp. 947–9.

79. See, for example, the claims of the Abbé de Sertillanges (1908), p. 337. Many Catholic thinkers like Turgeon (1906), p. 64, believed that 'la religion catholique a véritablement ennobli et magnifié la femme'. The Protestant journal *La Femme* expressed similar views, for example: 'Le christianisme, en créant un monde nouveau, éleva le niveau moral, celui de la femme en particulier', *La Femme*, no. 2 (15 January 1879), p. 9.

80. For a discussion of Maria Deraismes' views on women's moral superiority see Rabaut (1985), p. 39. For Comte's views on women's mental inferiority and moral superiority see his 'Social Statistics; or Theory of the Spontaneous order of Human Society' (1839), in Bell and Offen (1983), p. 221.

81. McMillan (1981), pp. 374–6.

82. See J. F. McMillan (1981), p. 375.

83. M. M., 'Notre Programme', *Le Féminisme chrétien* (1896), pp. 1–7.

84. 'L'Orphelinat des Arts', *Moniteur des arts*, no. 1397 (3 February 1882), p. 37.

85. For a history of the *Orphelinat*, see Marie Laurent, 'L'Orphelinat des Arts', *Revue des revues*. Reprinted in *Journal des femmes artistes*, no. 17 (October 1891), p. 1. The *Journal des femmes artistes* followed the activities of the *Orphelinat* keenly, covering the annual meetings and progress of the pupils. See, for example, no. 15 (August 1891), p. 1. Jules Gerbaud, editor of the *Journal des femmes artistes* had covered its activities when he was involved with *La Femme dans la famille et dans la société*, see no. 12 (4–11

July 1880), p. 3. Reports on the tombola are given in the *Chronique des arts*, no. 17 (29 April 1882).

86. G. de B., 'Portrait de Mme La Duchesse d'Uzès, par M. Jacquet', *L'Art francais*, no. 179 (27 September 1890).

87. E. Manuel, 'Un Congrès féminin', *Revue de famille*, vol. 1 (1 January 1891), p. 41. For a detailed account of the genesis of the conference see *Actes du Congrès International des Œuvres et Institutions Féminines (1889)*, p. 1.

88. 'l'immense quantité des femmes françaises... attachées à leurs devoirs de mères de famille, austère dans leurs moeurs, ardentes dans leurs sentiments, fidèles à leur Dieu, à leur honneur et à leur patri'. Reported in E. Manuel, 'Un Congrès féminin', *Revue de famille*, vol. 1 (1 January 1891), p. 41.

89. The Congress forbade any discussion of 'secte et de dogme, de politique militante et de lutte de classes'. *Actes du Congrès International des Œuvres et Institutions Féminines (1889)* p. IV. Jeanne Schmahl described the conference as follows: 'First there was the official congress, presided over by M. Jules Simon, and composed of diverse benevolent institutions under the direction of women, though but very remotely relating to the question of women's rights'. Schamhl (1896), p. 87.

90. The discussions were covered in detail in *La Citoyenne*, no. 147 (July 1889), p. 1, and no. 148 (July 1889), p. 1.

91. 'Moi, j'y saisis un trait commun, je sens notre institution sœur des vôtres, étant également fille de progrès et de la fraternité'. From Mme Bertaux's speech, reprinted in *Journal des Artistes*, no. 5 (9 February 1890).

92. See *Actes du Congrès International des Œuvres et Institutions Féminines (1889)* for a list of delegates, pp. 523–8.

93. For Simon's views on women during the period of the Congress, see his *La Femme du vingtième siècle* (1892).

94. For official publicity put out by the organising committee, see 'Congrès Français et International du Droit des Femmes', *La Citoyenne*, no. 143 (April 1889), p. 1. For a detailed account of the congress see Moses (1972), pp. 285–9 and Bidelman (1982), pp. 176–7. See also the published proceedings of the conference, *Congrès Français et International du Droit des Femmes*, (1889).

95. See Wilkins (1975), p. 16. See also the conference report published by Mme Vincent, 'Premier Congrès de la Fédération Française des Sociétés jointe à l'Union Universelle des Femmes', in B.H.V.P., Fonds Bouglé, Manuscrits, Congrès, Boite 2.

96. See C. Dissard 'Le Congrès Féministe de Paris en 1896', *Revue internationale de sociologie*, no. 7 (July 1896), pp. 537–52. See also Hause and Kenney (1984), pp. 28–8 and Wilkins (1975), pp. 5–28.

97. Hause and Kenney (1984), pp. 28–9.

98. See unclassified document, Archives de la Préfecture de Police, dossier BA/1651, no. 90772. Announcements of meetings were made in the *Union's* journal. See *Journal des femmes artistes*, no. 26 (31 March 1892), p. 1, and no. 27 (20 April 1892), p. 1.

99. On the history of the commission and its long campaign to erect a monument in her honour and have a street named after Deraismes, see *Société pour l'Amélioration du Sort de la Femme*, no. 2 (July–September 1894), pp. 100–11. For Gerbaud's presence, see *ibid.* p. 109.

100. See the report written by the *comissaire de police*, 20 June 1896, Archives de la Préfecture de Police, dossier BA/1651, no. 90772.

101. J. Gerbaud, 'Le Groupe de la Solidarité des Femmes', *Journal des femmes artistes*, no. 17 (October 1891), p. 3.

## CHAPTER 4: REASON AND RESISTANCE

1. See the extensive *Actes du Congrès International des Œuvres et Institutions Féminines, passim*, for a detailed account of the organisation of the congress and the role played in it by the *Union*. For Mme Bertaux's speech, see pp. 386–9.

2. For a discussion of the construction of a Republican history of the Revolution in the face of right and left-wing competing narratives, see Nora (1984), pp. 523–60.

3. According to a contemporary source, 68 congresses in all were organised to coincide with the *Exposition*, of which 53 were planned to take place between 12 June and 10 October. See *Le Figaro* (11 May 1890), p. 2. Klejman and Rochefort (1989), p. 82, put the number at 75.

4. See Jules Simon's opening address in *Actes du Congrès International des Œuvres et Institutions Féminines* (1890), pp. ix–xv.

5. See her speech reprinted in *Congrès Francais et International du Droit des Femmes, 1889*, pp. 24–31.

6. 'Société universelle où l'invention de chacun devient la propriété de tous.' *Actes du Congrès International des Œuvres et Institutions féminines* (1890), p. 386.

7. See, for example, the coverage of the congress in the conservative *La Femme*. The writers in this journal were thankful that good sense had reigned at this congress and that the question of political rights was not on the agenda. But even the idea of access to careers, which was an important concern at the congress, was seen by this paper as of minority interest. The rights that they wished to proclaim for all women were: 'le droit d'aimer sans mesure, le droit de se dévouer, le droit de procurer la paix, le droit de beaucoup souffrir'. 'Nos droits', *La Femme*, no. 21 (1 November 1889), p. 161.

8. See 'Congrès International des Œuvres et Institutions féminines', *La Citoyenne*, no. 147 (July 1889), p. 1.

9. 'Etre Prix de Rome! à part la preuve d'aptitude pour le grand art, cela signifie se trouver désormais à l'abri des plus terribles éventualités, c'est avoir dans l'Ecole des Beaux-Arts, une famille qui vous prend en tutelle, vous prodigue sans frais le plus large enseignement avec les plus illustres professeurs, vous soutient d'abord, vous encourage ensuite et vous protège toujours'. *Actes du Congrès International des Œuvres et Institutions Féminines* (1890), p. 389.

10. 'Le Congrès émet le voeu qu'il soit créé à l'Ecole des Beaux-Arts une classe spéciale séparé des hommes, où la femme pourra, sans blesser les convenances, recevoir le même enseignement que l'homme, avec faculté dans les conditions qui règlent cette école d'être admise à tous les concours d'esquisses ayant pour conséquence l'obtention du Prix de Rome.' *Actes du Congrès International des Œuvres et Institutions Féminines* (1890), p. 389.

11. *Actes du Congrès International des Œuvres et Institutions Féminines* (1890), p. 389.

12. *Actes du Congrès International des Œuvres et Institutions Féminines* (1890), pp. 385–6. For the proposals about women's entry into the schools of music, see p. 473; for demands made in the name of women doctors see p. 396.

13. The literature to date on this issue has been exclusively of an empirical nature, which has sought to chronicle the 'events' of the struggle in chronological order. See in particular Yeldham (1980), pp. 53–9; Radycki (1982), pp. 9–13 and Slatkin (1981). In addition to these are the personal reminiscences and early biographies, in particular Lepage (1911), and Demont-Breton (1926), vol. 2, pp. 196–201.

14. Marina Sauer's recent study constructs a familiar chronological narrative, but one based almost exclusively on the useful, but limited archive AJ 52 971 in the Archives Nationales. Her comparative study of German art educational provision is interesting. See Sauer (1990).

15. 'Cela arrivera un jour parce que les choses justes arrivent toujours tôt ou tard', Demont-Breton (1926), p. 197. This tale finds its way into most Demont-Breton biographies. See, for example, the section on her in Langlade (1929), vol. 2, pp. 87–8. It is on Demont-Breton's account and that of Radycki (1982) who faithfully follows her narrative, that scholars like Ackerman (1986), pp. 166–7, have based their accounts.

16. See the list of delegates in *Actes du Congrès International des Œuvres et Institutions Féminines* (1890), pp. 523–8.

17. This event is alluded to in the literature of the 1890s. See for example, 'Pour les femmes', *Le Temps* (15 November 1892), p. 1.

18. Lepage (1911), p. 96 and pp. 167–8.

19. Although Marina Sauer mentions an article published in 1880 by Marie Bashkirtseff on the issue, this is seen as an isolated precursor to the important events of 1889. See Sauer (1990), pp. 7–10.

20. 'Qu'on ne m'accuse point de me faire l'apôtre des revendications féminines; ce serait bien mal comprendre ma pensée, car je suis plus que tout autre ennemie de l'emancipation des femmes au sens politique, et, par certains côtés, social, que l'on attache à ce mot. Je veux simplement qu'une jeune fille bien douée, puisse recevoir, comme les jeunes gens, le grand enseignement artistique, et donner libre carrière à ses ambitions, si elles sont justifiées.' Quoted in Lepage (1911), p. 140.

21. For an analysis of Republican educational theory and a reading of the gendering of roles in school literature promoted by Republican educationists, see Clark (1977), pp. 74–104.

22. Auclert's letter was published in 'Chronique', *Le XIXe Siècle* (November 1881), cutting in the B.H.V.P., Fonds Bouglé, Fonds Hubertine Auclert.

23. 'le courage et le persévérence des femmes ont fait le reste.' G. Lejéal, 'Le Mouvement féministe', in Larousse, *Revue encyclopédique*, no. 61 (15 June 1893), p. 587.

24. 'Les Professions féminines', *La Femme*, no. 1 (1 January 1889), pp. 3–4. By 1890, according to Patrick Bidelman, 202 women had received degrees. There were 35 medical doctors, 69 *baccalauréats* in science, 67 in literature, 16 *licences* and 2 degrees in pharmacy. See Bidelman (1982), p. 39. *La Revue scientifique des femmes* put the numbers of women doctors as much higher; whereas between 1868 and 1869 only four women had qualified as doctors in France, by 1887 to 1888 they identified 114. See 'La Femme médicine au XIXe siècle', *La Revue scientifique des femmes*, no. 1 (January 1889), pp. 8–9. In 1893, the *Revue encyclopédique* published its own figures: in the seven *Facultés de médicine* 129 women were enrolled, in the *Faculté de Droit de Paris* there were 2, in the *Faculté des Sciences* 29, in the *Faculté des Lettres* 249, and at the *Ecole de Pharmacie* 14 women were following the courses. See G. Lejeal, 'Le Mouvement féministe', *Revue encyclopédique*, no. 61 (15 June 1893), p. 587.

25. One chapter of her thesis was devoted to 'professions littéraires et artistiques'. Here she makes the point that careers which could be engaged in privately, without necessitating the performance of public office, had always been more accessible to women. She addressed the exclusion of women artists from the E*cole des Beaux-Arts* which she saw as a grave injustice and an impediment to women's advancement in the arts. See Chauvin, (1892) pp. 273–9.

26. See the debate on the budget published in the *Journal officiel* (Débats parlementaires), (10 May 1889), p. 229.

27. *ibid*.

28. It was named as such by a decree of 7 October 1881, the year in which it was re-organised. See 'Ecole Nationale de Dessin pour les Jeunes Filles', *Moniteur des arts*, no. 1381 (14 October 1881), pp. 149–50. For a history of its founding and early directors, see A.N., F21 517 containing 'Extraits de l'annuaire historique et bibliographique', (1844). The daughters of the founder,

MM. Frère de Montizon, who themselves became directors of the school, were given State support after their retirement and until their deaths. See A.N., F21 514; F21 517; F21 291 and F21 282.

29. For a discussion of the curriculum at the *Ecole Nationale de Dessin pour les Jeunes Filles* and the parallel institution for young men, the *Ecole de Dessin et de Mathématique*, see Boussu (1877), pp. 190–204. In 1877, the name of the men's institution was changed to the *Ecole National des Arts Décoratifs*. See A.N., AJ 539. By 1893, the *Ecole Nationale de Dessin pour les Jeunes Filles* was referred to in official correspondance as *Section des Jeunes Filles de l'Ecole des Arts Décoratifs de Paris*. See letter from the director Louvirer de Lajolais to the Director of *Beaux-Arts*, 17 June 1893, A.N., AJ 53 128. For a summary history of the *Ecole Nationale de Dessin pour les Jeunes Filles*, see Yeldham (1980), pp. 42–5. For the promise of government-financed grants, see the speech delivered by the Marquis de Chennevières at the 1877 prize-giving, reprinted in the *Moniteur des arts*, no. 1221 (14 September 1877), p. 2.

30. 180 students shared one tiny toilet which served as their cloakroom and a place for wet umbrellas. In the small models room, 180 hats, coats and baskets were squeezed. The conditions were so insufferable that they provoked one mother into writing an open letter of complaint to the newspaper. See *Moniteur des arts*, no. 1627 (11 December 1885), p. 377.

31. 'On n'y cherche point à faire naitre en vous les hautes ambitions du grand art qui pourraient vous égarer hors de votre vraie voie; on s'y borne en développant en vous le goût de beau, à vous armer, pour une tâche plus modeste, des moyens de la réaliser dans la mesure de vos facultés et de vos besoins . . . Ce crayon qu'on vous met ici dans la main n'y doit point être un instrument de vanité et de célébrité, mais de modeste aisance et de bonheur domestique; il doit donner à votre vie l'indépendance et la dignité, la charmer et l'embellir. Vous le transmettrez à vos enfants comme un héritage de famille, destiné à leur procurer les mêmes profites et les mêmes jouissances que vous en aurez tirés vous-mêmes . . . car l'art, dégagé des préoccupations de la vanité, est essentiellement moralisateur, et, comme tout travail, il donne à ceux qui l'exercent d'une manière désintéressée ou pour un but morale, la satisfaction et la fierté de l'âme.' Speech reprinted in *Moniteur des arts*, no. 1289 (22 August 1879), p. 2.

32. 'La propagation du beau dans les œuvres de l'industrie, pour l'ennoblissement de la vie domestique et pour l'éducation du goût public'. *ibid.*

33. See 'Ecole Nationale de Dessin pour les Jeunes Filles', *Moniteur des arts*, no. 1381 (14 October 1881), p. 149. For a discussion of the role of drawing in Republican pedagogy, see Levin (1986), pp. 79–91.

34. Speech printed in *Journal des artistes*, no. 31 (4 August 1889), p. 244.

35. She sought, according to Bourgeois, 'de procurer des moyens d'existence aux jeunes filles pauvres, en leur apprenant les éléments de l'art décoratif; elle pensait que les qualités naturelles aux femmes développées par une instruction appropriée, leur permettraient de s'employer utilement dans un certain nombre d'industries artistiques. Elle songeait donc moins à former des artistes que des ouvrières d'art'. See letter published in the *Moniteur des arts*, no. 1909 (8 August 1890), p. 278.

36. 'Les futures ouvrières devenaient chaque année moins nombreuses et faisaient place à une catégorie d'élèves pour lesquelles le dessin n'est qu'un art d'agrément ou qui n'entreprennent des études sérieuses que dans l'espoir de devenir des artistes . . . aujourd'hui, malgré son titre modeste, c'est en réalité une école des beaux-arts où se forment surtout des artistes, avec toutes les ambitions que ce titre suppose.' *ibid.*

37. It is difficult to guage exactly when life-classes were instituted but it is clear that they were running in 1882 as the budget of the school indicates. Out of a total allocation of 40,200 francs, 250 were devoted to *modèles vivants et plantes*. See A.N., AJ 53 23. Documents of the later 1880s and 1890s show that life-models were still used in the school. See A.N., AJ 53 9.

38. From the archival sources it is clear that the school remained in the rue de Seine throughout the 1890s. See A.N., AJ 53 128.

39. For information on the founding of the *Ecoles Elisa Lemonnier* see the pamphlet published by her husband on the occassion of her death: *Elisa Lemonnier, fondatrice de la Société pour l'Enseignement Professionel des Femmes*, pp. 27–31. See also the regularly published accounts of the annual general meetings of the society, for example, the 1882 *Société pour l'Enseignement Professionnel des Femmes*.

40. For information on these schools see Lambeau (1898), pp. xviii–xxvi. See also Cougny (1888), pp. 176–7.

41. Lambeau (1898), pp. xxv–xxvi.

42. 'On encourage même les jeunes filles à apprendre le dessin en leur enseignant dans les écoles primaires, mais dès qu'elles veulent pousser plus loin leur instruction artistique, mille difficultés se dressent devant elles et la porte où elles pourraient frapper leur demeure obstinément close. C'est à peu près comme si l'administration des Beaux-Arts disait: Nous voulons bien des femmes artistes, mais nous voulons les enfermer dans la plus humble médiocrité; il leur sera permis de faire de l'art industriel, des éventails, des écrans, des petits pots de fleurs et des museaux de chat, mais nous le barrons la route qui mène aux honneurs et à la gloire que nous réservons pour nous seuls'. Lepage (1911), pp. 140-1. For Mme Bertaux's membership of the *Commission d'Inspection des Arts Industriels* see the *Société pour l'Enseignement Professionnel des Femmes* of 1882.

43. Lambeau (1898), pp. xxv–xxvi.

44. See *Société pour l'Enseignement Professionnel des Femmes* (1882), pp. 7–10.

45. The popularity of the *académies payantes* was increased by the advent of stricter entry requirements to the three *ateliers* of the *Ecole des Beaux-Arts* in the 1880s. For the relationship between the private academies and the *Ecole*, see Vaisse (1980), pp. 206–10.

46. M. Deraismes, 'Les Femmes au Salon', *L'Avenir des femmes*, no. 141 (6 August 1876), p. 116; Hoschédé (1882), p. 5.

47. M.-A. Belloc, 'Les femmes artistes à Paris', *Journal des artistes*, no. 42 (2 November 1890), p. 337.

48. 'ces ateliers sont de précieuses ressources pour ces intérressantes élèves, d'autant mieux que l'Ecole des Beaux-Arts leur reste impitoyablement fermée'. 'Les ateliers de femmes', *L'Art français*, no. 318 (27 May 1893), p. 1.

49. 'Sans doute, il existe à Paris un certain nombre d'ateliers. Mais, les uns, d'un prix exorbitant sont le rendez-vous des mondaines et des demi-mondaines élégantes qui s'y retrouvent par 'snobisme'. Elles forment la clientèle exclusive des quelques peintres à la mode. Les autres reçoivent des jeunes filles de la bourgeoisie, qui apprennent la peinture comme elles apprennent le piano, parce que ça marque bien, parce que c'est très comme il faut et tout à fait de bon ton.' Quoted in Lepage (1911), p. 135.

50. One writer described the academy as 'Cette sorte d'annexe à l'Ecole des Beaux-Arts'. 'Les Ateliers de femmes', *L'Art français*, no. 318 (27 May 1893), p. 1. For information on the fees paid in the men's and women's studios see Fehrer, 'History of the Julian Academy', in Shepherd Gallery (1989), p. 3.

51. 'On étudie la tête, les mains, les pieds, mais rarement le torse nu; et la figure est absolument prohibée'. M. Deraismes, 'Les Femmes au Salon', *L'Avenir des femmes*, no. 141 (2 July 1876), p. 103.

52. See Vaisse (1980), p. 209; Yeldham (1980), pp. 52–3; Hérold (1968). For detailed contemporary descriptions of the way the academy funtioned, see M.-A. Belloc, 'Les Femmes artistes à Paris', *Journal des Artistes*, no. 42 (2 November 1890), pp. 337–8 and F. Champsaur, 'Les jeunes filles peintres', *Moniteur des arts*, no. 1767 (27 April 1888), pp. 132–3. For personal accounts of the studio see *The Journal of Marie Bashkirtseff* (first published 1887, new ed. 1985) *passim* and Zillhardt (1932), pp. 32–41.

53. See Garb (1993), pp. 33–42.

54. See Lepage (1911), pp. 35–46.

55. *Congrès Français et International du Droit des Femmes* (1889), p. 28.

56. *Journal des artistes* no. 1, (10 May 1882), p. 1.

57. See Mme C. Cognet, 'Une Ecole de Peinture pour les Jeunes Filles à Rome', *La Revue politique et littéraire*, tome II (July 1881–January 1882), pp. 180–181.

58. For a discussion of the relationship between the *ateliers* and the rest of the *Ecole*, see Vaisse (1980), pp. 205–7. One woman artist, Mme Besnard, was to describe the *Ecole* as 'l'atelier Julian gratuit, avec les mêmes professeurs'. 'Elèves femmes aux Beaux-Arts', 20 April 1897, unidentified cutting in B.M.D., ref: Dos. 707 BEA.

59. 'Les femmes artistes ont leur liberté. Qu'elles en profitent! Que désirent-elles la condition d'élèves de l'Ecole!', 'Les Femmes artistes et l'Ecole des Beaux-Arts', *L'Art français*, no. 304 (18 February 1893), p. 1.

60. 'Je suis d'avis de n'admettre ni les femmes ni les hommes à l'Ecole des Beaux-Arts, que je considère comme une institution absolument inutile sinon dangereuse. Si l'intervention de l'Etat est insupportable dans un cas, c'est bien en matière d'art. L'art, en effet, ne peut se développer que par l'indépendance non seulement des élèves, mais des maîtres eux-mêmes, et cette fabrique officielle d'artistes, qui est du reste de création assez récente, n'a servi qu'à encombrer les expositions d'oeuvres sans intérêt'. *ibid*. A contemporary critic described the feelings of many male artists who, he reported, felt that they had passed through the august doors of the *Ecole*, learned its methods and formulae, but remained 'ignorant of Nature', blind in front of the landscape and 'deaf to the poetry of ordinary existance'. Those of them who had not 'irreperably lost their originality, their faculties of vision and comprehension' have had to spend long years countering this early distructive influence. 'All their energy is taken up with unlearning the *Ecole* in order to learn true life, art without formulae and nature unfettered'. The *Ecole*, they declared, was completely useless. H. Godin, *La Revue des Beaux-Arts*, no. 147 (26 February 1893).

61. See Wolff (1985), pp. 37–46; Adler (1989); Pollock (1989).

62. 'vous qui vous proclamez bien haut plus forts, plus intelligents, mieux doués que nous, vous accaparez pour vous seuls une des plus belles écoles du monde où tous les encouragements vous sont prodigues. Quant aux femmes que vous dites frêles, faibles, bornées, dont un grand nombre est privé même de la banale liberté d'aller et de venir par le mot convenances, vous ne leur accordez ni encouragement, ni protection, au contraire.' P. Orell, 'Les Femmes artistes', *La Citoyenne* (6 March 1881), pp. 3–4.

63. 'En mettant les femmes dans des conditions de lutte aussi disproportionnées, voudrions-nous par hasard avoir une base pour proclamer leur infériorité originelle!' Camille, 'L'Ecole des Beaux-Arts', *La Citoyenne*, no. 48 (9–15 January 1882), p. 1.

64. 'On nous demand avec une indulgente ironie combien il y a eu de grandes artistes femmes. Eh! messieurs, il y en a eu et c'est étonnant, vu les difficultés énormes qu'elles rencontrent.' P. Orell, 'Les Femmes artistes', *La Citoyenne*, no. 4 (6 March 1881), pp. 3–4. For similar contemporary

feminist views, see O. Aoudard, 'Les Femmes au Salon', *Le Papillon*, no. 6 (28 May 1882), p. 461 and O. Aoudard, 'Le Salon de 1883', *Le Papillon*, no. 5 (20 May 1883), p. 874.

65. A sore point throughout the two decades in which the debate raged was the issue of France's conservatism in relation to other countries. This was to become one of the major debating points in the Chamber in the 1890s, and prompted the sending of telgrams from the fine arts administration to the ambassadors in Denmark, England and Germany to establish current practice in these countries. See A.N., AJ 52 971, documents 38, 39, 40. As an issue, it was already well on the agenda in the early 1880s, when international links were being formed among feminists keen to compare their status in different countries and willing to join forces against masculine privilege. See, for example, Camille, 'L'Ecole des Beaux-Arts', *La Citoyenne*, no. 48 (9–15 January 1882), p. 1.

66. Camille, *ibid.*; O. Audouard, 'Les Femmes à Salon', *Le Papillon*, no. 6 (28 May 1882), p. 461.

67. P. Orell, 'Les Femmes artistes', *La Citoyenne*, no. 4 (6 March 1881), pp. 3–4; Jacques, 'La Femme a l'Ecole des Beaux-Arts', *La Citoyenne*, no. 74 (2 July–5 August 1883), p. 3.

68. Camille, 'L'Ecole des Beaux-Arts', *La Citoyenne*, no. 48 (9–15 January 1882), p. 1.

69. 'Assemblée Générale de l'Union des Femmes Peintres et Sculpteurs', *Moniteur des Arts*, no. 1867 (13 December 1889), p. 434.

70. There was no chance that this document could be ignored. On 1 March 1890, the *Ministre de l'Instruction Publique et des Beaux-Arts* sent a memo to the director of the *Ecole* informing him of the petition and the resolution unanimously adopted at the *Congrès des Œuvres*. See A.N., AJ 52 971, document 60. See also the *Journal des femmes artistes*, no. 1 (December 1890), p. 4. The original copy of the *Extrait du rapport fait au Congrès des Œuvres et Institutions Féminines*, sent to the *Ecole* by Mme Léon Bertaux, is in the A.N., AJ 52 971, document 58.

71. The minutes of the meetings of the *Conseil Supérieur* are kept in the Archives Nationales under the series AJ 52 20.

72. See A.N., AJ 52 971.

73. Financial difficulties were to be invoked repeatedly over the next years as the primary obstacle to women's entry to the *Ecole*. Few critics argued that current resources should be distributed more equitably. All worried about the additional funds which the introduction of courses for women would involve. This issue is amply documented in A.N., AJ 52 971. Such reasoning still informs Vaisse's account of the issue. Accepting the arguments of the officals at face value, he fails to notice that they are ideologically constructed and need to be interpreted symptomatically. See Vaisse (1980), vol. 1, p. 239.

74. A.N., AJ 52 20. Procès Verbaux des séances du Conseil Supérieur des Beaux-Arts', *Séance du mardi 25 mars, 1890*, p. 169.

75. According to Mme Demont-Breton's memoirs she

herself spoke after Mme Bertaux. There is no record of this in the report back to the *Conseil Supérieur*. See Demont-Breton (1926), vol. 11, p. 198.

76. See the letter in the A.N., AJ 52 971, document 54.

77. A.N., AJ 52 20, 'Procès Verbaux des séances du Conseil Supérieur des Beaux-Arts', *Séance du mardi 13 mai, 1890*, p. 176.

78. 'Des ateliers analogues à ceux qui existent seraient organisés et dont le personnel enseignant pourrait être le même que celui de l'Ecole des Beaux-Arts.' *ibid.*

79. 'Le Conseil supérieur partageant l'opinion de la sous-commission, par 8 voix contre 2, émet l'avis que "les jeunes filles puissent, avec le concours de l'Etat, trouver, pour leur éducation artistique les mêmes facilitiés que les jeunes gens".' *ibid.* p. 177. Versions of this statement were published in the *Journal des artistes*, no. 20 (25 May 1890), p. 154. It was reported in the *Moniteur des arts*, no. 1914 (12 September 1890), p. 318. It was this first official acknowledgement from the *Ecole* itself of the legitimacy of women's claims which prompted huge publicity. For a discussion of the public debate see *Moniteur des arts*, no. 1917 (3 October 1890), pp. 343–5.

80. 'N'y fera-t-on pas un peu la place des femmes? Si on laisse passer l'occasion sans en profiter, on donnera la preuve d'une mauvaise volonté,' 'Pour les femmes', *Le Temps* (15 November 1892), p. 1. Similar sentiments were expressed by Mme Bertaux. See Lepage (1911), p. 150. For the archival records of the permission for the enlargement of the school to include the Hôtel de Chimay, see A.N., AJ 52 20, '*Ecole Nationale et Spéciale des Beaux-Arts, rapport présenté au conseil par le directeur de l'école au commencement de l'année scolaire 1889–90*'. There were commentators who saw the enlargement of the *Ecole* at this point as providing an obvious solution to the problem of space. There would, they claimed, be no difficulty in allotting one large room to women in the newly acquired Hôtel de Chimay. See for example 'Une femme peintre', writing in *Le Gaulois*, reprinted in *Journal des artistes*, no. 38 (5 October 1890), pp. 301–2.

81. For an elaboration of these ideas see Shaw (1991).

82. I am grateful to conversations with Molly Nesbit and her Durning Lawrence lectures, delivered in 1991 at University College, London, for a theorisation of the relationship between 'body' and 'line'. For a discussion of this issue, see Nesbit (1992).

83. 'Les Femmes à l'Ecole des Beaux-Arts', *Moniteur des arts*, no. 1914 (12 September 1890), p. 318.

84. 'Les personnes qui s'émeuvent de la réunion d'hommes et de femmes devant un modèle nu ne se sont jamais trouvées dans la salle de dessin; la présence de quarante ou cinquante élèves donne une sorte d'impersonnalité au modèle, qui ne devient plus qu'un objet à dessiner. Ensuite, le nu n'est pas obscène: c'est souvent fort laid, mais

beaucoup moins égrillard qu'un décolletage ou un retroussé.' J. Antoine in *L'Art et Critique*, reprinted in *Moniteur des Arts*, no. 1917 (3 October 1890), p. 344.

85. Sainville, 'Chronique de la semaine', *Moniteur des arts*, no. 1915 (19 September 1890), p. 325.

86. 'ce serait mettre le feu près de la poudre et . . . cela produirait une explosion dans laquelle sombrerait l'Art tout entier.' Demont-Breton (1926), vol. II, pp. 198–9.

87. 'Espèce de gamin de Paris! Tu ne sais pas ce que tu dis! Lorsqu'un artiste travaille, songe-t-il à autre chose qu'à l'étude qui le passionne, qui lui donne du mal? Dans une semblable école, réalisation d'un légitime progrès, il n'y aurait plus des hommes et des femmes, mais des artistes animés d'une noble et pure émulation!' *ibid*.

88. 'Il est possible que toi, ô grand sculpteur, tu sois de marbre ou de bois comme tes statues, mais mois, à vingt ans, si j'avais vu un gentil petit minois féminin à côté de mon chevalet, au diable mon dessin! O! Guillaume! Tu n'es pas un homme!' *ibid*.

89. 'O!' Garnier! Tu n'es pas un artiste!' *ibid*.

90. See, for example, letter from Mme Bertaux of 11 May 1890 in A.N., AJ 52 971, no. 52.

91. 'L'admission des élèves du sexe faible dans les ateliers fréquentés par le sexe fort'. 'Les Femmes à l'Ecole des Beaux-Arts', *Journal des artistes*, no. 37 (28 September 1890), p. 293.

92. *ibid*. A similar point was made by an anonymous woman artist in *Le Gaulois*, reprinted in *Journal des artistes* (no. 38, 5 October 1890), pp. 310–12. A debate about the admission of wives to the Villa Médicis had taken place in 1870, but in the 1890s it seems that the men-only ethos was once again firmly entrenched. See AJ 52 16, 'Procès Verbaux des séances du Conseil Supérieur d'enseignment de l'Ecole des Beaux-Arts, 11 décembre 1863 to 9 juillet 1878.' I am grateful to Laura Fan for bringing this document to my attention.

93. 'Que l'Ecole soit ouverte aux femmes, dès la rentrée prochaine, non pas en créant de nouveaux ateliers, mais en accordant aux femmes le droit de compter pour une fraction dans le chiffre des admissions réservées jusqu'à ce jour aux hommes, et en plaçant ce groupe de femmes admises sous la direction d'un professeur de l'Ecole dans l'un des ateliers de ladite école, qui lui sera spécialement affecté.' *Journal des femmes artistes*, no. 1 (December 1890), p. 1.

94. A.N., AJ 52 20, Procès Verbaux des Séances du Conseil Supérieur des Beaux-Arts, *Séance de Mardi, 9 decembre 1890*.

95. 'Les femmes à l'Ecole des Beaux-Arts', *Journal des artistes*, no. 18 (17 May 1891), p. 145. See also Jules Gerbaud, 'Les Femmes à L'Ecole Nationale des Beaux-Arts', *Journal des femmes artistes*, no. 11 (1 May 1891), p. 3.

96. See J. Gerbaud, 'Les Femmes à l'Ecole Nationale des Beaux-Arts', *Journal des femmes artistes*, no. 11 (1 May 1891), p. 3; J.G. Najaille, 'Les Femmes au Conseil Supérieur des Beaux-Arts', *Journal des*

*femmes artistes*, no. 12 (15 may 1891), p. 1.

97. Louvrier de Lajolais, 'L'Enseignement des beaux-arts', *Moniteur des arts*, no. 1621 (26 June 1891), p. 767. His words were mocked in a feminist counter-attack: Jeanne Eureka, 'Au Conseil Supérieur des Beaux-Arts', *Journal des femmes artistes*, no. 14 (July 1891), p. 1.

98. *Journal des femmes artistes*, no. 1 (1 December 1890), p. 1.

99. *La Citoyenne* was one of the journals most interested in comparative provision for women professionals. See 'Les Femmes à l'Ecole des Beaux-Arts en Danemark', *La Citoyenne*, no. 179 (15 July 1891).

100. In the same way, the position of the woman artist in Paris was often romanticised by women artists from abroad. Parisian women artists objected to what they saw as a distorted image of their freedom. See 'Les Femmes dans les ecoles des arts', *Journal des femmes artistes*, no. 18 (15 November 1891), p. 3. It is possible that the very fact of being foreign allowed a freedom of movement which was unavailable to the French bourgeoise.

101. 'France . . . ne saurait refuser aux femmes ce qui leur est accordé en Angleterre, en Allemagne, en Suède, en Amérique, où il a été constaté, en outre, que l'ouverture des cours communs aux deux sexes n'a donné lieu à aucune critique, et à aucune constatation que les convenances aient été froissées. Il suffit de parler du South Kensington Museum, où les cours communs de dessin d'aprés l'antique et le modéle vivant sont réguliérement fréquentés par une nombreuse assistance d'hommes et de femmes, sans que la pudique Angleterre se soit émue d'une promiscuité qu'on prétend redoutable.' 'L'Enseignement des beaux-arts pour les femmes', *Le Temps* (25 June 1891), p. 2.

102. 'du caractère, du tempérament et des habitudes des femmes françaises', Jeanne Euréka, 'Au Conseil Supérieur des Beaux-Arts – l'Enseignement artistique des femmes', *Journal des femmes artistes*, no. 14 (July 1891).

103. For a contemporary discussion of these issues, see the Republican philosopher Fouillée (1898).

104. On the notion of the 'third sex' see Guillaume Ferero, 'Le Troisième sexe', *La Revue des revues* (1 January 1895), pp. 1–13.

105. 'Si la France est plus prude que l'Angleterre et si les députés sentent la rougeur leur monter aux joues à la pensée d'hommes et de femmes travaillant ensemble, ils pouvaient voter une Ecole annexe et des ateliers femelles que des portes solides et de forts verrous sépareraient des ateliers mâles'. A. Vacquerie, 'Les Femmes artistes', from series in *Rappel* (c. 1891, undated cutting.) B.M.D., ref: 707 BEA.

106. The expenses were estimated at 7,500 francs to assure a location and a further 134,600 francs per annum for personnel and materials. 'L'Enseignement des beaux-arts pour les femmes', *Le Temps* (25 June 1891), p. 2. For a breakdown of these costs, see fragment in A.N., AJ 52 971, document 42. For a detailed analysis of what such

an initiative would require, see document 44.

107. See 'Conseil Supérieur; Extrait de la séance de mardi 9 décembre 1890', A.N., AJ 52 970, document 50.

108. See the speech delivered by Mme Bertaux at the banquet of the *Union*, reprinted in *Journal des femmes artistes*, no. 20 (23 May 1892), p. 154.

109. J. Gerbaud, *Journal des femmes artistes*, no. 24 (1 March 1892), p. 1, and J. Gerbaud, 'Qui veut la fin, veut les moyens', *Journal des femmes artistes*, no. 26 (31 March 1892), pp. 2–3.

110. For a detailed report see *Journal des femmes artistes*, no. 29 (June 1892), p. 2

111. For a reprint of her letter written on 25 June 1892, see *Journal des femmes artistes*, no. 31 (November 1892), p. 3.

112. 'Pour les femmes', *Le Temps* (15 November 1892), p. 1. Auguste Vacquerie, *Rappel*, reprinted in *Journal des femmes artistes*, no. 32 (November 1892), p. 4.

113. *Journal officiel* (Débats parlementaires), (31 January 1893), pp. 304–6.

114. The Americans, he informed the Chamber, had overcome the problem of naked models in the presence of women artists by making the models wear masks. *ibid.* p. 304.

115. 'Il me semble que les tendances artistiques de la femme s'orienteraient d'une manière plus heureuse, plus utile, plus pratique et pour elle et pour nous, non pas vers ce qu'on appelle les beaux-arts, mais vers cet art décoratif qui n'a pas encore atteint dans ce pays tout le développement désirable (*très bien, très bien)*, vers cet art, qui peut être caractérisé par la formule voici: une étude à la suite de laquelle chaque artisan peut être en même temps une sorte d'artiste (*très bien)*, c'est-à-dire une étude ne séparant jamais, même dans les préoccupations les plus usuelles et les plus matérielles de l'utilisation des choses, cette notion d'art, ce sentiment de distinction et d'élégance qui est une des caractéristiques du génie française. (*Applaudissements.*) J'aimerais mieux voir les jeunes filles se tourner de ce côté; elles auraient tout à y gagner, et la société également, car lorsqu'a la sortie de la préparation esthétique dont je parle elles deviendraient mères de famille, elles trouveraient dans cet enseignement, non pas moins artistique, mais plus pratique ou mieux plus susceptible d'applications (*très bien)*, le moyen de rester des artistes tout en étant des mères de famille, tout en apportant au foyer domestique un ensemble de ressources qu'elles n'y apporteront peut-être pas au même degré si elles se sont livrées à ce qu'on appelle "l'Art" tout court. (*Applaudissements.*)' *ibid.* p. 306

116. For the central position that the rejuvenation of the decorative arts played in Republican thinking in the 1890s, see Silverman (1989).

117. In an interview after the debate, Gerville-Réache explained his willingness to withdraw his amendment, indicating that he had been taken by surprise at Dupuy's response who, before becoming a deputy, had assured him verbally of his support.

'Une Interview', *L'Art français*, no. 304 (18 February 1893).

118. G. Geffroy, 'Femmes, on vous trompe', *Le Figaro* (23 March 1893), p. 1.

119. According to one report, this was already the case. It was at this point that the *Ecole de Dessin pour les Jeunes Filles* was taken over by the *Ecole des Arts Décoratifs*. See Lepage (1911) p. 182.

120. 'Les femmes vous disent "Beaux-Arts", vous leur repondez, d'un air engageant: "Arts Décoratifs" . . . De quel droit prétendez-vous écouler sur les arts décoratifs des sujets ou sujettes qui se croient une vocation pour les beaux-arts?' *Le Temps* (1 February 1893), p. 1.

121. A. Bartet, 'La Femme et l'art', *L'Harmonie sociale*, no. 19 (18 February 1893), pp. 1–2.

122. Lepage (1911) p. 155.

123. 'Les Femmes artistes et l'Ecole des Beaux-Arts', *L'Art français*, no. 305 (25 February 1893).

124. See 'Les Femmes artistes et l'Ecole des Beaux-Arts', *L'Art français*, no 304 (18 February 1893); no. 306 (4 March 1893); no. 307 (11 March 1893).

125. Lepage (1911), pp. 156–7.

126. 'Les Femmes artistes et l'Ecole des Beaux-Arts', *L'Art français*, no. 304 (18 February 1893).

127. 'Les Femmes artistes et l'Ecole des Beaux-Arts', *L'Art français*, no. 305 (25 February 1893). In a letter to *L'Art français* Mme Bertaux made a detailed refutation of all the objections that had been made, reiterating women's demands for and education in '*le grand art*'. 'Les Femmes artistes et l'Ecole des Beaux-Arts', *L'Art français*, no. 307 (11 March 1893).

128. *La Femme*, no. 10 (15 May 1893), p. 80.

129. *Journal officiel* (Débats parlementaires), 29 November 1896, p. 1823.

130. 'Les Femmes artistes', *L'Art français*, no. 316 (13 May 1893), p. 34.

131. See letter from the *Ministre de l'Instruction Publique* to the *Directeur de l'Ecole Nationale des Beaux-Arts*, 24 February 1893, in A.N., AJ 52 971, document 37.

132. See *Journal des femmes artistes*, no. 41 (November 1893), pp. 2–3.

133. For the reluctance of the *Ecole* to admit women, see the lists of impediments which permeate the correspondance of the administration during this period. See A.N., AJ 52 971, documents 28, 30.

134. *Journal officiel* (Débats parlementaires), 16 February 1895, pp. 346–8.

135. For reports in the press, see 'A la Chambre', *La Lanterne* (17 February 1895), p. 2; 'Les Femmes à l'Ecole des Beaux-Arts', *Le Temps* (17 February 1895), p. 1; 'Les Femmes à l'Ecole des Beaux-Arts', *Journal des artistes*, no. 8 (24 February 1895), pp. 938–9; 'Beaux-Arts', *Journal des femmes artistes*, no. 39 (March 1895), p. 3.

136. Ferréol, 'Causerie', *L'Art français*, no. 454 (4 January 1896).

137. This was to cover the cost of hiring an extra teacher for drawing and modelling, extra anatomy classes and the appointment of six more guards. Other costs such as materials, models and

heating would also have to be covered. See A.N., AJ 52 971, document 28.

138. See letter from the *Directeur de l'Ecole* to the *Directeur de Beaux-Arts*, in A.N., AJ 52 971 document 30.

139. Firmin Javel, 'Causerie', *L'Art français*, no. 466 (28 March 1896). The debates of 1895 were followed up by a letter from the *Union* to the Minister of Fine Arts, indicating the interest with which the *sociétaires* were observing the course of events.

140. Speech reprinted in *Journal des femmes artistes*, no. 64 (May 1896), pp. 1–2. See also *Journal des artistes*, no. 21 (24 May 1896). p. 1459.

141. *Journal officiel* (Débats parlementaires), 28 November 1896, pp. 1823–4. This was preceded by an incident at the *Ecole* when a young woman artist was formally rejected from competing in the entry competitions on the grounds of being a woman. See 'L'Art et la femme', *L'Eclair* (4 November 1896), p. 1.

142. 'Il s'agit, bien entendu . . . d'assurer aux femmes l'enseignement supérieur de l'art de n'admettre à cet enseignement qu'une élite soigneusement choisie *(très bien, très bien)*.' *Journal officiel* (Débats parlementaires), 28 November 1896, p. 1824.

143. A.N., AJ 52 20. *Procès Verbaux des séances du Conseil Supérieur des Beaux-Arts, séance du jeudi 10 juin 1897*. When the *Conseil Supérieur* of the *Ecole* planned the first *concours* in which women were allowed to compete, Dubois requested that the number be fixed at eight.

144. 'La Femme moderne', *La Revue encyclopédique* (November 1896), p. 853.

145. H. Auclert, 'Les Femmes artistes', *Le Radical* (7 December 1896), p. 2; P. Georges, 'Les Femmes à l'Ecole Nationale des Beaux-Arts', *Le Féminisme chrétien (1897)*, pp. 21–2.

146. 'La Manifestation anti-féministe à l'Ecole des Beaux-Arts', *L'Eclair* (16 May 1897), p. 1.

147. These protests echoed the earlier ones held at the Sorbonne when male students objected to the overcrowding which they said was caused by the presence of women in the lecture halls. See 'La Guerre aux femmes', *Le Temps* (19 February 1893), p. 1; 'Mon petit journal', *Le Temps* (21 February 1893), p. 2. See also 'Egoisme masculin', *Le Temps* (15 May 1897), p. 1.

148. For a summary of these arrangements, see A.N., AJ 52 20, '*Ecole Nationale et Spéciale des Beaux-Arts, Conseil Supérieur, Rapport présenté au conseil par le directeur de l'école au commencement de l'année scolaire 1897–1898*', pp. 5–7.

149. For an analysis of the candidature and the acceptance rate, see *L'Almanach féministe* (1899), pp. 52–5. For the complaints of unfair judging by the two women students, see A.N., AJ 52 20, 'Procès Verbaux des séances du Conseil Supérieur des Veaux-Arts', *Séance du mardi, 12 octobre 1897*. For the detailed documentation of the controversy and an indication of the pressure exerted on the school to accept the women, see, A.N., AJ 52 971, documents 13, 22, 23, 24, 25, 26, 27. For

the lists of the first women students admitted to the *Ecole*, see A.N., AJ 52 471. For accounts by women students and reports of the shabby way in which they felt they were treated in the early years, see the collection of articles in B.M.D., ref: BEA.

150. *Journal officiel* (Débats parlementaires), 2 March 1899, p. 597; 19 January 1900, p. 112.

## CHAPTER 5: THE SEX OF ART

1. See 'La Vie à Paris', *Le Temps* (25 February 1888), p. 2; 'Lorgnette', 'Exposition de peinture et sculpture', *La Citoyenne*, no. 96 (May 1885), pp. 1–2.

2. The *Salon des Indépendants* has been retrospectively heroicised in modernist accounts, and has accrued a significance which far outweighs the relative importance attributed to it by artists seeking exhibition venues during the period. I am grateful to Martha Ward for discussions with her on the criticism of this *Salon*.

3. See the visiting card with the hand-written inscription: 'Mme Léon Bertaux . . . avec ses meilleurs compliments serait très heureuse de voir l'avis ci-joint inséré dans le Figaro', B. H. V. P., Fonds Marie Louise Bouglé, 4248, Autographs. For the wording of the invitation, see H. Havard, 'Exposition de l'Union des Femmes Peintres et Sculpteurs', *Le Siècle* (25 January 1882). Olympe Audouard noted that the press were invited to the opening, and affirmed that many took advantage of this invitation. 'Le Féminin dans l'art', *Le Papillon*, no. 45 (25 November 1883), p. 771. For a description of inclusions which came with the invitation, see 'La Curieuse note', published by the *Chronique des arts*, no. 7 (13 February 1886), p. 50.

4. The *Moniteur des arts* was one of the very few journals which approached the first show without any speculation on the gender of the artists. See, for example, 'L'Exposition du Cercle des arts libéraux', *Moniteur des arts*, no. 1396 (27 January 1882), p. 26. Even when it defended the second show against hostile criticism, it did this in terms of notions of quality, not speculations on the suitability of the profession to women artists. See L. de Fresnes, 'L'Exposition des Femmes', *Moniteur des arts*, no. 1460 (23 February 1883), p. 54. By 1884, though, its critic was speculating on the position of the male critic in relation to the woman artist. (See note 5, below.)

5. 'Par un poulet gracieux, élégant, et parfumé, l'Union des Femmes Peintres et Sculpteurs nous a convoqués à visiter l'exposition. H. Havard, 'Exposition de l'Union des Femmes Peintres et Sculpteurs', *Le Siècle* (25 January 1882). For a typical example of a male critic describing his position as difficult, see Jean Robert, 'L'Exposition des Femmes Peintres et Sculpteurs', *Moniteur des arts*, no. 1522 (7 March 1884), p. 73.

6. G. Dargenty, 'Chronique des expositions', *Courrier de l'art*, no. 9 (1883), p. 102.
7. G. Dargenty, 'Exposition des Femmes Peintres et Sculpteurs', *Courrier de l'art*, no. 7 (13 February 1885), p. 113
8. 'Les femmes n'ont fait aucun chef d'œuvre dans aucun genre'. It was Havard who made this sweeping claim, only to cite women's real talents in their traditional role: 'Elles n'ont inventé ni l'église Saint-Pierre, ni la Vénus de Médicis, ni l'Apollon du Belvédère. Elles n'ont inventé ni l'algèbre, ni la pompe à feu, ni le métier à bas, – mais elles ont fait quelque chose de plus grand que tout cela; c'est sur leurs genoux que se forme ce qu'il y a de plus excellent au monde, un honnête homme et une honnête femme'. H. Havard, 'Exposition de l'Union des Femmes Peintres et Sculpteurs', *Le Siècle* (25 January 1882).
9. C. Bonheur, 'Art: La Huitième Exposition de l'Union des Femmes Peintres et Sculpteurs', *La Chronique moderne*, no. 5 (March 1889), p. 25.
10. Cardon was described as a supporter of 'l'école féminine artistique' in 'Le Salon de 1880', *La Femme dans la famille et dans la société*, no. 5 (15–21 May 1880), p. 25.
11. In 1883, Olympe Audouard reported seeing Albert Wolff, surrounded by people and avidly taking notes, at the opening of the *Salon des femmes*. 'Le Féminine dans l'art', *Le Papillon*, no. 45 (25 February 1883), p. 771. For Wolff's alleged anti-feminist attitudes, see Louise Koppe, 'La Femme et M. Albert Wolff', *La Femme dans la famille et dans la société*, no. 22 (26 September–3 October 1880), p. 2.
12. 'Les Françaises, et en particulier les Parisiennes ont tant de goût dans leurs ajustements, elles sont si coloristes dans l'agencement de leurs toilettes, si vraiment artistes dans leur habileté à meubler les maisons, que l'on s'attendrait à trouver plus de fantaisie, de grâce et de brio dans leurs productions artistiques, – Tout cela se glace dès qu'elles ont la palette à la main. Elles peignent terne, et presque toutes échouent dans la composition. Du tour de main, mais pas de cerveau.' H. le Roux, 'La Vie à Paris', *Le Temps* (5 March 1887), p. 2.
13. 'Il n'est pas jusqu'au choix d'un pareil local qui ne semble empreint des plus honnêtes sentiments et des calmes vertus de la vie domestique. 'On prétend que le cercle ou l'on fume à tuer le salon ou l'on cause, me disait un ami: les femmes peintres ont tenu à honneur de convaincre le public que cercle et salon (de peinture) peuvent encore faire bon ménage'. Ici, en vérité, tout se passe comme en famille.' F. Lhubert, 'Exposition de L'Union des Femmes', *L'Artiste* (5 February 1882), p. 219.
14. 'C'est une erreur que ce Salon féminin, car il permet de constater un défaut général qui tient au sexe apparemment: point de génie créateur, absence presque générale de caractère. Pourquoi ne pas entrer plutôt tout simplement dans le mêlée du grand Salon annuel, où le bon grain est accepté, quelquefois même un peu d'ivraie avec, et où les rares peintresses d'un talent robuste, triomphent doublement, à côte avec leurs confrères barbus?' T.B. 'Causerie', *Journal des demoiselles*, no. 4 (16 April 1889), p. 46. For a discussion of the nature and readership of this journal, see Langlois (1979), pp. 192–3.
15. 'Ne forçons pas notre talent, nous ne ferions rien avec grâce. Et la grâce est le premier devoir, la science obligatoire pour une femme.' *ibid.*
16. See, for example, the review by 'Lorgnette', 'Les Dames artistes', *La Citoyenne*, no. 106 (March 1886), p. 2.
17. For the reassurance see P. Dupray, 'XIVe Exposition de l'Union des Femmes Peintres et Sculpteurs', *Journal des artistes*, no. 11 (17 March 1895), p. 966. For the lamentation see T. Natanson, 'XVe Salon des Femmes Peintres et Sculpteurs', *La Revue blanche*, vol. 10 (1896), pp. 186–7.
18. Uzanne (Eng. ed, 1912) p. 22–7.
19. J. Leclercq, 'Union des Femmes Peintres et Sculpteurs', *Chronique des arts*, no. 6 (11 February 1889), p. 54. Not surprisingly, this critic accompanied his comments with his concerns over the incompatibility of art and marriage: 'Elles sont pourtant parfois jolies, ces jeunes filles qui exposent, mais, quand on fait de l'art, le mariage est une déchéance.'
20. 'Il y a de la confection d'un corsage à la composition d'un tableau, de la toilette à l'œuvre d'art une distance que le cerveau de ces dames – infériorité essentielle ou défaut d'éducation – ne franchit pas'. T. Natanson, 'XVe Salon des Femmes Peintres et Sculpteurs', *La Revue blanche*, vol. 10 (1896), p. 187.
21. A. Bourret, 'Exposition des Femmes Peintres et Sculpteurs', *Journal des artistes*, no. 9 (26 February 1888), p. 67.
22. 'Ce qui donne pour les vrais curieux un attrait tout particulier à cette exposition, ce n'est pas l'inspection des quelques centaines de mètres de toile peinte, dont les dames artistes tendent les murs du Palais de l'Industrie; non, c'est l'occasion unique que l'on nous offre là d'entrer dans le génie féminin, de devenir un peu de secret sentimental des filles d'Eve.' 'La Vie à Paris', *Le Temps* (25 February 1888), p. 2.
23. 'This living mystery, the source of man's life, the desire of his heart, the embodiment of his happiest aspirations, the enigma he studies with passion and abandons in despair, this Sphinx, dumb and insensible . . . has always in some measure escaped the observation of the moralist, the brush of the painter, or the chisel of the sculptor . . . Women without number have been described and portrayed, but 'Woman' has never been accurately represented.' Uzanne (1912), p. 15.
24. de Soissons (1984), pp. 75–6. The French critic commenting on women flower painters in Boston, makes this point, but one which he alleges is equally applicable in the European context.
25. For a discussion of the gendering of drawing as 'masculine', see Blanc (1867), p. 22. For a discussion of this in relation to women's work, particu-

larly that of Berthe Morisot, see Garb (Autumn, 1990).

26. de Soissons (1894), pp. 77–8.

27. M. Deraismes, 'Les Femmes au Salon', *L'Avenir des femmes*, no. 141 (6 August 1876), p. 117.

28. 'Une œuvre d'art ne peut pas avoir un sexe déterminé; il n'y a pas un art féminin et un art masculin, il y a des gens de talent et de génie, et il y a des œuvres bonnes ou mauvaises.' E. Urban, signing herself as *Artiste-peintre*, 'Les Expositions féminines', *Le Journal des femmes*, no. 37 (January 1895), p. 3. Urban was sympathetic to the shows as a means of countering institutional prejudice or career hurdles suffered by women, but she firmly denounced any view which held that essentialist properties based on sex could be found in art works. She claimed for women the right to be as competitive and self-seeking as men, whose ambition was regarded as natural and healthy whilst women's was frowned upon as destructive and unsisterly.

29. For an elaboration of the doctrine of 'equality in difference' and its place in Republican political thought, see Offen (1984), pp. 665–6.

30. A. Puéjac, 'A l'auteur de l'article intitulé "Les Femmes artistes"', *La Femme*, no. 12 (15 June 1887), p. 90.

31. For a discussion of the view of gender promulgated by Darwin and his followers, see Dijkstra (1986), pp. 160–209. For a comprehensive study on the reception of Darwin's theories in France see Conry (1974). For information on 'revolutionary transformism', see Nye (1984).

32. Vogt, (1864), pp. 81–2. Vogt was the professor of Natural History at the University of Geneva and elected foreign associate of the anthropological society in Paris.

33. For many, differences of race and sex could be connected, in that both were naturally inscribed and necessary to the advancement of civilisation. See, for example, the views of Gustave Le Bon, as discussed in Barrows (1981) and Nye (1975).

34. For a general discussion on the response of science to *la femme nouvelle* see Silverman (1989) pp. 63–74. For a discussion of the links between the discoveries of 'science' and an antagonism towards feminism see Fee (1979), pp. 415–33.

35. Professor M. Benedict, 'La Question féminine', *Revue des revues* (August 1895), p. 183. Benedict is described as a professor from the University of Vienna. His views are lauded by the editors of the journal for their objectivity and impartiality.

36. G.J. Romanes, 'Mental Differences Between Men and Women', *The Nineteenth Century*, vol. XXI (May 1887), p. 666.

37. 'la femelle de l'homme', *La Grande Encyclopédie*, vol. 17, p. 143.

38. *ibid.* pp. 144–5.

39. H. de Varigny, 'Le Cerveau de la femme', *Revue des revues* (1 January 1895), pp. 14–20.

40. For a discussion of the links and alliances formed between the French psychiatric profession and the Republican State, see Goldstein (1982). Fouillée's views on sexual difference were published in 'La Psychologie des sexes et ses fondaments physiologiques', *Revue des deux-mondes*, vol. 119 (15 September 1893), pp. 397–429.

41. See, for example, the review of Jacques Lourbet's pro-feminist 'La Femme devant la science contemporaine' (in which Lourbet challenges current scientific views on women's capacities) by Gaston Richard, who accuses Lourbet of not having taken sufficient account of the law of regression whose necessary result was 'que la maternité, en perfectionnant la moralité, risque le plus souvent de lui fermer la haute activité intellectuelle'. *Revue philosophique*, vol. 43 (1987), p. 435.

42. 'les lobes occipitaux qui sont les plus developpés et ont plus d'importance et ce sont ceux où la physiologie localise les centres émotifs et sensitifs'. *La Grande Encyclopédie*, p. 145.

43. *ibid.* p. 148.

44. See, for example, G. le Bon, 'La Psychologies des femmes et les effets de leur éducation actuelle', *Revue scientifique*, vol. XLVI, no. 15 (11 October 1890), pp. 449–60.

45. G.J. Romanes, 'Mental Differences Between Men and Women', *The Nineteenth Century*, vol. 21 (1887), p. 658.

46. 'les femmes n'ont presque jamais la maîtrise de soi, le sang-froid indispensable de cette opération'. Anon, 'Les femmes artistes', *La Femme*, no. 10 (15 May 1887), p. 74. This was followed one month later by an enraged response endorsing women's abilities in art and mentioning as proof Vigée Lebrun, Clémence Mayer and Rosa Bonheur. See A. Puéjac, 'A l'auteur de l'article intitulé "Les Femmes artistes", *La Femme*, no. 12 (15 June 1887), pp. 89–90.

47. de Varigny summarises Lombroso's views in *La Grande Encyclopédie*, p. 144. Fouillée (1895, transl. 1900) pp. 32–3 refutes these.

48. See, for example, O. Audouard, 'La Question des Bas-bleus', *Le Papillon*, no. 52 (16 April 1882), pp. 410–11.

49. 'L'esthétique masculine est une esthétique de forme, l'esthétique féminine est une esthétique de mouvement.' C. Dissard, 'Essai d'esthétique féminine', *La Revue féministe*, vol. 1 (1895), pp. 10–12.

50. O. Audouard, 'Le Féminin dans l'art', *Le Papillon*, no. 45 (25 February 1883), p. 771.

51. 'La plupart des œuvres de femmes portent une marque évidente de faiblesse et d'infériorité cérébrable (sic) . . . C'est que le rôle de la femme n'est pas de guider les peuples, mais bien celui de guider les enfants. Elle-même est une espèce de grand enfant nerveux, incapable de juger les choses à froid, avec justesse et bon sens. Voila pourquoi les écrits de la plupart des bas bleus sont remplis de tant d'exagérations, d'emballements inutiles, de phrases épatoires et vides' V. Joze, 'Le Féminisme et le bon sens', *La Plume*, no. 154 (15 September 1895), p. 392.

52. 'J'espérais, en entrant dans cette salle du Palais de l'Industrie, ressentir une impression spéciale, un petit choc, quelque chose enfin qui correspondit à

l'odor di femina de Don Juan. Je n'allais chercher ni le bien, ni le mal; je n'espérais pas y trouver de chefs-d'œuvre et il m'importait peu d'y recontrer des croutes, mais je croyais avoir au moins droit à du féminisme. Il m'était permis de supposer que du sein de cette exhibition exclusive s'exhalerait un parfum artistique sui generis, un montant particulier ne dérivant ni du savoir ni du génie, mais de cette entité complexe si subtile, si déliée, si fugitive, si intéressante, l'émotion féminine. Désillusion amère. Il n'y a rien de pareil. Toutes ces œuvres, assez médiocres pour la plupart, sentent l'impulsion masculine qu'a subie le cerveau de leurs auteurs . . . Pas une n'a su éviter la grossière masculinisation.' G. Dargenty, 'Chronique des expositions', *Courrier de l'art*, no. 9 (1 March 1883), p. 102.

53. Dargenty thought that women should 'decouvrir dans ce qu'elles font les qualités gracieuses et délicates dont elles sont douées, une pointe de ce je ne sais quoi qui les distingue de nous, une sorte de formule, enfin, correspondante à leur constitution. Je ne vois dans toute cette peinture aucune trace d'emportement, de nervosité . . . Votre peinture, mesdames, n'a pas de sexe, et voilà ce que je lui reproche.' 'Exposition des femmes peintres et sculpteurs', *Courrier de l'art*, no. 7 (13 February 1885), p. 114.

54. G. Dargenty, 'Exposition des femmes peintres et sculpteurs', *Courrier de l'art* (26 February 1886), p. 98.

55. For an extreme proponent of this view, see G. Ferrero, 'Le Troisième Sexe', *Revue des revues* (1 January 1895), p. 6. For a discussion of the fear of the *hommesse*, see Chapter Four 'Amazone, Femme Nouvelle, and the Threat to the Bourgeois Family', in Silverman (1989), pp. 63–74.

56. See the extract from a book by M. Rafaëlli, printed in 'Les Femmes peintres et la caricature de la femme', *Moniteur des arts*, no. 1701 (18 March 1887), p. 85.

57. See, for example, the affectionate description of her as 'un petit homme' by Albert Wolff in a long apppreciative article published in *Le Figaro*, extracts of which appeared in 'L'Opinion du voisin', *Moniteur des arts* (18 July 1890), p. 257.

58. For a representative defence of Bonheur in these terms, see Omnia, 'La Peinture de la femme', *La Femme dans la famille et dans la société*, no. 26 (24–31 October 1880), p. 7.

59. For an appreciation of Mme Achille Fould's painting in these terms, see 'Rosa Bonheur', *L'Art français*, no. 363 (7 April 1894).

60. 'sous prétexte de faire le bonheur de la femme en la délivrant de ce qu'elles appellent le "joug du mari", voudraient la priver d'une protection salutaire et de tout ce qui fait sa joie; qui dans le but de réaliser de vanines chimères, cherchent à étouffer en elle tout élan instinctif, toute attraction naturelle.' V. Demont-Breton, 'Rosa Bonheur', *Revue des revues* (15 June 1899), p. 611.

61. From *Le Temps*, reprinted in *Journal des femmes artistes*, no. 7 (1 March 1891), p. 2.

62. J. le Fustec 'L'Union des Femmes Peintres et Sculpteurs', *Journal des artistes*, no. 6 (13 February 1887), p. 42.

63. 'Ne craignez pas de montrer vos défauts, ils vaudront encore mieux que leurs qualités', 'Union des Femmes Peintres et Sculpteurs', *Courrier de l'art*, no. 10 (7 March 1890), p. 75.

64. 'Avec une générosité naturelle . . . la femme artiste paraît douter d'elle-même; elle porte jusqu'à l'exagération la déférence envers ses maîtres, et ceux-ci l'influencent au point de devenir dangereux pour son indépendance et son développement.' R. Sertat, 'Les Femmes artistes', *Le Public* (24 February 1890), p. 2.

65. In his words: 'tandis qu'il semble utile de dénoncer la trop docile tendance de la femme peintre ou sculpteur à accepter, sans les contrôler, les leçons masculines et à se les assimiler jusqu'à y perdre sa propre personnalité, quel bruit nous revient? Les femmes artistes ne se contenteraient plus loin le besoin de tutelle et n'exigeraient pas moins que l'admission à l'Ecole des Beaux-arts . . . Voilà, certes des revendications auxquels nous ne nous attendions guère. Déjà trop d'influences étrangères ont marqué l'œuvre féminine d'estampilles qui paraissent ineffaçables. L'enseignement académique de l'Ecole ne ferait qu'aggraver le mal.' R. Sertat, 'Les Femmes artistes', *Le Public* (24 February 1890), p. 2.

66. 'Il est dans l'obéissance aveugle, dans le servilisme tueur d'idées, dans la passivité empoisonneuse d'originalité, dans l'admiration religieuse et, par conséquent, irraisonnée du professeur, dans le désir de lui ressembler, dans la persuasion que, plus on s'en rapproche, mieux on l'imite et plus on est fort!' G. Dargenty, 'Union des Femmes Peintres et Sculpteurs', *Courrier de l'art*, no. 10 (7 March 1890), p. 2.

67. See catalogue for the eighth exhibition, 1889. It is interesting to note that the Salon, unlike the *Salon des femmes*, barred most copies during this period, putting the stress on 'the originality of individual artists'. For a discussion of the place of the copy in relation to contemporary notions of originality, see Benjamin (1989), pp. 176–201.

68. Uzanne (transl. 1912), p. 127.

69. But it was not only critics hostile to the 'new woman', in all her guises, who commented on her over servile attitude and too faithful obedience to her teachers. Even those critics like Emile Cardon, who were exceptionally complimentary and encouraging of the women's exhibitions, lamented what he saw as the lack of originality in the shows and the too obvious evidence of the teacher's hand. E. Cardon, 'Causerie', *Moniteur des arts*, no. 1819 (1 March 1889), p. 65. One writer for *La Revue féministe* put it: 'We would have preferred to see less talent and more originality. Most of the exhibited works have been handled by consummate artists, perfectly in possession of their art, but not sufficiently free from the influence of their masters.' J. Chanteloze, 'L' Art féminin', *La Revue féministe* (1896), p. 151.

70. G. Dargenty, 'Chronique des expositions',

*Courrier de l'art*, no. 10 (7 March 1890), pp. 74–5.

71. 'Il ne me parait pas impossible qu'elles arrivent à avoir un art, à elles, où les raffinés d'impression fine les puissent reconnaître du premier coup. Qu'elles traitent donc les élégances de la vie et le décor familier! Elles y apporteront un goût incomparable, et, comme elles arrivent très vite au métier, elles ajouteront une note exquise aux travaux documentaires de ce temps.' Extract from *Le Temps* reprinted in *Journal des femmes artistes* (1 March 1891), p. 2.

72. See Shiff (1984), pp. 70–98.

73. 'Les hommes ont dans leur génie une tendance a sortir d'eux-mêmes, un désir d'entrer en rapport direct avec les choses, de les saisir en soi, dans leur vérité, dans leur réalité, dans leur caractère. Ils soupçonnent en dehors d'eux l'existence d'un monde de formes et d'idées qu'ils s'efforcent de percevoir et de comprendre. Dans ces deux exercices de l'esprit, ils apportent plus de curiosité, plus d'impartialité que de passion. Il n'en va pas de même avec les femmes, qui ne connaissent jamais qu'elles-mêmes, qui sont une impossibilité enfantine adorable de ne jamais sortir de soi, de leurs préventions, de leurs impressions, de leurs haines, de leur amour . . . Elles n'ont point l'idée de l'ordre logique, de l'enchainement, de la valeur absolue des idées; elles substituent à tout cela l'ordre et l'enchainement qui leur agrée le plus, elles ne reconnaissent de valeur aux événements et aux idées que dans le degré où ils les touchent: impressionistes, je vous le dis, en histoire, en morale, en littérature, en grammaire, en analyse logique, en mathématiques, en chimie et, par conséquent, en peinture.' H. Le Roux, 'La Vie à Paris', *Le Temps* (25 February 1888).

74. de Soissons (1894), pp. 76–7.

75. R. Marx, 'Berthe Morisot', *Revue Encyclopédique* (1896), p. 250.

76. For a comment on the dearth of Impressionist paintings at the *Salons des femmes*, see 'L'Exposition Annuelle de l'Association des Femmes Artistes', *La Famille*, no. 545 (March 1890), p. 167. This critic greeted this fact with pleasure, however.

77. 'C'est que la femme est un être spontané, impressionnable et nerveux, il ne faut pas lui demander la recherche de la pensée, mais seulement la notation des impressions et des sensations qu'elle éprouve.' From criticism of the seventh exhibition, quoted in Lepage (1911), p. 70.

78. For an appreciation of Mme Delacroix-Garnier's work, see C. Ponsonhailhe, 'Exposition des Femmes Peintres et Sculpteurs', *L'Art français*, no. 459 (8 February 1896). The announcement that her work won the prize was made in 'Union des Femmes Peintres et Sculpteurs', *Moniteur des arts*, no. 2222 (14 February 1896), p. 66.

79. R. Sertat, 'Berthe Morisot', *Journal des artistes*, no. 23 (13 June 1892), p. 173.

80. T. Natanson, 'Berthe Morisot', *La Revue blanche*, vol. 10 (1896), p. 251.

81. Duret (1906, tranl. 1910), p. 173.

82. Lecomte (1892), pp. 105–6.

83. H.N. 'Berthe Morizot' (*sic*) *Journal des artistes*, no. 10 (10 March 1895), p. 955.

84. 'Aux frais artistes, aux sincères, vous [women artists] ne ferez aucun tort; ils garderont intact le monopole des œuvres puissantes et le don des forces créatrices; à vous, troupe légère, le domaine, où ils resteront toujours inférieurs, des arts plus délicats, des notes plus intimes et plus douces; à vous, l'aquarelle et le pastel, le paysage, la fleur et l'enfant.' P. Borel, 'L'Exposition des Femmes Peintres', *La Nouvelle Revue*, vol. 57 (March–April 1889), p. 625.

85. L. Lagrange, 'Du rang des femmes dans les arts', *Gazette des beaux-arts* (1860), p. 39.

86. F. de Jouval, 'L'Exposition des Œuvres Féminines', *Le Papillon*, no. 43 (12 February 1882), p. 339.

87. C. Bigot, 'Les Petits Salons artistiques', *La Revue politique et littéraire* (4 March 1882), p. 280.

88. J. Alesson, 'Conseil à une jeune artiste', from *Progrès des femmes*, reprinted in the *Journal des artistes*, no. 21 (21 May 1893), p. 162.

89. J. Claretie, 'La Vie à Paris', *Le Temps* (31 January 1882).

90. 'beaucoup ont du talent, non pas toutes pour faire des portraits, de la grande peinture, mais pour gagner largement leur vie dans différentes branches d'art industriel, ce qui est mieux.' Cardon's support for women's art was consistant. He particularly understood the need for poor women to work and endorsed art as a means of doing this, seeing his support for the *Union* as part of an overall policy of support for women in a liberal Republic. For an impassioned defence of women's need to work and an argument for artistic training as a means towards this, see his 'Septième Exposition de l'Union des Femmes Peintres et Sculpteurs', *Moniteur des arts*, no. 1759 (March 1888), p. 65.

91. 'Très peu de grands ouvrages, point de tableaux d'histoire, quelques scènes de genre, des portraits en nombre, des fleurs, des fruits, quelques paysages, un seul portrait en pied.' H. Havard, 'Exposition de l'Union des Femmes Peintres et Sculpteurs', *Le Siècle* (25 January 1882).

92. 'Les Femmes artistes', *Journal des artistes*, no. 3 (15 January 1899), p. 2163.

93. One critic posited this opposition as the reason why there need be no competition between men and women. J.L. Fustec, 'Exposition des Femmes Peintres et Sculpteurs', *Journal des artistes*, no. 9 (6 March 1887), pp. 73–4.

94. The critic E. Muntz had put it as follows in 1873: 'Les femmes, fidèles à leurs instincts, s'attachent de préférance aux genres faciles, exigeant de l'élégance plutôt de l'énergie et de l'invention: l'aquarelle, la miniature, la peinture sur porcelaine etc.' *Chronique des arts*, no. 22 (31 May 1873), p. 213.

95. For a slightly earlier discussion of the difficulties faced by the woman sculptor, see M. Deraismes, 'Les Femmes au Salon', *L'Avenir des femmes*, no.

142 (3 September 1876), p. 134. Some twenty years later a critic evoked the dirt and physical labour that went with sculpting, insinuating that this was not appropriate for a woman. See C. Ponsonailhe, 'Exposition des Femmes Peintres et Sculpteurs', *L'Art français*, no. 459 (8 February 1896). For a discussion on the lack of training facilities for women sculptors, see O. Audouard, 'Le Féminin dans l'art', *Le Papillon*, no. 47 (11 March 1883), p. 788. Despite the view that sculpture was 'unfeminine', there were a surprising number of women who chose to become sculptors. For an explanation of this, see Vachon (1893), p. 593. See also Lepage (1911), p. 24.

96. See the euphoric criticism which greeted the exhibition of this work when it was shown at the seventh exhibition of the *Union*. 'L'Exposition des Femmes Peintres et Sculpteurs', *L'Art français*, no. 45 (3 March 1888). It is interesting to compare this response with the more ambivalent and complex response to the more sexually explicit work of Camille Claudel. See Mitchell (1989), pp. 419–47.

97. Anon. 'La Vie à Paris', *Le Temps* (25 February 1888), p. 2. Similar claims for Mme Bertaux were made five years earlier: 'Mme Lèon Bertaux est le meilleur et le plus brillant des arguments vivants en faveur de cette thèse que le génie n'a pas de sexe, c'est-à-dire qu'il peut être l'apanage de la femme aussi bien que de l'homme.', *Le Papillon* (11 March 1883), p. 785.

98. Frétillon in *Voltaire*, reprinted in *Journal des artistes*, no. 27 (10 July 1887), p. 213.

99. 'aller à la synthèse en cherchant l'unité; annihiler tout détail anatomique nuisible à l'ensemble, inutile au mouvement d'une figure; corriger toute laideur, supprimer toute trivialité; avant tout choisir de belles lignes, de belles formes, et ne jamais copier, – interpréter toujours'. Quoted by A. Germain, 'Idéalisme et modernisme', *Moniteur des arts*, no. 2000 (29 January 1892), p. 33.

100. For the most graphic rendering of these terms see Blanc's 1867 discourse on painting (transl. 1874), p. 97: 'Nature is a poem, but a poem obscure, of unfathomable depth, and of a complexity that seems to us sublime disorder . . . Nature gives us all sounds, but man alone has invented music. She possesses all woods and marbles; man alone has drawn from them architecture. She unrolls before our eyes countries bristling with mountains and forests, bathed by rivers, cut by torrents; he alone has found in them the grace of gardens. Every day she gives birth to innumerable individuals and forms of endless variety; man, alone, capable of recognising himself in this labyrinth, draws thence the elements of the ideal he has conceived, and in submitting these forms to the laws of unity, he, sculptor or painter, makes of it a work of art.'

101. L. Just, 'Le Salon des femmes', *Journal des artistes*, no. 7 (21 February 1892), p. 58.

102. 'Nos illustrations', *L'Art français*, no. 362 (31 March 1894).

103. For a discussion of women artists and the male nude, see Garb, 'The Forbidden Gaze; Women Artists and the Nude in late 19th Century France', Adler and Pointon, 1993.

104. 'Lorgnette', 'L'Exposition de L'Union des Femmes', *La Citoyenne*, no. 52 (5–11 February 1882), p. 2.

105. 'A travers le féminisme: L'Union des Femmes Peintres et Sculpteurs', *Le Féminisme chrétien* (1896), p. 94.

106. Raffaëlli, 'Les Femmes peintres et la caricature de la femme', *Moniteur des arts*, n. 1701 (18 March 1887), p. 85. For a rebuttal of his position see J. Le Fustec, 'M. Rafaëlli et les femmes artistes', *Journal des artistes*, no. 12 (26 March 1887), p. 90.

107. Frétillon, *Voltaire*, reprinted in *Journal des artistes*, no. 27 (10 July 1887), p. 213.

108. Anon. 'L'Union des Femmes Peintres et Sculpteurs', *L'Art français*, no. 307 (11 March 1893).

109. O. Audouard, 'Le Féminin dans l'art', *Le Papillon*, no. 45 (25 February 1883), p. 771.

110. A.E. Guyon-Verar, 'Les Salons', *Journal des artistes*, no. 8 (21 February 1897).

111. Anon. 'Les Femmes artistes'. *La Lanterne* (20 February 1890), p. 2.

112. Anon, *L'Artiste* (March 1886), pp. 173–4. Women's qualities, of course, were not conceived of as necessarily all virtuous. See, for example, the comments of the critic for *L'Evénement* some ten years later: 'je veux voir transparaître la mère, l'amoureuse ou simplement la fine médisante qu'est au fond toute vraie fille d'Eve', H. Rebell, 'L'Assemblée des Bas-Bleus', *L'Evénement* (11 June 1896), pp. 1–2.

113. G. Dargenty, 'Union des Femmes Peintres et Sculpteurs', *Courrier de l'art*, no. 11 (14 March 1884), p. 126.

114. H. Mornand, *La Revue génerale*, no. 177 (15 March 1891), p. 115.

115. 'On ne pourra pas dire du moins que le pinceau a masculinisé la femme jusqu'à lui faire passer le goût de ce qui lui va si bien . . . Pour ma part, je l'avouerai . . . je préfère bien le *Pantier de lilas blancs et violets* de Mme de Gaussaincourt, par exemple, ou tel autre bouquet de vulgaires roses et de plus vulgaires marguerites, à quelque grande machine – prétendue historique que nous avons vue en d'autres endroits, dénotant beaucoup d'efforts avec moins de sentiments, et sourtout moins de résultats.' Un Artiste, 'Les Femmes peintres et sculpteurs', *La Citoyenne*, no. 94 (March 1885), pp. 2–3.

116. For an assertion of flower arranging as a traditional female art, see R. Sugères, 'La Femme dans l'art', *La Revue féministe* (1897), p. 216.

117. For an appreciation of her work in these terms, see C. Ponsonailhe, 'Exposition des Femmes Peintres et Sculpteurs', *L'Art français*, no. 459 (8 February 1896).

118. Un Artiste, 'Exposition des Femmes Peintres et Sculpteurs', *La Citoyenne*, no. 142 (March 1889), p. 3.

119. H.E. 'Exposition des Femmes Artistes', *Journal*

*des artistes*, no. 8 (23 February 1883), p. 1.

120. 'c'est la façon merveilleuse dont les femmes arrivent à rendre le regard: les yeux sont vivants, expressifs; des yeux qui parlent!' O. Audouard, 'Le Féminin dans l'art', *Le Papillon*, no. 45 (25 February 1883), p. 771.

121. See the discussion on the portrait of the doctor Mme Guénot, by L. Mercier, H.E.. 'Exposition des Femmes Artistes', *Journal des artistes*, no. 8 (23 February 1883), p. 1.

122. Anon. 'Union des Femmes Peintres et Sculpteurs', *Moniteur des arts* (14 February 1896), p. 66.

123. 'Le peintre s'est moins attaché au trait descriptif qu'a l'évocation intellectuelle, c'est moins la femme que l'artiste qu'il a portraiturée'. F. Javel 'Mme Demont-Breton et les femmes artistes', *L'Art français*, no. 410 (2 March 1895).

124. C. Ponsonailhe, 'Exposition des Femmes Peintres et Sculpteurs', *L'Art français*, no. 459 (8 February 1896).

125. G. Sénéchal, 'Aux femmes artistes', *Le Libéral* (18 March 1890), p. 3.

126. Anon. 'La Vie à Paris', *Le Temps* (25 February 1888), p. 2.

127. J. Chanteloze, 'L'Art féminin', *La Revue féministe* (1896), p. 152.

## CHAPTER 6: L'ART FÉMININ

1. *Journal des femmes artistes*, no. 36 (February 1893), p. 1.

2. In Ingrès' words: 'le dessin, c'est la probité de l'art', *Journal des femmes artistes*, no. 36 (February 1893), p. 1.

3. 'Est-il une exposition moderne en '*ant*' ou '*iste*' qui offre dans son ensemble la valeur d'une œuvre de maître? Lorsque les connaissances fondamentales de l'Art se trouvent observées, soit dans une esquisse, soit dans une étude, il y a œuvre et parfois chef-d'œuvre.' Une sociétaire, 'Cloture de notre 11e Exposition', *Journal des femmes artistes*, no. 26 (31 March 1892), p. 2.

4. 'tout en cultivant avec passion le grand art, ne négligeait aucun des devoirs de la famille et de la société. Epouse dévouée, mère de famille admirable'. Quoted in an obituary for Mme Peyroll-Bonheur, *Journal des femmes artistes*, no. 12 (15 May 1891), p. 4.

5. See the speech delivered at the banquet of the *Union*, published in the *Journal des femmes artistes* (17 May 1895), p. 1.

6. 'N'est-elle pas autant que l'homme, à même de pénétrer, non seulement les tendresses, mais aussi les anxiétés, les douleurs poignantes de la vie, elle qui pénètre dans les mansardes et les chaumières pour y porter la charité aux malheureux, elle qui entend leurs confidences, elle qui les aide et les console?' From a speech delivered by Mme Demont-Breton at the *Union* banquet, published in *Journal des femmes artistes* (17 May 1897), p. 2.

7. 'Plus la femme se trouvera dans les conditions d'existence voulues pour pénétrer les sentiments humains qui la charment le plus fortement plus son oeuvre sera intéressante et forte et plus elle continuera à apporter un élément particulier, de nature à compléter et à enrichir l'art de son pays'. V. Demont-Breton, 'La Femme dans l'art', *Journal des femmes artistes*, no. 28 (12 July 1896), p. 1513.

8. For a speech in which Mme Demont-Breton seeks to elevate the decorative arts from its traditional status as a minor art, see *Journal des femmes artistes*, no. 77 (May 1898), p. 2. Mme Bertaux's views on this matter were made clear in a speech quoted by Lepage (1911), p. 193.

9. '"grand art"; dont la recherche peut se rencontrer dans la plus petite toile, ... est la résultante de connaissances acquis et d'inspirations personelles élevées. Le génie ne peut se développer sans culture; c'est cette haute culture que l'Etat refuse aux femmes et qu'il leur doit'. *Journal des artistes*, no. 50 (15 December 1889), p. 395.

10. For a typical defence of women's capacity for *le grand art*, see Mme Demont-Breton's speech at the 1897 banquet, *Journal des femmes artistes*, no. 71 (May 1897), p. 2.

11. Une sociétaire, 'Causerie', *Journal des femmes artistes*, no. 23 (12 Februay 1892), p. 2.

12. Bouguereau was a teacher at the women's studio of the Académie Julian and therefore came into contact with many aspiring women artists. A number of women listed themselves as his students in the catalogues for the *Salons des femmes*. He took an interest in the *Union's* activities as his presence as a guest of honour at the 1898 'Fête annuelle' testifies. See the *Journal des femmes artistes*, no 77 (May 1898), p. 2.

13. For a statement on the status of the *étude* whose power must not be over-exaggerated, although it need not always lead to '*mauvais tendances*', see L.B. (Une sociétaire) 'Causerie', *Journal des femmes artistes*, no. 5 (1 February 1891), p. 1. It is highly likely that this was written by Mme Bertaux. Besides having her initials, the tone used and the sentiments expressed are consistant with those used by her elsewhere. A copy of the Gardner was made by Mlle Augusta Beaumont. See catalogue for the 8th exhibition of the *Union*, 1889, no. 41. A contemporary critic claimed that every mother would want a reproduction of the Gardner painting in which the baby resembled '*un petit saint Jean Baptiste*'. F. Bournand, 'Mlle E. Gardner', *Paris-Salon*, vol. 1 (1889). For a discussion of Gardner's life and career see Fidell-Beaufort (1984), pp. 2–9.

14. For a discussion of the imagery of the 'modern madonna' in late nineteenth-century France, especially in relation to the work of Mary Cassatt, see Mathews (1980). For a discussion of Morisot and motherhood, see Higgonet (1992).

15. For representative statements of this type see Jean Alesson's lament on the demise of the 'Ideal' at the Salon of 1888, in 'Les Femmes artistes au Salon de 1888', *Journal des artistes*, no. 24 (10 June 1889), p. 191. See also O. Audouard, 'Le Sens esthétique', *Le Papillon*, no. 6 (27 May 1883), p. 878 and the

views of B. Prost, a critic for *L'Art français,* who lamented the servile copying of nature of contemporary artists and the resultant loss of interest in the intellectual elements of art, inspiration, creation, style, taste, sentiment, all essential for an elevated aesthetic conception. Reprinted in *Journal des femmes artistes,* no. 41 (September 1893), p. 4.

16. For a broad discussion of these issues see Marlais (1992).

17. Gérôme accompanied this diatribe with expressions of his xenophobic anxiety about the numbers of foreigners at national exhibitions. These remarks were made in response to a survey conducted by the *Journal des artistes* (8 April 1894), reprinted in the *Journal des femmes artistes,* no. 48 (May 1894), p. 4.

18. 'Nous traversons une époque de doute qui a jeté son ombre sur l'idéal artistique et littéraire de toutes les nations . . . , plus fortes et plus croyantes en notre art, reprenons possession de nous-mêmes en face de toutes les sectes nouvelles: décadents, intransigeants, incohérents, indépendants, etc. et remercions-les cependant de nous avoir enseigné ce qu'il faut éviter'. Une sociétaire, 'Causerie', *Journal des femmes artistes,* no. 23 (12 February 1892), p. 1.

19. 'il ne place pas le souci du corps au-dessus des pures jouissances de l'idéal, il redoute que son travail devienne plutôt un objet de consommation que la manifestation d'une idée'. Une sociétaire, 'Causerie', *Journal des femmes artistes,* no. 23 (12 February 1892), p. 1.

20. On neo-Lemarckism as the basis of the French eugenics movement, see Schneider (1982), pp. 268–91.

21. For an account of degeneration theory see Nye (1984).

22. The move away from naturalism can be situated within a broader rejection of science and positivist forms of explanation, which characterised certain groups in the 1890s. See Paul (1968), pp. 299–327.

23. 'il n'est pas peut-être téméraire de supposer que l'idéal féminin rendra à l'art ce que le monde lui demandait à son origine'. From a toast given by Mme Bertaux at the tenth anniversary celebrations of the *Union.* Reprinted in *Journal des femmes artistes,* no. 13 (June 1891), p. 3.

24. 'Combattons, mes amies, . . . cette fureur de singularités modernes. Par nous, femmes, par le caractère de nos travaux, que l'Art redevienne avec force civilisatrice, qu'il redonne au monde ce qu'on lui demandait à l'origine, ce qu'il a donné: l'oubli des réalités, l'éblouissement de la pure lumière en place de la nuit profonde. L'Art c'est l'invention. Inventons ce qui console le coeur, charme l'esprit et fait sourire le regard. Voilà, certes une mission bien féminine. Oui, créons, femmes, nous le devons, et nous le pourrons, cet art nouveau qu'on attend l'Art féminin.' L.B. (Une sociétaire), 'Causerie', *Journal des femmes artistes,* no. 5 (1 February 1891), p. 2.

25. Le Rédaction, *Journal des femmes artistes,* no. 1 (1 December 1890), p. 1.

26. In the words of Mme Demont-Breton: 'La femme est essentiellement idéaliste, romanesque dès le premier printemps de son adolescence et avant d'avoir commencé son propre roman'. 'La Femme dans l'art', *Journal des artistes,* no. 28 (12 July 1896), p. 1513.

27. Sec Fouillée, (1895, transl. 1990), pp. 21–22.

28. Quoted in Bellet (1979), p. 23.

29. See, for example, Comte, 'Social Statistics; or Theory of the Spontaneous order of Human Society', (1839), quoted in Bell and Offen, (1983), p. 221.

30. See the entry for 'sentiment', *La Grande Encyclopédie,* vol. 29, p. 1013. For a typical argument on the above lines, see Fouillée (1895).

31. The term *péril moral* is used by Jules Simon in his preface to the first volume of his *Revue de famille* (1888), p. 1.

32. From a speech made by Mme Demont-Breton at the *Fête Annuelle,* reprinted in the *Journal des femmes artistes,* no. 77 (May 1898), p. 2.

33. 'Cette honteuse littérature soi-disante *naturaliste,* beaucoup de ceux qui s'en nourrissaient la flétrissent maintenant avec dégoût; ces qualifications humiliantes de *décadents* et de *fin de siècle* . . . beaucoup de nos jeunes gens les repoussent avec énergie. Nous, femmes de France, mères, soeurs, amies de ces jeunes gens, aidons-les donc dans cette voie nouvelle de tous nos voeux, de toutes nos prières, de toute notre ardents sympathie.' *La Femme,* no. 15 (1 August 1890), p. 113.

34. 'Vaincre les tendances au matérialisme, favoriser le progrès moral en ce qu'il a de plus grand et de plus élevé; travailler . . . à la régéneration humaine'. Mme Roger de Nesle, 'Rapport sur la Société de l'Union des Femmes Poètes', *Actes de Congrès International des Œuvres et Institutions Féminines,* Section 111 (1890), p. 455.

35. 'C'est l'épurement par l'idéalisme, de toutes les sociétés humaines; c'est la paix universelle dont l'avènement est inscrit dans le livre de Dieu'. De Nesle (1890), p. 455.

36. Hundreds of letters of support for the *Revue scientifique des femmes* are preserved in the B.H.V.P., Fonds Bouglé, which contains the Fonds Céline Renooz.

37. 'C'est à la femme qu'incombe cette tache. C'est elle qui, à l'aide de cette faculté que lui reconnaissent les hommes, mêmes les plus injustes: l'intuition, doit rendre, au vieux monde, la lumière qui fera renaître la vie intellectuelle qui s'en va, la vie morale qui disparaît, la foi dans la vérité supreme, l'enthousiasme pour les grandes et saintes causes.' C.R., 'Régéneration morale par la science', *La Revue scientifique des femmes,* no. 2 (June 1888), p. 49.

38. 'à faire revivre dans l'humanité l'amour du vrai, le culte du bien, l'horreur du vice, le mépris de toutes les vénalités'. C.R., 'Régéneration morale par la science', *La Revue scientifique des femmes,* no. 2 (June 1888), p. 49.

39. 'Toutes les formes de l'Art, les plus élévées comme les plus modestes, peuvent y trouver leur place. Que les femmes auteurs, poètes, critiques, que sais-

je? Que toutes celles qui pensent et travaillent fassent comme nous; qu'elles se réunissent, et toutes ensemble, nous formerons une vaste et fière association dont le centre naturellement, sera notre chère Société, aujourd'hui florissante et prospère.' L.B. (Une sociétaire), 'Causerie', *Journal des femmes artistes*', no. 5 (1 February 1891), p. 2.

40. See a letter from Mme Bertaux to Mme Renooz in B.H.V.P., Fonds Bouglé, Fonds Céline Renooz, Boîte 2, lettres à Celine Renooz, 1888 à 1896.

41. Quoted in Lepage (1911), p. 48.

42. 'charmer le cœur humain par la vue des belles formes et en même temps de développer ses plus nobles sentiments par la représentation des actions héroïques ou tendres.', Lepage (1911), p. 48.

43. 'Vous le voyez, mesdames, notre domaine n'a pas de bornes. Soyons de grands artistes; nous resterons dans notre rôle, parfaitement d'accord avec les lois que la nature, la société, la famille nous imposent. Le culte d'art nous laissera dans notre sphère; les hommes feront les lois et au besoin feront la guerre pour les défendre; la vie publique leur appartient; ils la gardent. Sûres d'être à notre place, enrôlons dans le divin culte de l'art, toutes nos forces vives, nos belles passions. Nous y trouverons du pain, quelquefois la fortune, et, selon nos destinées, des joies et des consolations. La femme y gagnera, et la société tout entière avec elle.' Lepage (1911), p. 50.

44. 'restons femmes dans la société, dans la famille; montrons qu'on peut être artiste, et même grande artiste, sans cesser de remplir la somme de devoirs qui est notre gloire et notre honneur. Restons femmes: au point de vue artistique aussi: ne calquons pas nos maîtres, créons selon notre sentiment. Même avec l'intention de les égaler, ne copions pas les chefs-d'œuvre; donnons naissance à un art qui portera la marque du génie de notre sexe; restons femmes, restons artistes, restons unies.' From a toast delivered by Mme Bertaux at the 10th anniversary banquet of the *Union*, reprinted in *Journal des femmes artistes*, no. 13 (June 1891), p. 3.

45. This was as true for Berthe Morisot, the allegedly 'natural painter' as for anyone else. See her letters (new ed. 1986) and the journal of Marie Bashkirtseff (1887, new ed. 1985) for numerous accounts of the struggles involved in the business of painting. For Maria Deraismes's dismissal of intuition and natural ability as an adequate basis for artistic excellence, see 'Les Femmes au Salon', *L'Avenir des femmes*, no. 141 (6 August 1876), p. 115.

46. For a discussion of women's production in this sphere, see Higonnet (1987), pp. 16–36 and Parker (1984), pp. 147–88.

# Bibliography

ARCHIVAL SOURCES

## Archives Nationales:

AJ 52 20:       Ecole des Beaux-Arts
AJ 52 24:       Ecole des Beaux-Arts
AJ 52 26:       Ecole des Beaux-Arts
AJ 52 27:       Ecole des Beaux-Arts
AJ 52 33:       Ecole des Beaux-Arts
AJ 52 73:       Ecole des Beaux-Arts
AJ 52 471:      Ecole des Beaux-Arts
AJ 52 971:      Ecole des Beaux-Arts
AJ 53 8:        Ecole des Arts Décoratifs
AJ 53 9:        Ecole des Arts Décoratifs
AJ 53 10:       Ecole des Arts Décoratifs
AJ 53 11–15:    Ecole des Arts Décoratifs
AJ 53 23:       Ecole des Arts Décoratifs
F7 12842:       Dossier de sociétés et de journaux, 1895–1925
F7 12843:       Dossier de journaux, 1896–1924
F17 13600:      Ecole de Rome
F18 312–425:    Presse, Paris, 1820–1894
F21 560:        Le Budget de Beaux-Arts
F21 291:        Mme de Montizon, Fondatrice de l'Ecole de Dessin pour les Jeunes Filles
F21 282:        Mme de Montizon, Fondatrice de l'Ecole de Dessin pour les Jeunes Filles
F21 514:        Mme de Montizon, Fondatrice de l'Ecole de Dessin pour les Jeunes Filles
F21 517:        Mme de Montizon, Fondatrice de l'Ecole de Dessin pour les Jeunes Filles
F21 4417:       Dossier des sociétés artistiques de Paris
F21 4483:       Ecole du Louvre
F21 5711:       Conseil Supérieur des Beaux-Arts

## Bibliothèque Historique de la Ville de Paris:

Fonds Marie-Louise Bouglé: 4247–4248: Autographies. Containing:

Fonds Hubertine Auclert:      Boîte 1: Coupures de presse
                              Boîte 2 et 3: Correspondance
Fonds Céline Renooz:          Boîte 2, lettres à Céline Renooz, 1888 à 1896
Dossier: Groupes et associations:   Boîte 2, Suffragisme
Dossier: Congrès, 1.          Congrès Général des Sociétés Féministes, Paris, 1892
Dossier: Congrès, 2.          Congrès Féministe International, 8/12 avril 1896
Dossier: Congrès, 4.          Congrès Officiel des Œuvres et Institutions Féminines, Paris, 18/23 juin 1900

## Archives de la Préfecture de Police, Paris.

D/B 228:        Dossier, Clubs/Réunions Publiques
BA/30:          Congrès internationales
BA/1651:        Le Mouvement féministe

## Bibliothèque Marguerite Durand

DOS. 396 FEM:   Féminisme – histoire
DOS. 370 ENS:   Enseignement
DOS. 064 BEA:   Femmes appartenant à l'Académie des Beaux-Arts

DOS. 700 EXP:   Expositions et Salons de peinture par des femmes
DOS. 700 SOC:   Union des Femmes Peintres et Sculpteurs
DOS. 707 BEA:   Femmes à l'Ecole des Beaux-Arts
DOS. 707 LOU:   Femmes à l'Ecole du Louvre
DOS. BON:       Rosa Bonheur
DOS. DEM:       Virginie Demont-Breton

## Musée d'Orsay, Centre du documentation

DOS:    Léon Bertaux
DOS:    Virginie Demont-Breton
DOS:    Rosa Bonheur
DOS:    Madeleine Lemaire
DOS:    Louise Abbéma
DOS:    Henriette Ronner
DOS:    Esther Huillard

## Published Sources

NEWSPAPERS

L'Evénement
La Chronique moderne
Le Constitutionnel
Le Figaro
La Fronde
La Lanterne
Le Libéral
L'Observateur français
Le Public
Le Siècle
Le Temps

JOURNALS

Annuaire illustré des beaux-arts
L'Artiste
L'Avant-Courrière
L'Avenir des femmes
L'Art français
Le Bas-Bleu
Bulletin hebdomadaire de l'artiste
La Chronique moderne
Chronique des arts et de la curiosité
La Citoyenne
Courrier de l'art
Le Droit des femmes
La Famille
Le Féminisme chrétien
La Femme
La Femme dans la famille et dans la société
Les Gauloises
Gazette des beaux-arts
Gazette des femmes

La Grande Dame
L'Harmonie sociale
Journal des artistes
Journal des demoiselles
Le Journal des femmes
Journal des femmes artistes
Journal official, Chambre des députés (débats parlementaires)
Le Monde illustré
Moniteur des arts
Moniteur des cercles
La Nouvelle Revue
Le Papillon
La Plume
La Revue blanche
La Revue des arts décoratifs
La Revue des deux-mondes
La Revue encyclopédique
La Revue de famille
La Revue féministe
La Revue générale
La Revue philosophique
La Revue politique et littéraire
La Revue scientifique
La Revue scientifique des femmes
La Revue Internationale de sociologie
Société pour l'amélioration du sort de la femme et la revendication de ses droits
La Tribune des femmes

## PRIMARY SOURCES

ABERDEEN, Countess of, Transactions of the International Congress of Women, 7 vols, London, 1900

Actes du Congrès International des Œuvres et Institutions Féminines publiés par les soins de la commission nommé par le comité d'organisation, Paris, 1890

ALLESSON, J., Les Femmes Artistes au Salon de 1878, Paris, 1878

ALLESSON, J., Les Femmes décorées et les femmes militaires, Paris, 1891

Almanach féministe, 1899–1900, Directrice Marya-Chéliga, Paris

Annuaire de la Société des Artistes Français, Paris, 1887

AUCLERT, H., Hubertine Auclert, La Citoyenne 1848–1914, (ed. E. Taieb), Paris, 1982.

AUCOC, L., L'Institut de France, Lois, statuts et règlements concernant les anciennes Académies et l'Institut, de 1635 à 1889, Paris,

1889

AUDOUARD, O., *Guerre aux hommes*, Paris, 1866

AVENAL, H., *Histoire de la Presse française de 1789 à nos jours*, Paris, 1900

BASHKIRTSEFF, M., *Journal* (1887), introduction by R. Parker and G. Pollock, London, 1985

Bellier de la Chavignerie, E., and Auvray, L., *Dictionnaire général des artistes de l'école française*, Paris, 1868

BLANC, C., *Grammaire historique des arts du dessin*, Paris, 1867

BOURNAND, F., *Paris-Salon*, vol. 1, Paris, 1889

BOUSSOD, Valadon & Cie, *Exposition de Tableaux, Pastels, et Dessins par Berthe Morisot*, exhibition catalogue, (25 May–18 June 1892) introduction by G. Geffroy

BOUSSU, N., *Etudes administratives: L'Administration des Beaux-Arts*, Paris, 1877

CAMPBELL, H., *Differences in the Nervous Organisation of Man and Woman*, London, 1891

Cercle artistique et littéraire, rue Volney, *Annuaire de 1894–1895*, Paris

Chambre des députés, *Annexe au procès–verbal de la séance du 21 juin 1881*, no. 3783, session de 1881, article 8

CHAMPIER, V., *L'Année artistique 1879*, Paris

CHAMPIER, V., *L'Année artistique 1880–1881*, Paris

CHAUVIN, J., *Etude historique sur les professions accessibles aux femmes*, Paris, 1892

CHÉLIGA, M., 'L'Evolution du féminisme', *La Revue encyclopédique*, no. 169 (28 November, 1896), pp. 910–913

CLUNET, E., *Les Associations au point de vue juridique et historique*, Paris, 1904

*Congrès International du Droit des Femmes, actes, compte rendu des séances*, Paris, 1878

*Congrès Français et International du Droit des Femmes*, Paris, 1889

COUGNY, G., *L'Enseignement professionnel des beaux-arts dans les écoles de la ville de Paris*, Paris, 1888

CRAWFORD, V., 'Feminism in France', *Fortnightly Review* (April 1897), pp. 524–34

DELABORDE, H., *L'Académie des beaux-arts depuis la fondation de l'Institut de France*, Paris, 1891

DEMONT, A., *Souvenances, Promenades à travers ma vie*, Paris, 1927

DEMONT-BRETON, V., 'Rosa Bonheur', *La Revue des revues* (15 June 1899), pp. 604–19

DEMONT-BRETON, V., *Les Maisons que j'ai connues*, Paris, 1926

DERAISMES, M., *Eve dans l'humanité*, 1868, new edition with introduction by Klejman, L., Paris, 1990

*Dictionnaire de l'Académie des Beaux-Arts*, Paris, 1858

DUPANLOUP, F.A.P. (Bishop of Orléans), *La Femme chrétienne et française*, Paris, 1868

DUPANLOUP, F.A.P. (Bishop of Orléans), *La Femme studieuse*, Paris, 1875, (3rd edition)

DUPRÉ, P., and Ollendorf, G., *Traité de l'administration des Beaux-Arts: Historique, Législation, Jurisprudence*, Paris, 1885

DURET, T., *Manet and The French Impressionists*, 1906, English translation, 1910

*Elisa Lemonnier, fondatrice de la Société pour l'Enseignement Professionnel des Femmes*, Paris, 1874

FIDIÈRE, O., *Les Femmes artistes à l'Académie Royale de peinture et de sculpture*, Paris, 1885

FOUILLÉE, A., 'La Psychologie des sexes et ses fondements physiologiques', *Revue des deux-mondes*, no. 119 (15 September 1893), pp. 397–492

FOUILLÉE, A., *Tempérament et caractère selon les individus, les sexes et les races*, Paris, 1895

FOUILLÉE, A., *Psychologie du peuple français*, Paris, 1898

FOUILLÉE, A., *Woman: A Scientific Study and Defence*, translated by. Rev. T.A. Seed, London, 1900

FRANK, L., *La Femme dans les emplois publics*, Brussels, 1893

Galerie Georges Petit, *Société Internationale de peintres et sculpteurs*, Première exposition, Paris, 1882

Galerie Georges Petit, *Société Internationale de peintres et sculpteurs*, Deuxième exposition Paris, 1883

GASTON, R., 'Review of J. Lourbet ' "La femme devant la science contemporaine" ', *Revue philosphique*, vol. 43 (1897)

*La Grande Encyclopédie*, Paris, c 1898

HOSCHEDÉ, E., *Les Femmes artistes*, Paris, 1882

LAMBEAU, L. (ed.), *L'Enseignement professionnel à Paris*, vol. 1, 1871–1896, Paris, 1898

LAMI, S., *Dictionnaire des Sculpteurs de l'école française au dix-neuvième siécle*, Paris, 1914

LAROUSSE, P., *Grand Dictionnaire du dix-*

*neuvième siècle*, 17 vols, 1866–1890

LARROUMET, G., *L'Art et l'Etat en France*, Paris, 1895

LE BON, G., 'La Psychologie des femmes et les effets de leur '"éducation actuelle"', *Revue scientifique*, vol. 46, no. 15 (11 October 1890), pp. 449–60

LECOMTE, G., *L'Art Impressionniste d'après la collection privée de M. Durand-Ruel*, Paris, 1892

LEMAISTRE, A., *L'Ecole des Beaux-Arts dessinée et racontée par un élève*, Paris, 1889

LEMAISTRE, A., *Nos jeunes filles aux examens et à l'Ecole*, Paris, 1891

LEPAGE, E., *Une Conquête féministe: Mme Léon Bertaux*, Paris, 1911

MARION, H., *Psychologie de la Femme*, Paris, 1900

MARONIEZ, G., *Virginie Demont-Breton*, Paris, 1895

MILL, J.S., *The Subjection of Women*, London, 1869

MOORE, G., *Modern Painting*, London, New York, 1898

MORISOT, B., *The Correspondence of Berthe Morisot*, edited by D. Rouart, 1953, introduction by K. Adler and T. Garb, London, 1986

Palais de l'Industrie, Union Central des Arts Décoratifs, *Exposition des Arts de la femme*, 1892

Palais de l'Industrie, Union Central des Arts Décoratifs, *Exposition des Arts de la femme*, 1895

PROUDHON, P.J., *La Pornocratie, ou les femmes dans les temps modernes*, Paris, 1875

PROUST, A., *L'Art sous la République*, Paris, 1892

RIBIÈRE, A., *Les Femmes dans la science*, Paris 1897

RICHER, L., *La Femme Libre*, Paris, 1877

RICHER, L., *Le Code des Femmes*, Paris, 1883

ROMANES, G.J., 'Mental Differences between Men and Women', *The Nineteenth Century*, vol. 21, no. 123 (May 1887), pp. 654–72

de RONCHAUD, L., 'De l'Encouragement des Beaux-Arts par l'Etat', *La Nouvelle Revue* (March, 1885), pp. 137–41

ROYER, C., 'L'Enseignement professionnel en France', *La Société nouvelle*, vol. 10 (1889), pp. 306–29

SAY, L., and Chailley, M.J., *Nouveau Dictionnaire d'Economie politique*, Paris, 1891

SCHMAHL, J., 'Progress of the Women's Rights Movement in France', *The Forum*, vol. 22 (September 1896), pp. 79–92

SERTILLANGES, A.D., *Féminisme et Christianisme*, Paris, 1908

SHAW SPARROW, W., *Women Painters of the World*, London, 1905

SIMON, J., *La Femme du XXe siècle*, Paris, 1892

*Société pour l'enseignement professionnel des femmes*, Versailles, 1882

*Société de l'Union des Femmes Peintres et Sculpteurs*, Paris, 1888

de SOISSONS, S.C., *Boston Artists: A Parisian Critic's Notes*, Boston, 1894

de, SOLENIÈRE, E., *La Femme-compositeur*, Paris, 1895

STRANAHAN, C.H., *A History of French Painting*, London, 1889

STANTON, T., *The Woman Question in Europe*, New York, 1884

STANTON, T., *Reminiscences of Rosa Bonheur*, New York, 1910

TERISSE, M.C., *Notes et Impressions à travers le féminisme*, Paris, 1896

THUILIÉ, H., *La Femme: Essai de sociologie physiologique*, Paris, 1885

TURGEON, C., *Le Féminisme français*, 2 vols, Paris, 1902

Union des Femmes Peintres et Sculpteurs, *Catalogue pour l'exposition de 1884*

Union des Femmes Peintres et Sculpteurs, *Catalogue des œuvres de Mlle Bashkirtseff*, Paris, 1885

Union des Femmes Peintres et Sculpteurs, *Catalogue pour l'exposition de 1885*

Union des Femmes Peintres et Sculpteurs, *Catalogue pour l'exposition de 1887*

Union des Femmes Peintres et Sculpteurs, *Statuts*, Paris, 1888

Union des Femmes Peintres et Sculpteurs, *Catalogue pour l'exposition de 1889*

Union des Femmes Peintres et Sculpteurs, *Catalogue pour l'exposition de 1890*

Union des Femmes Peintres et Sculpteurs, *Catalogue pour l'exposition de 1891*

Union des Femmes Peintres et Sculpteurs, *Catalogue pour l'exposition de 1892*

Union des Femmes Peintres et Sculpteurs, *Catalogue pour l'exposition de 1896*

UZANNE, O., *Le Bric-à-brac de l'amour*, Paris, 1879

UZANNE, O., *La Femme à Paris*, Paris, 1894

UZANNE, O., *The Modern Parisienne*, 1894, English translation, London, 1912

La Duchesse d'Uzès, *Le Suffrage féminin au*

*point de vue historique*, Meulan, 1914

La Duchesse d'Uzès, *Souvenirs*, Paris, 1939

VACHON, M., *La Femme dans l'Art, Les protectrices des arts, Les femmes artistes*, Paris, 1893

VALABREGUE, A., *Les Princesses Artistes*, Tours, 1888

VENTO, C., *Les Peintres de la Femme*, Paris, 1888

VENTO, C., *Les Salons de Paris en 1889*, Paris, 1891

VIVIANI, R., *1870–1920: Cinquante Ans de féminisme*, Paris, no date

YRIARTE, C., *Les Cercles de Paris, 1828–1864*, Paris, 1864

## SECONDARY SOURCES

ABENSOUR, L., *Histoire générale du féminisme, des origines à nos jours*, Paris, 1921

ABRAY, J., 'Feminism in the French Revolution', *American Historical Review*, vol. 80, no. 1 (February 1975), pp. 43–62

ACKERMAN, G.M., *The Life and Work of Jean-Léon Gérôme*, Paris, London, New York, 1986

ADLER, K., *The Unknown Impressionists*, Oxford, 1988

ADLER, K., 'The Suburban, The Modern and 'une Dame de Passy', *Oxford Art Journal*, vol. 12, no. 1 (1989), pp. 3–13

ADLER, K., and Garb, T., *Berthe Morisot*, London, 1987

ADLER DAVIS, S., 'Fine Clothes on the Altar: The Commodification of Late Nineteenth Century France', *Art Journal*, vol. 48, no. 1 (Spring 1989), pp. 85–9

AGULHON, M., *Le Cercle dans la France bourgeoise: 1810–1848*, Paris, 1977

AGULHON, M., *Marianne into Battle: Republican Imagery and Symbolism in France, 1789–1880*, 1979, English translation, Cambridge, 1981

ALBISTUR, M., and Armogathe, D., *Histoire du féminisme français*, Paris, 1977

ANGRAND, P., *Naissance des Artistes indépendants, 1884*, Paris, 1965

AQUILINO, M.J., 'The Decoration Campaign at the Salon du Champ de Mars and the Salon des Champs-Elysées in the 1890s', *Art Journal*, vol. 48, no. 1 (Spring 1989), pp. 70–84

ASHTON, D., *Rosa Bonheur, A Life and A Legend*, London, 1981

AUSPITZ, K., *The Radical Bourgeoisie: The Ligue de l'Enseignement and the Origins of the Third Republic, 1866–1885*, Cambridge, 1982

BAKHTIN, M., 'Discourse in the Novel', printed in M. Holquist (ed.), *The Dialogic Imagination*, Austin, 1981, p. 280

BARROWS, S., *Distorting Mirrors, Visions of the Crowd in Late Nineteenth Century France*, New Haven, 1981

BARTHES, R., 'Myth Today', *Barthes: Selected Writings*, 1982

BATAILLE, M.L., and Wildenstein, G., *Berthe Morisot*, Paris, 1961

BAUDOT, J., *Renoir: Ses amis, ses modèles*, Paris, 1949

de BEAUVOIR, S., *The Second Sex*, (first published France 1949), London, 1983

BELL, S.G., and Offen, K.N., *Women, The Family and Freedom*, 2 vols, Stanford, 1983

BELLANGER, C., *Histoire générale de la presse française*, Paris, 1969

BELLET, R., 'La Femme dans l'idéologie du Grand Dictionaire universel de Pierre Larousse', *La Femme au XIXe siècle: Littérature et idéologie*, Lyons, 1979, pp. 19–28

BÉNÉZIT, E., *Dictionnaire critique et documentaire des peintres, sculpteurs, dessinateurs et graveurs*, Paris, 1976

BENJAMIN, R., 'Recovering Authors: The Modern Copy, Copy Exhibitions and Matisse', *Art History*, vol. 12, no. 2 (June 1989), pp. 176–201

BERNHEIM-JEUNE, *Cent œuvres de Berthe Morisot*, exhibition catalogue (7–22 November 1919), Paris

BERTOCCI, P.A., *Jules Simon – Republican Anticlericalism and Cultural Politics in France, 1848–1886*, Columbia and London, 1978

BIDELMAN, P.K., 'The Feminist Movement in France: The Formative Years, 1858–1889', Ph.D. dissertation, Michigan State University, 1975

BIDELMAN, P.K., 'The Politics of French Feminism: Léon Richer and the Ligue française pour le Droit des Femmes, 1882–1891', *Historical Reflections*, vol. 3 (1976), pp. 93–120

BIDELMAN, P.K., *Pariahs Stand up! The Founding of the Liberal Feminist Movement in France, 1858–1889*, Westport, Conneticut,

1982

BLANCHE, J.E., *Les Arts Plastiques, la troisième république, 1870 à nos jours*, Paris, 1931

BOIME, A, 'The Salon des Refusés and the Evolution of Modern Art', *Art Quarterly*, vol. 32, no. 4 (1969), pp. 411–23

BOIME, A., *The French Academy and French Painting in the Nineteenth Century*, (first published 1971), New Haven and London, 1986

BOIME, A., 'Entrepreneurial Patronage', in E. Carter (ed.), *Enterprise and Entrepreneurs in nineteenth and twentieth-century France*, Baltimore and London, 1976

BOIME, A., 'The Teaching Reforms of 1863 and the Origins of Modernism in France', *Art Quarterly* (Autumn 1977), pp. 1–39

BOIME, A., 'The Case of Rosa Bonheur: Why should a Woman want to be more like a Man?', *Art History*, vol. 4, no. 4 (December 1981), pp. 384–406

BOUGLÉ, C., and Moysset, H. (eds.), *Proudhon: Œuvres complètes*, Paris, 1935

BOUILLON, J.P., and Kane, E., 'Marie Bracquemond', *Woman's Art Journal*, 5 (1984/1985), pp. 21–27

BOUILLON, J.P., 'Sociétés d'artistes et institutions officielles dans la seconde moitié du XIXe siècle', *Romantisme*, no. 54 (1986), pp. 89–113

BOXER, M.J., *Socialism faces Feminism in France, 1879–1889*, Ph.D. dissertation, University of California, 1975

BOXER, M.J., 'Women and the Origins of the French Socialist Party: A Neglected Contribution', *Third Republic / Troisième République* (Spring-Fall 1977), pp. 105–167

BOXER, M.J., 'Socialism faces Feminism: The Failure of Synthesis in France, 1879–1914', in Marilyn J. Boxer and Jean H. Quataert (eds.), *Socialist Women, European Socialist Feminism in the Nineteenth and Early Twentieth Centuries*, New York, 1978

BOXER, M.J., 'When Radical and Socialist Feminism were Joined: The Extraordinary Failure of Madeleine Pelletier', in Jane Slaughter and Robert Kern (eds.), *European Women on the Left*, Connecticut, London, 1981, pp. 51–73

BROUDE, N., 'Edgar Degas and French Feminism c 1880: ' "The Young Spartans, the Brothel Monotypes and the Bathers Revisited." ', *The Art Bulletin*, vol. 70, no. 4 (December 1988), pp. 640–59

BUNOUST, M., *Quelques femmes peintres*, Paris, 1936

BUTHMAN, W.C., *The Rise of Integral Nationalism in France*, New York, 1939

CIXOUS, H., 'The Laugh of the Medusa', *Signs*, Summer 1976, revised for E. Marks and I. de Courtiurun (eds.), *New French Feminism*, Brighton, 1981

CLARK, L.L., 'Social Darwinism and French Intellectuals, 1860–1915, Ph.D. dissertation, The University of North Carolina at Chapel Hill, 1968

CLARK, L.L., 'The Molding of The Citoyenne: The Image of the Female in French Educational Literature 1880–1914', *Third Republic / Troisième République*, nos. 3 and 4 (Spring-Fall 1977), pp. 74–104

CLINTON, K.B., 'Enlightenment Origins of Feminism', *18th Century Studies*, 8 (1974–1975), pp. 1283–99

CONRY, Y., *L'Introduction du Darwinisme en France au XIXe siècle*, Paris, 1974

CRESTON, D., *Fountains of Youth: The Life of Marie Bashkirtseff*, London, 1936

DANAHY, M., 'Marceline Desbordes-Valmore and the Engendered Canon', *Yale French Studies*, no. 75 (1989), pp. 129–47

DECAUX, A., *Histoire des françaises*, 2 vols, Paris, 1972

DIJKSTRA, B., *Idols of Perversity, Fantasies of Feminine Evil in fin-de-Siècle Culture*, New York, Oxford, 1986

DURO, P., ' "Les Demoiselles à Copier" in the Second Empire', *Woman's Art Journal*, vol. 7, no. 1 (Spring/Summer 1986), pp. 1–7

DYER, C., *Population and Society in Twentieth Century France*, London, 1978

DZEH DJEN, L., *La Presse Féministe en france de 1869 à 1914*, Paris, 1939

ELWITT, S., *The Making of the Third Republic: Class and Politics in France, 1868–1914*, Baton Rouge, Louisiana, 1975

ELWITT, S., *The Third Republic Defended: Bourgeois Reform in France, 1880–1914*, Baton Rouge, Louisiana, 1986

EVANS, R.J., *The Feminists: Women's Emancipation Movements in Europe, America and Australasia, 1840–1920*, London, 1977

EVANS, R.J., 'Feminism and Anticlericalism in France, 1870–1922', *The Historical Journal*, vol. 25, no. 4 (1982), pp. 947–9

FEE, E., 'Nineteenth Century Craniology: The Study of the Female Skull', *Bulletin of the History of Medicine*, vol. 53, no. 3 (Fall 1979), pp. 415–33

FEHRER, C., 'New light on the Académie Julian

and its founder (Rodolphe Julian)', *Gazette des Beaux-Arts* (1984), pp. 207–14

FIDELL-BEAUFORT, M., 'Elizabeth Jane Gardner Bouguereau: A Parisian Artist from New Hampshire', *Archives of American Art Journal*, vol. 24, no. 2 (1984), pp. 2–9

FLAMANT-PAPARATTI, D., *Bien-pensantes, cocodettes et bas-bleus*, Paris, 1984

FOSCA, F., *Histoire des cafés de Paris*, Didot, Paris, 1935

FOX-GENEVESE, E., 'Placing Women's History in History', *New Left Review*, no. 133 (1982), pp. 5–29

FRAISSE, S., *Clémence Royer Philosophe et femme de sciences*, Paris, 1985

GABHART, A., and Brown, E., 'Old Mistresses: Women Artists of the Past', *Walters Art Gallery Bulletin*, vol. 24, no. 7 (1972)

GARB, T., *Women Impressionists*, London, 1986

GARB, T., 'Review of Charlotte Yeldham, Women Artists in Nineteenth Century England and France', *Woman's Art Journal*, vol. 8, no. 1 (Spring/Summer 1987), pp. 45–8

GARB, T., ' "Unpicking the Seams of her Disguise": Self-Representation in the Case of Marie Bashkirtseff', *Block 13* (Winter 1987/88), pp. 79–86

GARB, T., 'Revising The Revisionists: The Formation of the Union des Femmes peintres et sculpteurs', *Art Journal*, vol. 48, no. 1 (Spring 1989), pp. 63–70

GARB, T., ' "L'Art Feminin": The Formation of a Critical Category in Late Nineteenth-Century France,' *Art History*, vol. 12, no. 1 (March 1989), pp. 39–65

GARB, T., 'Berthe Morisot and the Feminising of Impressionism', T.J. Edelstein (ed), *Perspectives on Morisot*, New York, 1990

GARB, T., 'The Forbidden Gaze: Women artists and the male nude in late nineteenth-century France', K. Adler and M. Pointon (eds.), *The Body Imaged: The Human Form and Visual Culture since the Renaissance*, Cambridge, 1993

GARRIGOU-LAGRANGE, J.M., *Les associations*, Paris, 1975

GENET-DELACROIX, M.C., 'Esthétique officielle et art nationale sous la Troisième République', *Le Mouvement sociale*, no. 131 (April – June 1985), pp. 105–20

GENET-DELACROIX, M.C., 'Vies d'artistes, art académique, art officiel et art libre en France à la fin du dix-neuvième siècle'. *Revue d'histoire moderne et contemporaine*, vol. 33 (January–March 1986), pp. 40–73

GOLDSTEIN, J., 'The Hysteria Diagnosis and the Politics of Anticlericalism in Late Nineteenth-Century France', *Journal of Modern History*, vol. 54 (1982), pp. 209–39

GOLIBER, S.H., 'The Life and Times of Marguerite Durand – A Study, in French Feminsm', Ph.D. dissertation, Kent State University, 1975

GORDON, F., *The Integral Feminist: Madelaine Telletier, 1874–1939*, Oxford, 1990

GREEN, N., 'The Nature of the Bourgeoisie: Nature, Art and Cultural Class Formation in Nineteenth-Century France', Ph.D. dissertation, Portsmouth Polytechnic, 1986

GREEN, N., 'All the flowers in the field: The State, Liberalism and Art in France under the early Third Republic', *The Oxford Art Journal*, vol. 10, no. 1 (1987), pp. 71–84

GREEN, N., 'Dealing in Temperaments: Economic Transformation of the Artistic field in France during the Second Half of the Nineteenth-Century', *Art History*, vol. 10 no. 1 (March 1987), pp. 59–78

GREEN, N., 'Circuits of Production, Circuits of Consumption: The Case of Mid-Nineteenth-Century French Art Dealing, *Art Journal*, vol. 48, no. 1 (Spring 1989), pp. 29–34

GREENHALGH, P., *Ephemeral Vistas: The Expositions Universelles, Great Exhibitions, and Worlds Fairs, 1851–1939*, Manchester, 1988

GREER, G., *The Obstacle Race: The Fortunes of Women painters and their work*, London, 1979

HAUSE, S.C., *Hubertine Auclert: The French Suffragette*, New Haven & London, 1987

HAUSE, S.C., and Kenney, A.R., 'The Development of the Catholic Women's Suffrage Movement in France 1896–1922', *The Catholic Historical Review*, Vol. 67, No. 1 (January 1981)

HAUSE, S.C., and Kenny, A.R., *Women's Suffrage and Social Politics in the French Third Republic*, New Jersey, 1984

HEROLD, M., *L'Académie Julian à cent ans*, Paris, 1968

HESS, T.B., and Baker, E.C.. *Art and Sexual Politics*, New York, London, 1971

HIGGONET, A., 'Secluded Vision: Images of Feminine Experience in Nineteenth-Century Europe', *Radical History Review*, no. 38 (1987), pp. 16–36

HORVATH, S.A., 'Victor Duruy and the Contro-

versy over Secondary Education for Girls', *French Historical Studies*, vol. 9 (1975), pp. 83–104

HUNGERFORD, C.C., 'Meissonier and the founding of the Société Nationale des Beaux-Arts', *Art Journal*, vol. 48, no. 1 (Spring 1989), pp. 71–7

HUTTON, P.H. (ed.), *Historical Dictionary of the Third French Republic*, Westport, Conneticut, 1984

IRIGARAY, L., 'Any Theory of the '"Subject" Has Always Been Appropriated by the Masculine', *Speculum of the Other Woman*, Paris 1974, English translation, New York, 1985, pp. 133–46

IRIGARAY, L., 'The Power of Discourse and the Subordination of the Feminine', *This Sex Which Is Not One*, New York, 1985, pp. 68–85

KLEJMAN, L., and Rochefort, F., *L'Egalité en marche*, Paris, 1989

KLUMPKE, A.E., *Memoirs of an Artist*, (ed. L. Whiting), Boston, 1940

LA PAUZE, A., *Histoire de l'Académie de France à Rome*, Paris, 1923

LANDES, D.S., 'French Entrepreneurship and Industrial Growth in the Nineteenth Century', *Journal of Economic History*, vol. 9, no. 1 (1949), pp. 45–61

LANGLADE, E., *Artistes de mon temps*, Paris, 1929

LANGLOIS, P.F.S., The Feminist Press in England and France 1875–1900, Ph.D. dissertation, University of Massachusetts, 1979

LAURENT, J., *La République des Beaux-Arts*, Paris, 1955

LECLÊRE, A., *Le Vote des femmes en France*, Paris, 1929

LETHÈVE, J., *Daily Life of French artists in the Nineteenth Century*, 1968, English edition, London, 1972

LEVIN, M.R., *Republican Art and Ideology in Late Nineteenth-Century France*, Anne Arbor, 1986

LINDSAY, S.G., 'Berthe Morisot: Nineteenth-Century Woman, as Professional, T.J. Edelstein (ed), *Perspectives on Morisot*, New York, 1990

MAGRAW, R., *France 1815–1914, The Bourgeois Century*, London, 1983

MAINARDI, P., *The End of the Salon*, Cambridge, 1992

MAINGOT, E., *Le Baron Taylor*, Paris, 1963

MARLAIS, M., *Conservative Echoes in fin-de-siècle Parisian Art Criticism*, Pennsylvania

State University Press, 1992

MARX, C.R., *Eva Gonzalès*, Paris, 1950

MATHEWS, N.M., 'Mary Cassatt and the "Modern Madonna" of the Nineteenth Century', Ph.D. dissertation, New York University, 1980

MATHEWS, N.M., (ed.), *Cassatt and her Circle, Selected Letters*, New York, 1984

MAYEUR, F., *L'Education des filles en France au XIXe siècle*, Paris, 1979

MCLAREN, A., 'Sex and Socialism: The Opposition of the French Left to Birth Control in the Nineteenth Century', *Journal of the History of Ideas*, 37 (1976)

MCMILLAN, J.F., *Housewife or Harlot: The Place of Women in French Society, 1870–1940*, New York, 1981

MCMILLAN, J.F., 'Clericals, Anticlericals and the Women's Movement in France under the Third Republic', *The Historical Journal*, vol. 24, no. 2 (1981), pp. 361–76

MELOT, M., ' "La Mauvaise Mère", Etude d'un thème Romantique dans l'estampe et la littérature', *Gazette de Beaux Arts*, vol. 79 (1972), pp. 167–76

MITCHELL, C., 'Intellectuality and Sexuality: Camille Claudel, The Fin-de-Siècle Sculptress', *Art History*, vol. 12, no. 4 (December 1989), pp. 419–47

MOSES, C.G., 'The Evolution of Feminist Thought in France, 1829–1889', M. Phil, George Washington University, 1972

MOSES, C.G., 'Saint-Simonian Men/Saint-Simonian Women: The Transformation of Feminist Thought in 1830s France', *The Journal of Modern History*, vol. 54, no. 2 (June 1982), pp. 240–67

MOSES, C.G., *French Feminism in the Nineteenth Century*, Albany, 1984

MOULIN, R., 'Champ artistique et société industrielle capitaliste', *Société, Science et Conscience de la Société, Mélanges en l'honneur de Raymond Aron*, Paris, 1971

MOULIN, R., *Le Marché de la peinture en France*, Paris, 1972

MULVEY, L., 'Changes: Thoughts on Myth, Narrative and Historical Experience', *Visual and Other Pleasures*, London, 1989, pp. 159–76

NESBITT, M., 'The Language of Industry', *The Definitively Unfinished Marcel Duchamp*, (ed. T. du Duve), Cambridge and London, 1991

NOCHLIN, L., 'The Invention of the Avantgarde', *Art News Annual*, vol. 34, 1968

NOCHLIN, L., 'Why Have There Been No Great Women Artists?', *Art News*, New York (January 1971), reprinted in Hess and Baker (see separate entry)

NORA, P. (ed.), *Les Lieux de mémoire*, Paris, 1984

NYE, R.S., *The Origins of Crowd Psychology; Gustave Le Bon and the Crisis of Mass Democracy in the Third Republic*, London, Beverly Hills, 1975

NYE, R.S., *Crime, Madness and Politics in Modern France: The Medical Concept of National Decline*, New Jersey, 1984

OFFEN, K., 'Depopulation, Nationalism and Feminism in fin-de-siècle France', *American Historical Review*, vol. 89, no. 3 (June 1984), pp. 648–77

ORTNER, S.B., 'Is Female to Male as Nature is to Culture?', *Woman, Culture and Society*, (eds. M.Z. Rosaldo and L. Lamphere), California, 1974

ORWICZ, M.R., 'Anti-Academicism and State Power in the Early Third Republic', *Art History*, vol. 14, no. 4 (December 1991)

ORY, P., 'Le ' "Grand Dictionnaire" de Pierre Larousse', vol 1: 'La République', *Les Lieux de mémoire*, ed. P. Nora, 4 vols, Paris, 1984

ORY, P., 'Le Centenaire de la Révolution française', vol 1: 'La République', *Les Lieux de mémoire*, ed. P. Nora, 4 vols, Paris 1984

OZOUF, M., *L'Ecole, l'Eglise et la République*, 1871–1914, Paris, 1963

PALMADE, G., *French Capitalism in the Nineteenth Century*, English edition, Newton Abbot, 1972

PAUL, H.W., 'The Debate over the Bankruptcy of Science in 1895', *French Historical Studies*, vol. 5, no. 3 (1968), pp. 299–327

PERROT, P., 'Le jardin des modes', J.-P. Aron, *Miserable et Glorieuse, La femme de XIXe siècle*, Brussels, 1984

MUSÉE du Petit Palais, *Le Triomphe des Mairies*, Paris, 1986

MUSÉE du Petit Palais, *Quand Paris dansait avec Marianne*, Paris, 1989

PEVSNER, N., *Academies of Art, Past and Present*, London, 1940

PHILLIPS, C.S., *The Church in France 1848–1907*, London, 1936

PARKER, R., and Pollock, G., *Old Mistresses: Women, Art and Ideology*, London, 1981

POLLOCK, G., *Mary Cassatt*, London and New York, 1980

POLLOCK, G., 'Art, Artschool, Culture: Individualism after the Death of the Artist', *Block*, no. 11 (1985/6)

POLLOCK, G., *Vision and Difference: Femininity, Feminism and Histories of Art*, London, 1988

POPE, B.C., 'Angels in the Devil's Workshop: Leisured and Charitable Women in Nineteenth Century England and France', in R. Bridenthal and C. Koonz (eds.), *Becoming Visible, Women in European History*, Boston, London et al, 1977

PUJET, J., *La Duchesse d'Uzès*, Uzès, 1972, 2nd edition

RABAUT, J., *Histoire des féminismes françaises*, Paris, 1978

RABAUT, J., *Féministes à la belle époque*, Paris, 1985

RADYCKI, D., 'The Life of Lady Art Students: Changing Art Education at The Turn of the Century', *The Art Journal* (Spring 1982)

REWALD, J., *The History of Impressionism*, London, 1973

RIÈSE, L., *Les Salons littéraires parisiens du Second Empire à nos jours* Toulouse, 1962

RIFKIN, A., 'The Sex of French Politics,' *Art History*, vol. 6, no. 3 (September 1983), pp. 368–73

SAUER, M., *L'entrée des femmes à l'Ecole des Beaux-Arts 1880–1923*, Paris, 1990

SCHNEIDER, W., 'Toward The Improvement of the Human Race: The History of Eugenics in France', *Journal of Modern History*, vol. 54, no. 2 (June 1982), pp. 268–91

Shepherd Gallery, *The Julian Academy, Paris 1868–1939*, New York, 1989

SHIFF, R., *Cézanne and the End of Impressionism*, Chicago, London, 1984

SHOWALTER, E., *The Female Malady: Women, Madness and English Culture, 1830–1890*, London, 1987

SILVER, C.B., 'Salon, Foyer, Bureau: Women and the Professions in France', in Joan Huber (ed.), *Changing Women in a Changing Society*, Chicago and London, 1973, pp. 74–89

SILVERMAN, D.L., 'Nature, Nobility and Neurology: The Ideological Origins of Art Nouveau in France, 1889–1900', Ph.D. dissertation, Princeton University, 1983

SILVERMAN, D.L., *Art Nouveau in fin-de-siècle France*, California, 1989

SLATKIN, W., 'Women Artists (sic) And EBA: a study of institional (sic) change in Late Mineteenth (sic) Century France', 1981,

unpublished manuscript, Centre du Documentation, Musée d'Orsay, Paris

SMITH, B.G., *Ladies of the Leisure Class*, Princeton, 1981

*Société de l'Union des Femmes Peintres et Sculpteurs*, 1979

SOWERWINE, C., *Sisters or Citizens? Women and Socialism in France since 1876*, Cambridge, 1982

SULLEROT, E., *Histoire de la presse féminine en France, des origines à 1848*, Paris, 1966

TERDIMAN, R., *Discourse/Counter Discourse: The Theory and Practice of Symbolic Resistance in Nineteenth Century France*, Ithaca and London, 1985

THOMAS, E., *The Women Incendiaries*, 1963, English translation, London, 1967

TICKNER, L., *The Spectacle of Women: Imagery of The Suffrage Campaign 1907–1914*, London, 1987

TINT, H., *The Decline of French Patriotism 1870–1940*, London, 1964

TOURNEUX, M., *Salons et expositions d'art à Paris 1801–1870, Essai Bibliographique*, Paris, 1919

VAISSE, P., 'La Troisième République et les peintres: Recherches sur les rapports des pouvoirs publics et de la peinture en France de 1870 à 1914', Thèse, Doctorat d'Etat, Université de Paris IV, 1980

VAISSE, P., 'Salons, expositions et sociétés d'artistes en France 1871–1914,' in *Saloni, Gallerie, Musei e loro influenza sullo sviluppo dell'arte dei secoli XIXe XX*, ed. F. Haskell, Atti dell XXIV Congresso Internazionale di Storia dell'Arte, Bologna, 7, 1981

VAISSE, P., 'Annexe sur l'image du marchand de tableaux pendant le XIXe siècle',

*Romantisme*, 40 (1983), pp. 77–86

VICINUS, M. (ed.), *Suffer and Be Still: Women in the Victorian Age*, Indiana, 1973

WARD, M., 'Impressionist Installations and Private Exhibitions', *Art Bulletin*, vol. LXXIII, no. 4 (December 1991)

WAUGH, L.J., *The Images of Women in France on the Eve of the Loi Camille Sée 1877–1880*, Chicago, 1977

WEBER, E., *France, Fin-de-Siècle*, Cambridge, Massachusetts, 1986

WEXLER, V.G., 'Made for Man's Delight: Rousseau as Anti-Feminist', *American Historical Review*, vol. 81 (1976), pp. 260–91

WHITE, H., and White, C., *Canvases and Careers: Institutional Change in the French Painting World*, New York, 1965

WILDENSTEIN, D., 'Salon des Refusés de 1863: Catalogue et Documents', *Gazette des Beaux-Arts* (September 1965)

WILKINS, W.H., 'The Paris International Feminist Congress of 1896 and its French antecedants', *North Dakota Quarterly* (Autumn 1975), pp. 5–28

WOLFF, J., 'The Invisible flâneuse: Women and the Literature of Modernity', *Theory, Culture and Society*, vol. 2, no. 3 (1985)

YELDHAM, C., *Woman Artists in Nineteenth-Century France and England*, 2 vols, New York and London, 1984

ZELDIN, T., *Conflicts in French Society: Anticlericalism, Education and Morals in the 19th Century*, London, 1970

ZELDIN, T., *France 1848–1945: Politics and Anger*, Oxford, 1978

ZELDIN, T., *France 1848–1945: Ambition and Love*, Oxford, 1979

ZILHARDT, M., *Louise Catherine Breslau et ses amis*, Paris, 1932

# Index